*The Woman of Ideas in French Art, 1830–1848*

# The Woman of Ideas in French Art, 1830–1848

*Janis Bergman-Carton*

Yale University Press
New Haven and London

Published with assistance from the Charles A. Coffin Fund.

Designed by Deborah Dutton.
Set in New Baskerville type by The Composing Room of Michigan, Inc.,
Grand Rapids, Michigan.
Printed in the United States of America by Edwards Brothers, Inc., Ann
Arbor, Michigan.

**Library of Congress Cataloging-in-Publication Data**

Bergman-Carton, Janis.
    The woman of ideas in French art, 1830–1848 / Janis Bergman-Carton.
      p.    cm.
    Includes bibliographical references (p.    ) and index.
    ISBN 0-300-05380-0
    1. Women in art.  2. Art, French.  3. Art, Modern—19th century—
France.  I. Title.
    N7638.F8B47  1995
    760′.04424′094409034—dc20                94-31440
                                                     CIP

A catalogue record for this book is available from the British Library.

10  9  8  7  6  5  4  3  2  1

# Contents

# Illustrations

1. Wattier. *Ce que l'on voit trop souvent: Jeunes filles lisant le roman de Faublas.* 1828. Paris, Bibliothèque Nationale, Cabinet des Estampes. Photo B. N.

2. Anonymous. *A Versailles, à Versailles, du 5 octobre 1789.* c. 1789. Paris, Musée Carnavalet. Cliché phototèque des musées de la Ville de Paris. ©1994 ARS, New York/SPADEM, Paris.

3. *Cast of the Seal of the First Republic.* 1792. Paris, Archives Nationales, Collection de Sceaux.

4. Thomas Rowlandson. *The Contrast.* 1792. London, British Museum.

5. Michel Delaporte. *Les Parisiennes du 27, 28, et 29 juillet, 1830.* 1830. Paris, Bibliothèque Nationale, Cabinet des Estampes. Photo B. N.

6. Anonymous. *Héroïsme des dames de Paris dans les journées des 27, 28, 29 juillet 1830.* 1830. Paris, Bibliothèque Nationale, Cabinet des Estampes. Photo B. N.

7. Michel Delaporte. *Scène du 27 juillet—première victime.* 1830. Paris, Bibliothèque Nationale, Cabinet des Estampes. Photo B. N.

8. Anonymous. *Le Monde renversé.* 1842. Paris, Bibliothèque Nationale, Cabinet des Estampes. Photo B. N.

9. Anonymous. *Occupations journalières des Saint-Simoniens.* 1832. Paris, Bibliothèque Nationale, Cabinet des Estampes. Photo B. N.

10. Anonymous. *La Femme libre. Elle est trouvée!* From *La Charge,* 20 April 1833. Paris, Bibliothèque Nationale, Cabinet des Estampes. Photo B. N.

11. Anonymous. *Détails sur un double suicide de Perret-Desessarts et de Claire Démar.* 1833. Paris, Bibliothèque Nationale, Cabinet des Estampes. Photo B. N.

12. Paul Gavarni (Sulpice-Guillaume Chevalier). *Les Femmes Politiques.* In *Les Français peints par eux-mêmes.* 1842. Courtesy of the Harry Ransom Humanities Research Center, University of Texas at Austin.

13. Jean-Ignace-Isidore Grandville. *La Littérature nous refait une virginité.* n.d. Paris, Bibliothèque Nationale, Cabinet des Estampes. Photo B. N.

14. Paul Gavarni (Sulpice-Guillaume Chevalier). *Tout, nous le savons bien, n'est pas couleur de rose.* From *Le Diable à Paris, Paris et les parisiens,* 1845–46. Courtesy of Perry-Castañeda Library, University of Texas at Austin. Photo by Ron Jameson.

15. Paul Gavarni (Sulpice-Guillaume Chevalier). *Le Compte.* From *Le Diable à Paris, Paris et les parisiens,* 1845–46. Courtesy of Perry-Castañeda Library, University of Texas at Austin. Photo by Ron Jameson.

16. François Le Villain. *L'Auguste Famille.* 1832. Paris, Bibliothèque Nationale, Cabinet des Estampes. Photo B. N.

17. Anonymous. *Marie-Caroline.* 1833. Paris, Bibliothèque Nationale, Cabinet des Estampes. Photo B. N.

18. Nicolas-Eustache Maurin. *Je suis bien.* c. 1832. Paris, Bibliothèque Nationale, Cabinet des Estampes. Photo B. N.

19. Alcide Lorentz. *Miroir Drolatique.* 1842. Paris, Bibliothèque Nationale, Cabinet des Estampes. Photo B. N.

20. Jules Boilly. *Mme G. Sand.* 1837. Paris, Bibliothèque Nationale, Cabinet des Estampes. Photo B. N.

21. Bernard-Romain Julien. *George Sand.* 1838. Paris, Bibliothèque Nationale, Cabinet des Estampes. Photo B. N.

22. Anonymous. *Ce beau candidat.* 1848. Paris, Bibliothèque Nationale, Cabinet des Estampes. Photo B. N.

23. Auguste Charpentier. *George Sand.* 1839. Paris, Musée Carnavalet. Cliché phototèque des musées de la ville de Paris. © 1994 ARS, New York/SPADEM, Paris.

24. Anonymous. *La Gigogne politique de 1848.* 1848. From *Le Monde Illustré,* 16 August 1884. Paris, Bibliothèque Nationale. Photo B. N.

25. Henri Emy. *Manifestations des femmes.* From *Le Charivari,* 31 March 1848. Courtesy of Houghton Library, Department of Printing and Graphic Arts, Harvard University.

Print Collection, Miriam and Ira D. Wallach Division of Art, Prints, and Photographs. Astor, Lenox, and Tilden Foundations.

41. Honoré Daumier. *Académie des femmes*. From *Le Charivari*, 2 August 1843. Boston, Houghton Library, Department of Printing and Graphic Arts, Harvard University.

42. Honoré Daumier. *Emportez donc ça plus loin . . .* From *Le Charivari*, 2 March 1844. Paris, Bibliothèque Nationale, Cabinet des Estampes. Photo B. N.

43. Honoré Daumier. *Dis donc . . . mon mari . . .* From *Le Charivari*, 1 February 1844. Boston, Museum of Fine Arts.

44. Honoré Daumier. *Ma bonne amie, puis-je entrer . . .* From *Le Charivari*, 30 May 1844. New York Public Library, Print Collection, Miriam and Ira D. Wallach Division of Art, Prints, and Photographs. Astor, Lenox, and Tilden Foundations.

45. Honoré Daumier. *Toast porté à l'émancipation des femmes . . .* From *Le Charivari*, 12 October 1848. Boston, Museum of Fine Arts.

46. Honoré Daumier. *L'Insurrection contre les maris . . .* From *Le Charivari*, 20 April 1849. Paris, Bibliothèque Nationale, Cabinet des Estampes. Photo B. N.

47. Honoré Daumier. *Ah! Vous êtes mon mari . . .* From *Le Charivari*, 23 May 1849. New York Public Library, Print Collection, Miriam and Ira D. Wallach Division of Art, Prints, and Photographs. Astor, Lenox, and Tilden Foundations.

48. Honoré Daumier. *Citoyennes . . . on fait courir le bruit . . .* From *Le Charivari*, 4 August 1848. Waltham, Massachusetts, Brandeis University Libraries, Benjamin A. and Julia M. Trustman Collection.

49. Honoré Daumier. *Ecce homo*. c. 1849. Museum Folkwang Essen.

50. Honoré Daumier. *Le Meunier, son fils, et l'âne*. 1849. Glasgow Museums: Burrell Collection.

51. Honoré Daumier. *Voila une femme . . .* From *Le Charivari*, 12 August 1848. Waltham, Massachusetts, Brandeis University Libraries, Benjamin A. and Julia M. Trustman Collection..

52. Honoré Daumier. *La Laveuse*. 1850. Paris, Musée d'Orsay. Photo R. M. N.

53. Honoré Daumier. *La République*. 1849. Paris, Musée d'Orsay. Photo R. M. N.

54. Philippe Van Bree. *L'Atelier de femmes peintres*. c. 1833. Brussels, Galerie d'Arenberg. Photo Speltdoorn et fils.

55. Paul Delaroche. *The Reading Lesson*. 1848. Reproduced by permission of the Trustees of the Wallace Collection, London.

73. Emile Signol. *Jesus Christ Pardoning the Adulterous Woman.* 1842. © Detroit Institute of Arts, Founders Society Purchase, Acquisitions Fund.

74. Gustave Courbet. *La Liseuse d'Ornans.* 1868–72. Washington, D.C., National Gallery of Art. Chester Dale Collection. © 1993.

75. Engraving after painting attributed to Correggio. *La Madeleine au désert.* From *Journal des Artistes,* 25 July 1841. Paris, Bibliothèque Nationale. Photo B. N.

76. J. B. C. Corot. *Forest of Fountainbleau.* c. 1830. Washington, D.C., National Gallery of Art, Chester Dale Collection. © 1993.

77. J. B. C. Corot. *La Madeleine lisant.* 1854. Paris, Musée d'Orsay. Photo R. M. N.

78. Correggio. *The Magdalene.* c. 1515. London, National Gallery.

79. Lithograph after Camille Roqueplan. *Ste. Madeleine.* From *Revue des peintres* (1837). Paris, Bibliothèque Nationale. Photo B. N.

80. Engraving after T. Gechter. *La Madeleine au désert.* From *L'Illustration* 1 (1844). Courtesy of Perry-Castañeda Library, University of Texas at Austin. Photo by Ron Jameson.

81. Jules Lefebvre. *Marie-Madeleine dans la grotte.* 1876. St. Petersburg, Hermitage Museum.

82. Attributed to Louis Boulanger. *George Sand.* From *Aesculape,* February 1953.

83. Attributed to Louis Boulanger. *George Sand en Madeleine.* c. 1839. *Historia* 355 (June 1976).

84. Eugène Delacroix. *Madeleine dans le désert.* 1845. Paris, Musée Delacroix. Photo R. M. N.

85. Henri Lehmann. *Portrait of Mme Clémentine Karr.* 1845. Minneapolis Institute of Arts.

86. Mlle Rivière. *Portrait of a Lady with a Lyre.* 1806. Moscow, Pushkin State Museum of Fine Arts.

87. Baron Gros. *Sappho at Leucade.* 1801. Musée Baron Gérard. Cliché spécial de la ville de Bayeux.

88. J. L. David. *Sappho and Phaon.* 1809. St. Petersburg, Hermitage Museum.

89. Nicolas-André Monsiaux. *Socrates and Aspasie.* 1801. Moscow, Pushkin State Museum of Fine Arts.

90. Elizabeth Vigée-Lebrun. *Mme de Staël as Corinne.* 1808–9. Photo Alrège S. A., Collection Château de Coppet.

91. François Gérard. *Corinne at Capo Miseno.* 1821. Lyon, Musée des Beaux-Arts. Photo Studio Basset.

92. Théodore Chassériau. *Sapho prête à se précipiter du rocher de Leucade.* 1849. Paris, Musée d'Orsay. Photo R. M. N.

# Acknowledgments

In one sense the process of writing this book began ten years ago with a dissertation. In another sense it began with a question that I have been thinking about since I was twelve years old: what has to happen (or not happen) to a girl in order for her to identify herself as an intellectual being, as a person of ideas? It is a question that has figured in my life, in part because I always have had the incredible good luck to be surrounded by strong and smart women. This was true of my earliest and most longstanding friendships with Emily Berger and Nancy Dangel. And it is true of the relationships I have established as an adult with Lily Bezner, Anna Carroll, Elizabeth Butler Cullingford, Susan Sage Heinzelman, Ellen Krasik, Eunice Lipton, the late Joan Lidoff, and Jane Marcus. These are all what my friend Liz would call "women of opinions," women who speak and think and act in the world. I thank them with all my heart for enriching this project and my life.

The question of how a girl comes to hold a position of power continues to occupy my thoughts in even more personal and pressing ways as I watch my daughters, Jacqueline and Rebecca, negotiate their places in the world. Their self-possession and strength is a daily source of pleasure and inspiration. In many ways, the imperative for this study came from them.

I would also like to acknowledge some of the individuals who kept me engaged and energized throughout my years as a student. Sandra Hind-

man was my first teacher, in a class at Johns Hopkins University, to demonstrate the rigors and pleasures of thinking about visual culture. Richard Brettell introduced me to the staggering power of images in the classroom. Jacqueline Barnitz and John R. Clarke have been truly generous and inspiring mentors. And Anne McCauley, who was my adviser at the University of Texas at Austin and first read this as a dissertation, taught me more than anyone else about reading and research and excellence.

My work on this book was sustained in more concrete ways through the generosity of many institutions and people. My wholehearted thanks go to the staffs of the Archives Nationales, the Cabinet des Estampes of the Bibliothèque Nationale, the Bibliothèque de l'Arsenal, the Documentation du Louvre, and the Musée Carnavalet. I am also grateful to the Samuel H. Kress Foundation, the Social Science Research Council, the Swann Foundation for the Study of Caricature, the Woodrow Wilson Foundation, the University of Texas at Austin, and Southern Methodist University, whose generous research grants made this book possible.

To those who have provided suggestions and read parts of the manuscript along the way, my deep thanks: Elizabeth Childs, John R. Clarke, Holly Clayson, Susan Sage Heinzelman, Linda Henderson, Nancy Keeler, Pat Kruppa, Annette Leduc, Eunice Lipton, Anne McCauley, Jane Marcus, Kirsten Powell, and Richard Shiff. Thanks, too, to my colleagues at Southern Methodist University for their generosity and support; to Françoise Gacougnelle for her assistance with several translation questions; to Judy Metro and Heidi Myers at Yale University Press, who have made this first book experience a pleasure rather than a nightmare; and to my parents for their love and for their confidence in me.

Finally, I would like to acknowledge my greatest debt. For my husband, Evan Carton, gratitude is a completely inadequate expression. His dazzling critical intelligence and his intellectual and emotional partnership have sustained me throughout this process and through many years of my life. This book is dedicated to him.

*The Woman of Ideas in French Art, 1830–1848*

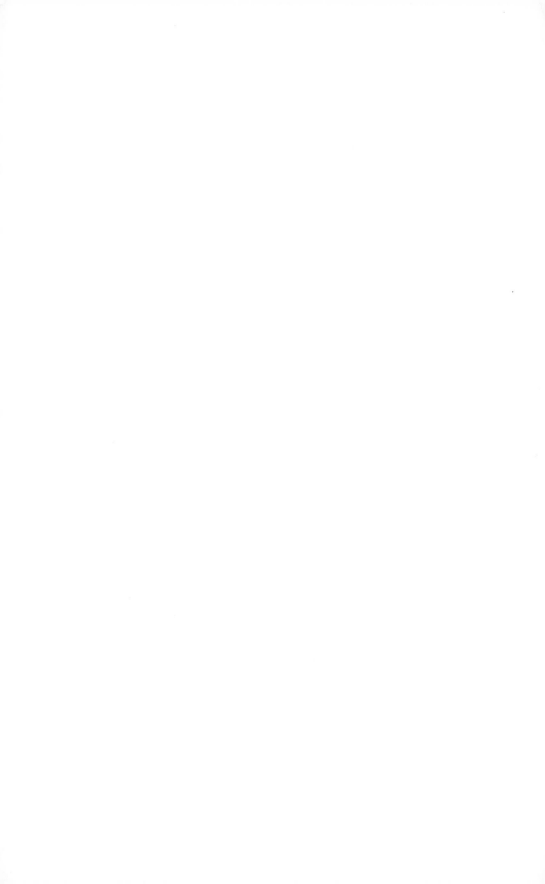

# Introduction

The 1970s and 1980s produced many iconographical studies of female typological imagery in nineteenth-century French caricature and painting. These studies, dominated by accounts of courtesans and women victimized into prostitution by social and economic constraints, have called attention to an obsession with the condition of French working-class women. But their focus on victimized women has perpetuated this single model of female identity at the expense of other more complex and equally historical ones. In this book I resurrect an alternative model, prevalent in nineteenth-century art and life yet ignored in twentieth-century critical literature: that of the intellectual or political woman, the "woman of ideas."

Although the concept of the woman of ideas in France is centuries old, the classification is not.[1] More commonly and derogatorily labeled *le bas-bleu, le femme-homme,* or *l'amazone-littéraire,* the woman of ideas is a typology born of the success and controversies surrounding such figures as Christine de Pisan and Germaine de Staël, women whose published works were viewed by many as invasions of the masculine realm of written culture. The phrase "woman of ideas" refers to a figure principally identified by her nineteenth-century contemporaries (satirically or not) as an intellectual being who recognizes and uses the power of words to influence public opinion. It does not refer to the scores of intelligent and talented women with careers in painting, music, or education, fields in which women were able to function in a manner less threatening to male assessments of the

"feminine nature."[2] Rather, the label is intended exclusively to designate women operating in the fields of literature and politics—two highly visible, valued, and interactive aspects of French public life.

Though women in literature are part of a longer and more accepted tradition than are women in other fields, historically they have been the focus of the most virulent and misogynist attacks. Because of their large representation in a highly politicized profession, and because their ability to use the French language has given them access to the discursive structures of French culture, women of letters have always been associated with actual and potential challenges to the hegemony of male privilege. The period of challenge addressed in this book is the July Monarchy, the years from 1830 to 1848, when Louis-Philippe ruled France as its first constitutional monarch. These years also mark the first era of revitalized female literary and political activity since the French Revolution. This revitalization was, in part, a function of a shift in the power structure of the French literary community from the private arena of salon culture to the public arena of mass media. The woman of ideas flourished with the rapid growth of the popular press. Certain middle- and working-class women to whom most professions had been closed because of legal, economic, or educational restrictions were able to claim a career in letters after 1830.

The visibility of the woman of ideas was further enhanced by the reemergence of a women's emancipation movement that developed in the context of utopian socialist reform rhetoric. Leaders of French socialist movements tended to associate women's rights with workers' rights and general political reform. Charles Fourier and the Saint-Simonist leader Prosper Enfantin, for example, viewed female liberation as the natural measure of the larger struggle to achieve a communal society free of inequities.

In this book I map the changing position of the woman of ideas in July Monarchy caricature and painting. Moreover, I examine how high art, which imposed a patriarchal and culturally normalizing vernacular of religious and nationalistic iconography, domesticated the image of deviant womanhood evoked in caricatures of the woman of ideas. My study foregrounds the contribution of the visual arts to the cultural mechanisms that undermined the power and visibility that the woman of ideas achieved after 1830 and that guaranteed her legal disenfranchisement after the failure of the Revolution of 1848.

Although I have been influenced by the literature of T. J. Clark, James Cuno, Michael Driskell, Michael Marrinan, and Neil McWilliams on July Monarchy art, and Linda Nochlin, Marcia Pointon, Griselda Pollock, Carol Armstrong, and Lisa Tickner on conventions of the female body, I am indebted most profoundly to social historians and cultural mythographers. It is, for instance, the work of Neil Hertz, Lynn Hunt, and Joan Landes on

female political iconography, and Natalie Zemon Davis' feminist revision of Bakhtin's theories of spectacle and masquerade that figure most prominently in my analysis of the gendered politics of nineteenth-century liberal republicanism. Walter Benjamin's discussions of the French *physiologie* tradition and Roland Barthes' analyses of social mythmaking and the semiotics of bourgeois culture underpin my characterization of the woman of ideas and her presence in the dominant cultural metaphors of the July Monarchy.

In this book I move between a recovery of the narratives of excess and perversity that characterized female intellect during the July Monarchy and a discussion of the broader cultural practices used to consolidate relations of power in which these narratives figured. I am particularly interested in the micropolitical moments of resistance that offer strategies for the rescripting of conventional typologies of the woman of ideas. This is most richly explored in the work of women who were both producers and objects of representation, authors of a text and the text itself.

In the first chapter I outline the lineage of the woman of ideas and her shifting classifications from eighteenth-century *salonnière* to nineteenth-century bourgeois *femme-auteur* and *prolétaire Saint-Simonienne*. I survey the qualities ascribed to her irrespective of class origins and underscore the historically continuous intersection of "the woman question" with controversies over class fluidity and social reorganization. Finally, I suggest how the shift from what Joan Landes describes as "the iconic imagery of the Old Regime to the symbolic structure of bourgeois representation was constitutive of modern politics as a relation of gender."[3] The conflation of the sexual and the political within nineteenth-century visual and textual figurations of the woman of ideas forms the subtext of this study.

In Chapter 2, I classify the varieties of women of ideas that appeared in caricatural series between 1830 and 1848 and account for their increase in quantity and their deviation from conventional representations. In particular I look at the journalistic and social reformist activities of a community of working-class Saint-Simoniennes and the expanded opportunities for a career in letters for intellectual women within what Saint-Beuve labeled *la littérature industrielle*, the increasingly lucrative and commercially interdependent enterprises of journalism and literature.

In Chapter 3, I juxtapose a detailed iconographical analysis of Honoré Daumier's three lithographic series on the woman of ideas (the most extensive caricatural treatment of the subject) with his twenty-one chronologically proximate paintings of ideal womanhood. What is striking in nearly every work produced by Daumier during the Second Republic is the artist's preoccupation with maternal duty. I discuss his reduction of the female form to the dichotomy of angelic mother or demonic whore both in terms of the increased vocality and visibility of the woman of ideas in this period

and contemporary philosophical efforts to elaborate a religion of woman-hood. Revitalizing the ideological constructs of Jean-Jacques Rousseau, social theorists like Jules Michelet and Auguste Comte—responding to a post-1789 republican impulse to find secular replacements for deposed Christian and monarchic patriarchies—cast the woman of ideas as Lilith, a female type antithetical and dangerous to the maternal ideal.

I begin the discussion of manifestations of this theme in painting and sculpture in Chapter 4. I look specifically at the impact of the woman of ideas on the iconographical revisions of two traditions: images of *la liseuse* and images of Mary Magdalene. The proliferation and interplay of these two themes during the July Monarchy are contextualized within the rise in female literacy rates and the elaboration of the socialist construct of *la femme-messie*. The veneration of both Mary Magdalene and the woman of ideas as the redemptrice of France in this period by romantic philosophers and socialist reformers inspired a series of works that sought to refashion the objectifying conventions of the female figure and to generate a new iconography of female interiority.

In Chapter 5, I similarly propose a rereading of painted images that respond to the intellectual woman's notoriety and prolificacy, but within the arena of portraiture. I begin by looking at early nineteenth-century muse portraits and representations of the first woman of ideas, Sappho, and analyze the changes in print culture that allowed for increased female participation in the literary community. In the second half of the chapter I deal with the commodification of the *femme-auteur* portrait within the context of the commercialization of the book trade and conclude with case studies of portraits of Louise Colet, Marie d'Agoult, and George Sand. The figurations of these three femmes-auteurs demonstrate the range of experimentation within portraiture of literary women between 1830 and 1848, from artists who continued to identify with the normalizing category of the muse to those who actively sought to challenge and problematize representations of the intellectual woman.

In conclusion, I suggest how the iconography of the woman of ideas in French caricature is adapted to the conventions of allegorical imagery. Within this genre, in which gender confusion is deployed as a metaphor for *le monde renversé,* the equation of sexual and political threat is most explicit. By exploring not only the graphic and comic expressions of this female type but also its painted, high art transmutations, I seek to expose a powerful cultural mechanism for subverting female behavior that deviates from the social norm. I attempt to move beyond the establishment and classification of new material to explore the historiographical and theoretical implications of the question of how visual imagery mediates social constructions of gender.

# 1

## *The Woman of Ideas in France During the* Ancien Régime

Le dix-huitième a proclamé le droit de l'homme; le dix-neuvième proclamera le droit de la femme.—Victor Hugo

Dans les monarchies, elles ont à craindre le ridicule, et dans les républiques la haine.—Germaine de Staël

The phenomenon of the French woman of ideas has been associated historically with the kinds of opportunities for education and leisure time that were the exclusive privilege of the aristocracy. Although this book is concerned principally with the July Monarchy—a period of significant increase in opportunities as well as of a shift in the class identification of the woman of ideas to include bourgeois and even working-class women—it seems important to begin by establishing a set of qualities that can be ascribed to the woman of ideas, irrespective of class origins.

French women writers, from Héloïse to Colette, have involved themselves either deliberately or inadvertently in a multivalent political act. During the *ancien régime* the decision to write was made primarily by women with time, education, and resources—women who were in the best position to perceive the inequitable distribution of aristocratic advantage.[1] In other words, the female literary tradition before the nineteenth century was the province of women who belonged to the politically and economically domi-

nant culture. Such women were painfully aware of the contradiction between their wealth of material assets and their impoverished powers of self-determination. Awareness of this contradiction continued to shape the character of the woman of ideas even after 1789. The Revolution had showcased the institutionalized inequities of French society and opened the door of outrage to women in a wider economic spectrum. A heightened sensitivity to the discrepancy between possibility and reality—whether we speak of aristocratic women before the Revolution or of the middle-class *femme-auteur* or *prolétaire Saint-Simonienne* after—seems always to have been the psychological precondition to the evolution of the woman of ideas and the guarantor of her simultaneous politicization.

Women who resisted the sanctioned roles of wife, mother, and financial and psychic dependent made up a small minority.[2] So it is surprising that a second characteristic of the woman of ideas has been her centrality to the debates over the value and cultural position of women that have taken place since the twelfth century. Before the seventeenth century these debates tended to focus on women's moral character; later, questions about their intellectual capacity and social function were raised. However characterized, the woman of ideas has been at the core of the "woman question." Figures like Héloïse, Christine de Pisan, and Louise Labé—women who were among the least representative of female experience within their respective periods—have been invoked during every revival of the philosophical argument over the role of women, either as ideals or as negative models of female behavior. For advocates of greater equality the woman of ideas signified female potential. For those opposed she represented the threat of social degeneration.

During the *ancien régime* the woman question was debated within the framework of taste and style. After the Revolution, when the lives of men and women of the Third Estate were spotlighted, the issues began to change. Bourgeois and poor women, more visible and vocal in a climate sympathetic to the concept of restructuring the hierarchy of power, enlarged feminist concerns to include economics, education, and law—the areas that to this day are the locus of concern for the woman of ideas.[3]

Although the priorities of the woman of ideas have changed with the social origins of those who articulate them, feminist and antifeminist arguments continue to operate within the same theoretical structure. That structure represents the most constant and distinguishing feature of discussions about the intellectual woman. Both before and after 1789 the definition and status of the woman of ideas were intimately connected to larger questions of social reorganization.[4] One of the most cogent discussions of this relation appears in Carolyn Lougee's 1976 treatment of the

seventeenth-century *querelle des femmes*—the social and ideological precursor of nineteenth-century writings on the woman of ideas.[5] Lougee revises the tradition of isolating the "womanism" debate (the discussion of the legal and moral status of women) from larger cultural issues, relocating the argument concerning the woman of ideas within the contemporaneous controversy over class fluidity and social fusion. According to Lougee, the salon—a highly visible and powerful seventeenth-century cultural institution wherein well-positioned women gathered distinguished individuals from the world of politics and letters in the reception rooms of their homes—often functioned as an arena in which class breakdown could occur. Salon society (which determined literature and politics as areas in which the modern woman of ideas would operate) was perceived by the nobility as a jealous and imitative appropriation of the privilege of aristocracy and an extension of court life beyond the parameters of the traditional elite. As Lougee argues, learned women, or *les femmes savantes*, were attacked principally because of their class aspirations. Molière's *salonnières*, for example, are ridiculous not because the notion of a thinking woman is a contradiction in terms but because it appears to connote an unworthy and vulgar copy of an elegant and genteel aristocratic original.[6]

Writers contemptuous of salonnières like Madeleine de Scudéry, Lougee argues, were those uncomfortable with the social fusion associated with the salon. The most obvious and oversimple readings attribute male discomfort to the salonnière's intellectual and social standing, which was enhanced through the illicit education she received in the salon. Although it is true that the salon functioned as "newspaper, journal, literary society and university"[7] for an intelligentsia that included the salonnière, Lougee convincingly argues that its most unsettling feature lay elsewhere. In salons the *nouveaux riches,* who had already profited from the legal benefits of *ennoblement,* received the legitimizing stamp of social acceptability. Resistance to the power of the salonnière had more to do with her part in the obfuscation of class identities than with her intellectual pretentions. Thus, Lougee claims, the seventeenth-century querelle des femmes was more a deflection of aristocratic anxiety over social mobility than a serious consideration of the rights of women.

In the eighteenth century the woman question continued to be debated in concert with the issue of class stratification. In addition to her identification with the salon and with a social-climbing clientele, the woman of ideas became increasingly associated with the novel, a literary genre disparaged by many producers of elite art as immoral and déclassé. The French novel was in part an outgrowth of such revisionist philosophical arguments for female authority as Saint-Gabriel's *Mérite des dames* (1640),

François Poullain de La Barre's *De l'Egalité des deux sexes* (1673), and Marie de Gournay's *Egalité des hommes et des femmes* (1622). These works generated a body of literature that elevated conventionally female qualities like intuition, passion, and emotion (qualities later associated with the romantic artist) and denigrated the traditionally male ethos of brute force and strength. The secularization of neo-Platonic celebrations of love as the natural creative principle of world harmony spawned a concept of womanhood fundamental to the eighteenth- and nineteenth-century "woman's novel" and to the discourse of romanticism.[8] In the tradition of Madeleine de Scudéry and Marie Madeleine de Lafayette, the eighteenth-century novel typically featured noble heroines capable of deep and virtuous love who are destroyed by unworthy and exploitative male lovers.

Outside the salon, print culture provided the most important community for the woman of ideas in the eighteenth century. A career in letters afforded women—especially those from the middle class—an opportunity for commercial success and economic independence. But, perhaps more significantly, it gave women the power to create fictions that questioned and even rescripted the experience of women in French culture. Though legally prohibited from managing their own property, their own finances, and even their own personal relationships, eighteenth-century women novelists had access to a vehicle of social protest. As a principal purveyor of the female creator–male destroyer paradigm, the novel became identified as a feminized genre and the novelist as a subversive.

The novel's threat to traditional social and sexual hierarchies is rehearsed repeatedly in eighteenth- and nineteenth-century essays and prints. Wattier's *Ce que l'on voit trop souvent: Jeunes filles lisant le roman de Faublas* (1828) for example, represents an increasingly common subject in the visual arts (fig. 1). A trio of young women in various stages of deshabille, symbolic of the depraved powers of the novel, revel and swoon over passages they read aloud to one another. This lithograph was part of a pervasive cultural attack on the novel as a morally and artistically bankrupt genre; the rhetoric of the attack, however, betrays a fear of the newly literate constituencies eager to assimilate the alternative behavioral models sanctioned by such works of fiction as François-Thomas Arnaud's *Eustasia, histoire italienne* (1803).

Though male writers of novels outnumbered female writers in the eighteenth century by at least eight to one, the genre continued to be most strongly associated with female readers and authors.[9] To identify a degraded art form with a female sensibility was to control, diminish, and make a concrete target of any real power the woman of ideas might have had as a novelist or even as a novel heroine. In the eighteenth and nineteenth centu-

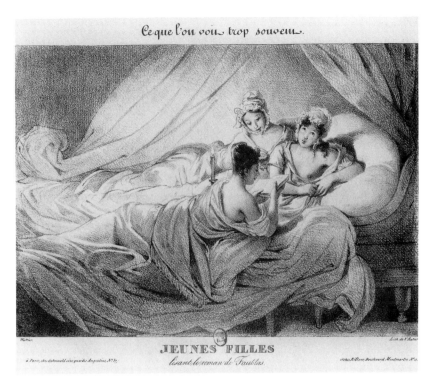

Ce que l'on voit trop souvent.

JEUNES FILLES
lisant le roman de Faublas.

1. Wattier. *Ce que l'on voit trop souvent: Jeunes filles lisant le roman de Faublas.*

ries there was an outpouring of writing about women who were corrupted by the novel and the salon. Numerous essays and anecdotes document a real fear of female domination in Enlightenment society that contradicts every fact of female experience available to us.[10] Thus, as Madelyn Gutwirth has observed, at the same moment that the Parlement de Paris was legislating the inequality of women in the *Ordonnance des donations*[11] Montesquieu was writing in his *Lettres persanes* that "people complain in Persia that the government is controlled by two or three women: it is much worse in France, where women generally govern, and not only assume wholesale all control of authority, but even divide among themselves the retailing of it."[12]

The stereotype of the woman of ideas was altered after 1789. Before the Revolution she was at least an intimate of the aristocracy, if not its native daughter. Her work was principally literary but often reflected or implicitly critiqued sexual and economic institutions before it was fashionable to do so. Like Christine de Pisan and Louise Labé, women of ideas were some-

times class hybrids or products of the kind of fluid circumstance that sensitized them to questions of social inequity. Because of their ambiguous sense of class identification and lack of place in conventional social communities, women like Stéphanie de Genlis turned to writing, a countercultural activity that maximized the advantages of uncertain social identity.

This typological description remained largely valid after 1789, particularly for the increasing number of middle-class female writers. The most radical change in the profile of the woman of ideas at the turn of the century, however, was its inclusion of working-class women.[13] Physically involved on the barricades and intellectually engaged in journalism, pamphleteering, and collective political action, *les femmes prolétaires* gave birth during the Revolution to the stereotype classified during the July Monarchy as *le bas-bleu militant*.[14]

In the upheaval of 1789 women—particularly poor women—were unprecedentedly vocal and active.[15] Believing that the rhetoric of democracy might apply universally, a few women seized the opportunity to promote their own concerns. Their collectivist activities during the Revolution presaged those of the feminist movements of the July Monarchy and Second Empire in social composition, strategy, and issues. Though there were women from all backgrounds participating in Revolutionary activities, the most combative new figures were poor working women, for whom the central issue was subsistence. They wrote and demonstrated not as salonnières or novelists but as militants. Their actions—which included circulating seditious petitions, inciting food riots, and engaging in *taxation populaire*—posed direct challenges to patriarchal authority.[16] Economic hardship combined with radical shifts in authority and the promise of constitutional reform encouraged many women to ignore the risks and add their demands to those being considered by the National Assembly.

The moment of female activism most often illustrated and anecdotalized is the October Insurrection of 1789 (fig. 2). Increased bread prices and the surge of unemployment as aristocrats fled Paris prompted a group of women from the central market districts and the faubourgs to march on Versailles, challenging the king's seeming indifference.[17] They demanded bread and the National Assembly's relocation to Paris. The success and violence of the October Days spawned two cultural mythologies of the woman revolutionary that were to endure throughout the nineteenth century: the anarchic whore on the barricade and the heroic *femme du peuple*. During periods of revolutionary violence these mythologies of female political activism would be increasingly conflated in the popular imagination with the notion of the woman of ideas.

Along with street demonstrations and pamphleteering during this

period came the first women's collective activities in France.[18] One of the earliest political interest groups for women of the Third Estate was the Société des républicaines-révolutionnaires, founded in 1793 by journalists Pauline Léon and Claire Lacombe. Its membership unified the feminist and revolutionary interest groups and contributed to the large production of pamphlets and brochures on women's issues.[19] Representing educated women from the working and middle classes, the group voiced radical social and economic demands that included increased educational opportunities for girls, employment protection, and greater self-determination within marriage.[20] Its most literary and vocal advocates of women's rights included Théroigne de Méricourt and Olympe de Gouges. Méricourt, a professional singer, promoted the idea of women's clubs, organizing among others the Club des amis de la loi in 1790. The widowed De Gouges, daughter of a butcher, turned to writing plays, novels, and essays to convey her politics, as had Christine de Pisan and many other women left without means of support. In 1791 she published her most well-known work, *Déclaration des droits de la femme et de la citoyenne,* which sought greater sexual freedom for women and political rights equal to men's.

Linked to the most radical elements of the Republic, these *sans-culottes* by 1793 found themselves among the political opposition. De Méricourt was publicly whipped. De Gouges was tried for treason and guillotined for her anti-terror propaganda. Lacombe and Léon were arrested and im-

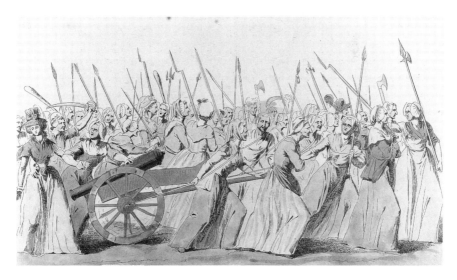

2. Anonymous. *A Versailles, à Versailles, du 5 octobre 1789.*

prisoned. In 1795 the Société des républicaines-révolutionnaires was out-lawed, and women were barred from all forms of public participation when laws that prohibited their public assembly and free speech were passed. Among the remaining evidence of their brief empowerment are popular prints, especially those that allegorize the Revolution in a female form.

The activities of the woman of ideas between 1789 and 1795 were among the most extreme demonstrations of radical social reorganization, the fundamental precept of the Revolution. Reactionary responses to this precept and to the feminists who espoused it can be found in the prolifera-tion of symbols and images that contributed to the new iconology of the Republic. The symbols appeared in various forms—in medals, engravings, paintings, and street pageants—and functioned as a program of public in-struction, disseminating the new Republican ideology and replacing mo-narchic authority. The bourgeois Republic, as Joan Landes asserts, was constituted in and through a discourse on gender relations. In 1792 the goddess of liberty was selected as the emblem of the new Republic (fig. 3). Using a female figure to allegorize political values was by no means a new strategy. There is a lengthy tradition in the visual arts of using the female form to signify such abstract concepts as liberty or charity.[21] The gender play with these allegorical figures took on a new intensity after 1792, how-ever, as political conflicts of the period increasingly were expressed in sex-ual terms. The tranquil, classical, and generalized female figure of the goddess of liberty—different in every way from the masculine and partic-ularized visage of Louis XVI—was intended to erase the iconic imprint of the father-king.[22] But while the virginal goddess signified the beautiful and domesticated Revolution, her body was also the site of oppositional debate. The hideous Revolution, a construct of counterrevolutionary sentiment that often equated political upheaval with the increasing influence of the woman of ideas, was evoked in engravings and broadsides as the grotesque transmutation of liberty. One of the most widely circulated examples is a British response to the French Revolution. Thomas Rowlandson's etching *The Contrast* (1792; fig. 4) pits the classical reserve and dignity of this per-sonification of British liberty against the savage and hideous cruelty of its French counterpart. Rowlandson's image of social disorder, like the major-ity of French and British counter-revolutionary allegorizations, is figured as a mélange of Medusa (the image of terror that Freud equates with the terror of castration) and the contemporary myth of the whore on the barri-cade.[23] Thus the woman of ideas in both her caricatured and allegorized incarnations provided a safe locus for the rechanneling of political anxi-eties after the Revolution.

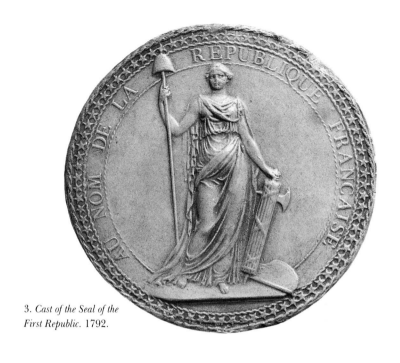

*3. Cast of the Seal of the First Republic.* 1792.

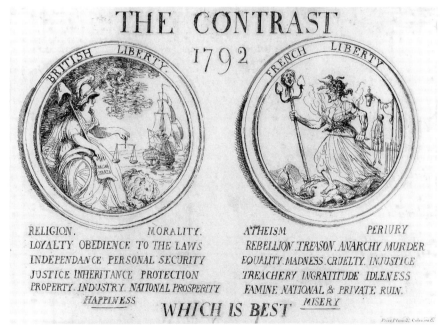

4. Thomas Rowlandson. *The Contrast.* 1792.

After 1795 feminist politics had few avenues of expression. Salon society, which during the Revolution was appropriated from the liberal aristocracy by educated women of the *haute bourgeoisie,* had provided the legitimate environment in which male *philosophes* like the Marquis de Condorcet could argue the question of women's rights (though usually as a side issue to the question of social fusion).[24] But by 1795 even the salons had come under attack as institutions unnaturally controlled by women. As Claire Moses illustrates in *French Feminism in the Nineteenth Century,* the rise in feminist activity between 1789 and 1795 was as rapid and dramatic as its postrevolution suppression. The reaction to the increased vocality and visibility of women was the first of many instances of absolute agreement between the right and the left where women were concerned. Both sides blamed women and sought to punish them for precipitating the Revolution or for undermining it. Royalists blamed their loss of authority on the decadent feminization of aristocratic culture; republicans blamed women for infiltrating the public arena and for inciting discord among male revolutionaries.[25]

Ironically, the most lashing damage to the cause of women can be attributed to Jean-Jacques Rousseau, the republican left's leading spokesperson for democratic principles. With Rousseau, a new model of male liberal politics was established. This model deviated from the historical pattern wherein those who advocated social reorganization were also those who supported increased opportunities for women. Rousseau's social theory of the family underpins nineteenth-century liberal theory, from Michelet to Proudhon. This liberal theory comfortably reconciles efforts to democratize the male power structure with strategies to delimit and domesticate female avenues of influence. Fundamental to this middle-class liberal philosophy was a change in the cast (but not in the form or gender) of the hierarchies of authority. After the Revolution, theological abstraction and worship of the monarchy were replaced by comparable but perhaps more insidious institutions: a religion of the home and a domestic version of the patriarchy. Similarly, Catholic typology and symbology were abandoned only for equally restrictive and normalizing secular paradigms.

The implications of the new models and the attributes of moral and civilized society endorsed by such Enlightenment thinkers as Rousseau, Diderot, and Buffon are inscribed in eighteenth-century paintings of maternal and familial bliss by Greuze, Fragonard, and others.[26] Such works have been contextualized by Carol Duncan as part of the bourgeois cultural mechanism that simultaneously idealizes and constrains women in their roles as wives and mothers. These "angels of the house" are central to the

nineteenth-century construct of "home as sanctuary," man's spiritually redemptive haven from the corruption of modern public life.

Rousseau redefined the woman of ideas as a female type antithetical and dangerous to the maternal ideal. His philosophical writings were seminal to postrevolutionary republicanism, a highly gendered discourse that was dependent on a cult of domesticity and the silencing of women in the public arena. "What makes you think more highly of a woman," Rousseau wrote. "To see her busy with feminine occupations, with her household duties, with her children's clothes about her, or to find her writing verses at her dressing table surrounded with pamphlets of every kind?"[27] "The genuine mother of a family is no woman of the world," he asserts. "She is almost as much of a recluse as the nun in her convent."[28]

Rousseau's theory undermined the position of the woman of ideas in the nineteenth century. Her flaw was no longer her inability to measure up to some feminine aristocratic ideal of gentility and wit. Instead, her character type became a cultural emblem of deviant social behavior, a receptacle for every kind of challenge or threat to political or social convention: "I would a hundred times rather have a homely girl, simply brought up, than a learned lady and a wit who would make of my house a literary circle over which she would serve as president. A female wit is a scourge to her husband, her children, her friends, her servants, to everybody. From the lofty height of her genius, she scorns all her womanly duties, and is always trying to make a man of herself after the fashion of Mlle de l'Enclos."[29]

Rousseau's writings offered philosophical justification for the growing hostility toward women, especially women of ideas, after the Revolution. He provided a literary precedent for the subordination of women to men that was sanctioned socially by the masculinist cult of Napoleon worship and legally by the Civil Code in 1804. Women of ideas with republican sympathies were in the difficult position of having to reconcile their admiration for Rousseau's social theory (and for his idealized representation of female intellect and will in *Julie, ou la nouvelle Héloïse*) with his ideas about women. As Vivian Folkenflik has observed, that conflict is underscored in a comparison of the prefaces to the 1788 and 1814 editions of *Lettres sur les ouvrages et le caractère de J. J. Rousseau,* by Germaine de Staël, the most important early-nineteenth-century woman of ideas. De Staël launched her writing career with this homage to Rousseau.[30] Only after achieving her own hard-won success twenty-six years later, after being constantly accused of usurping a male professional identity, did she recognize and address the disjunction between her personal politics and her early, almost unqualified praise of Rousseau. In the preface to the reissued edition of *Lettres,* De Staël

substitutes an essay on the irrational fear of literary women for her original laudation. The preface to the 1814 edition begins with the disclaimer that the work originally was published without her consent the year she entered society.[31] In the remainder of the preface she outlines the need for women to receive a serious education. Without referring directly to Rousseau's advocacy of an exclusively domestic education for women (or even to Rousseau himself), De Staël critiques the illogic of his ideas about women in the context of his revisionist social theory. "What are we to think of a man whose pride is so modest that he prefers blind obedience in a wife to enlightened sympathy? The most touching examples of conjugal love are found in women worthy of understanding their husbands and sharing their fate. Marriage reaches its full beauty only when it can be founded on mutual admiration."[32]

It is on De Staël that the nineteenth-century typology of the French middle-class woman of ideas was based. Her ideal of mutual admiration and respect between men and women is everywhere in her fiction and in that of the generations of women writers she influenced. De Staël also exemplifies the typological identity of the woman of ideas as an outsider, a product of fluid social and cultural origins. Swiss, Protestant, and privileged but middle class, she was raised among French Catholic aristocrats. Her education was one of mixed messages: gentility and elegant manners on the one hand, and, on the other, literature and politics, intellectual pursuits to which she was exposed constantly from a very young age in her mother's salon. She was trained unconventionally as a girl to think and to speak; as a consequence, she was both one of the most influential voices during the Napoleonic era and one of the most maligned. She was vilified by Napoleon and by republicans and legitimists alike for her "unfeminine" writing and behavior.[33]

De Staël's political novels and essays, born of these attacks, demonstrate the contradictions and failures in logic between republican theory and practice through the example of attitudes toward women like herself. *De la Littérature* (1800), for example, critiques the post-Revolution reduction of women to absurd mediocrity and suggests that such a redirection reflects the Republic's failure to comprehend its own informing philosophy.[34] Arguing that the principles of the Revolution can only be understood and transmitted over time and through cultural rather than political mechanisms, De Staël calls for a new literature to educate the enlarged but as yet unenlightened power structure on ways to integrate passion with self-reflection. This is precisely the talent she associates with women, as her enormously popular epistolary novels *Délphine* (1802) and *Corinne* (1807) demonstrate.

These tales of human potential devastated by rigid and wrongheaded social codes were wildly inspirational to women writers all over the world in the nineteenth century. *Corinne*, especially, became in Ellen Moers' words "a kind of children's primer for girls of more than ordinary intelligence who looked beyond domestic life."[35] In fact, it was only through such novels that feminist issues were rehearsed at all in the first quarter of the century. *Corinne* was important to nineteenth-century feminists for its depiction of a highly creative and successful intellectual woman who maintained economic and social independence. And it was generative for figures like Charles Fourier and Henri Comte de Saint-Simon, who were committed to the concept of woman as a kind of apostle of peace and progress. *Corinne* was as much an attack on Napoleonic ideology as it was a condemnation of French attitudes toward women. It celebrates in a female form intellectual freedom and art and assails imperialist gestures and the Bonapartist cult of brute force.

De Staël's belated refutation of Rousseau's attempts to exorcize the woman of ideas from the gender paradigms of the new republic was a mature response to years of struggle against institutionalized efforts to silence her voice. As a salonnière in the late eighteenth century, she merely had been mistrusted. But as a political figure and writer in Napoleonic France, she was despised and attacked for her resistance to the everwidening schism within liberal republican discourse between the private, domestic spaces of women and the public, power arenas of men.

The potency of De Staël's legacy in the nineteenth century is suggested by an article in the inaugural edition of the legitimist journal *La Mode*. It is a memorial piece written by Benjamin Constant in 1827, ten years after De Staël's death. The editors chose to reprint the essay in 1830 as "one of the first duties of the publishers of this journal, intended especially for women."[36] Claiming this commemoration as somehow appropriate and necessary to the function of the journal, the editors assert that "this *hommage* provides indisputable evidence of their respectful admiration for the sex of which Mme de Staël has been proclaimed the Voltaire."[37] The article and the strategic function of its republication demonstrate both De Staël's importance as a female model and the normalizing process to which such female models were subjected during the July Monarchy. Constant presents her not as a prolific and seminal literary figure but as a heroine of womanly duty. Her support of the Revolution and its ideals is explained away as a situation into which she was forced by circumstance. Constant provides a selective history that disguises or omits the details of De Staël's politics and literary output. Instead, in a brutal extension of the tragedy of Corinne, it extracts her from the realm of the active and the public and

redeems her through association with more acceptable female behavior. "Les deux qualités dominantes de Mme de Staël," Constant confides, "étaient l'affection et la pitié" [Mme de Staël's two dominant characteristics were her devotedness and compassion"].[38] Her most important traits, and those that dominate the piece, are her "talent de conversation," the fact that she was "la plus attentive des amies," and, most important, the detail that "son amour pour son père a toujours occupé la première place" [her love for her father always took precedence].[39]

These two texts—De Staël's ambivalent reassessment of Rousseau and Benjamin Constant's redemptive revision of De Staël's life within the context of a legitimist journal—suggest the complexity of the situation for the woman of ideas who was both a producer and an object of representations. This polarity informs every figuration of the woman of ideas whose typological identity was appropriated in the nineteenth century as a crucial site upon which issues of gender politics and social reorganization were rehearsed. In the following chapters I explore the tensions exemplified by De Staël's struggle to legitimize the woman of ideas as an author of texts and Constant's effort to neutralize her example by reconstituting her as the text itself. This cycle of reclamation and cooptation of the power of the woman of ideas was replayed throughout the nineteenth century, increasing with the number of women engaged in the public sphere. The public woman posed an irritating challenge to the republican ideology of womanhood. Her resistance to the cult of maternity and domesticity—and the figuration of that resistance in French caricature and painting between 1830 and 1848—is the subject of the chapters that follow.

# 2

## Le Monde Renversé: *July Monarchy Typologies of the Woman of Ideas*

Although the obsession with femaleness that Victor Hugo described as "a cult of womanism" could be said to characterize the nineteenth century generally, one of its most rigorous manifestations took place between 1830 and 1848. The outpouring of literature about women in that period is usually associated with the preponderance of romantic fictions about madonnas, muses, and guardians of sacred domestic spaces. But the cult of womanism responded to fact as well as to fiction, to an aspect of French life too often ignored even by feminist historians: the revival of a strong female voice and presence in literature and in politics.[1]

From its inception, the July Monarchy was associated with female activism in intellectual and political arenas. Folkloric commemorations of the 1830 Revolution, for instance, like *Les Héroïnes parisiennes, ou actions glorieuses des dames*, published in 1830, mythologized the brave women who organized patrols, assisted the wounded, and participated in the fighting.[2] The presence of women on the barricades figured significantly in pictorial representations of the Revolution as well. Delacroix's *Liberty on the Barricades* was one of several paintings exhibited in the Salon of 1831 that recognized the events of 1830 and, to some extent, the "actual" participation of such women as Marie Deschamps and Julie Fanfernot.[3] Female participation was also commemorated in popular prints. Michel Delaporte's *Les Parisiennes du 27, 28, et 29 juillet 1830* and the anonymous *Héroïsme des dames*

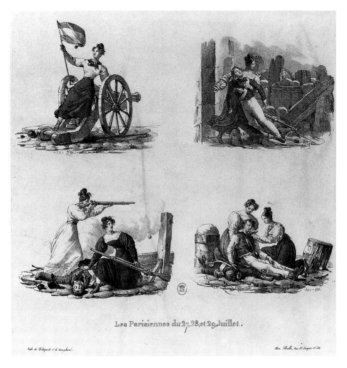

5. Michel Delaporte. *Les Parisiennes du 27, 28, et 29 juillet, 1830.* 1830.

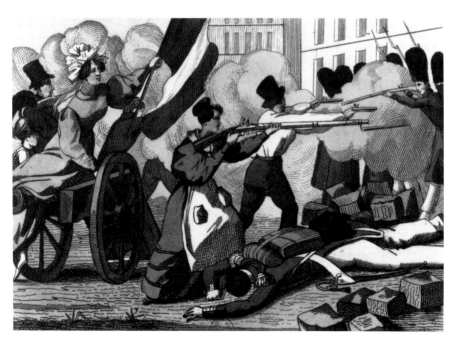

6. Anonymous. *Héroïsme des dames de Paris dans les journées des 27, 28, 29 juillet 1830.* 1830.

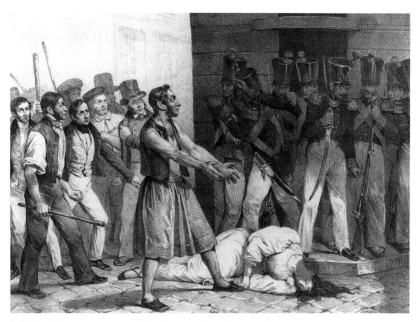

7. Michel Delaporte. *Scène du 27 juillet—première victime.* 1830.

*de Paris dans les journées des 27, 28, 29 juillet 1830* (figs. 5 and 6), for instance, depict the involvement of women in the overthrow of the Bourbon regime. One particularly popular theme in low-cost prints of "Les Trois Glorieuses" was the story of the revolution's first victim. Images like Delaporte's *Scène du 27 juillet—première victime* (1830) helped disseminate the legend about the first casualty of the fighting: a young woman shot at the Place des Victoires (fig. 7).

Demonstrations of exceptional physical courage and self-sacrifice by women during war were generally honored. After all, France had a respected tradition of the *femme-soldat* dating back to the fifteenth century, when Jeanne d'Arc led the French armies and secured Charles VII's right to the throne. Women soldiers who, like Jeanne d'Arc, fought to protect and preserve male dominion, continued to be venerated in France. But as I suggest in Chapter 1, a new breed of femme-soldat was conceived during the French Revolution. She differed from her progenitors in one important way: "The regiments of the old France [were formed through] enlistment; the armies of the new France [are] rising as a mob."[4]

The model of politicization and collectivist action for the nouvelle femme-soldat was influenced by the experience of the woman of ideas for the next two decades. Her ability to reach and mobilize large constituencies

within the arenas of social and literary politics was the source of her power and often the target of her critics. Increasing numbers of female writers and activists gained access to the public domain during the July Monarchy. In magazines, novels, and on the streets they argued for the redistribution of legal and economic privilege in France. These women—who appropriated the weapon of language and the strength of numbers to fight the absolute authority of masculinist culture—were subject to the most virulent attacks in the popular press.[5]

During the July Monarchy the newly acquired capacity of the woman of ideas to capture and control an audience through collectivist activism and print culture generated textual and pictorial representations of a world turned upside down. It is this view of *Le Monde renversé,* exemplified by a series of colored woodcuts of that title (fig. 8), that is the subject of this chapter. After documenting the woman of ideas' increased visibility and vocality in this period in the context of the revival of a female emancipation movement and of the explosion of the popular press, I will survey the themes of domestic upheaval and gender reversal traditionally deployed to caricature this female type. I will conclude with a look at the theme of transvestism, a motif that was revived intermittently in caricatures of the woman of ideas and that functioned at once to destabilize and reify French social structures.[6]

## Arenas of Influence for the Woman of Ideas

The prominence of the woman of ideas in the 1830s and 1840s was determined by several factors precipitated in large measure by the rise of the industrial economy in France. Such feminist historians as Joan Scott and Karen Offen have explored how industrial development, which increased the distinction between public and private realms, marginalized women and precluded their participation in any serious social or economic function. But what historians often neglect are the large number of women who were empowered by this same social and economic revolution. The two arenas in which women were able to operate most effectively after 1830 were the reemerging woman's emancipation movement and the popular press.[7]

The woman's emancipation movement was encouraged and facilitated by debates over universal suffrage and *la question sociale.* The rekindled feminist concerns of the July Monarchy focused on the vote, on access to jobs and education, and on liberalization of the restrictive marriage laws sanctified by the Civil Code. The 1830s saw the earliest impulse

# LE MONDE RENVERSÉ.

Les femmes font la patrouille.

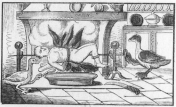

Le cuisinier à la broche, les oies la tournent.

La terre est en haut, le ciel en bas.

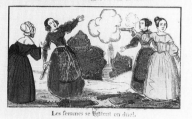

Les femmes se battent en duel.

8. Anonymous. *Le Monde renversé.* 1842.

OCCUPATIONS JOURNALIÈRES DES SAINTS-SIMONIENS (A MÉNIL-MONTANT.) N.º 13.

Saint-Simonien épluchant les légumes.

Saint Simonien Frotteur.

Saint-Simonien récurant la Batterie de Cuisine.

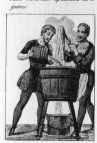

Saint Simonien faisant la lessive.

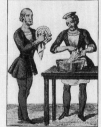

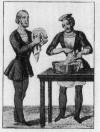

Saint-Simonien lavant la Vaisselle.

La toilette du Saint-Simonien.

IMAGE POPULAIRE

Exécutée dans le goût des imageries dites d'Épinal, 1852.

9. Anonymous. *Occupations journalières des Saint-Simoniens.* 1832.

to socialism in France as a response both to the economic and social crises precipitated by industrial expansion and to the sense of betrayal felt by many who had participated in the July Revolution. Female liberation was viewed by Charles Fourier and other French socialists as the natural measure of the humanist ideal of general emancipation.[8] The ideological descendants of Fourier saw political and sexual repression and inequality as cognate forms of civilization's corruption of the inherent goodness and natural relations of humankind. Fourier's utopian society called for the liberation of conventionally frustrated and imprisoned human emotions. To this end, it emphasized a new marital system based on the "law of passionate attraction" under which marriages were freely made and sustained by mutual choice. Thus, Fourier's vision of Harmony, the final stage of social renovation, depended in large measure on the equality of women and, particularly, on their sexual freedom.

Some of the earliest followers of Fourier were converts from another utopian movement, Saint-Simonism. Inspired but never led by Claude Henri, Comte de Saint-Simon (who died in 1825), this group was active and popular between 1826 and 1834 under the leadership of Prosper Enfantin and Saint-Amand Bazard.[9] Its greatest influence was felt immediately after the Revolution of 1830, a period of intensive recruitment, especially among working-class women.[10] The Saint-Simonist family represented an alternative domestic, religious, and economic structure for women. Its offer of a communal lifestyle and its emphasis on sexual freedom as part of a philosophy that elevated rather than denigrated women and integrated them into the power hierarchy made the Saint-Simonist environment particularly appealing to working women like Jeanne Deroin and Julie Fanfernot, whose participation in the July Revolution ultimately had done nothing to alter their social condition. The utopian community provided a seamstress like Désirée Veret and an embroiderer like Suzanne Voilquin with the extraordinary opportunity to escape financial and physical hardship and begin their lives again as *nouvelles femmes*.[11]

Saint-Simonist interventions into class and gender paradigms formed the subject of many popular prints in the 1830s. A pair of woodcuts from 1832, for example, *Occupations journalières des Saint-Simoniens* (fig. 9) and *Occupations des dames St. Simoniennes* speculate in the tradition of *Le Monde renversé* on the consequences of this group's experimentation with gender roles. With mops and dust rags in hand, the Saint-Simoniens are shown in the private spaces of the home performing such conventionally female tasks as peeling vegetables, washing floors, and even squeezing into corsets. Their delicate features and demure, downward gaze stand in contradistinc-

tion to the aggressive stance and confident gesturing of the St. Simo-niennes. Unlike their male counterparts, the St. Simoniennes appear out-of-doors or in public places. They deliver speeches, hunt, garden, and sole shoes. This imagery of role reversal at once protests a world turned upside down and concretizes a model of resistance to that world.

Although Saint-Simon himself had written little about women, the doctrine and movement he inspired assumed an increasingly feminist ori-entation. Women's rights seemed a natural addendum to his interest in reorganizing the world by allowing spiritual power to supplant brute force, an idea that received expression in his last work, the unfinished *Le Nouveau Christianisme*.[12] Saint-Simon's followers personified the idea of global reor-ganization in the form of an androgynous god, literally composed of a man and a woman. This "couple saint, divin symbole d'union de la sagesse et de la beauté" was charged with regenerating society by replacing France's legacy of war and destruction with a Saint-Simonist agenda—universal association, emancipation of the poor, and equality of the sexes.[13] Bazard and others called for "un homme et une femme . . . le couple suprême, symbole vivant de l'amour, type réalisé du progrès social, générateur de l'humanité, l'élève, la dirige et l'assiste sans cesse."[14] The male half of the Saint-Simonist hierarchy was firmly in place by 1831; after Bazard's sudden death, Enfantin had declared himself *le chef unique* of Saint-Simonism, and the "Father of Humanity."[15] The widely publicized search for his female counterpart, "La Mère," which took Saint-Simonist missionaries as far as Constantinople and Egypt, was the subject of many lectures and essays in the early 1830s.

Those years marked a period of increasing theoretical female power within the Saint-Simonist hierarchy that corresponded directly to the de-creasing real authority of women. In August 1832 a group of Saint-Simoniennes, former *industrielles* who had witnessed but never partaken of the limited leadership opportunities available to women within the com-munity, broke with Enfantin in one of the first separatist feminist ventures of the nineteenth century. Calling themselves "les prolétaires Saint-Simoniennes," the members of the group founded *La Femme libre,* a news-paper published by and for women. Though the women called themselves les prolétaires Saint-Simoniennes, the group was composed of women from the lower levels of the urban middle class or the upper levels of the working class.[16] *La Femme libre* was produced in their own homes, at their own expense; they signed their articles with first names only, asserting that "if we continue to take men's names . . . we shall [continue to] be slaves."[17] Their intent was to reestablish the natural but disguised alliance between

*des femmes du peuple* and *des femmes priviligées* and expose the analogues between class and sex oppression through an analysis of male-constructed codes of sexual morality.[18]

*La Femme libre,* like the quest for la mère, was satirized often in the popular press in lithographs like *La Femme libre. Elle est trouvée* (fig. 10), which appeared in 1833 in the *juste-milieu* publication *La Charge.* Images such as this one conflated and thereby trivialized several disparate aspects of Saint-Simonist culture. The lithograph from *La Charge* speculates on Prosper Enfantin's meeting with la mère, the female messianic figure with whom he will share his authority. The worldwide search, however, has turned up a chimpanzee. Although the chimp appears delighted with her new mate, Enfantin is horrified and attempts to escape her grip.

The legend also identifies the chimp and the search for la mère with *La Femme libre.* The title of that feminist journal engendered a great deal of satirical commentary and imagery punning on the notion of the "free woman," misconstruing the journal title's declaration of autonomy as an advertisement for sexual favors. By rendering the Saint-Simonienne as a primate and tying her accomplishment to an unrelated venture sponsored by the male Saint-Simonist hierarchy with whom she, in fact, had chosen to sever her relationship, these caricatures preserved the illusion of a unified and containable countercultural danger.

Even treatments of the more sinister consequences of embracing the ideology of Saint-Simonism dehistoricized and homogenized the community into a single, graspable threat. *Détails sur un double suicide* (fig. 11), a poster circulated in 1833, warns of the tragic repercussions for naïve and disenchanted youths who yield to the temptation of Saint-Simonist flesh. Like the majority of prints satirizing Enfantin's community in this period, the poster depicts the Saint-Simonist challenge to the sacred bourgeois institutions of marriage and family as the ploy of sexually depraved individuals. Although the image refers to the recent double suicide of two excommunicated members of the Saint-Simonist community, Claire Démar and Perret des Issarts, it represents the danger in the form of Père Enfantin and a female counterpart who stand on each side of a tomb inscribed with the words: "Aux victimes de l'amour." Contrary to the poster's implication, Démar and Enfantin had little use for one another. She had been a member of the community, but her 1833 brochure *Ma loi de l'avenir* (which Enfantin refused to publish) criticized "Le Père" for his conservatism and called for legal and social reforms that were considered too radical for the utopian socialists.[19] She was voted out of the group in 1833, and, soon after, she and her considerably younger lover shot each other in the head. Despite their

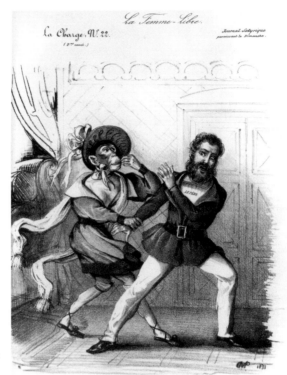

10. Anonymous.
*La Femme libre. Elle est trouvée!* 1833.

## DÉTAILS SUR UN DOUBLE SUICIDE,

Commis par un Saint-Simonien et une Saint-Simonienne, qui se sont tués tous deux en se tirant un coup de pistolet à bout portant, samedi soir, rue Folie-Méricourt, n° 9, à Paris. Autres détails sur leur fatale résolution, sur les pompes et funérailles qui auront lieu demain au cimetière du Père-Lachaise, à l'occasion de leur inhumation. Discours prononcé par le père Enfantin sur la tombe de ces deux malheureuses victimes de l'amour et de la jalousie. Chants funèbres des Saints-Simoniens, etc. Conversation intéressante entre eux. Lettres extraordinaires qui ont été trouvées sur la table à côté de leur lit.

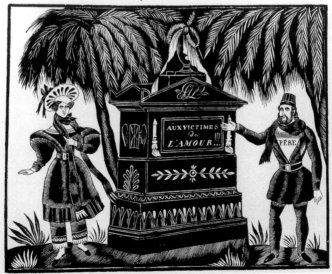

11. Anonymous.
*Détails sur un double suicide de Perret-Desessarts et de Claire Démar.* 1833.

split, Enfantin and Démar are represented in this poster as one and the same.

Like the discourse of bourgeois republicanism, the attacks on the ideological alternatives to republicanism were waged in gendered terms. The scenario of the aging siren who seduces and destroys a vulnerable male youth was an ideal tool for discrediting this aberrant subculture as something degenerate and feminized. It was a paradigm invoked repeatedly during the July Monarchy to reproach the woman of ideas and her supporters.[20]

*La Femme libre* and the journalistic activities of "les prolétaires Saint-Simoniennes" provided the principal model and inspiration for dozens of women's magazines launched during the July Monarchy. The vastly expanded press industry was just one aspect of a larger revolution in consumer products and written information required to meet the cultural and educational demands of a rapidly increasing urban population. Journalism and popular fiction—frequently the loci for the popularization and dissemination of political and social ideas—were the aspects of French print culture most accessible to the woman of ideas. The popularity of women's journals within the context of the emergence of the popular press during the July Monarchy suggests the second key arena in which the professional identity and parameters of achievement of the woman of ideas evolved.

The most direct descendants of the feminist and separatist sensibility that informed *La Femme libre* appeared in 1848 and 1849 in socialist journals like *La Voix des femmes*. The few earlier attempts to launch journals that would continue the mission of *La Femme libre* to forge class alliances and articulate a feminist agenda were short-lived. Julie Fanfernot published only one issue of *L'Eticinelle* (1833), and Eugénie Niboyet's *Le Conseiller des femmes* (1833–34) lasted ten months. The vast majority of new women's magazines represented a bourgeois appropriation of the feminist enterprise and a capitalization on the vogue of such new cultural typologies as *la femme-messie* and *la femme émancipée*. The enterprise that came closest to *La Femme libre* in seriousness and purpose was Madeleine Poutret de Mauchamps' *Gazette des femmes*, a journal that analyzed French legal codes that pertained to the rights of women. Poutret de Mauchamps was the subject of more slanderous attacks than any other female journalist in the 1830s. The nature of those attacks and the caricatural series by Honoré Daumier that they spawned are discussed at length in Chapter 3.

Several specialized journals published by men in this period demonstrated an interest in providing a forum for women. *Le Citateur féminin, Recueil de la littérature féminine ancienne et moderne*, for instance, the project of

M. P. Prouteau and M. Vallotton d'André, was begun in 1835. This journal of biographies, poetry, and short fiction by women was published four times a year. Twelve or thirteen women writers were showcased in each issue, approximately half of whom were contemporary. Rather than subverting the achievements of intellectual women, *Le Citateur féminin* attempted to "nurture" and provide women with public exposure that would enable them to continue the process of "breaking free from the prisons in which men have placed them." "Why, today, would one not try to construct an arena that would make room for all greatness? This is our purpose. . . . We are coming to help women in their noble efforts by creating a journal devoted entirely to them; and, to show woman what she is capable of, we place before her eyes what she has already created."[21]

Such male feminism, not uncommon in the 1830s and 1840s, was a mixed blessing. Like its counterpart in utopian socialist reform rhetoric, it perpetuated a system in which issues of women's achievements and autonomy were raised and debated within a patriarchal framework. At the same time, it provided a space in which feminist concerns could be rehearsed. *Le Citateur féminin,* for instance, republished in an 1835 issue a lengthy and provocative article by Eugénie Niboyet (founder of the Lyonnaise newspaper *Le Conseiller des femmes* and of the Athénée des femmes, the first free women's university, also in Lyon) that had had only limited circulation. "De L'Exagération en ce qui concerne les femmes et leur émancipation" was an analysis of contemporary male attitudes toward female emancipation and an explanation of the necessity for equal education opportunities. It asks and answers the question posed repeatedly in the pages of *Le Citateur féminin:* "Pourquoi ne remplirais-je pas une fonction sociale? Pourquoi ne serais-je pas poète, artiste, savante, industrielle?"[22]

Though several women's journals that began publishing in this period treated the issue of women's rights and explored the social implications of increased female intellectual activity, most were there to capitalize on a new and lucrative market. They were feminine rather than feminist journals that more often reinscribed rather than resisted traditional gender roles. Between 1800 and 1845 the number of French journals for women more than doubled, and the vast majority of these new publications played a critical role in the cultural construction of the modern bourgeois woman.

*Le Journal des jeunes filles* demonstrates how by the mid-1830s the concept of the woman of ideas had already been coopted and commercialized in journalism and fiction as a trendy female type, *la femme pensée. Le Journal des jeunes filles* published tips on how a woman might appear serious and informed without betraying her true feminine nature. The claim that its

featured poetry and stories by such femmes pensées as Delphine de Girardin and Louise Babeuf were intended to provide the informed woman with a connection to a female intellectual community is betrayed by the prevalence of such stories as "La Jeune Fille poète."[23] Published in March 1846, "La Jeune Fille poète" addresses the dangerous trend of encouraging young "poetesses" to believe they could be gifted with genius. The narrative follows the redemption of an overly confident young girl named Céline who, after a humiliating recognition of the frivolous sentimentality of her work, is saved from her misguided pride in her own talent in time to assume her natural female domestic duties upon the death of her mother.

One of the most popular genres that evolved in the publishing industry in this period was the journal of *modes* and *moeurs*. Magazines such as *La Mode* (1829–54) and *Psyche* (1835–78) provided detailed accounts of the latest trends in fashion and *toilette*. They nurtured the cult of female consumerism that reached its full maturity during the Second Empire and cultivated interest among middle-class women in a new preoccupation: obsessive self-adornment. Journals of education and instruction were the other major contributors to the construction of the nineteenth-century bourgeoise. These journals put aside the frivolous considerations of fashion and taste in favor of discussions of the moral imperatives of the modern wife and mother. While *La Musée des familles* defined itself as a treasure trove of erudite subjects meant to provide an evening of wholesome family entertainment, Madeleine Sirey's *La Mère de famille* was one of many Roman Catholic journals directed specifically at the heart of the middle-class domestic unit—the mother. *La Mère-institutrice et L'institutrice-mère*, a journal of literary, religious, and moral instruction designed to counter the "changement complet [s'est] opéré dans la position des femmes" was another.[24] This magazine offers an example of the intimate relation nurtured in nineteenth-century capitalism between profit and control of female behavior. The rhetoric of *La Mère-institutrice* functioned both as a mechanism of normalization and as an advertisement for classes in the art of being a good governess; classes were taught by the editor, D. Levi, on the rue de Lille. The women of ideas featured in this journal included only writers like Amable Tastu, whose texts on maternity and female duty reaffirm the importance of traditional female occupations. "Leur [women's] rôle sera, comme il l'a toujours été, d'établir l'harmonie dans la famille, et d'en réunir les élémens s'ils tendaient à se séparer."[25]

The magazine that most powerfully disseminated the bourgeois ethos of female self-sacrifice was the *Journal des femmes*. Like *Le Citateur féminin* it featured work by famous women writers and partook in the debate over the

social role of women. Articles by such women of ideas as Constance Aubert and Mélanie Waldor filled its pages in an apparent challenge to the patriarchal assumption that "les femmes auteurs ne sont plus femmes."[26] But its surveys of famous women of ideas were perfunctory and interspersed with recipes for cherry syrup and with fashion tips for weekend outings. While juxtapositions like these were common in the women's magazines that flooded the market in the 1830s and 1840s, they are conspicuous in the *Journal des femmes,* which is distinguished from the others by the ideological integrity and consistency of its presentation. It is precisely its rare combination of genuine commitment to the concerns of women and the definition of those concerns in exclusively familial terms that make it perhaps the most insidious journalistic promotion of an essentialist opposition between domesticated womanhood and female professional identity. Though, in fact, most of the women writers cited in this study maintained a complex construction of professional and domestic roles, their identities were dichotomized constantly in the *Journal des femmes* and elsewhere.

Between May 1832 and January 1837 the articles in the *Journal des femmes* shared as their common goal the education of women. The concern for women's education, however, was not based on a belief in their inherent equality to men. Rather, it was tied to the increasingly popular perception that women's most important social function was to educate the next generation of French (male) citizens. The argument for ameliorating the position of women in consideration for their responsibilities as mères-éducatrices was centuries old. But post-Revolution preoccupations with education and pacifism made the argument as credible with the general population as it had always been among women of ideas. The editor of the *Journal des femmes,* Fanny Richomme, used the journalistic medium to reconceive the role of the modern bourgeois woman. She was to be liberated but not promiscuous, informed but not précieuse, and religiously devoted to the home rather than the church. Articles on subjects ranging from hygiene and nutrition to science and literature were full of rhetoric about the "emancipation" of women's minds, but only for the purpose of allowing them to fulfill their domestic missions. Its goal was to teach women how to realize themselves in their homes, how to fill their days and avoid the "ennui" that might drive them to seek escape and solace in novels or lovers. Promoting the idea that "l'empire d'une femme est son ménage,"[27] it helped sustain a fantasy of power among nineteenth-century women that camouflaged or made bearable their actual powerlessness: "It is through the positive influence of women that one can regenerate men, improve education and legislation, ameliorate private and public morals, quiet hate-

ful emotions, prevent deadly discord, perhaps one day put an end to the scourge of war, finally soften hardships that afflict the sad humankind."[28]

The most persuasive and popular myth of female power focused on women's roles as teachers of their children. In fact, a large percentage of the womanism books written in the nineteenth century were mother-teacher tracts. Pauline Guizot's *Education domestique, ou lettres de famille sur l'éducation* (1826) and Clarisse Beaudoux's *La Science maternelle* (1844) are just two of hundreds of books published on the ideal of the mother-teacher as a "universal agent of humanity's regeneration."[29] Women who succeeded in this role were referred to admiringly in popular parlance as *femmes-enfants* or *mères-éducatrices*. Those who did not were branded *femmes-dragons*.

The concept of the *femme-institutrice* had various cultural manifestations. In addition to its centrality to theories of the modern bourgeois family, the myth of woman as teacher or moral exemplar extended for some beyond the confines of the home. A pervasive belief among romantic and utopian socialist theorists during the July Monarchy was that certain women were uniquely privy to a spiritual life that had been lost to the male generation of postrevolutionary France. The myth of the *femme-messie,* a female prophet and intermediary between God and man who was thought to facilitate the harmonious progress of life, became a common female archetype in literature and social theory. The principle of the femme-messie was invoked often, even by women of ideas in novels and essays, to authorize their cultural and political voices.

The importance of women as apostles of progess was examined, for example, by poet Mélanie Waldor in *Journal des femmes*. She argued that the socially responsive qualities in contemporary literature were the result of the example set by women: "La plupart des hommes ne sont que ce que les femmes les font. . . . Ce sont elles qui développent ou étouffent leurs vices." The only hope for the decaying, traditionally male-dominated field of literature would be if women were to "prendre place dans leur siècle et imposer aux hommes leurs noms et leurs écrits." Waldor asserts that the immorality of life and art during the July Monarchy prompted the most enthusiastic revitalization of "la cause des femmes" in French history. "C'est ainsi qu'une carrière qui fut si long-temps fermée aux femmes, et que toutes à présent sont appelées à parcourir, rendra notre siècle riche en femmes-auteurs." Thus, according to Waldor, the ever-growing number of great women writers in this period came about as a moral imperative. "C'est aux femmes, puisque la lice leur est ouverte, et que leur voix n'est plus étouffée, à donner l'exemple de tout ce qui est grand et noble."[30]

After 1830 journalism and literature became lucrative and inter-dependent commercial enterprises and often political vehicles.[31] The commercial appeal of *roman-feuilleton,* or serialized novels, improved news-paper sales; in turn, newspapers offered a quicker and cheaper means of getting fiction into print and attracting large audiences. It was the mass exposure and financial compensation offered by this new industry that launched and sustained the careers of such women as George Sand and Delphine de Girardin. They and hundreds of others were given publishing opportunities that otherwise would have remained inaccessible to them. As the conditions of intellectual life after 1830 were altered and commodified —and as the French literary industry abandoned traditional forms of patronage in favor of a commercial profit system—a career in letters prom-ised both prestige and financial reward. Large increases in literacy, espe-cially among working-class men and middle-class women, contributed to a newly diversified reading public.[32] This period of intellectual emancipa-tion and shifting audience demographics spawned new literary genres like the *chronique,* genres through which *femmes de lettres* often began careers. As a serialized novelist, an editor or a publisher of literary and political maga-zines, and as the targeted reader of the numerous *modiste* journals, the woman of ideas became during the July Monarchy a fashionable female model and a favorite subject for caricaturists. The activities of such women as Flora Tristan and Hortense Allart inspired thousands of now neglected caricatures by Honoré Daumier, Paul Gavarni, Edouard de Beaumont, and others.

## Caricatural Imagery of the Woman of Ideas

French comic printmaking flourished after 1830. Its evolu-tion was inextricably tied to France's industrial development and to the shift from a rural, agrarian economy to an urban, industrial one. In France this process began in the 1820s and was accelerated by the policies of Louis-Philippe and his July Monarchy government. Louis-Philippe's reign was also distinguished by a revitalization of an open press. The Revolution of 1830 that had brought him to power was precipitated by angry journalists who denounced and used as a rallying cry Charles X's severe restrictions on free speech. Louis-Philippe ensured his smooth accession to power by pledging to abolish press censorship forever. His unprecedented relax-ation of censorship laws resulted in a proliferation of newspapers and journals, several of which regularly featured comic illustrations that de-

rided the monarch and his cabinet. This period is considered the heyday of French political caricature.

Much of the satirical imagery directed against the government was commissioned and published by Charles Philipon, who founded the most influential journals of this genre, *La Caricature* and *Le Charivari*. Both journals were issued by La Maison Aubert, the *magasin des caricatures* established by Philipon and his brother-in-law Gabriel Aubert in 1829. The journals, available by subscription only, originally alternated between social commentary and incisive political caricature. Though correspondences between image and text were erratic in *Le Charivari* until the late 1840s, one can trace subjects recurring in the text that eventually culminate in a series.

The flowering of French caricature by such figures as Honoré Daumier, Paul Gavarni, and J. J. Grandville also benefited from the introduction of lithography into France. Invented in about 1799 by the German musician Aloys Senefelder, lithography challenged the primacy of etching and engraving in French printmaking. Its direct, fluid, and autographic quality made it ideally suited to caricature and book illustration.

An assassination attempt in 1835 prompted Louis-Philippe to reimpose censorship of texts and images critical of his government and to put an end to the barrage of comic lithographs that mocked him and mourned his betrayal of the Revolution's republican ideals. As a result of these "September Laws," many journals were forced to stop publishing or to completely reorient their purpose. *La Caricature* was one of the casualties, and *Le Charivari* turned to art and literary reviews and to caricaturing scenes from everyday life. The July Monarchy typology of the woman of ideas evolved in this context, an ostensibly benign and apolitical genre of social caricature.

The earliest figurations of the woman of ideas appeared in satires of the bourgeois family and in book illustration. Daumier's series on "Moeurs Conjugales" for *Le Charivari* in the late 1830s, for instance, contains several cuts of women so absorbed by their reading that they neglect their domestic responsibilities. But the first representations of women who produce as well as consume the printed word began to appear in the early 1840s in the form of book illustrations. French print culture was by no means stifled by the September Laws. In fact, those laws stimulated a diversification and amplification of the literary industry after 1835 in the form of lucrative pseudojournalistic enterprises developed by such entrepreneurial publishers as Charles Philipon and Pierre-Jules Hetzel, who also vastly expanded production of illustrated volumes.

A popular genre that emerged in this climate—and the genre in which one can locate the earliest representations of the femme-auteur—was char-

acterized by Walter Benjamin as "panorama literature." Prefiguring the *flâneur's* stroll through the streets of Paris, panorama literature provided an anecdotal chronicle of the sights and sounds of this ever-changing urban center. One type of panorama literature that contributed substantially to the typology of the woman of ideas was a genre called the *physiologie*.[33] The physiologie was cultivated principally by Philipon and Hetzel in the late 1830s and early 1840s as a moneymaking variation on the comic illustrated journal. These cheap paperbound pocket volumes consisted of idiosyncratic essays classifying Parisian professions, avocations, and types. Intimately tied to the phenomenon of social caricature as defined by La Maison Aubert—the publishing house of *Le Charivari,* in which many of these typological studies first appeared in serialized form—the physiologie functioned as a powerful mechanism for inscribing class and gender paradigms. Its capitalization on the fears engendered by the transformation of France into an industrialized state was disguised behind a veneer of humor. Faced with radical changes in the population and complexion of French society, middle-class audiences in particular were drawn to the physiologie, whose pseudoscientific claims attempted to fix identities that were in reality changing.

One part of this effort to classify and thereby contain the population was the definition of the woman of ideas. In many ways, Honoré Daumier was at the center of this project in the visual arts. His caricatures, often conceived and shaped by the editorial board of La Maison Aubert, equated the woman of ideas exclusively with the bourgeois femme-auteur. Like their textual counterparts in other Maison Aubert publications, Daumier's caricatures erase any suggestion of class fluidity by reactivating the conventional picture of the woman of ideas as a distracted housewife or as a sexually frustrated widow. He fabricates a homogenizing vision of an outsider, a woman at once barred from the legitimate French community of letters and removed from any normalized domestic context.

Because Daumier produced the only large and cohesive body of prints devoted to the woman of ideas before 1848, I have devoted an entire chapter to his output. In Chapter 3 I discuss the evolution of "Les Bas-Bleus" (1844), "Les Divorceuses" (1848), and "Les Femmes socialistes" (1849) in the context of his other caricatural series, his forays into painting in the 1840s, and his collaboration with the editors and legend writers of La Maison Aubert. This subject received steady coverage in La Maison Aubert publications beginning in 1836, coverage that was first visualized and consolidated in Daumier's 1844 series on the bluestocking. As I establish in Chapter 3, Daumier was to have a central role in the explosion of prints dealing with this subject in 1848 and 1849.

The vast majority of representations of the woman of ideas appeared during the short-lived Second Republic, a period just following the Revolution of 1848 that saw an outpouring of vitriolic prints that deflected anxieties over the threat of massive social reorganization onto an emblem of that challenge—the newly politicized, collectivist activities of literary women. In the remainder of this section I will trace the figuration of the woman of ideas before and after 1848, outside the oeuvre of Daumier. And I will examine the thematic undercurrent of transvestism in these images.

Before 1848 the subject of the intellectual woman was treated principally in popular theater and, as I have suggested, within the antifeminist campaigns of La Maison Aubert. The themes that dominate textual and visual characterizations include the commercialization of literature, the emasculation of husbands, maternal irresponsibility, and sexual promiscuity. Aside from the physiologies and caricatural series commissioned by Philipon, all other figurations of the woman of ideas occurred in book illustrations. In omnibus volumes like *Les Français peints par eux-mêmes* (1840–42), she is one of dozens of Parisian types described in words and pictures. This eight-volume project, which surveys the habits, customs, and tastes of Parisians, was conceived in an effort to capitalize on the success of les physiologies through larger and more expensive versions that relied on the celebrity of its writers and illustrators to sell books. Two essays in the text, Horace Viel-Castel's "Les Femmes politiques" and Jules Janin's "Le Bas-Bleu," deal directly with the woman of ideas. What is striking about her representation in panoramic literature of this sort is the disparity between text and image. While Viel-Castel and Janin write of her prostitution of literature and dissolution of the family, Gavarni and Pauquet, the illustrators of these essays, create almost ennobling characterizations. The illustrations, no doubt conceived independently of the texts, are neither charged nor derisive. The women are shown alone, engaged in writing or contemplation. There is no narrative of domestic irresponsibility or allusion to a sexual agenda that detracts from their principal identification as writers. Legitimizing images like Gavarni's from *Les Français peints par eux-mêmes* (fig. 12) contrast sharply with the essays that accompany them, which attempt to undercut the woman of ideas. Dissonance between text and image is not uncommon in early romantic book illustration, but these instances are extreme. It can be explained in part by the difference in significance of the woman of ideas to the male writer and to the male graphic artist in this period. To Viel-Castel and Janin, she signified direct competition for state pensions, commissions, and magazine space; to Gavarni and Pauquet, her increased prolificacy and involvement in the collaborative book phenomenon of the early 1840s meant more jobs, not fewer.

A second multivolume moneymaker that treated the subject of the literary woman was Jules Hetzel's *Scènes de la vie privée et publique des animaux* (1840–42). Hetzel conceived the book as a vehicle for J. J. Grandville's (Jean-Ignace-Isidore Gérard) career and his own financial independence. Although the stories in this collection are more cohesive than in most omnibus volumes, the illustrations by Grandville still bear only a thematic relation to the sections they accompany. The success of *Scènes de la vie privée et publique des animaux*, like that of *Les Français peints par eux-mêmes*, was a function of its array of celebrity writers, several of whom were women. George Sand and Marie Menessier-Nodier were among the contributors to this compendium of stories that together formed a thinly disguised critique of French government and culture. The stories, released initially in installments between 1840 and 1842, respond to a revolt among the animals, which feel exploited by man, in the *Jardin des plantes*. A fox convinces the animals that their best weapon is intelligence and encourages them to produce a book of, by, and for animals that will assist them in their search for an alternative form of government. The animals drawn by Grandville and the stories penned by Balzac, Sand, and others elicit solutions ranging from absolute monarchy to utopian socialist communities.

Images of literary women appear in three of the illustrations. Figure 13, for instance, is one of the eight images that originally accompanied P. J. Stahl's (Hetzel's pseudonym) "Story of a Hare." Ostensibly, it depicts the moment in the tale when a magpie writes down the story of an old hare's life from his dictation. But the image is genericized to permit its reuse in a number of different publications. The composition's conformity to established narrative paradigms of the woman of ideas and tenuous connection to the text it "illustrates" is underscored by the image's reissue in several subsequent publications, each time with a different legend. The original legend read: "La Littérature nous refait une virginité" [Literature gives us back virginity]. When it accompanied Stahl's "Story of the Hare" the legend read: "The magpie, who wrote the hare's story from his dictation." Though the magpie plays only a small and innocuous role in Hetzel's tale, as the original legend suggests, Grandville's figuration communicates something more sinister. Majestically perched on a thickly cushioned sofa, the femme-auteur looks up from her writing to gather her thoughts. With pen in one hand and cigarette in the other, she contemplates her next sentence. The emasculative potential of her mission is signified by the dagger that hangs from her belt and points toward her genital area; it is a phallic emblem that appears to have been appropriated from the haggard and stooped-over statue (a reproduction of the Farnese Herakles) behind her whose own sexual parts are camouflaged by the woman's fan that is draped over his

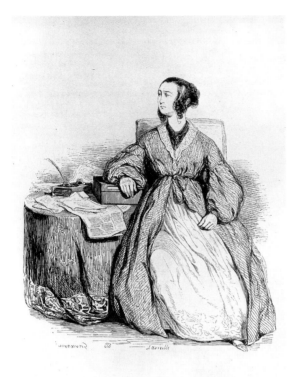

12. Paul Gavarni (Sulpice-Guillaume Chevalier). *Les Femmes Politiques*. In *Les Français peints par eux-mêmes*. 1842.

13. Jean-Ignace-Isidore Grandville. *La Littérature nous refait une virginité*.

shoulder and weighs him down. The deliberate interchangeability of such book illustrations, which allowed Grandville's image to be recycled and comfortably juxtaposed with a variety of legends, was a shrewd marketing strategy. It maximized the caricaturists' opportunities to continue to collect revenues for work already completed. But it also meant that the same profit motive that created opportunities for women within the literary industry encouraged the perpetuation of a conventionalized and disempowering vision of the woman of ideas.

One artist who occasionally forged a slightly different conception was Paul Gavarni (Sulpice Guillaume Chevalier), who did not figure the woman of ideas as a bourgeois femme-auteur or see her in relation to any conventional domestic identity. Much more than either Daumier or Grandville, Gavarni was sympathetic not only to the literary enterprise, but particularly to the woman writer.[34] Trained in industrial design at the Conservatoire des arts et métiers, Gavarni began his career, like Grandville, with fashion plates and then was briefly in the employ of *Le Charivari*. By far the most socially active of the three, he was a regular at literary and theatrical salons, where he came in constant contact with women writers. The salon of the Duchesse d'Abrantès, to which he was introduced by Balzac in 1831, was the source of many of his encounters with the female literary community.[35] Abrantès herself was a writer, and in addition to three lithographic portraits he made of her during their acquaintance, Gavarni illustrated at least one of her short stories.[36] His friendships with the Comtesse Dash, Elisa Mercoeur, Eugénie Foa, and Mélanie Waldor also led to commissions to illustrate their prose and poetry. He also produced lithographs to accompany several texts by Delphine de Girardin and her mother, Sophie Gay.

Gavarni is best known for his lithographs of the romantic bohemia that chronicle the lives of artists, flâneurs, *lorettes*, and students. The subtext for most of this work is the tense relations between the sexes, an issue that preoccupied him personally and professionally throughout his life. His images are dominated by strong and independent women who cow foolish and tongue-tied men. Later in the decade representations of the woman of ideas are conflated regularly with lorettes and courtesans by artists like Edouard de Beaumont, who sought to identify and denigrate them as whores. But Gavarni's figurations of the femme-auteur are unique among his images of women, deemphasizing the sexuality and corporeality of the writer and focusing on her mental processes. Furthermore, they picture her not as an aberration but as a natural part of the literary community.

"Hommes et femmes de plume" represents Gavarni's principal treatment of the subject of the woman of ideas. It first appeared in *Le Diable à Paris, Paris et les parisiens* (1845–46), another omnibus volume of celebrity

writers produced by Jules Hetzel. The premise for this pastiche of essays by famous writers is established in the introduction, where we learn that Satan, bored with Hell, has come to Paris to interview notables about life in the capital city. Overwhelmed with stories of poverty, greed, and suicide, he concludes that Paris is worse than Hell. To substantiate this conclusion, he sends a messenger to gather essays by well-known French writers describing their city. The result of this effort, interspersed with statistical data revealing the impact of industrialization on the poorer classes, forms the remainder of the book, whose subtext is a plea for charity and compassion.

Gavarni's "Hommes et femmes de plume" is part of a ninety-nine-image series entitled "Les Gens de Paris" that runs throughout the text. It accompanies Charles Nodier's brief essay "A quoi on reconnaît un homme de lettres à Paris." Nodier's piece is a glib satire on the cultivation of the identity of the man of letters in Paris—which no longer even requires that one write a book. The essay does not mention the issue of women who write, yet Gavarni's series is equally if not more interested in the *femmes de plume*. The seven illustrations that make up "Hommes et femmes de plume" feature eight women and six men. Though their legends invoke some of the same scenarios of domestic disarray and nonsensical musing that one finds in other treatments of the subject, there are several important differences between Gavarni's representations of literary women and representations by Daumier and Grandville. First, his satire is distributed equally between the men and women writers, as if they were of the same breed. The literary community he depicts is naturally composed of men and women who live and work together. Second, he locates his female literati in bohemian rather than bourgeois Paris. They are part of the romantic fringe who define themselves apart from bourgeois norms. Daumier and Grandville, on the other hand, disdain the woman writer both for her naissance within and destruction of the modern bourgeois family.

Though the legends that accompany images like *Tout, nous le savons bien, n'est pas couleur de rose* (fig. 14) and *Le Compte* (fig. 15) poke fun at the femme de plume for her heavy-handed prose and preoccupation with profit, the images do not. They feature casually and modestly dressed women, in a fashion appropriate to their environment and activity, deeply engrossed in thought. They provide a visual model of female interiority and quiet beauty quite different from most graphic representations of the woman of ideas. These figures, perhaps, are responsive to the literary women with whom Gavarni socialized regularly. The sympathy and intimacy with which Gavarni rendered these apartment interiors and their male and female inhabitants suggest a familiarity that could only be achieved through regular observation.

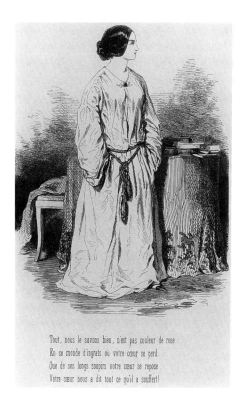

14. Paul Gavarni (Sulpice-Guillaume Chevalier). *Tout, nous le savons bien, n'est pas couleur de rose.* 1845–46.

Tout, nous le savons bien, n'est pas couleur de rose
En ce monde d'ingrats où votre cœur se perd.
Que de ses longs soupirs votre cœur se repose .
Votre cœur nous a dit tout ce qu'il a souffert!

15. Paul Gavarni (Sulpice-Guillaume Chevalier). *Le Compte.* 1845–46.

LE COMPTE.

Égarements divers et pensers charitables :
Six francs. — Regrets choisis : vingt francs. — « Mon idéal »
(Sous les traits adorés d'Alcindor) (l'animal!) :
Dix écus. — Et neuf francs de pleurs intarissables
Versés le mois d'avant au départ de Blinval......

Though the paradigms established or revitalized in the caricatures of Daumier, Grandville, and to some extent Gavarni influenced the huge body of prints produced in 1848 and 1849, more striking are the shifts in emphasis from small domestic eruptions in quiet interior spaces to raucous penetrations of the public domain, from the self-absorbed musings of individuals to the collective demands of armies of women. These changes were accompanied by the foregrounding of a countercultural theme that had been rehearsed throughout the July Monarchy in literature and popular imagery: transvestism.

The motif of transvestism had positive and negative readings in this period. In philosophical writings, for example, it was idealized through the lens of androgyny. The utopian visions of Pierre Ballanche, Auguste Comte, Prosper Enfantin, Charles Fourier, and Pierre Leroux, among others, equated the rehabilitation of "man" and the redemption of France with the recovery of a primordial bisexuality. For some, like Ballanche, this orientation bespoke a kind of social mysticism, wherein the image of the androgyne promised the restitution of an original, essential unity. For others, like Leroux and Fourier, it had a more pragmatic and political significance that translated into a commitment to the principles of emancipation, equality, and justice for women. In romantic literature, transvestism and androgyny signified a rebellion against the gender polarities inscribed in bourgeois culture. By confusing the traditional markers of class and sexual identity, the cross-dresser appeared as a figure of resistance to the hegemony of middle-class values. Dozens of novels—most compellingly, Théophile Gautier's *Mademoiselle de Maupin* (1835–36) and Balzac's *Séraphita* (1833–35)—deal with the theme of androgyny. The woman masquerading as a man is identified with a third sex that transcends prescribed social boundaries and facilitates the reconciliation of male and female principles. In fact, the vision of an idealized third sex in some sense informs Gavarni's image of the femme-auteur in "Les Hommes et femmes de plume." The mannishness of the woman writer in *Tout, nous le savons bien* and *Le Compte* stands in stark contrast with the curvaceousness of Gavarni's lorettes. Both men and women in "Les Hommes et femmes de plume" wear baggy and wrinkled robes that disguise rather than call attention to the figure's sexual identity and serve more as neutral pedestals on which to spotlight the focal point of the form—the physiognomic manifestations of the artist in thought.

While Gavarni relies on a unisex costume for his writers, the motif of cross-dressing—the performative act of moving costumed through public spaces—was much more prevalent during the July Monarchy. Cross-

dressing was perceived as a symbol of excess and transgression. Beyond its theoretical and metaphorical value in philosophical and literary discourse, it was associated with a lengthy historical tradition of rebellion. Natalie Zemon Davis' 1965 article "Women on Top" remains one of the most compelling discussions of gender masquerade. Though she cites political performances of male cross-dressers, like the Wiltshire enclosure riots of 1641, she maintains that in a male-dominated culture the figure of the female transvestite more strongly bespeaks insurgency and crisis.

Gender reversals were frequently the cause of political and social debate during the July Monarchy. One of the earliest and most powerful challenges to Louis-Philippe's authority, for example, took the form of a gender masquerade choreographed by Marie-Caroline du Bourbon, Duchesse de Berry, an extremely influential legitimist. The niece of Marie-Antoinette, Marie-Caroline devoted herself after the Revolution of 1830 to ensuring that her son, Henry IV, would take his rightful place on the throne. Fashioning herself after France's most illustrious cross-dresser, Jeanne d'Arc, the duchess dressed in the clothing of a male peasant and led an insurrection against Louis-Philippe in 1832. After she was caught and imprisoned in Nantes, the legitimist press mounted a campaign to discredit the bourgeois king and to venerate Marie-Caroline.[37] This cause célèbre was one of the first media events of the July Monarchy. Articles protesting her incarceration filled the pages of royalist magazines, and dozens of popular prints sanctifying her cause were issued. The prints took one of three forms. Some pictured the duchess in her prison cell at Nantes, invoking similar figurations of Marie-Antoinette. Others alternated between two of the most powerful pictorial traditions of female authority: the Holy Mother and the cross-dressed woman warrior. François Le Villain's lithograph *L'Auguste Famille* (fig. 16) derives from Raphael's *Madonna della Sedia*. But the features of Marie-Caroline are superimposed over those of the Virgin. The transformative power of that image of maternal devotion and self-sacrifice with which the Duchesse de Berry came to be associated was amplified by its frequent juxtaposition in the press with iconic counter-cultural representations like *Marie-Caroline* (fig. 17) an image that uncannily prefigures Delacroix's 1834 portrait of George Sand. Within a tondo format, Marie-Caroline is pictured from the chest up in a costume that blurs the boundaries of her class and sexuality. Her male clothing is set off by the long blonde curls that hang down to her shoulders and foreground the question of her gender.

In addition to such overt and direct gestures of defiance, the 1830s saw a great deal of experimentation with categories of the body and performa-

L'AUGUSTE FAMILLE.

M.ᵐᵉ la Duchesse de Berry, M.ᵗ le Duc de Bordeaux, Mademoiselle.

*Sur la toile animée, un habile pinceau.*
*D'un Dieu, près de sa mère, a retracé l'enfance :*
*J'ai tâché d'imiter un modèle si beau*
*Pour peindre des Français l'amour et l'espérance.*

*A. S.*

17. Anonymous.
*Marie-Caroline.* 1833.

MARIE-CAROLINE.

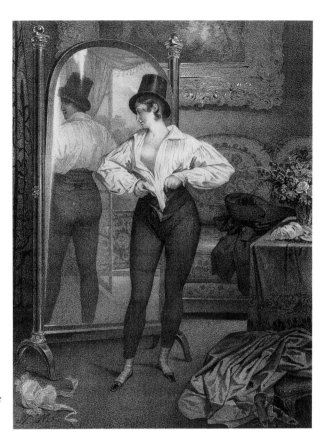

18. Nicolas-Eustache
Maurin. *Je suis bien.*
c. 1832.

tive masquerade that sought to redefine or reify social boundaries that had
been called into question. Much of this play occurred in the public context
of the *bal masqué,* a ritual of costumes and disguise associated with Carnival
that enjoyed a resurgence during the July Monarchy. Lithographs like
Nicolas-Eustache Maurin's *Je suis bien* (fig. 18) and Gavarni's *Des Habits
d'homme* (1837) suggest that cross-dressing was widely practiced in private
performances as well. One such private exercise in sexual politics took place
in the home of George Sand and Alfred de Musset in the early 1830s on the
occasion of a dinner party for Jean-Louis-Eugène Lerminier, a philosophy
professor and colleague at *La Revue des deux mondes.* According to Sand's
memoirs, the highlight of the evening was Musset's late appearance in
women's clothing.[38]

It was actually George Sand whose cultural politics and experimenta-
tion with gender reversal were most loudly and frequently debated during
the July Monarchy. Sexual inversion and masquerade informed nearly

every aspect of her literary production and self-presentation.[39] Within her own media of journalism and literature, the sexuality of this consummate nineteenth-century woman of ideas was the subject of continuous scrutiny.[40] The literary and pictorial construction of her identity, which foregrounded her body in the context of the political, came to emblematize the incipient social and sexual revolutions of the July Monarchy.

George Sand is, of course, a pseudonym adopted by Amandine Aurore Lucie Dupin Dudevant in 1832 for her first independent literary project, *Indiana*. A novel about an unhappy wife in a stultifying marriage quite like Aurore Dupin's, *Indiana* marked the beginning of a successful and sometimes lucrative career. Despite the potential restrictiveness of her early marriage, Sand managed, by means of an unusual separation agreement, to live for three-month periods alternately in Paris and at her country home in Nohant. This preserved the form of her marriage yet offered her the freedom to pursue a writing career. With an output of more than one hundred novels and plays in addition to a ten-volume autobiography, George Sand could not be passed over as a "woman who wrote books." She was a professional writer whose financial and critical success enabled her to support herself and to live as independently as any woman in the nineteenth century.

Sand's novels of the 1830s, peopled by women frustrated and constrained by limited educational opportunities and the slavery of marriage, scandalized and delighted Parisians. The hostility of her critics intensified, however, in the 1840s when, under the influence of socialist Pierre Leroux, Sand's novels began to address issues of class and property. She became the target of a barrage of articles in the republican and legitimist press designed to contain the threat of her challenging voice. These articles sought to trivialize Sand's power by figuring her as a creature whose purpose was to undermine the bourgeois institutions of marriage and family.

Sand was attacked in print constantly, but she rarely turned up in the comic illustrated press. To grant her the exposure of an individuated portrait would have been to grant her legitimacy and to contribute to her stature as cultural icon. Accordingly, the majority of caricatures that do exist refer to the writer in the legend rather than physicalize her. Although most of the caricatures of Sand avoid individuation, even the rare *portrait chargé* works to contain the threat of the woman it describes. In 1842 *Le Charivari* published one of the very few portraits chargés of a female subject ever to appear in its pages. The caricature by Alcide Lorentz (fig. 19) conflates aspects of several well-known portraits of Sand, including a lithograph by Jules Boilly (fig. 20) commissioned in 1837 for an album accompanying the text *Biographie des femmes auteurs contemporaines* and a widely

circulated portrait by Bernard-Romain Julien (fig. 21) that first appeared in 1838 in the *Galerie de la littérature*. Appropriating elements of portraits that honor Sand's talent, Lorentz recontextualizes them by using conventional sexual iconography to deflect our attention away from the writer's achievement and toward her unnatural sexuality.

The legend of the caricature translates: "If this portrait of George Sand leaves you perplexed, it is because both her genius and success remain obscure." The image consists of the full-length figure of Sand, encircled by smoke that emanates from the cigar in her left hand. Within the mandala of smoke are the title pages from several of her literary and political writings. She wears men's clothing and is pictured generating and standing on pillows of vaporous mass. Her intellectual product is visually and metaphorically equated with the smoky product of her cigar; both exist, it implies, as matter without substance, obscuring rather than clarifying. But her manner of dress is the focus of the image. The loose men's clothing that she had made for her on her arrival in Paris as a means of conserving money and allowing her to move anonymously through the streets is here expressed as sexual fantasy rather than cultural politics. Lorentz renders her male dress as just another smokescreen barely concealing her true agenda. Dividing her at the shoulders, Lorentz shifts the top half of her body slightly away from the torso, its lighter tonality associating it with the circular cloud of smoke. Eyes cast dreamily off to the right, elbow resting on a sheaf of papers, she is made to strike the pose of romantic inspiration. The remainder of her being, clad in skin-tight vest and pants, is articulated in darker lines and shadows that call particular attention to her breasts, waist, and crotch (which marks the center of the composition). The more corporeal and explicit treatment of her lower body serves to expose the pretense of intellect one reads on her face. Though Lorentz grants Sand the celebrity most caricatures sought to deny her, its recourse to a conservative figural tradition of the female body ensures diffusion of what is most subversive about the woman of ideas. The lithograph removes its subject from the world of thought and restores her to a traditionally female place in the realm of lust and desire.

*Ce beau candidat* (fig. 22) similarly seeks to expose the sexual fantasies that underlie Sand's intellectual pretensions. This unsigned caricature from 1848 also borrows elements from a well-known portrait, in this case Auguste Charpentier's painting of Sand from 1839 (fig. 23). The caricature shows Sand and Ledru-Rollin (an outspoken republican who served as Minister of the Interior for the Provisional Government after the 1848 Revolution) ascending a platform at a meeting of the Club des femmes. Though Sand, in fact, served as Ledru-Rollin's chief propagandist and

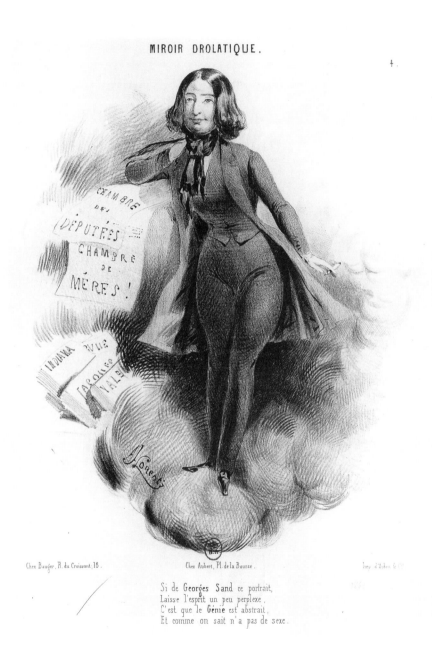

Chez Bauger, R. du Croissant, 16 .  Chez Aubert, Pl. de la Bourse .  Imp. d'Aubert & C.

Si de Georges Sand ce portrait,
Laisse l'esprit un peu perplexe ,
C'est que le Génie est abstrait,
Et comme on sait n'a pas de sexe .

19. Alcide Lorentz.
*Miroir Drolatique.* 1842.

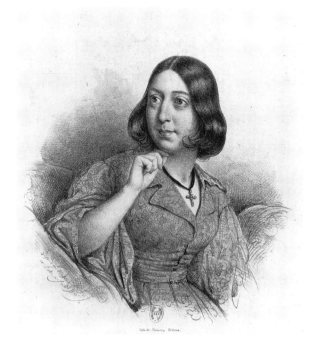

20. Jules Boilly.
*Mme G. Sand.* 1837.

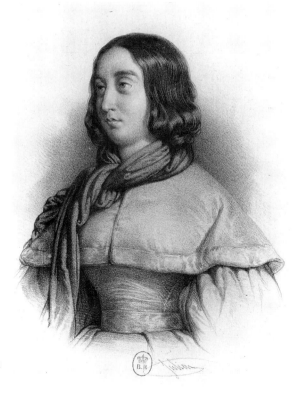

21. Bernard-Romain
Julien. *George Sand.*
1838.

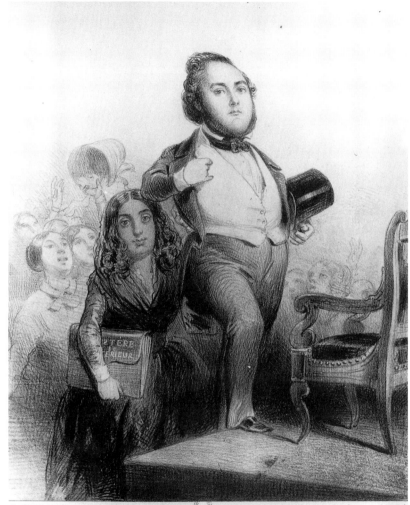

**CE BEAU CANDIDAT**

Réunira toutes les voix pour la **Présidence** ..........
du Club des femmes.
Ces dames voudraient elles jouer le Beau **Role-hein ?**

22. Anonymous.
*Ce beau candidat.* 1848.

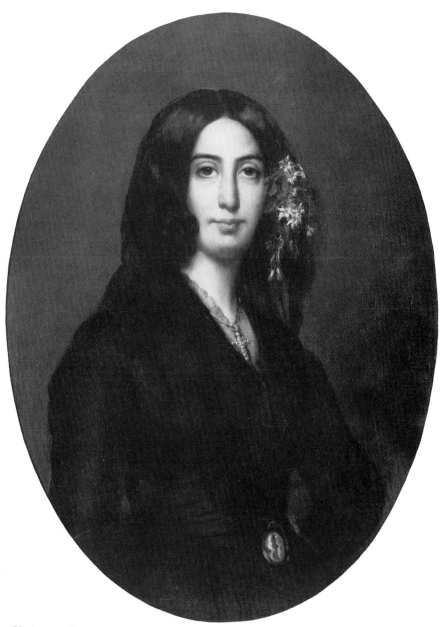

23. Auguste Charpentier.
George Sand. 1839.

close adviser, their relationship here is described in sexual terms. Their bodies form a centralized pyramid in which they almost seem to merge, her form a literal extension of his right arm. He climbs the steps to the platform and she follows, clutching his portfolio in one hand and presumably his genitals in the other. They are surrounded by adoring female faces who, as the legend tells us, "Join their voices (in support of Ledru-Rollin) for the presidency . . . of the club des femmes." George Sand experiences in a hands-on manner, so to speak, what the club members experience vicariously, as suggested by their groping, disembodied hands, which highlight the suspicious disappearance of Sand's left arm under Ledru-Rollin's cloak. Thus, the pun in the second sentence of the legend: "Ces dames, voudraient-elles jouer le Beau Rôle-hein? (These women, wouldn't they like to play this desirable role" or "play with this fine looking Rollin?") The subtext of their collaboration is further implied by the hats that break the staid parameter of their body pyramid. A round, open, hollow bonnet is held over Sand's head in contradistinction to the phallic projection of Ledru-Rollin's top hat, which he proudly clutches to his chest.[41]

The conflation of sexual and political threat that is implicit in these caricatures of George Sand is explicit in the timing and content of several textual descriptions that appeared during the same period. The equation of Sand's sexuality with societal dissolution is perhaps most strikingly enacted in a pair of articles in the legitimist journal *La Mode*. They are paired not because they were intended to be—in fact, they were published thirteen years apart—but because both appear at moments of extreme political tension (punctuated by the reimposition of press censorship after a period of relative freedom) and both characterize Sand's ambiguous sexuality as the embodiment of that tension.

The first was written by Jules Janin in September 1835 for a regular *La Mode* series called "Galerie Contemporaine" that featured benign biographical and career sketches of prominent French male writers. For this installment, however, *La Mode* departed from the traditional character of the series in terms of format and of the subject's gender. "Qui est-elle? Homme ou femme, ange ou démon, vice ou vertu," the piece begins, introducing the theme of deviance that is to dominate.[42] Nothing is revealed of Sand's childhood or early adult years, as had been the formula in other articles. Rather, the essay evolves as a kind of horrific myth about an androgynous creature who was born of and nourished by the destruction of Paris: "George Sand est l'enfant littéraire et politique des pavés de Juillet."[43] Starting with Sand's arrival in Paris on the arm of her lover, Jules Sandeau, in January 1831, Janin elaborates a modern-day version of Pandora's box: "Pour la femme qui s'enfuit loin de son mari, . . . 1830 était une

année bien choisie pour venir à Paris chercher fortune à ses passions."[44] The article explains that, like Sand, the city had just been wrenched from "l'abri de l'autorité royale" and left in "un véritable chaos plein de confusion et de désordre."[45] But while Paris was the victim of this unnatural shift of authority, Sand fed and thrived on it.

The remainder of the article berates Sand in a more ordinary manner for qualities typically associated with the woman of ideas. But it is the first section, the tale of monstrous birth, that remains the most unusual and startling feature. Why the departure from the "Galerie Contemporaine" format? Why spotlight Sand (the only woman in the series) in this particular issue of *La Mode*? Why return with such venom in 1835 to the events of 1830? One answer is suggested in the same volume of *La Mode* by the inclusion of several articles decrying Louis-Philippe's newly imposed September Laws. These laws forced many publishers to change the editorial policies of their journals if not shut them down completely. There is a dramatic difference in content and style between the issue of *La Mode* in which the George Sand article appears and subsequent ones. The shift is from antigovernment diatribes and occasional political caricature to accounts of dinner at Fountainbleau and to fashion plates. At this moment of emasculation and anger that could not be directly addressed, the editors of *La Mode* turned to George Sand, through whom they could exorcize their emotions without fear of the censor. This woman—intellectually, financially, and sexually liberated from patriarchal authority (her husband)—seemed to embody for Janin the most twisted and dangerous aspects of France's rebellion against its own patrimony in 1789 and again in 1830.

Though dozens of articles after 1835 rehearsed variants of the George Sand myth, one of the most extreme appeared in the aftermath of the Revolution of 1848, just following the violence of the Bloody June Days. At a moment that commenced the repressive and reactionary phase of the revolution, *La Mode* turned to George Sand yet again to purge the anxiety of political instability. But in 1848 the challenge to social order was even greater than it had been thirteen years earlier; accordingly, the rhetoric invoked was at times more frenzied. While the 1835 article is a Frankenstein tale about a creature spawned and nourished by the upheaval of 1830, the later version depicts Sand as the generative source of such events, as an unsigned lithograph of the same year *La Gigogne politique de 1848* (fig. 24) visualizes.[46]

The 1848 tale is also part of a *La Mode* series, this one called "Profils Républicains." As her inclusion in such a series suggests, George Sand had by this time gained a voice in contemporary political discourse. She was at the forefront of a group of women participating in the most radical revolu-

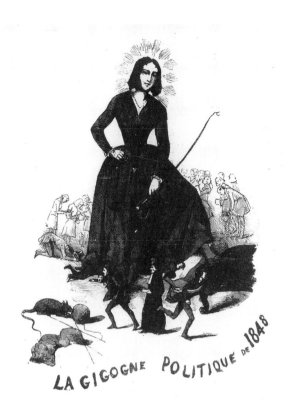

24. Anonymous. *La Gigogne politique de 1848.* 1848.

tionary politics in 1848, challenging the distribution of property and power in France. Clubs and newspapers run by women argued in this period for the right to vote and the right to divorce; they circulated petitions, sponsored free evenings of political drama for working-class audiences, and organized often nightly lectures on the legal position of women in France. Not surprisingly, in this postrevolutionary era, in which the ascendant Right and moderate factions inaugurated a program of official repression of political clubs and the periodical press, the woman of ideas again became a major target of popular journalistic attack. Deviant and ambiguous sexuality like George Sand's became in 1848 a dominant metaphor for the failure of the Revolution.

This equation informs the later *La Mode* piece wherein Sand, concealed by men's clothing as the devil by a serpent's form, has brought about the corruption of revolutionary ideals and the fall of revolutionary alliances. George Sand, the article asserts, disguises "himself" like Satan to

hide the immensity of "his" power and the sordidness of "his" enterprise. It characterizes Sand as an androgynous creature who ingratiated itself with the public at an opportune moment in 1831 when "France, dégoûtée de l'histoire que lui faisaient au jour le jour ses gouvernants, cherchait à se distraire de ses souffrances et de ses hontes par la lecture des oeuvres d'imagination Balzac, Sue et George Sand."[47] When Sand appeared to attack only royalty, religion and morality, "he" was read with admiration, but when *Lélia* was published, a "composition monstrueuse, presque satanique," people began to suspect the subtext of "his" true identity.[48]

The article quickly abandons the concept of a biographical essay and, in the climactic moment, implores its audience to expose the *monstruosité* that is George Sand by rejecting and desexing this "ministère de l'émancipation des femmes." The admonition is no longer to contain or naturalize Sand's confusion of male and female identity; it calls for the exorcism of this horrific amalgam of the two. All hope for the restoration of order and well-being is contingent on her obliteration.

George Sand's function in the French cultural imagination, as the symbolic site on which political and sexual tensions converged, was expanded in 1848 to include the women of ideas generally. The transgressions associated with literary and political women throughout the 1830s and early 1840s were transmuted in 1848 into figurations of a female grotesque. Reacting to an increase in women's vocality, class solidarity, and collectivist action, male journalists and caricaturists in the republican and legitimist press waged a campaign to contain the challenges to social order.[49] That campaign included widespread denunciations of Sand, trivializations of female contributions to the revolutionary effort, and debasement of the worst offenders as sexual deviants or transvestites.

The community that united many different female voices after 1848 centered on the feminist/socialist newspaper *La Voix des femmes* and the political club it spawned. Often compared with Madeleine Poutret de Mauchamp's *Gazette des femmes*—the target of La Maison Aubert's nastiest attack in the 1830s—*La Voix des femmes* forged an unprecedented coalition of women from diverse economic levels and political orientations.[50] The aristocratic salonnière Anaïs Ségalas joined with bourgeois femme-auteur Eugénie Foa and former "prolétaires Saint-Simoniennes" Suzanne Voilquin, Désirée Gay, Eugénie Niboyet, and Jeanne Deroin to petition for legal reforms, promote the candidacies of their male supporters for seats on the Constituent Assembly, and argue for the extension of voting rights to all citizens, male and female.[51] In the period between February and April 1848, after the Revolution and before the elections to choose a new republi-

can leadership, caricatures of the female activists focused principally on the *clubbistes* and their campaign to reinstitute divorce laws in France. Images like Henri Emy's *Manifestations des femmes* (fig. 25) featured armies of overweight and open-mouthed women neglecting their domestic duties.[52] Emy's lithograph pictures a sea of beleaguered husbands staggering beneath the psychological and physical weight of their wives' activism. They are shown carrying their spouses on their backs, suggesting that it is only the slavish cooperation and support of these husbands that makes female intrusion into the political arena possible.

Most of the satirical imagery on the *Voix des femmes* group produced in this two-month period safely replays the domestic narratives with which the woman of ideas had been described earlier in the July Monarchy. There was, however, a second female revolutionary organization, unrelated but constantly identified with the *Voix des femmes* group, that was frequently satirized in the press. The Vésuviennes was a legion of working-class women warriors formed in March 1848. It was, in a sense, a logical culmination of France's longstanding fascination with the phenomenon of women on the barricades. As I indicate in Chapter 1, there was visual documentation of female involvement in the street fighting of the Revolutions of 1789 and 1830. The many memoirs written to recount the events of 1848 also include descriptions of women warriors.[53] Struck by the bravery and patriotism of women in 1848, a chemist named Daniel Borme circulated posters all over Paris in March 1848 urging the formation of a female regiment to be called Les Vésuviennes. He invited unmarried women between the ages of fifteen and thirty to enlist. This gesture resulted in both the creation of a female regiment and an outpouring of articles in the popular press satirizing the notion of these femmes libres fighting side by side with the national guard.[54]

Substituting the phrase "free women" for "unmarried women" reinvoked the separatist Saint-Simonienne venture of the early 1830s that had been trivialized as a cover for sexual promiscuity. The same strategy was expanded to defuse the power and integrity of this enterprise. In sharp contrast with the serious issues raised in the Vésuviennes' *Constitution politique des femmes* (the patriotic belief in national service, the importance of marriage and shared domestic responsibilities from the vantage point of women who had experienced poverty and single-parenting), coverage in the press worked to reconventionalize the identification of these women. The first caricature series by Cham (Charles Henri Amédée, Comte de Noé) began in March 1848 in *Le Charivari* (the journal that took responsibility ten years earlier for the denigration of the *Gazette des femmes*).

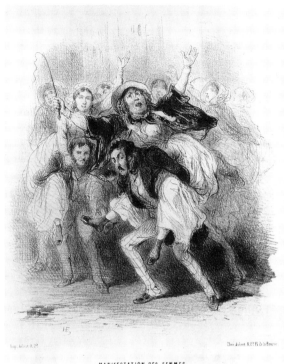

25. Henri Emy.
*Manifestations des femmes.*
1848.

MANIFESTATION DES FEMMES.

Plus de vilains maris .... vive le Divorce !..

Though Cham's style and technique were different from Daumier's in every way—wood engravings on a miniature scale, grouped from four to nine on a page—the scenarios of abandoned children and cuckolded husbands were drawn directly from "Les Bas-Bleus." A four-image Vésuviennes series by Gustave Doré was quickly inaugurated in the *Journal pour rire* in May 1848. But it was Edouard de Beaumont, modeling his representations of Parisian women after Gavarni, who became the principal illustrator of the women warriors. His influential series for *Le Charivari,* also begun in May 1848, severed any connection the woman warrior might have had with an acceptable female role and reconnected her with the tradition of street whore. He had transformed "les Vésuviennes" into "les lorettes." Images like *M'ame Coquardeau, j'te defends . . .* (fig. 26), published in *Le Charivari* on 1 May 1848, picture the soldier as a flimsily dressed coquette. In a tightly fitted costume, she bends slightly at the waist to thumb her nose at her husband, who stands before her holding three crying babies. His nightdress stands in contradistinction to her male clothing, and the con-

26. Edouard de Beaumont. *M'ame Coquardeau, j'te défends . . .* 1848.

spicuously empty space between his legs (exaggerated by the width of his stance and the shortness of his gown) spotlights the provocative placement and phallic projection of the rifle in her hands.

In late May and June, as Laura Strumingher has argued, representations of the woman of ideas grew increasingly less attractive than before, focusing around gender reversals and transvestism. Women had not been allowed to vote in the April elections, and the male supporters of a feminist and socialist agenda had made a poor showing. The Executive Committee elected to replace the Provisional Government was much less sympathetic to the *Voix des femmes* group and to any constituency agitating for real social reforms. Increasing anxiety about the direction of the republic and its new and fairly reactionary government was exacerbated by the reintroduction of press restrictions in July that sent shock waves through the journalistic community.[55] Just as male anger at the September Laws had been deflected onto George Sand in 1835, concern over the regressive policies of the newly

*July Monarchy Typologies of the Woman of Ideas*

elected Executive Committee was redirected toward the female activists of 1848.

In June Edouard de Beaumont's Vésuviennes lost some of their coquettish quality. The caricatures published in *Le Charivari* featured more phallic imagery and less playful gender reversal. The shift in tone in textual and pictorial representations of the woman of ideas was part of a campaign of antifeminism that was bred in the conservative postelection climate of France. For example, riots were staged at meetings of the Club des femmes to force its disbandment. But it was the June Uprising, the six days of violent street fighting sparked by the government's closure of national workshops, that precipitated the most vicious and transformative imagery.

The failure of the revolution was characterized in gendered terms. Edouard de Beaumont's noncharged drawing for *L'Illustration*, titled *Dévastation du poste de la place Maubert* (fig. 27) relies on an image of castration and female violence (a woman charging through the street with the decapitated head of a male soldier adorning the end of her upraised sword) to signify the Bloody June Days. What was implicit in his drawing—that the flowering of female power was responsible for the failure of the revolution—was explicit in his book on the subject published in 1851, *L'Epée et les femmes*, an eight-volume history of the world that attributes every human catastrophe

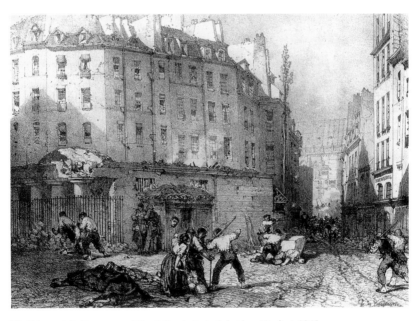

27. Edouard de Beaumont. *Dévastation du poste de la place Maubert.* 1848.

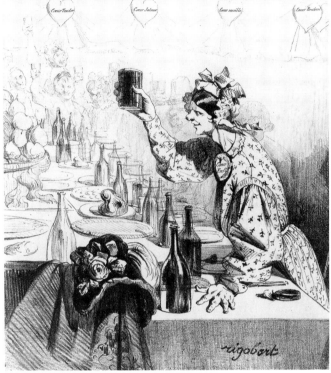

28. Rigobert. *Les Toasteuses*. 1848.

to a female troublemaker. The sensation of a world turned upside down was translated into such shocking images as Rigobert's *Les Toasteuses* (fig. 28) and Bélin's *Ce qu'on voit et ce qu'on entend* (fig. 29), both of which feature monstrous clubbistes of uncertain sex seated at banquet tables. Their threat to French society is suggested by the reaching gestures of their stubby, gnarled hands toward sharpened knives and forks.

Even more striking was the production of *portraits chargés* of the female monsters of 1848. Throughout the 1830s and 1840s the only woman of ideas who was granted the exposure of caricatural treatment was George Sand. But after June 1848 a series of portraits chargés were issued as part of a campaign to target and silence the ringleaders. One of the subjects of this assault of words and pictures was Jeanne Deroin, a former Saint-Simonist who helped found *La Voix des femmes,* and then an even more radical paper

called *Politique des femmes*. She continued her fight for women's political rights even after she was forced to change the name of her journal (women were legally prohibited from using the term *politique*) and eventually to shut it down altogether.[56] Rather than give in to the pressure, in 1849 she accelerated her activities and illegally announced her candidacy for the National Assembly on posters all over the city. When that effort failed she began organizing a federation of workers' associations. Her relentless desire to participate and to effect change was not stifled until 29 May 1850, when she was arrested, tried, and imprisoned.[57]

Bertall's *Le Rêve de la mère Deroin* (fig. 30) was published in *Le Journal pour rire* on 28 April 1849, just after Deroin announced her candidacy for the Assembly. Deroin—portrayed as a scrawny, breastless hag with huge feet and a wide-open mouth—is shown in a delusional dream state. Bolt upright in bed, she stares disbelievingly at the vision of an androgynous Jeanne d'Arc hovering above her bed. Jeanne d'Arc's armor and mannish facial features are contradicted by the outline of breasts and nipples that protrude through her costume. According to the legend, Deroin dreams of la Pucelle d'Orléans' appearance and the mission to save France with which she charges her. Any credibility that the notion of a French female redemptrice may have had is undermined by the sequence of four names, Deroin's lineage, that appears in a cloud above her bed: "Jeanne d'Arc,

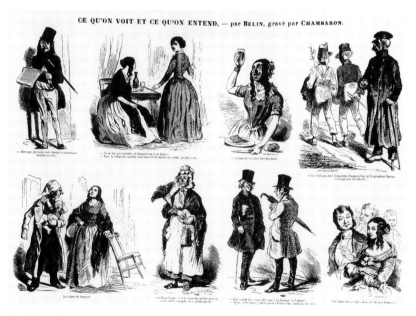

29. Bélin. *Ce qu'on voit et ce qu'on entend.* 1849.

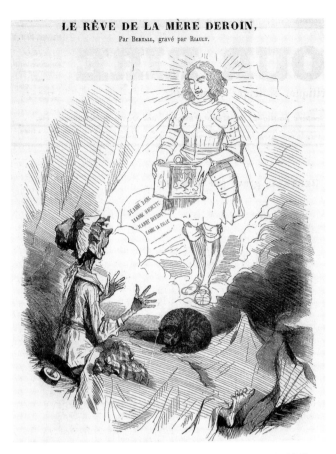

LE RÊVE DE LA MÈRE DEROIN,

Par Bertall, gravé par Riault.

30. Bertall (Charles Albert d'Arnoux). *Le Rêve de la mère Deroin.* 1849.

Jeanne Hachette, Jeanne Deroin, Jeanne La Folle." The first two Jeannes are famous historical women warriors who went into battle to fight for France. Their coupling with the last Jeanne, Jeanne La Folle—a legendary figure whose widowhood triggered madness—was a kind of demystification of all their achievements. The accomplishments of each of these Jeannes are erased and refashioned in this caricature as hallucination and the babbling of madwomen.

Writer Delphine de Girardin was another target of this campaign of slander. Throughout the 1830s she was considered one of the few acceptable and even appealing women of ideas, but by 1848 she was lumped together with the rest of the female grotesques. She had begun her career in a traditional manner, writing and reciting poetry and cultivating the role of muse to male genius. But after her marriage in 1836 to newspaper

mogul Emile de Girardin, her priorities were rearranged. She began writing a gossip column for her husband's paper, *La Presse,* under the male pseudonym Vicomte de Launay. In the 1840s she produced plays, and by the end of the decade her column, "Chroniques parisiennes," had assumed a feminist perspective, complaining that "la preuve qu'ils [les hommes] ne comprennent pas la République, c'est que dans leurs belles promesses d'affranchissement universel . . . ils laissent dans l'esclavage les femmes."[58]

*Une Muse en 1848* (fig. 31) is a portrait chargé conflating the features of Emile and Delphine de Girardin into one depraved challenge to all codes of social regulation. The sensual body of Delphine is seated at her desk busily penning her next article for *La Presse.* But her true monstrous identity is revealed in the hooves that are her feet, the man's features that define her face, and the Medusa-like head full of snakes. It is an image of the death of the feminine muse (signified by the lyre that is propped up behind her) and any normative model of female intellect, and her replacement in 1848 by the unnatural *femme-homme littéraire.* But it is also an image that signifies extreme danger on a broader political level. The danger that this satanic metamorphosis portends is suggested by the composition's identification with a tradition of postrevolution imagery linking political violence with the bloodthirsty journalist. *La Muse de 1848,* like the 1832 *L'Ecritoire de l'opposition* (fig. 32) is an ironic inversion of David's canonization of Marat in his famous painting commemorating the journalist's death. Blame for the wave of violence and the dissolution of revolutionary alliances after June 1848 is located in the image of this transgressive female jabbing her pen into the ink well, which is labeled with the word "vitriol."

During postrevolutionary periods the expression of political confusion in sexual terms is not uncommon. The social, economic, and sexual consequences of the Revolution's fulfillment posed a threat to many of the war's most fervent supporters—a threat that could not be expressed in conventional political terms. The self-protective response to that threat required a language of primal fear. It required a figure of the dark and hideous side of the Revolution that one would logically seek to eradicate; one convenient and powerful figure was that of unnatural womanhood. Thus, after 1849, the failure of the Revolution was explained by some, like socialist "reformer" P. J. Proudhon as "too strong a feminine influence." "The feminine element was in the majority," Proudhon wrote. "This was the failure of the Republic. . . . This was the Republic fallen to the female line."[59]

UNE MUSE EN 1848.

31. Anonymous. *Une Muse en 1848*. 1848.

*L'Ecritoire de l'Opposition.*

32. Anonymous. *L'Ecritoire de l'opposition*. 1832.

# 3

## *Ménagère ou courtisane:* Daumier's Vision of Female Intellect

P. J. Proudhon's widely circulated statement "Ou ménagère ou courtisane, il n'y a pas de milieu" is presaged in Honoré Daumier's three caricatural series on the woman of ideas.[1] Daumier produced the most extensive visual treatment of this subject during the July Monarchy. Between 1837 and 1849 he devoted more than sixty-five lithographs to the intellectual woman. Until recently, the one- or two-paragraph comments by Daumier scholars who discussed these images at all ranged from unselfconscious restatements of Daumier's antifeminist sentiments to assurances that Daumier was offended not by feminist theory but by feminists themselves.

In *Honoré Daumier: L'Homme et l'oeuvre,* published in 1888, Arsène Alexandre's characterization of Daumier's "Bas-Bleus" concludes simply that feminist women are those who do not want to resign themselves to being women. Almost a century later, the criticism of these series is barely more substantive. Howard Vincent writes that Daumier's attitude reflects nothing more than "dislike of the anti-feminine woman, the enthusiast . . . who is, after all, . . . a natural target for the satirist's laughter." Oliver Larkin explains that "Daumier's ridicule is directed not at the notion of reform but at its sententious high priestesses and camp followers." Most disconcerting are critics like Judith Wechsler, who avoids any mention of content at all, describing these images only as "virtuoso studies in the negative space between the two figures."[2]

Only two essays are devoted exclusively to Daumier's caricatures of the woman of ideas. They were written, not surprisingly, in the mid-1970s, when the impact of feminism on art history and criticism was first registered.[3] Françoise Parturier's essay in *Daumier: Intellectuelles ("Les Bas-Bleus" et "Femmes Socialistes")* and Caecilia Rentmeister's more scholarly "Daumier und das hässliche Geschlect" provide contextual enrichment that is essential to the reading of Daumier's imagery. But these essays are principally concerned with elucidating the present by resurrecting a comparable historical moment. Neither analyzes the lithographs in any detail nor examines their cultural resonance.

The paucity of critical attention devoted to Daumier's series "Les Bas-Bleus" (1844), "Les Divorceuses" (1848), and "Les Femmes Socialistes" (1849) can be explained, in part, by the preoccupation of art historians—especially those in nineteenth-century French studies—with courtesan imagery and figurations of motherhood. Until recently, gender studies of this period have been strikingly bound to conventional standards of womanhood.[4]

But the critical neglect of these series must also be understood in light of the lack of rigor of Daumier studies generally. Writings about this artist have consisted, for the most part, of efforts to elevate his work to the status of "high art" and the man to an emblem of social justice and individual freedom. As Michel Melot argues in "Daumier and Art History: Aesthetic Judgement/Political Judgement" (1988), Daumier criticism has been the province of collectors and social historians. Its only other vital arena has existed in exhibition catalogues produced for government-sponsored shows like "Daumier and His Republican Friends" that seek the political rewards of identification with the Daumier aura.[5]

In a sense Daumier has been studied as just one more emblematic type, like Robert Macaire or Joseph Prudhomme. But instead of symbolizing corruption or bourgeois complacency, he is a cliché of radical republicanism and heroic self-determination. It is only recently that art historians like Elizabeth Childs, James Cuno, and David Kunzle have begun to construct a more generative framework through which to look at Daumier's oeuvre. Their work moves beyond the identification of political content in Daumier's lithographs as an end in itself to remind us, for example, of the pragmatic and entrepreneurial dimension of Daumier's alliance with his editor, Charles Philipon, and of the surprisingly small and largely upper-middle-class origins of his audience. Childs' study "Exoticism in Daumier's Lithographs" is particularly important for its implicit expansion of the parameters of political caricature (going beyond obvious imagery of government officials and historical moments) to include social caricature, a

genre often falsely described as a kind of objective looking-glass for the world.[6] Social caricature commonly is misperceived as a benign and politically neutral form of satire that pokes fun at cultural oddities.

In this chapter I offer a reconsideration of that premise through a discussion of Daumier's series on the woman of ideas. I focus on the power of these social caricatures to fix class and gender identities that are, in reality, fluid.[7] But through an examination of Daumier's reconventionalized figure of the woman of ideas, I also will suggest how this female type came to signify an oppositional alternative to more normative categories of womanhood.

Like his contemporaries Bertall, De Beaumont, and Cham, Daumier downplayed what was genuinely powerful about women of ideas by figuring them only as negative models of female behavior. Rather than picturing the literary and political woman in situations that acknowledge her talents and successes, she most often is shown disrupting households, neglecting children, and opportunistically using her fame to satisfy unnatural sexual appetites.

Although Daumier's series must be seen as part of the larger response in the popular press to the increased visibility of the woman of ideas, its fundamental context remains the antifeminist policies of *Le Charivari,* the journal in which all of the lithographs appeared, and its forerunner, *La Caricature.*[8] The first textual references to the woman of ideas in these publications appeared in nonsatirical book reviews that were descriptive and promotional rather than analytical. In fact, many titles of books reviewed reappear on page four, in the section devoted to advertisements.[9]

Accounts of books by women were friendly in the early 1830s, but they were supplanted later in the decade by hostile, satirical articles on the woman of ideas. As I suggest in Chapter 2, the change is due in part to Louis-Philippe's September Laws of 1835, which forced Charles Philipon to redirect the satirical focus of his journal, *Le Charivari.*[10] Philipon altered the format of *Le Charivari* to include art and literary criticism and social caricature. Daumier's series on the woman of ideas, like most of his lithographic work produced between 1835 and 1848, has been relegated to this so-called lesser aspect of his oeuvre, to the period that traditionally has been treated as one in which the artist was forced to suppress his political concerns in favor of benign scenes of everyday life.[11]

The number of articles on the woman of ideas in *Le Charivari* increased dramatically after 1835. The legally mandated shift in editorial focus from the government of Louis-Philippe to such subjects as the plays of Virginie Ancelot must have foregrounded an inequitable situation: the avenues for women writers to publicize women's issues were growing as the

opportunities for Philipon and his staff to exercise their own political agenda were waning. The animosity toward the woman of ideas evident in *Le Charivari* after 1835 is directed particularly at the newly professionalized bourgeois femme de lettres.[12]

The hostility toward the nineteenth-century woman of ideas derived from her increasing enjoyment of the financial and critical rewards once reserved exclusively for men. It also reflected her evolution in this period from mere femme-auteur to what the nineteenth-century playwright and essayist Frédéric Soulié labeled "le bas-bleu militant."[13]

Female politicism in the early 1830s involved, most prominently, working-class Saint-Simoniennes whose journalistic enterprise provided the model for many women's magazines launched in the mid to late 1830s and in the 1840s, the majority of which signified the bourgeois appropriation of the feminist enterprise.[14] The individual who appears to have emblematized the bourgeois "bas-bleu militant" and whose activities prompted the first sustained attack on the woman of ideas in *Le Charivari* was Marie-Madeleine Poutret de Mauchamp, who in 1836 established a moderate republican "Journal de législation et de jurisprudence" called the *Gazette des femmes*. The model for the *Gazette des femmes* was Désirée Veret and Reine Guindorf's Saint-Simonist newspaper *La Femme libre* (1832–34). Although the writers for *La Femme libre* were harangued constantly in the legitimist and *juste-milieu* press in the early 1830s, they barely received mention in Philipon's publications. Their working-class origins seem to have ensured the benign neglect if not sympathy of Philipon, who reserved his contempt for the bourgeois women whom he accused of arrogating the feminist rhetoric of Veret and Guindorf and capitalizing on the vogue of *la femme émancipée*.[15]

Honoré de Balzac's novella *The Illustrious Gaudissart* suggests how lucrative and chic the image of la femme émancipée had become by 1837, the year the work was published. Gaudissart, the quintessential commercializer of ideas, sells insurance by day and subscriptions to the Saint Simonist journal *Le Globe* by night. The emptiness of feminist rhetoric is parodied during an explanation to his wife of the complexities of producing an appropriate sales pitch for *Le Globe*: "You do not know what the emancipated woman is," he blusters. "The Saint Simonism, the antagonism, the Fourierism, the criticism, and the passionate exploitation; well, it is—in short, it is ten francs by subscription, Mme Gaudissart."[16]

Poutret de Mauchamp's purpose, articulated in the first issue of the *Gazette des femmes*, was to educate women about legal issues and to provide a platform to agitate for political and civil rights reform. She held highly publicized weekly meetings to build a constituency and to guide supporters

in the writing of petitions that argued for such issues as the admittance of women to the Institut de France, the reestablishment of divorce, and, most provocatively, the eradication of article 213 of the Civil Code, which dictated: "The husband owes protection to his wife; the wife obedience to her husband."[17] Her journal flourished between 1836 and 1838 until she, like the Saint Simonist guru Père Enfantin, was officially silenced after being tried and convicted on fabricated morals charges.

*Gazette des femmes* was prominent during the years when *Le Charivari* first began to assault the woman of ideas. One of the earliest attacks appears in a review of Théodore Muret's comedy "Les Droits de la femme," which opened at the Théâtre français in May 1837. The reviewer analyzes the female protagonist's development, under the influence of Poutret de Mauchamp, from innocent to "bas-bleu militant": "Madame read the novels of George Sand, she cried at performances of 'Marie,' and she was up-to-date on all of the demonstrations and insurrectional activities recently publicized by women through the voice of the press and the popular theatre."[18]

"Les Droits de la femme" concerns the brainwashing of a young woman by Poutret de Mauchamps and the woman's subsequent salvation by a clever man. The paradigm to which the play and its review conform— the impressionable victim manipulated by an evil female mentor—was reproduced often in the pages of *Le Charivari* to account for the evolution of the woman of ideas.[19]

The review of Muret's play is followed, several issues later, by a lengthy article titled "Curiosités littéraires: Les Demoiselles de lettres," which describes the phenomenon of the provincial woman of ideas through a woman who is nicknamed by her family *la dixième muse,* the name assigned female poets during the Restoration and July Monarchy.[20] In a scenario that bears a striking resemblance to the sad legend of Daumier's father, she is said to discover one morning that life in the provinces is too limited.[21] She flees to Paris, where she makes the ritualistic visits to George Sand, who does not receive her, and Poutret de Mauchamp, who welcomes her with open arms.[22] A week later la demoiselle de lettres is no longer recognizable, having become the myth, "preaching the liberation of women and the enslavement of men."[23]

Throughout 1837 *Le Charivari*'s invectives against the woman of ideas intensified. The journal printed mock petitions from Poutret de Mauchamp to Louis-Philippe and expanded the rubric of the woman of ideas to include current female heads of state like Queen Victoria of England and Queen Marie-Christine of Spain. In diatribes that gave thanks for the French *lois saliques* and ridiculed Victoria's and Marie-Christine's incompetence and

unnatural relations with men, writers in *Le Charivari* warned of France's fate should Poutret de Mauchamp's efforts to empower women succeed.[24] The journal's use of the same generalizing rhetorical formulae to describe women as different in stature and responsibility as Poutret de Mauchamp and Queen Victoria seems to have been part of an effort to suppress evidence of individual accomplishment and to defuse any cultural position these women may have attained.

The first caricatural figurations of the woman of ideas in *Le Charivari* appeared in the late 1830s. Like many of the early textual representations, they focused not on the woman of ideas but on her victims. Many drew their themes from such popular Restoration prints as Wattier's *Ce que l'on voit trop souvent: Jeunes filles lisant le roman de Faublas* (see fig. 1), a lithograph that condemns the novel as a subversive and artistically bankrupt genre capable of inciting dangerous female behavior—a paranoia that finds its literary climax in Flaubert's Second Empire novel *Madame Bovary*.

Other early caricatural figurations of the woman of ideas explore the consequences of allowing women to read decadent literature. They focus on the tendency of the outpouring of books by and about women either to encourage dangerous sexual mores or to disrupt the family hierarchy. In a lithograph by Gavarni that appeared in *Le Charivari* on 15 June 1836 as part of his "Fourberies des femmes" series (fig. 33), a husband enters his wife's bedroom with a pistol, thinking that he has heard a man's voice. He is chastened by the sight of the woman, who appears to be dozing in a chair with a copy of *Le Mérite des femmes,* a treatise by Ernest Legouvé on the rights and virtues of women, on her lap.[25] The duped husband calls himself "un monstre d'ingratitude" as the viewer is cued by the man's hat, which the wife hides beneath her chair, and the pair of men's shoes, nervously peeking out from a curtain, that the husband's relief is naïve. Thus the book and its rhetoric of female virtue are exposed as decoys, modes of deception that camouflage the base sexual desires of women.

A related type of caricature of the woman of ideas prevalent in *Le Charivari* in this period focuses on the impotent husbands of wives who have fallen under the spell of the unscrupulous women who write novels.[26] The wives are standardly represented in chairs or beds reading books that have reduced them to a semiconscious state; they are limpid and detached, as if possessed by a demonic spirit. Honoré Daumier's first representation of the woman of ideas, part of his "Moeurs Conjugales" series, is of that second type. In *Je me fiche bien de votre Mme Sand*, a lithograph of 1839 (fig. 34), a man holds a pair of trousers and stands before his wife, who is seated in an easy chair absorbed in a novel. Their torsos incline backwards, his in a gesture of indignant disbelief and hers conforming to the angle of her

DÉSAPPOINTEMENT

emblait pourtant avoir entendu la voix d'un homme dans sa chambre ?.... Mais elle dort , ell
:nt. Oh! Angélique , je suis un monstre d'ingratitude ? . . . . .

Lith de Caboche Gregoire & Cⁱᵉ pres Bauthin 10

33. Paul Gavarni (Sulpice-Guillaume Chevalier). *Désappointement*. 1836.

chair, punctuating the physical and psychic distance between them. His unmended pants stand in the center of the composition in counterpoint to the book. With disheveled hair, grimacing mouth, and protruding nose, he appears the emasculated, ineffectual fool. She is individuated principally by her dress and posture, her blurred and undistinguished facial features likened to the white pages of the text that consumes and becomes her identity. She is one of the brainwashed creatures invoked often in the pages of *Le Charivari* during the late 1830s as the conduit of feminist legal reformers like Poutret de Mauchamps and as the sad consequence of gender models like Queen Victoria.

"I don't give a damn about your Mme Sand," the husband declares in Daumier's legend, "who prevents women from mending trousers. . . . We either need to reestablish divorce or suppress those authors." As Philippe Roberts-Jones notes, this image was published on 28 June 1839, the same time that Sand's novel *Spiridion* was published and the same year that Sand's portrait by Auguste Charpentier was hung at the Salon (and, in fact, repro-

duced in *Le Charivari* just two and a half weeks earlier). It was also the year that Sand's most provocative book, *Lélia*, was rereleased.[27] Critics, including Capo de Feuillades, were so incited by *Lélia* that they advised readers to lock it up so as not to contaminate young girls, who need protection from a work as perverse as this.[28]

The woman of ideas herself is absent from such caricatures as these that depict, instead, the social consequences of her actions; they include her as an objectified concept rather than as a physical entity.[29] They depict only voices that are heard through male distortions and are understood as the destructive force that transforms good women into shells, incapable of fulfilling domestic obligations.

Daumier's second lithograph on this subject, *Un Intérieur parisien* (fig. 35), is also part of the "Moeurs Conjugales" series, but it appears in *Le Charivari* in May 1842, a full three years later. Like the first, it reenacts a scene of domestic disorder engendered by a woman corrupted by novels. What is different, however, is that the husband no longer complains and that he, too, appears bloodless and inanimate. Furthermore, the legend in this later work is descriptive rather than dialogic: "Monsieur is the homemaker; madame is thinking of being the homewrecker." The husband quietly mops the floor and attempts to maintain the very domestic order that the wife's novel inspires her to disrupt.

By 1842 the association between women who read and domestic disarray had become commonplace. The scenario in the drawings would have been instantly recognizable—even without identifying the artist or describing the husband's misfortune—to an audience that had been inundated for two years with similar parables in the popular theater and press concerning the French version of the British bluestocking.

The English term *bluestocking* was coined in the eighteenth century to describe learned men and women who gathered to emulate the French literary salon.[30] In England, however, the salon had a more middle-class than aristocratic cast. In fact, the Bluestocking Circle had a strong philosophical and moralistic orientation: it was shaped in part by a desire to correct the aristocratic frivolity and self-indulgence that had characterized most drawing-room gatherings in England and France. By the end of the eighteenth century, as the "Blues" became more vocal, the term came to connote a pedantic woman. It was this connotation of a sisterhood of vocal, middle-class, pretentious literary women that was imported into France in the early nineteenth century. And it was this English type, voicing concerns over issues of education and social reform, that, along with the salonnière, was an important forerunner of the nineteenth-century French woman of ideas.

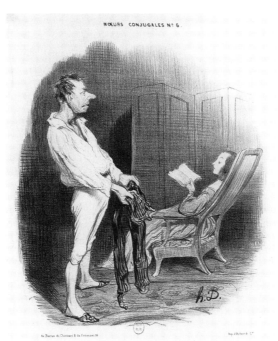

MOEURS CONJUGALES N° 6

Je me fiche bien de votre M<sup>me</sup> SAND.. EU qui empêche les femmes de raccommoder les
pantalons et qui est cause que les dessous de pied sont décousus !.. Il faut rétablir le divorce
ou supprimer cet auteur là !

34. Honoré Daumier.
*Je me fiche bien de votre
Mme Sand . . . 1839.*

35. Honoré Daumier.
*Un Intérieur parisien.*
1842.

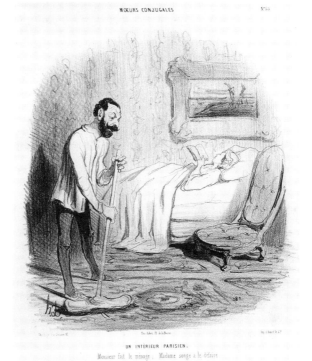

MOEURS CONJUGALES                    N°55

UN INTERIEUR PARISIEN.
Monsieur fait le ménage ; Madame songe a le séduire

Charles Philipon appropriated the term *bas-bleu* as the standard referent for the woman of ideas in the late 1830s, the same period in which his invectives against her intensified. To have continued to use the label *femme de lettres* or *femme-auteur* would have been to continue to associate women writers like Delphine de Girardin and Virginie Ancelot with the historic and esteemed tradition of the French homme de lettres. Philipon's increased and widespread deployment of the term *bas-bleu* (which came to be regarded only as derogatory) in the late 1830s and early 1840s coincided with the ascendancy of the bourgeois femme-auteur with whom the label is associated most closely. This link lent typological authenticity and legitimacy to his campaign to undermine her.

The bas-bleu was the subject of a number of plays in the early forties that included Ferdinand Langlé and F. de Villeneuve's "Le Bas-Bleu" at the Théâtre des Variétés, Pacini's opéra-séria "Saffo" ("the celebrated bas-bleu from the island of Lesbos") at the Théâtre des Italiens, and "Les Petits Bas-bleus" at the Théâtre de France. Most were variations on the theme of misguided women who, after having followed the example of an unethical bas-bleu, were saved from humiliation or destitution by a wise man. And most of the plays end in marriage—the institution usually maligned by the female protagonists in the early moments of the play—with a promise, like that made by Athenais in the Langlé and De Villeneuve comedy, that from now on pants will be worn only by husbands, and "I will use my quill only for my hats."[31]

Daumier's caricatural series, which appear to have been in large part dictated by Philipon, often capitalized on well-received themes from the popular theater. But the decision to develop "Les Bas-Bleus" in 1844 seems to have been a response principally to the success of several *physiologies* published between 1840 and 1842.

"Les Bas-Bleus," Daumier's first and largest series on the woman of ideas, consists of forty lithographs issued in *Le Charivari* between 30 January and 7 August 1844. The series draws extensively from Frédéric Soulié's *Physiologie du bas-bleu* (1841–1842), Edmond Texier's *Physiologie du poète* (1841), and Jules Janin's "Un Bas-Bleu" (1842), a typological essay included in *Les Français peints par eux-mêmes* (1841–1842). The first plate of the series, for instance (fig. 36), concretizes Soulié's description of "le bas-bleu véritable" who "floats between forty-five and fifty-five years old, . . . [who has] a skinny body, . . . a sad smile, . . . [and] an emaciated bosom."[32] The lithograph features a woman examining herself in a full-length mirror. Behind her hangs a painting that invokes one of Daumier's engravings of la dixième muse published three years earlier as the frontispiece to Texier's *Physiologie du poète*. She is surrounded by discarded clothing that

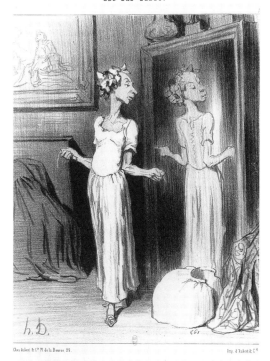

Chez Aubert & C^e Pl de la Bourse. 29. Imp. d'Aubert & C^ie

C'est singulier comme ce miroir m'applatit la taille et me maigrit la poitrine! Que m'importe ?°... M^me de Staël et M^r de Buffon l'ont proclamé... le génie n'a point de sexe.

36. Honoré Daumier. *C'est singulier comme ce miroir m'aplatit la taille . . .* 1844.

had padded her straight silhouette, making it appear curvaceous and conventionally female. Having removed the false garments, she is shown to be vainly and foolishly attributing her sexlessness to the mirror's inadequacies rather than her own. She stands facing us, glancing over her left shoulder to see the reflection of her curveless back. A literal embodiment of the popular phrase *la femme-homme de lettres,* this long-nosed, weak-chinned figure marvels at the "distortions" of her mirror: "It's curious how this mirror flatters my height and slims my chest. What does it mean? Mme de Staël and M. de Buffon proclaimed it . . . genius has no sex."

We, who are given a direct frontal view of the bas-bleu, are privy to the visual joke that her chest is a mirror image of her back, in or out of the reflection. Daumier and his legend writer pun on the famous phrase "genius has no sex"—intended by De Staël to assert the intellectual equality of women—to shift focus from the bluestocking's success as a thinker to her failures as a woman. The lithograph offers its audience a moral lesson:

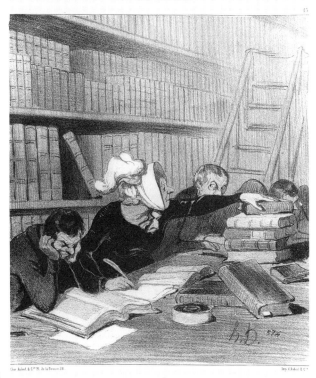

37. Honoré Daumier.
*Monsieur,*
*pardon si je vous gene*
*un pêu . . .* 1844.

—Monsieur, pardon si je vous gêne un peu . . . . mais vous comprenez qu'écrivant en ce moment un roman nouveau, je dois consulter une foule d'auteurs anciens ! . . . . . .
— (Le Monsieur à part) Des auteurs anciens ! . . parbleu elle aurait bien dû les consulter de leur vivant, car elle a dû être leur contemporaine !

women who substitute the life of the mind for the life of the home are no longer women.

More than half of Daumier's "Bas-Bleus" are berated for their dearth of sexual and intellectual powers. Within that genre, most are also maligned for their role in denigrating the literary arts. During the July Monarchy the literary establishment debated the merits of the growing commercialization of literature. The success of the woman of ideas was often made part of this debate. For instance, in *Monsieur, pardon si je vous gêne un peu* (fig. 37), published on 8 March 1844, a foolish old woman consumed by her desire for fame fails to recognize the inappropriateness of her aggressive behavior. She dominates the table of a library reading room. Her right elbow intrudes on one neighbor's space as her other arm reaches out unselfconsciously toward a stack of books, blocking the man to her left. The tidy

*Daumier's Vision of Female Intellect*

arrangement of the volumes behind them echoes the self-contained dignity of the male readers, just as the only book that is askew and disrupts the continuity and order is the one behind the bluestocking's head. Its irregularity underscores hers, the only female intellect in this otherwise male arena.

In the early 1840s *Le Charivari* published many articles on the women with whom male writers had to compete for jobs and government subsidies. The most venomous attacks focused on the phenomenon of journalistic nepotism—the practice of giving women undeserved publishing opportunities that they abused by sentimentalizing and cheapening literature.[33]

The identification of the bas-bleu with the bourgeois femme-auteur, who subverts the concept of family and corrupts the conventions of literature, pervades the typological studies of Texier, Soulié, and Janin. Texier's *Physiologie du poète*, for example, a project to which Daumier contributed forty-one woodcut illustrations, classifies by type the poets of Paris. The male poets range from aristocratic gentleman to members of the proletariat, a striking social and economic diversity. Furthermore, none is accused of subverting the social order, though each is vulnerable to charges of vanity and self-absorption. Conversely, the discussion of female poets is relegated to the final two chapters and makes no such class distinction. Texier's representation of la dixième muse is uniformly bourgeois. Moreover, when charges of self-centeredness are levied against her rather than her male counterpart, the tone is harsh and moralizing: "The tenth muse has multiplied at a terrifying rate. She has grown without cultivation like a fungus . . . in the pages of serialized novels and on page four of the daily newspapers."[34]

Charles Philipon, who undoubtedly was on the editorial board that planned Daumier's series, was the editor of Soulié's *Physiologie du bas-bleu*.[35] Soulié's text recapitulates many of the characterizations of the woman of ideas first explored in *Le Charivari* in the late 1830s. Like most physiologies, it disguises an idiosyncratic choice of content under the veneer of scientific classification and the rhetoric of social truism.

The text is divided more or less chronologically to describe the bas-bleu before 1789, under Napoleon, and during the Restoration. This history functions as a prelude to a six-chapter exposition on the contemporary bas-bleu. The arbitrariness of what purports to be a legitimate categorization of a popular female type is revealed in chapter 6, "Bas-Bleu marié, deuxième espèce." This second type, according to Soulié, is the ambitious bas-bleu who is "the most evil of all."[36] This chapter contains not a description of a type of bas-bleu but the story of an ambitious wife who offers herself to a cabinet minister in order to obtain for her husband a position as

consul of state. Nothing in the chapter beyond its title would prompt us to identify the woman as a bas-bleu.

The label often was used indiscriminately in journalism and popular literature during the July Monarchy as a synonym for the aggressive female. It signified the freedom and confidence with which many women were operating in the public arena more than their involvement in literary activities. This is made explicit in Soulié's opposition of *le bas-bleu contemporain* to her aristocratic ancestors, whose influence was restricted to the private sphere of the salon. He asserts that the contemporary bas-bleu is contemptible, like everything that operates in the public domain.[37]

Janin also cites the Revolution of 1830 as marking the sudden glorification of the written and spoken word and the hideous metamorphosis of the once charming salonnière into an obsessive, fame-hungry bas-bleu whom he implicitly holds responsible for this situation. In "Un Bas-Bleu" Janin charges that modern journalism, the progeny of the French Revolution, has cheapened and corrupted literature. His essay alternates between fiery assault on the preoccupation of the modern writer with issues of salability and unfocused description of the bourgeois bas-bleu, whom he implicitly holds responsible for this situation.

Male writers, angered at the greater freedom, notoriety, and often financial rewards enjoyed by some of their female competition, maligned the literary achievements of the woman of ideas as tainted and artistically bankrupt. To ensure the success of this strategy they reinforced it with a more damaging accusation: that the woman of ideas is both a literary whore and a sexual deviant responsible for the corruption of art and the dissolution of the bourgeois household.

The self-absorbed creatures who opt for the life of the spirit instead of the joys of marriage and maternity are merely foolish in Daumier's classification of les bas-bleus. Those who try to have it all are insidious. When Daumier's earlier depictions of the woman of ideas in the "Moeurs Conjugales" series (see figs. 34 and 35) presage the theme of family ruin, they invoke the bas-bleu only as a sinister offstage presence manipulating female puppets. By 1844, however, the corruption is complete. Women are no longer passively absorbing lessons from novels. They have put down their books and are acting out the once-fictive scenarios of the sexual revolution.

Daumier's first allusion to the monstrous bas-bleu who violates the integrity of both family and literature occurs in his final woodcut for *Physiologie du poète*. *Le Papa donnant la bouillie à son enfant* (fig. 38) depicts a husband in his dressing gown feeding his child. The wife is nowhere visible,

but we are to presume from Texier's prose that she is out cavorting with publishers while her husband fulfills her domestic responsibilities: "The muse's husband, the same husband who devotes himself to the care of the household while his wife engages in adulterous business with Apollo, must resign himself to the complete loss of his individuality. . . . He is only an object to his wife . . . her number one domestic."[38] Though both father and infant's faces are rendered in a rapid calligraphic line, the image is more illustrative than charged. And its textual characterization, like that in Daumier's chronologically coincident caricature from "Moeurs Conjugales" (see fig. 35), is descriptive rather than dialogic: "Le Papa donnant la bouillie à son enfant. Le mari de la muse a perdu sa qualité d'homme."

The domestic repercussions of the woman of ideas' unnatural entry into the public arena form the dominant themes of Daumier's "Les Bas-Bleus." Daumier's pastiche portrait of the bas-bleu elaborates the ideas raised in the last chapters of Texier's *Physiologie du poète* and mirrors in content, though not always in structure, Soulié's and Janin's account of le bas-bleu. Beyond the specific parallels in characterization and anecdote, Daumier, Texier, Soulié, and Janin share a preoccupation with the woman of ideas' capacity for sapping men of their virility and subverting gender hierarchies.

Several prints from Daumier's series, for example, engage the popular metaphorical question of "Who wears the pants?" In *Une femme comme moi* . . . (fig. 39) an incredulous wife, having just flung her husband's pants in his face, shouts, "A woman like me . . . sew a button? . . . You are crazy." Her torso, arms, and dress—curved and animated as if by a wind of fury— contrast with the stable vertical of her husband's humbled and pantless figure. His fingertips touch in embarrassment before his genitals in a gesture of shame as his pants, which in tonality and animation of line appear to belong more appropriately to the wife, seem to wear *him.* The way the pants are made to hover about his head read at once as a controlling vise and as a ridiculous woman's bonnet. "Oh, great!" the husband grumbles. "She is no longer satisfied to wear the pants. . . . Now she must throw them at my head!"

A second group of lithographs elicit our sympathy by focusing on the emasculated men forced to assume their wives' household duties. For instance, in *Depuis que Virginie à obtenu le septième accessit* (fig. 40), published on 18 April 1844, a husband, whose clothing, posture, and facial expression echo Daumier's le mari de la muse from *Physiologie du poète*, sorts through mounds of dirty linen. Behind him his wife, hand to her chin, stands absorbed in a book. "Ever since Virginia got the seventh prize for poetry at the

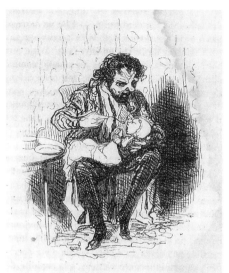

38. Honoré Daumier.
*Le Papa donnant la bouillie
à son enfant.* 1841.

Le mari de la Muse, ce même mari qui vaque

39. Honoré Daumier.
*Une femme comme
moi . . .* 1844.

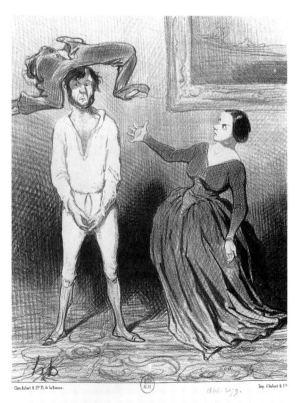

Une femme comme moi . . . remettre un bouton ? . . . vous êtes fou ! . . . .
Allons bon ! . . voila qu'elle ne se contente plus de porter les culottes . . . . il faut encore
qu'elle me les jette à là tête ! . . . .

Académie française," we are told, "it always has to be me . . . who counts the laundry." The theme of third-rate or undeserved literary prizes was a consistent one in the 1840s. The Académie des femmes, founded by Louis-Joseph-Alphonse-Jules de Castellane in 1843, was the focus of a great deal of attention in Maison Aubert publications and elsewhere. A lithograph (fig. 41) by Daumier, for example, published on 2 August 1843, four months before the "Bas-Bleu" series began, focuses on this institution. Jules de Castellane, in a powdered wig and self-important stance, places a crown of laurel on the head of a kneeling "Corinne." She is surrounded by an audience of skinny and awkward bas bleus who observe the ritual in religious silence. The legend reads: "A new Richelieu founding an academy of another kind . . . a feminine kind." Jules de Castellane's efforts to affect the aristocratic dress and demeanor of Cardinal Richelieu (who founded the "real" French Academy in 1635) are undermined by Daumier's positioning of a chair behind him. The chair's back protrudes like a tail from Castellane's jacket, instantly connecting him with representations of the lechery and devilry of the Saint-Simonist patriarchy.[39]

Jules de Castellane was, in fact, a Saint-Simonist, and Philipon's interest in belittling him by exposing his ties to the utopian socialist movement are explicit in the essay "Cancans de presse," published in *Le Charivari* on 25 March 1844. This article, which appeared midway through the run of Daumier's "Les Bas-Bleus," begins: "People claim that the works of [l'Académie des femmes] would be difficult to place. That is an error. *Le Globe* [the Saint-Simonist paper] has just opened its columns to everything these female academicians can produce." The emptiness of the accolades offered to the membership of the Académie des femmes—gestures likened to the allegedly sexually motivated search for la mère in 1833 initiated by Saint-Simonist guru Prosper Enfantin—are betrayed by the revelation in this article that "it is not the newspaper that pays its writers; . . . it is the writers who pay the newspaper."

Philipon's exposé of Jules de Castellane's use of his own funds to ensure the publication of the writing generated by his organization is part of the effort to tarnish the successes of women of ideas in the 1840s. The practice of paying to have one's work published was, in fact, not uncommon among both women and men who lacked the necessary contacts in the book trade. But it is represented in *Le Charivari* as more evidence of the inadequacy of the woman of ideas both inside and outside the home.

Daumier's most damning critiques of the bas-bleu extend her domestic crimes to the arena of maternal irresponsibility. The images of women neglecting their children expand the scenario of *le mari de la muse* to include the presence of the wife, who is shown either leaving the house for a

40. Honoré Daumier.
*Depuis que Virginie a
obtenu le septième accessit
de poésie . . . 1844.*

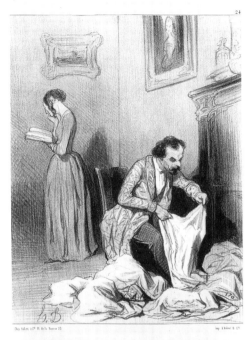

Depuis que Virginie a obtenu la septième accessit de poésie à l'Académie française il faut
que ce soit moi . . . . moi capitaine de la garde nationale . . . qui compte tous les samedis le
linge à donner à la blanchisseuse . . . et je le fais parceque sans cela ma femme me laverait la tête

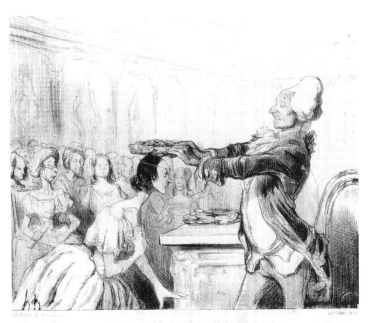

ACADÉMIE DES FEMMES.

41. Honoré Daumier. *Académie des femmes.* 1843.

meeting with her "editor" or shrewishly barking orders at her husband. In *Emportez donc ça plus loin . . .* (fig. 42), published on 2 March 1844, a husband is shown standing, baby in arms, behind the lyre-shaped chair in which his wife sits. The chair/lyre emasculates him, as does his willingness to stay at home in his dressing gown and care for his child (who even appears to nurse at his breast). The wife, seated amid the clutter she calls her work (though there is more paper crumpled up in the trash than there is on the desk before her), shouts for her husband, who is holding their child, to "take that farther away. . . . Ah, Mr. Cabassol, it's your first child, but I can promise you that it will be your last."

Daumier's most cynical figuration of the unfit mother, *Dis donc . . . mon mari . . .* (fig. 43), features a pregnant woman blowing smoke rings in the face of her husband cum house servant. He polishes a bowl as she pontificates about her various creative projects. In a reversal of conventional gender signs, his body is self-contained and likened to the rounded vessel shape usually associated with the female form; the bas-bleu, meanwhile, is a pastiche of extrusions: her left hand, her cigarette, her profile features, and her enormous belly that point accusingly toward her husband. "Say, husband," she informs him dispassionately, "I have a mind to

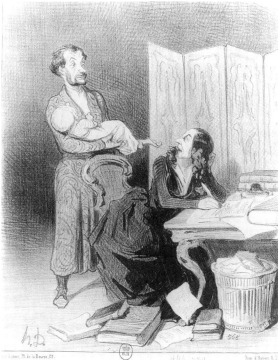

42. Honoré Daumier. *Emportez donc ça plus loin . . .* 1844.

Emportez donc ça plus loin . . . il est impossible de travailler au milieu d'un vacarme pareil vous promener à la petite provence , et en revenant, achetez de nouveaux biberons pas Cabassol ! Ah! Mr Cabassol c'est votre premier enfant, mais je vous jure que ce sera

call my play *Arthur* and entitle my child Oscar. But no, on second thought, I will decide nothing before consulting my collaborator."

Punning on the idea of a collaborator who is insinuated to have spawned both the play (which rests on the table behind her) and the child, the lithograph demeans the woman of ideas as both untalented and unfaithful. Her husband stands passively by, symbolically robbed of his virility by the dust rag arranged to suggest impotence juxtaposed with the huge protrusion of his wife's belly, for which he clearly can claim no responsibility.

The association of the woman of ideas with domestic disarray and sexual licentiousness is pervasive in textual descriptions and caricatures during the July Monarchy.[40] The duped husband and provocative verb *collaborate* are staples of these later versions. In another lithograph from "Les Bas-Bleus," *Ma bonne amie, puis-je entrer . . .* (fig. 44), a woman writer and a male companion are startled and appear to recover from a compromising position as the husband tentatively peeks in. He asks, "Sweetheart, may I come in? Have you finished collaborating with Monsieur?"

This theme is common in the literature on les bas-bleus as well. In fact, this Daumier caricature probably was inspired by an identical anecdote that concludes chapter 5 of Frédéric Soulié's *Physiologie du bas-bleu,* which takes as its particular focus the bizarre marriage arrangements of the bas-bleu. Soulié concludes his chapter on "Bas-Bleus contemporains. Bas-Bleus mariés"—which, like Daumier's series, details the peculiar reversal of gender roles between the successful and visible bas-bleu and *le mari-domestique* —with the story of a recent visit to the home of a well-known woman writer. Soulié writes that the husband returned just as he arrived. After checking on the woman's availability, her husband reported, "'You cannot see her. She is locked in there with M.———. They are collaborating.'"[41] Within the genre of the physiologie, Jules Janin's "Un Bas-Bleu" most strikingly and viciously literalizes this equation of literary and sexual transgression: the woman of ideas is paid handsomely, Janin complains, "to write the most abominable invectives that offend principles of grammar and common sense."[42] If the public wants dramas, he continues, she writes a drama, choosing her subject carefully to maximize opportunities for blood and violence. She is, in other words, a literary whore who, in the name of providing bread and a good education for her three beloved children, will write a story of infanticide. It is bearable, he explains, when male writers sell out because they are not charged with the moral education of the next generation. The danger comes when the teachers of our children prostitute themselves as they write of virtue, when "what she has sold all her life in bedrooms and taverns she will even sell in books."[43]

**43. Honoré Daumier.**
*Dis donc . . . mon mari
. . . 1844.*

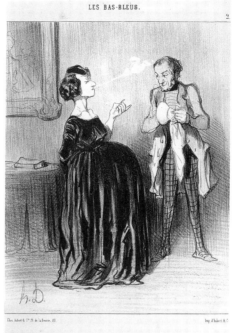

Dis donc.. mon mari ... j'ai bien envie d'appeler mon drame **Arthur** et d'intituler mon
enfant **Oscar**!.. mais non.. toute réflexion faite, je ne déciderai rien avant d'avoir consulté mon
collaborateur !.....

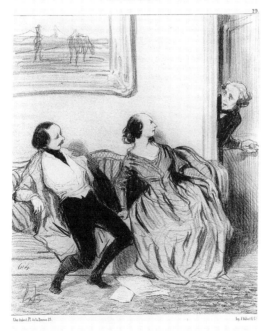

**44. Honoré Daumier.**
*Ma bonne amie, puis-je
entrer . . . 1844.*

— Ma bonne amie, puisje entrer !.... as-tu fini de collaborer avec monsieur ?......

Representing women writers not as women who write but as sexless hags and promiscuous shrews is not a neutral act. The lithographs of "Les Bas-Bleus" ignore individual achievement and censor the details of a new female reality with which others might identify. They transmute an arena of power into a tired and destructive paradigm of female deviance. Daumier's antipathy toward the woman of ideas seems to have been encouraged and shaped by the policies and sensibilities of those for whom he worked at La Maison Aubert. By 1841 the publishing house had become the premier lithographic printer-publisher in Paris, playing a dominant role in the physiologie trade that spawned Daumier's series.[44] The development of "Les Bas-Bleus" was consistent with Philipon's shrewd rethinking of his financial and editorial position after 1835 and the redirection of his business toward its natural audience, the haute bourgeoisie, which produced most of the women writers.

Like all good entrepreneurs, Philipon had it both ways: he at once denigrated and cultivated the bourgeois woman of ideas who composed a significant percentage of his audience. He published texts and images that at once trivialized their achievements and flattered them with attention. Philipon's awareness of the need to balance ridicule with flattery is suggested by one of Le Charivari's rare serious essays, "Salon de 1844," which appeared midway through Daumier's "Les Bas-Bleus" series. The ostensible purpose of the article was to call for salon criticism devoted exclusively to women artists, but its real agenda appears to have been to appease an audience unsettled by Daumier's treatment of the woman of ideas. Its subtext differentiates the woman of ideas from women with professional identities; it elucidates the differences between women of real talent and bas-bleus.

"Salon de 1844" contrasts Daumier's unfaithful wives and irresponsible mothers who "scribble poems and novels" with women who exercise more appropriate and conventional talents. A woman painting or singing, the article explains, tends to be attractive whereas "a drinker of ink is as disagreeable to the sight as to the mind."[45] This is true, we are told, because women are creatures of feeling rather than knowledge. Therefore, since being a savant requires learning and thought and being an artist above all requires emotion, women are more suited to the latter. Logically, we are attracted to la femme-artiste because she seems to obey her nature, unlike la femme-homme de lettres, who repulses us and appears "a sort of monster."

"Salon de 1844" appears to be a conciliatory effort on Philipon's part to suggest an alternative and acceptable female type with whom his female readership might safely identify. It signals the desire of Le Charivari to participate in the vogue of ridiculing la femme pensée without risking the

loss of her subscription fees. But to target the woman of ideas for satirical attack after 1835 was logical for another reason as well. *Le Charivari*, like La Maison Aubert, was an organization composed of male writers who were at once ambivalent about their own complicity in *la littérature industrielle* and threatened by their female competition. To identify the woman of ideas with the prostitution of literature allowed them to deflect concern about their own role in the commodification of literary culture. Jules Janin's significant comparison, in its very imperiousness, betrays this anxiety. The French man of letters, compliant with the September Laws and suppliant to a degraded popular taste, may have sold out. But compared with his new women colleagues and competitors, he might not seem so diminished in moral, literary, and sexual stature. For even if both men and women writers were working the same market, it could not so easily be said of the former that they were selling in books what they may have been selling all their lives in bedrooms and taverns.

### "Les Divorceuses" and "Les Femmes Socialistes"

Coverage of the woman of ideas by *Le Charivari* remained steady throughout the 1840s in articles that ranged from scathing accounts of such feminist sympathizers as "Le MaPah" to tirades against government subsidies for women writers, and in 1848 the efforts to undermine the woman of ideas grew substantially in number and virulence.[46] Textual and visual descriptions of the early 1840s had cast the woman of ideas as a source of domestic disharmony and gender confusion. She was rendered as the monstrous procreator of societal chaos in accounts of 1848 and 1849, years when such images were pervasive in French caricature. In the late 1840s she was not pictured as she was in 1844, shirking her female responsibilities. In fact, in 1848 she was almost totally removed from the activities of the conventional wife and mother. Fewer than one-third of the images in Daumier's later series, "Les Divorceuses" (1848) and "Les Femmes Socialistes" (1849), even include men or children, whose neglect had been the subject of more than half the images in "Les Bas-Bleus." After the Revolution of 1848, Philipon and Daumier became preoccupied with the new politicized identity of the woman of ideas—the woman who was writing pamphlets rather than novels and who was addressing the Constituent Assembly rather than her literary agent. She was no longer a frivolous, self-centered bas-bleu who neglected husband and home. After 1848 she was a conspiratorial shrew, plotting the dissolution of the family and precipitating the demise of the Republic.

The full-scale attack on the woman of ideas in the popular press did not begin until July 1848, when the euphoria of the promise of 1789 fulfilled was replaced by rifts of self-interest. Before June, women activists were merely one group among many jockeying for power and influence in the elaboration of a platform for the Provisional Government. The lifting of restrictions on assembly and free speech after the Revolution had generated dozens of new political clubs and newspapers. Within this climate, the feminist communities of the early 1830s were revitalized. Encouraged by the empowerment within the Provisional Government of male allies like Victor Considérant and Pierre Leroux and the revolutionary rhetoric of universal suffrage and social reform, a group of former Saint-Simoniennes joined with several holdovers from the *Gazette des femmes* and launched the first daily feminist newspaper, *La Voix des femmes*. The newspaper spawned one of the most powerful of the women's political clubs to evolve during the Second Republic, the Société de la voix des femmes, the organization at which Daumier directed much of his satire.

The Société de la voix des femmes, or, as it came to be called, the Club des femmes, wrote and circulated petitions, participated in the staging of free evenings of political drama for working-class audiences, organized lectures on the legal position of women in France, and sponsored the illegal candidacies of several women to the Constituent Assembly.[47] Though *La Voix des femmes* had begun publishing on 19 March 1848, its widespread condemnation did not begin until July, just after the reimposition of press restrictions. Just as Louis-Philippe's September Laws had precipitated an assault on the woman of ideas in 1835, so the Constituent Assembly's reintroduction of a *cautionnement* payment in July 1848 generated a tirade against les femmes socialistes. The programmatic suppression of the press in this period included more than 300 prosecutions against 185 republican journals and the outright closure of more than 15 newspapers.[48]

*Loi cautionnement* and harassment were only two aspects of the repressive measures inaugurated by an increasingly conservative "revolutionary" government after the horrific violence of the 22 June uprising. By all accounts, the period between the April 1848 elections, which produced a conservative Constituent Assembly, and the June worker's revolt, which put an end to the illusion of class harmony, was one of great ambivalence for those whose material interests were at odds with their philosophical convictions. As the power of the right and moderate factions increased, fervent suppporters of the Revolution, like Daumier and Philipon, saw the dismantling of the social programs that had been established to curb unemployment and improve working conditions—the very premises of the revolutionary platform. They were also once again witnesses to and victims of

*Daumier's Vision of Female Intellect*

the "official" repression of the periodical press. This time, however, the repression was perpetrated not by the constitutional monarch but by the Revolutionary government that had ousted him.

The frustration of republicans and legitimists alike at the failure of the principles of the Revolution that they had helped mount was expressed in a barrage of journalistic attacks that dominated the popular press between July 1848 and April 1849. The attacks were not intended to curtail dangerous activities but seemingly to deflect concern about the dissolution of revolutionary alliances and political convictions. The woman of ideas was a frequent target of these attacks. In the weeks following the reimposition of the cautionnement, one-half to two-thirds of *Journal pour rire* (text and imagery) was devoted to the scores of women activists engaged in the most radical aspects of revolutionary politics, challenging the distribution of property and social hierarchies in France. These vocal and visible women were the logical emblems of social transgression by means of which male writers could safely and indirectly rechannel their anger from the betrayal of the Revolution to the Revolution itself. Ambiguous sexuality became a dominant metaphor for the failure of 1848, and the image of the woman of ideas was invoked constantly as a cultural sign for social threat.[49]

Daumier's last two series on the woman of ideas, "Les Divorceuses" and "Les Femmes Socialistes," appeared in this context between August 1848 and June 1849. The contempt for the feminist activists that informs these images derives both from Daumier's scorn for the democratic socialist community with which they were affiliated and from the threat they posed to his personal vision of ideal womanhood. The socialists of the 1830s and 1840s differed from their republican counterparts in their philosophical predispositions and their greater concern with long-term social reform. Although their methods and goals differed, they were unified in their desire to replace monarchic rule with popular sovereignty. The 1848 feminists—like the entire socialist community—recognized the potential power in the vote and departed from earlier apoliticism. They shared the republican desire and fight for political rights but differed in that they asked that those rights be extended to women as well. They asked that universal suffrage be truly universal.

After the Revolution the democratic socialists argued for the most extreme social reforms, including female emancipation. Consequently, they were the targets of a conservative bourgeois and liberal republican backlash after the June Days. Male socialists like Pierre Leroux, P. J. Proudhon, Etienne Cabet, and Victor Considérant, typecast in the popular press as the radical fringe element, were increasingly blamed for the breakdown of revolutionary alliances. But as virulent as the condemnations of

Leroux, Proudhon, Cabet, and Considérant were, they were far outnumbered by those of les femmes socialistes.[50] It was the woman of ideas who was the principal scapegoat after June 1848. One could criticize and blame her unrestrainedly for all that seemed unnatural and threatening about the events of 1848 without fear of being branded a counterrevolutionary.

Daumier's aversion to the socialist roots of 1848 feminism offers only a partial explanation of the lithographs that denigrate women who were political allies. The insufficiency of this explanation is underscored by the other major caricatural series he undertook in these years, "Les Représentants représentés," which mocks the newly elected Constituent Assembly. While the socialists represented in that series are slightly more wild-eyed and frenetic than their republican counterparts, the sarcasm is divided fairly equally among them. Missing is the absolute clarity of purpose that one finds in his attack in those same years on "Les Divorceuses" and "Les Femmes Socialistes." To understand why Daumier's political satire in 1848 is undefined when directed at men but explicit when directed at women, one might consider his personal as well as his national politics.

Within the meager biographical material that is available, the only descriptive detail repeatedly invoked by friends and admirers concerns Daumier's fierce commitment to privacy and to the preservation of his domestic life. Thus, his attack on the 1848 feminists who were demanding the right to work, the right to vote, and the right to divorce appears consistent with his personal ideals. Women such as these seem to have symbolized for Daumier societal degeneration and the dissolution of the family.[51]

In Daumier's series "Les Divorceuses" and "Les Femmes Socialistes" the source of that degeneration is identified—as it was in 1844—with the bourgeois woman of ideas. Daumier ridiculed only the bourgeois elements of this feminist community rather than their often more vociferous working-class counterparts. Although other caricaturists, like Edouard de Beaumont, Cham, and Gustave Doré, charged by Philipon with similar tasks, produced venomous series on Les Vésuviennes, the most radical woman's club in Paris in 1848, Daumier never even mentioned it. The club members' origins, like those of their Saint-Simonienne prototypes a decade earlier, seem to have undercut any desire Daumier might have had to ridicule them.[52]

While Les Vésuviennes were harangued in Philipon's journals, Daumier focused on the threat to society posed by bourgeois feminists. His first series in the Second Republic targeted the socialist campaign to reestablish divorce. Ignoring the equally prominent and undeniably justified concerns of les femmes socialistes—true universal suffrage, national workshops for women as well as men, equal educational opportunities—

Daumier generated a myth of women activists as the self-serving choreographers of domestic disharmony.

Daumier's six-image series "Les Divorceuses" appeared in *Le Charivari* between 4 August and 12 October 1848. The subject of divorce had been raised earlier in *Le Charivari* in response to debates in the National Assembly over proposed legal reforms that called for the reintroduction of divorce in France, the sanctioning of polygamy, and the granting of permission for priests to marry.[53] Caricatures on the issue of divorce by Henry Emy and Cham appear throughout April, May, and early June with stories that characterize the movement to change the divorce laws as the last desperate efforts of widows and spinsters to recirculate a new crop of men.[54]

For a short period after the June Uprising, discussions of the feminist pro-divorce campaign subsided because the major vehicles for disseminating information had been silenced. *La Voix des femmes* had stopped publishing in late June at about the same time that the club it had spawned was shut down by the government.[55] But rather than silencing the women, government repression ultimately appears to have stimulated more activity. Jeanne Deroin broke with "la vénérable mère en divorce,"[56] and Eugénie Niboyet launched a new and less equivocally feminist-socialist journal, *Politique des femmes*. The Club des femmes, like all socialist organizations after the crackdown, adopted ingenious strategies to circumvent government repression.

Meeting under other auspices, the Club des femmes continued to receive coverage in the popular press. That coverage climaxed in daily accounts of a series of eight debates on divorce that took place in July. According to the descriptions in *Le Charivari* and *Le Journal pour rire*, the meetings were more like public theater than political debate. Coverage focused on the concerted effort to sabotage the gatherings by men who dressed as women to gain admittance then shouted down speakers and incited riots. The effort was successful, leading to a second government crackdown that closed the club once again. It was this sequence of events that inspired Daumier's series "Les Divorceuses."[57]

"Les Divorceuses" is not substantially different from the slightly later "Les Femmes Socialistes." Each was stimulated by the same group of women—the Club des femmes—but at a different moment in its cycle of political action. The six plates of "Les Divorceuses" feature some combination of spinster, widow, or old married "hag" making a spectacle of herself at one of the many political meetings held in the late summer and early fall of 1848 or at home acting out the anarchic principles to which she had been exposed at such meetings. There are fewer scenarios than there were in "Les Bas-Bleus," and the women are far more masculine and misshapen.

The decision to conclude "Les Divorceuses" with *Toast porté à l'émancipation des femmes . . .* , published on 12 October 1848 (fig. 45), was certainly a response to the actions of the Minister of Justice, who had just legally preempted further discussion of the subject by dismissing all petitions for the reintroduction of divorce.

Though the specific issue of divorce was dropped after November, the characters and themes of "Les Divorceuses" were revived the following April in Daumier's ten-image series "Les Femmes Socialistes." These caricatures were inspired by the banqueting craze that swept Paris between December 1848 and June 1849 and the opportunities it provided for feminist Jeanne Deroin to promote her candidacy for the Legislative Assembly. In an effort to circumvent government bans on club meetings, democratic socialists and their feminist counterparts staged frequent "banquets" at which lengthy "toasts" took the place of speeches.[58] Deroin and the banquet phenomenon provided fodder for many stories and caricatures in Philipon's journals in the late spring of 1849.[59]

The women in Daumier's later two series on the woman of ideas are more demonic and conspiratorial than those of "Les Bas-Bleus." Twelve of the sixteen images that compose the two later series center on the ruminations of a group of "hags." *L'Insurrection contre les maris . . .* (fig. 46) from "Les Femmes Socialistes," for example, depicts the secret ceremony of three witchlike creatures. The trio of lumpish, grimacing feminists are shown taking an oath upon a man's top hat (the phallic counterpart in caricatural shorthand to the open female bonnet) to devote themselves to the rebellion against husbands. The talonlike fingers of the bourgeois women hover like vultures above the symbol of manhood in a reaffirmation of the misguided priorities of feminist activism of the late 1840s. Comparable trios occur throughout the two series writing petitions, drunkenly toasting their emancipation, and swearing revenge for their public and private humiliations. These feminist coveys often are referred to in Philipon's *Journal pour rire* as "les trois Niboyennes" (colleagues of feminist socialist Eugénie Niboyet), identifying them with the three witches in *Macbeth.*

Another lithograph from "Les Femmes Socialistes" demonstrates the increasing virulence of some of these enactments of domestic anarchy. In *Ah! Vous êtes mon mari . . .* (fig. 47), a woman fearlessly drags her husband by the collar to the front door as their small child clings protectively to his father's leg. The wife shouts, "So, you are my husband, eh? You are the master, eh? Well, I have the right to throw you out of your own house. Jeanne Deroin proved that to me last night. Go take it up with her."[60]

*Daumier's Vision of Female Intellect*

45. Honoré Daumier.
*Toast porté à l'émancipation des femmes . . . 1848.*

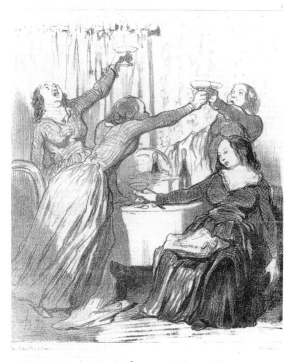

Toast porté à l'émancipation des femmes, par des femmes déjà furieusement émancipées

46. Honoré Daumier.
*L'Insurrection contre les maris . . . 1849.*

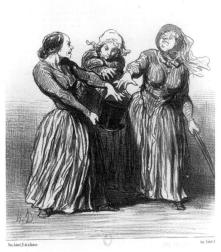

L'insurrection contre les maris est proclamée le plus saint des devoirs !

Like the earlier bas-bleu prints in which George Sand was an un-physicalized presence, these series occasionally refer to Deroin as a disem-bodied voice. We do not see her coediting the first daily newspaper by and for women. We do not see her organizing the women's suffrage movement. We do not see her chairing a meeting of her political club. In fact, we do not see her at all. Like Sand four years earlier, Deroin is a sinister offstage presence manipulating female puppets. But those puppets are no longer passively absorbing those lessons from novels as they were in 1844; they are self-consciously and aggressively acting out the sexual revolution within their own homes.

Daumier's discomfort with the sexual revolution, which was an inte-gral part of the political revolution of 1848, took precedence in his imagery. What is explicit in his lithographs of the woman of ideas is implicit in the paintings he began to produce in earnest in 1848 when Salon restrictions were temporarily relaxed. Emblematic of the threat posed by the unnatural women are compositional affinities between a number of the prints from "Les Divorceuses" and "Les Femmes Socialistes" and paintings produced in these same years. A representation of a meeting of the Club des femmes in "Les Divorceuses," for instance (fig. 48), bears a striking compositional similarity to a contemporaneous painting called *Ecce homo* (fig. 49).[61] Both depict mob scenes in which justice and common sense are sacrificed to ignorance and superstition. Both are organized around a prominent pyra-midal arrangement of forms made dynamic by the thrust of a gesturing arm. In each, a sea of heads and limbs reacts to the message of the elevated speaker, the focal point of the pyramidal arrangement. "Citizens," the feminist shouts, "the report is spreading that we are about to be denied a law for divorce. . . . Let's organize ourselves here once and for all and declare that the nation is in danger." The female voice urging the crowd to attack patriarchal authority reverberates in the moment Daumier has cho-sen for his painting as well. In *Ecce homo,* an even more sacred patriarchal authority is being sacrificed. Pictured is Christ's appearance before Pilate, who wishes to release him but for the clamor of the Jews that he be put to death. We are shown Pilate asking the crowd, as a gesture of goodwill on Passover, whether he should free Barabbas (a murderer and traitor) or Christ.[62]

Similarly, the posture and gesture of the crazed wife attempting to throw her husband out of the house (see fig. 47) from "Les Femmes Social-istes" recurs in a strange painting that Daumier sent to the open Salon in 1849, *Le Meunier, son fils, et l'âne* (fig. 50). This oil, the first Daumier ever exhibited at the Salon, illustrates a La Fontaine fable of the same title, a fable in which a miller and his son journey to town to sell their donkey. In

the fable, their trip is interrupted four times by various townspeople who advise them on the most sensible method of transporting the animal. The episode illustrated in Daumier's painting, in which three jeering hussies (reminiscent of the many trios of witches populating his lithographs) offer their opinion, is no more or less important than the other three. It would be curious enough had Daumier merely chosen this moment to illustrate the fable. But it is striking in 1849 that he chose to make the taunting women the focus of the composition, allowing them to obscure the very subjects of the fable, the miller and his son.[63]

Before 1848 political reform rhetoric had provided the context for sexual liberation. After 1848 the sexual revolution became the arena of debate over the feared perversion of traditional moral standards. For Daumier, those tensions defined themselves between 1848 and 1850 as an increasing polarity between his images of shrews and images of madonnas. The abusive wife in the lithograph from "Les Femmes Socialistes" and the three taunting women in the painting suggest the dark side of Daumier's dichotomy. The light side preoccupied him equally throughout the Revolution. In fact, it became his idealized image of the redemptive Republic—motherhood.

Daumier's aesthetic and psychological reduction of womanhood into angels and demons is enacted, for example, in a caricature from "Les Divorceuses" published in *Le Charivari* on 12 August 1848 (fig. 51). The lithograph is divided into a dark, shadowed region of grimacing spinsters with sagging breasts and the illuminated realm of the young mother and child. The legend reads, "There goes a woman who, at our solemn hour, stupidly occupies herself with her children. . . . How can such narrow, dull-witted creatures still exist in France!"

The humor of this image relies on irony and presumes a shared awareness on the part of the viewer that what is being said is the opposite of what is meant. The caricature's dependence on the audience's immediate understanding and assent suggests much about the power of these sentiments in 1848. The reality of that power is reinforced by the fact that even feminist propaganda in 1848 shifted from the rhetoric of free love to the only acceptable myth of womanhood—maternity.

In 1848 feminist language reclaimed the identification of women with motherhood, transforming something confining into something liberating. As Claire Moses has written, feminists used their maternal roles to justify rather than discourage their participation in the public domain. In support of the concept of equal educational opportunities, for example, Jeanne Deroin argued that "the mother of future generations, she from whom will be born the glorious citizens of a world reborn, must not be a

47. Honoré Daumier.
*Ah! Vous êtes mon mari
. . . 1849.*

—Ah! vous êtes mon mari, ah! vous êtes le maître . . . . . . eh! bien moi, j'ai le droit de vous flanquer à
la porte de chez vous . . . . . Jeanne Deroin me l'a prouvé hier soir ! . . . allez vous expliquer avec elle! . . .

LES DIVORCEUSES.

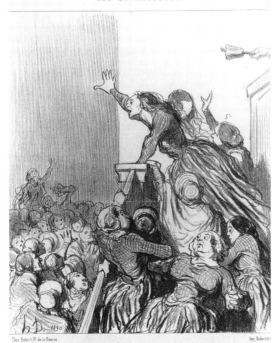

48. Honoré Daumier.
*Citoyennes . . . on fait
courir le bruit . . . 1848.*

--Citoyennes . . . . . . . . on fait courir le bruit que le divorce est sur le point de nous être refusé . . . .
constituons - nous ici en permanence et déclarons que la patrie est en danger! . . . . .

49. Honoré Daumier.
*Ecce homo.* c. 1849.

50. Honoré Daumier.
*Le Meunier, son fils, et
l'âne.* 1849.

LES DIVORCEUSES.

— Voilà une femme qui,à l'heure solennelle où nous sommes, s'occupe bêtement de ses enfans.....
qu'il y a encore en France des êtres abruptes et arrieres!

51. Honoré Daumier.
*Voila une femme . . .* 1848.

slave. She would be unworthy to carry them in her womb and to prepare them from childhood for the great destinies that await them."[64] Deroin insisted on women's participation in public life on the grounds that "it is above all this holy function of motherhood . . . that requires that women watch over the futures of their children and gives women the right to intervene not only in all acts of civil life, but also in all acts of political life."[65]

To define a woman by her maternal capacity was not a new idea. In the fifth book of *Emile: De l'éducation* (1762), Jean-Jacques Rousseau described women not as inferior to men but different. He wrote that women exist to serve and obey men—to be wives, mothers, and housekeepers. Daumier, like his father, was an avid reader of Rousseau and received contemporary support for this reductive view of womanhood from his friend and confidante Jules Michelet. Michelet was a regular visitor to Daumier's studio between 1848 and 1851, where they are purported to have discussed a collaboration on an illustrated history of France. Michelet was one of the most eminent scholars in France and one of the few contemporary figures

*Daumier's Vision of Female Intellect*

to receive unqualified praise and support in the otherwise satirical pages of *Le Charivari*.

Daumier was undoubtedly familiar with Michelet's writings of the late 1840s, most significantly *Le Prêtre, la femme, et la famille* (1845) which urges that traditional worship of religious abstractions be replaced with a religion of the home. Michelet saw the Revolution of 1848 as a continuation of 1789 and the reawakening of French republicanism as a moral rebirth. In his argument in favor of the reconstitution of the traditional family he saw women as the crucial, stable elements of that vision and praised them lavishly, but only in the context of their domestic capacities. Standing in firm opposition to utopian socialist revisions of the conventional family structure that presupposed female emancipation, Michelet insisted that a woman's social and physiological inferiority demand a monogamous family life; she must be married and have a household because she cannot live without man.[66] Furthermore, "from the cradle woman is a mother and longs for maternity. To her, everything in nature, animate and inanimate, is transformed into little children."[67]

Jules Michelet, like his contemporary, Ernest Legouvé, elaborated a religion of womanhood as part of the post-1789 impulse to find secular replacements for deposed Christian and monarchic patriarchal models.[68] Michelet and Legouvé characterize the female ideal within their respective new religions by opposing her to an unnatural and dangerous "other"—in both cases, a woman of ideas. In Michelet's chapter on "La femme de lettres" in *La Femme* (1852) and Legouvé's on "La femme libre" in *Histoire morale des femmes* (1849), the woman of ideas is identified as the type most oppositional and dangerous to the maternal ideal.

Daumier, too, was preoccupied with restoring motherhood to its sanctified place within the social order and condemning the activities of women who shirked this responsibility. This duality informs nearly every lithograph and painting that he produced during the Second Republic. Daumier countered the aggressive and unnatural women of "Les Divorceuses" and "Les Femmes Socialistes" with placid, heroic mothers. Between 1848 and 1851, there are no fewer than twenty-one paintings on the theme of maternity. Most of them are like *La Laveuse*, a roughly textured, simply composed study of a working woman and her child (1850; fig. 52). Its quietude and large, ennobled forms recall Millet's heroic peasants. But these are Daumier's urban heroes, shadowy figures nearly reduced to abstract shapes. We read them as anonymous silhouettes. Like chunks of earth, these typological signs for worker and mother stand in stark contrast with the highly agitated and angular renderings of the bourgeois women of

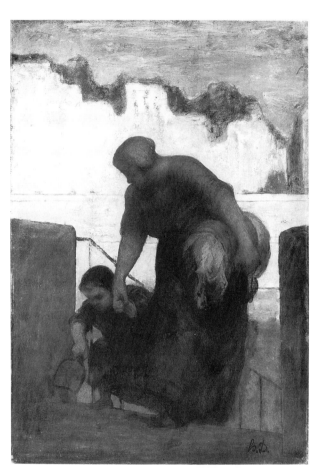

52. Honoré
Daumier. *La
Laveuse*. 1850.

ideas in the lithographs who are most often shown making noise or wildly
gesticulating.

Daumier's maternal ideal was so essential an expression of his aes-
thetic and political sensibility that in 1848, when asked by his peers Gustave
Courbet and François Bonvin to submit a sketch to the competition for a
symbol appropriate to the new regime, he chose the allegorical image of
Charity, the maternal protector (fig. 53). The artists submitting sketches
had been instructed to depict a single figure to represent the Republic. The
allegorical models selected by the various artists ranged from Libertas,
the goddess of freedom, to Victoria, the goddess of victory. Daumier was
the only participant to select Charity for his image, and he was one of the
very few to ignore the instructions to use only one figure, as the concept of
motherhood required the inclusion of children.[69] Set against a neutral

*Daumier's Vision of Female Intellect*

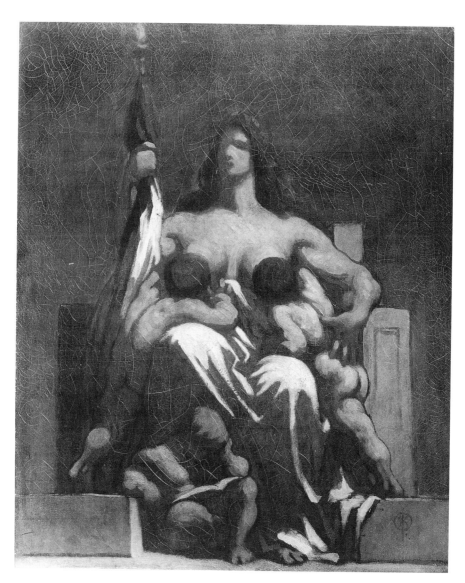

53. Honoré Daumier.
*La République*. 1849.

backdrop, the huge, heroic woman sits upon a throne as two children nurse at her breast and a third receives instructional nourishment at her feet.[70]

Daumier domesticated and pacified his figure of the Republic, transforming it into an image of the beautiful Revolution.[71] The domesticating impulse itself, however, suggests an underlying anxiety about the social consequences of 1848. The revolutionary concept that had once been inspiring was now, at least in part, a source of fear. And the dark side of that political enterprise—the ugly Revolution—also received expression in sexual terms.[72] Its most vivid and frequently invoked image, an image that presents itself as an ironic variation on Delacroix's *Liberty on the Barricades,* is this account by Victor Hugo of a female participant in the political events that precipitated the bloody June Days: "A young woman, beautiful, dishevelled, terrible. This woman, who was a whore, lifted her dress to her waist and shouted to the National Guardsmen . . . 'Fire, you cowards, if you dare, on the belly of a woman.' . . . A volley of shots knocked the wretched woman to the ground."[73] Here, in this representative anecdote recorded in the pages of Victor Considérant's socialist journal *La Démocratie Pacifique,* is the quintessential equation of political and sexual threat, wherein revolutionary mania is signified by a taunting, aggressive, horrific woman. In language that celebrates antirepublican violence while enacting a metaphoric rape, the political and sexual reaction to the most radical implications of the revolution reaches its climax.[74]

The relegation of women, during the Second Republic, to the types of angel or demon, madonna or whore, ensured the failure of the feminist vision. Women activists attempted to define themselves in a multitude of roles, and their efforts were systematically thwarted, in part, by the eventual failure of social reform in 1848, but, more significantly, by their own failure to demythologize the popular image of divided womanhood perpetuated by Daumier and others. The efforts of political and intellectual women in the 1830s and 1840s to achieve a new freedom of body and mind, had, in fact, prompted a more vicious and reductive polarization that withheld from women both sexual and intellectual legitimacy. Thus after 1849 the voices of the feminist movement were silenced for several decades more.

# 4

*Reading Through the Body: The Woman and the Book
in French Painting, 1830–1848*

Caricatures offer the most numerous and, in a strange way,
the least obstructed visualizations of the woman of ideas. This does not
mean that the caricatural vision is an unmediated, neutral document of
female reality. Far from it. But the overlays of satire and psychosexual
obfuscation are built in to its audience expectation. The manipulative codes
and authorial interventions are more visible in satirical imagery than they
are in "high art" media. Although caricatures of the woman of ideas power-
fully reimpose normalizing female paradigms, they at least retain some
archaeological trace of the classifications, the names, the dates, and the
challenges.

July Monarchy caricatures of the woman of ideas fixed class and gen-
der identities that were in fact fluid. Paintings and sculptures of the subject,
on the other hand, made indistinct and variable what was once stable. As I
demonstrated in Chapters 2 and 3, caricatures of bluestockings and femi-
nist socialists reinscribed gender norms; they diminished the power and
originality of the intellectual woman by repeatedly casting her as the devi-
ant opposition to a male-constructed ideal. While the caricatures spewed
venom at the woman of ideas, however, paintings and sculptures partici-
pated in a kind of psychic violence of dehistoricization. As part of the deep
structure of July Monarchy culture, these high art forms were protected
from the ordinary and the everyday by genre conventions that encouraged
the artist to veil or subordinate topical detail to a more generalizing and

(theoretically) universalizing aesthetic. Thus, while the woman of ideas was not attacked viciously in high art, as she was in caricature, she was not identified either.

One fascinating example of a painting that, to some extent, evaded this process of dislocation is Belgian artist Philippe Van Bree's *L'Atelier de femmes peintres* (1833; fig. 54).[1] Unlike other comparable representations of a male artist's female students, such as Adrienne Grandpierre's *Intérieur d'atelier de peinture* (1822), for example, *L'Atelier* operates metaphorically and satirically, like one of Daumier's bluestocking lithographs, to critique the currency of female challenges to male-dominated culture.

*L'Atelier de femmes peintres* is the pendant piece to Van Bree's *L'Intérieur de mon atelier à Rome,* both of which describe the interior of the artist's Italian studio in Rome and the activities of his female models and students. In *L'Intérieur,* the pensive artist, Van Bree, is seen from a distance in a workroom off of the atelier, presumably meditating on a volume of classical literature that will inspire him in his work on the unfinished canvas in the center of the painting. In front and slightly to the left of the canvas, three of Van Bree's models, in various stages of deshabille, eat, drink, and toy with studio props as they rehearse gestures and poses of distinguished precursors. The most important of these, the central group, is a quotation of Tintoretto's *Aphrodite* that intertextually engages the midground figures on the pedestal, Eros and Psyche.

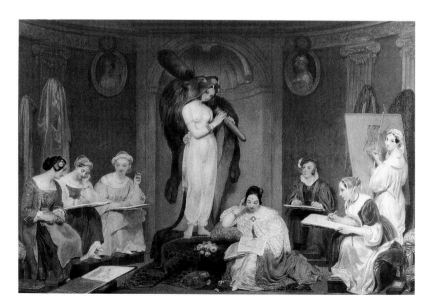

54. Philippe Van Bree. *L'Atelier de femmes peintres.* c. 1833.

*Reading Through the Body*

The cryptic elements of this narrative are understood only by looking at Van Bree's two works in relation to one another. In *L'Atelier* and *L'Intérieur,* the female presence dominates and controls studio activity. Both works allegorize the dangers of solidarity among women and the misguided concept of sisterhood.[2] In *L'Intérieur,* the juxtaposition of Aphrodite with Eros and Psyche invokes the legend in which Eros is sent by his mother Aphrodite to inspire in her rival, Psyche, an irrational love for some foolish and ugly mortal. Dazzled by Psyche's beauty, Eros, instead, sets out to win her love. He isolates her in a beautiful palace where she is tended by invisible servants and visits her at night in complete darkness exacting her promise that she will not try to "see" him. Psyche almost loses Eros (true love) by momentarily believing her sinister sisters, who try to convince her that her husband is a monster whom she must expose and destroy.

The pendant, *L'Atelier de femmes peintres,* also characterizes the hazards of female solidarity, but in this image the consequences are more serious than is the mere sacrifice of true love. In *L'Atelier,* Van Bree's female students are arranged in a semicircle around two of the three models that appear in *L'Intérieur.* The students are shown drawing the centralized figures, one of whom stands on a raised platform wearing the skin of a lion and clutching a huge club (the attributes of Hercules), and the other sits at her counterpart's feet reading the feminist journal *La Femme libre.* The destructive female voice in this picture emanates from the journal, which challenged its readers to assert their power in sexual and legal matters. The model who reads *La Femme libre* formally echoes and supplants the figure of the male artist in *L'Intérieur.* Both are seated, eyes cast down, hand to chin, engrossed in a text. In *L'Atelier* the power of the word has been usurped by contemporary female tongues and readers; its dictum is physicalized in the figure of the standing model who appropriates the iconography and persona of ultimate masculine power and strength.[3]

This theme of female abuse of power, particularly the power of the word, is far more common and overt in caricature than in painting. Although Van Bree's detail and direct appeal to contemporary anxieties about the modern woman's rapid entry into the community of thinkers have parallels in a handful of paintings, the majority of high art manifestations of the woman of ideas consist of subtle iconographical shifts that make the process of recovering or re-viewing these works quite difficult. The appropriation and disguise of the woman of ideas within the iconographical revisions of two distinguished traditions form the subject of this chapter. I am concerned principally with the preponderance and confluence during the July Monarchy of images of *la liseuse* and of Mary Magdalene. By historicizing the theme of the reading woman, I hope to evoke the subtle

and often camouflaged allusions to the woman of ideas in one of the most orthodox structures of high culture, religious art. Reclamations of Mary Magdalene by social reformers and romantic philosophers as the redemptrice of France influenced her representation and intersected with a similar veneration in this period of the woman of ideas as a prophetess of the future. An understanding of the rhetorical and figural relationships of these two female *initiatrices* requires an examination of the iconographical transfigurations of la liseuse.

The most fundamental and accessible pictorial response to the woman of ideas is within the centuries-old tradition of the woman reading. Representations of women consuming texts (novels, newspapers, fashion magazines)—much like the central anecdote in Van Bree's *L'Atelier*—are increasingly common after 1830 as this tradition is revitalized and altered. Between 1830 and 1850 more than sixty paintings entitled "La Liseuse" were exhibited at the Salon, a figure that only hints at the actual number of works of that title produced.[4] Many of those paintings—even those shown at the Salon—are unlocatable. Some are inaccessible because they remain unpublished and in private collections. Others are now known by other titles. Many are just lost. Because the theme of la liseuse has been regarded as a less important genre subject produced for a less informed market, no historiographical imperative has required its consolidation and study. The minimal attention the theme has received focuses on its currency among Realists and its reinvocation of seventeenth-century Dutch models.[5] Given its prevalence, particularly in the second half of the century, it is surprising that this theme has remained so understudied. The reading woman was a favorite subject for canonical figures like Bonvin, Cassatt, Corot, Fantin-Latour, Manet, Morisot, and Renoir. But just as the social construction of modern female experience removed women from public arenas of power, historical constructions of modernist iconography have left little room for the theme of the woman engaged in affairs of the mind. Modernist scripture, beginning with the word of Baudelaire, has focused on the urban cityscape and its actors. The only major female role cast within its drama is that of the courtesan, for some the perfect embodiment and for others the grotesque quintessence of modern womanhood.

The subject of "woman" is a crucial fixture of one of the seminal essays defining modernism, Baudelaire's "Painter of Modern Life." As a "creature of show" and an "object of pleasure," woman is Baudelaire's ideal transmitter of that long-ignored component of modern art and beauty, the transient.[6] Baudelaire's commentary on spectacle and fashion describes—or perhaps invents—the public posturing of women who affect the attitude of absorption rather than engage in genuine thought in order to enhance

*Reading Through the Body*

their status as "the object of the most intense admiration and interest that the spectacle of life can offer to man's contemplation."[7]

The iconography of la liseuse has, until recently, been at odds with Baudelaire's characterization of the early modernist aesthetic. The realm of la liseuse consists of interior spaces, domestic and psychological. Furthermore, its subjects are more often than not the relatives of the artist—wife, sisters, mother, and daughters.[8] The familial and the autobiographical are not the dominion of the decidedly masculine protagonist of modernism, the *flâneur*. The "man of the crowd" who moves anonymously and inconspicuously through the streets of Paris is at liberty to do so as no woman could.[9] Thus, paintings of la liseuse have been seen as the purview of the feminized self of the artist, there to satisfy sentimental need but not the rigorous demands of a quintessentially modern art.[10]

Though the figure of the woman reading has been tangential to the narrative of modernism, it is central to the concerns of this study. I by no means wish to suggest that every painting of a woman reading depicts a woman of ideas. I am interested in the subtle nineteenth-century revisions of the genre's conventions that react to a changing female condition, the works that evoke the audience for or the training ground of the woman of ideas. In this analysis I will not discuss the huge body of works in which a book appears as a mere prop or as a sign of piety, wealth, or erudition. I am occupied exclusively with images in which the act of reading adds a narrative dimension to a portrait.

The tradition of the reader in western art was well established by the mid-nineteenth century. The pictorial sources for representations of the modern male reader—principally scholars and men of letters—can be found in religious art, in depictions of saints and prophets.[11] Figural prototypes for the female reader are similarly located in religious art; they can be identified with one of two aspects of Marian iconography (devotional images of the Virgin as mère-éducatrice and narrative treatments of the Annunciation) and in representations of the penitent Mary Magdalene. *The Ince Hall Madonna* after Jan Van Eyck, for example, pictures the seated Virgin with child on her lap, absorbed in a book. But while such images of devotion and maternal responsibility are conceptual and inspirational models for nineteenth-century secularizing versions of the subject—like Adolphe Cals' *La Lecture* (1854), Paul Delaroche's *Reading Lesson* (1848; fig. 55), and Henry Scheffer's *Une Scène d'intérieur* (1840)[12]—modern treatments of this theme also must be considered within the context of contemporary debates over female education and literacy.

The issue of equal education for women has been revived in every period of "feminist" activity in France since the thirteenth century.[13] As I

55. Paul Delaroche. *The Reading Lesson.* 1848.

have indicated, the July Monarchy was a particularly fertile epoch for this
kind of discussion. Several interest groups associated with the political left
(specifically, the Saint-Simonists and the Fourierists) waged campaigns to
challenge the institutionalized inequities of French society—including
those suffered by women. At the same time, Louis-Philippe's government,
guided by nationalistic pride, devoted serious energy to France's educa-
tional system. Prior to the educational reforms of the 1830s, schooling in
France was virtually unregulated. Some schools fell under the jurisdiction
of the Catholic Church, and others were at the mercy of random state
intervention and experimentation. Beginning in 1833, Louis-Philippe's
minister of public instruction, François Guizot, wrote and implemented

several policies that focused on teacher training and standardization of school programs. There followed a significant rise in school enrollment, and the number of primary schools doubled within fifteen years. Not surprisingly, these reforms had a much greater impact on boys because the Guizot laws addressed requirements for girls' schools only in the vaguest of terms.[14] Girls' education at every socioeconomic level remained inferior to boys'. Whether the girls were wealthy and attended private boarding schools or were taught at home by their mothers, their education was essentially marriage training. Even the rhetoric demanding better educational resources for females was inspired by a conservative vision of women's contribution to society. With the exception of a handful of feminists like Reine Guindorf and Jeanne Deroin, who argued that educational reform was a political right and the only guarantor of economic independence, most social theorists believed that women needed quality schooling only because they were charged with rearing the next generation of male citizens.[15]

Paintings like those by Cals, Delaroche, and Scheffer concretize that position, recalling late-eighteenth-century vignettes on the religion of home and family as theorized by Fénelon and Rousseau. As Carol Duncan has demonstrated, many eighteenth-century depictions of maternal devotion belonged to a larger body of works that drew on images of the Holy Family and precedents in Dutch and French seventeenth-century genre painting.[16] These works were inflected by contemporary discussions of marriage and parenting that claimed to hold in the balance the moral regeneration of France. Though this preoccupation persisted into the nineteenth century, the emphasis shifted from the happy mother to the good mother who nourished the mind as well as the body. Daumier's 1848 competition sketch for the symbol of the Republic (see fig. 53) is an abstraction of this principle. It is also a useful illustration of the change in tone that accompanies the change in emphasis.

The growing body of nineteenth-century works concerned with the mère-éducatrice conveys a seriousness and political imperative distinct from eighteenth-century scenes of physical and emotional nurture.[17] This is as true in Daumier's allegorization of the theme as it is in Delaroche's more particularized but still iconic circular format (see fig. 55) wherein the half-length figure of the modern holy mother, a working class Marianne, oversees the education of her two citizen-children.[18]

Though the vogue for images of the mère-éducatrice began among aristocrats and haute-bourgeoisie during the Restoration, by the July Monarchy (particularly during the resurgence of revolutionary fervor in 1848, as *The Reading Lesson* suggests) it was adapted to working-class subjects as

well. Particularly popular among Realists like Cals and Bonvin, these mères-éducatrices of the people often exuded a kind of moral purity.[19]

Works like these subtextually legitimized women's claim to the right to an education, albeit in the narrow terms of Rousseau.[20] They also engaged a changing female condition in the July Monarchy. The rise in portrayals of women reading—women of all classes, be they mothers or isolated individuals—suggests the modern woman's growing access to the world of thoughts and ideas. Though no systematic literacy figures exist for Paris, they have been deduced from studies of the *départements.* It is estimated that by 1820 eighty-four percent of the male population and sixty percent of the female population were reading and writing. Furthermore, it is believed that by 1848 eighty-seven percent of the ouvriers and seventy-nine percent of the ouvrières were totally literate.[21] One of the most interesting aspects of these findings is that between 1820 and 1848 the jump in literacy rates was significantly higher for women than for men, a fact that inspired alarm among social critics who were anxious about modern literature catering to degraded tastes and among political analysts fearful about relinquishing the power of the word to once disenfranchised hands.[22]

Interest in the growth of female literacy formed the subject of many articles, novels, and plays between 1830 and 1848. Within painting, however, depictions of single female figures reading were most plentiful in the mid to late nineteenth century, when they took one of two forms: the devout virginal woman seated in her home, in a hard, straight-backed chair studying a religious text, or her sexualized counterpart, shown slouching in an overstuffed armchair or reclining out-of-doors in a state of semi-undress, gripped by the escapist fantasy of a novel.

The former type has a longer lineage that derives, as stated earlier, from scenes of the Annunciate.[23] Since Carolingian and Ottonian times, the main attribute of Annunciation scenes has been the prayer book from which the Virgin is interrupted by the appearance of Gabriel. This dimension of the Virgin Annunciate has numerous typological descendents in the visual arts, especially in seventeenth- and nineteenth-century genre paintings of pious women reading in domestic interiors, a well-known example of which is Robert Campin's *Merode Altarpiece* (c. 1425). Seventeenth-century Dutch painting, particularly Rembrandt's portraits of his mother reading or works like Pieter Janssens Elinga's *Femme lisant dans un intérieur* (c. 1665; fig. 56), contributed to a similar vogue for la liseuse among nineteenth-century Realists and Naturalists. In Elinga's picture a woman sits midground faced away from us and toward a source of light, a window. She functions as an intermediary or conduit, much as the Virgin does, between us and the Word that is symbolized by the light. Though an image

like Elinga's interested nineteenth-century artists, Rembrandt's model appears to have had even greater impact, particularly his series of close-up portraits of his mother reading that deemphasize environment in favor of physiognomic detail and characterize the source of spiritual light as the product of some mystical marriage between figure and text rather than as something external and unavailable to mortals.[24] Rembrandt's predilection for blurring distinctions between genre and portraiture seems also to have been influential. In the nineteenth century, artists like Bonvin, Corot, Cassatt, and Renoir frequently paint family members and assign the works titles like "La Liseuse." Some are idolizing images of piety, and others are proud records of the pastimes of the modern woman, leisured and literate.

It is the latter type, *la liseuse moderne,* who is of greater concern to this study. As I detail in Chapters 2 and 3, la liseuse moderne was a staple feature in caricatures of the woman of ideas. She usually was characterized as a mindless sponge absorbing dangerous lessons from novels and ignoring maternal and spousal duties. The growing numbers of painted and sculpted representations of la liseuse moderne draw on both nineteenth-century caricature and eighteenth-century painted prototypes in the oeuvres of artists like Fragonard and Boucher. Manifestations of this subject vary from those in which the text is a sign of leisure time or erudition to those that illustrate the dangers of books in the hands of unsupervised and impressionable young women. Octave Tassaert's lithograph *Le Roman* (1832; fig. 57), for example, features a three-quarter view of a young middle-class woman seated in an easy chair before a fire. Unaware of our presence and riveted by the text, the sitter in *Le Roman* is, in many ways, a modernization of Elinga's *Femme lisant dans un intérieur.* The Bible has been replaced by a novel, and the source of light has more to do with libido and heat than with spirit and illumination. Though Tassaert's reader owes much to an image like Jean-Honoré Fragonard's *La Liseuse* (c. 1776; fig. 58) in terms of the intimacy suggested by this unauthorized glimpse of the engrossed female reader, there are some fundamental differences. Tassaert's liseuse is not casual or relaxed, as Fragonard's is. The young woman in *Le Roman* is spellbound: she leans forward, and her free hand, rather than resting on the chair arm, is slightly raised and appears about to gesture, about to participate in the action of the text. Tassaert's image, like Compte-Calix's 1841 lithograph *Roman qu'on lit* and Victor Bornschlegel's 1847 painting *Jeune fille à son premier roman,* presents in still restrained and decorous terms the questionable influence of modern literature (a fair amount of it written by women) on young girls.[25]

Genre depictions of lazy domestics offer a popular nineteenth-century variation on the theme. Whereas earlier incarnations, like Nicolas

56. Pieter Janssens
Elinga. *Femme lisant
dans un intérieur*.
c. 1665.

57. Octave Tassaert.
*Le Roman*. 1832.

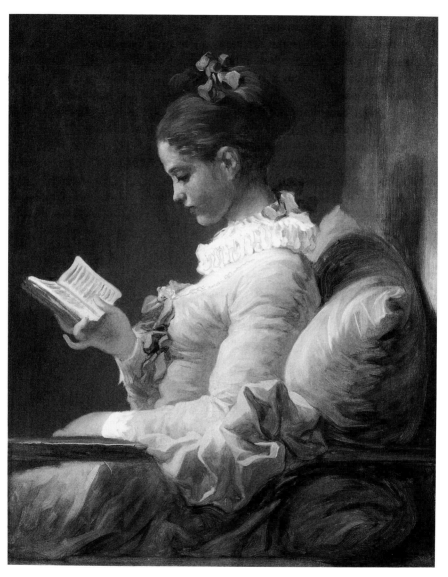

58. Jean-Honoré Fragonard.
*A Young Girl Reading.* c. 1776.

Maes's *The Idle Servant* (1655), might feature sleeping maids surrounded by dirty dishes, nineteenth-century treatments find her captivated by a book. Jean-Baptiste-Antoine-Emile Béranger's *Maid Doing the Room* (1848; fig. 59), like A. F. Prefontaine's *La Lecture du roman chez la lingère* (1848) or François Bonvin's much later *La Servante* (1870), spotlight idle female workers whose immersion in a book leaves them indifferent to the surrounding disorder. In the Béranger, the text removes the servant from her mundane task and bestows on her a temporary imaginative identity. This alter ego is signified by a prominently lit bronze statuette of a languorous female nude.[26]

Such anecdotes were prevalent in popular literature as well.[27] Mathurin-Joseph Brisset's *Cabinet de lecture* (1843), for instance, includes among its visitors to the reading room an innocent domestic searching for "something . . . with castles, secret passages, old villains and lovers who will marry in the end."[28] Similarly, the most famous book about the perils of the wrong kind of reading, *Madame Bovary* (1857), includes among its contributors to Emma's deadly education an old laundress who came for a week each

59. Jean-Baptiste-Antoine-Emile Béranger. *Maid Doing the Room.* 1848.

month to the convent and "lent to the eldest ones, secretly, some novels that she had always kept in the pockets of her apron." The lady herself, we are told, like an alcoholic, "devoured long chapters during intervals in her work."[29]

*Madame Bovary* was in many ways the culminating text of the hundreds of essays and plays produced during the July Monarchy on the menace of "bad novels."[30] Flaubert's subject is a young woman whose convent education exposed her to the kind of art and literature that guaranteed her ruin. The cultural tastes she developed filled her with fantasies of passion and romance with which her real life compared badly. Unhappy in her marriage, "Emma wanted to know what the words felicity, passion, and ecstasy meant exactly in life; those words which had appeared to her so beautiful in books."[31] But even after she took a lover, the joys evoked in novels eluded her. "While writing to [Leon], it was another man she saw, a phantom fashioned out of her most ardent memories, of her favorite books."[32]

To understand the July Monarchy preoccupation with the literature of vice, one must remember that the concept of widespread literacy and the revolution of the printed word was recent and untested. Arguments that are for us obsolete about reading as the salvation or damnation of a society (comparable, perhaps, to twentieth century debates about the merits of television) were fresh and compelling in the 1830s and 1840s. Articles such as "Etudes religieuses: Influence des lectures frivoles" (1845), recognizing that "la lecture est devenue l'aliment de l'esprit" and "un besoin de toutes les classes," implored writers to behave responsibly as a civilizing cultural force.[33]

What appeared to be neutral presentations of this new fact of nineteenth-century life were rare and usually took the form of graphic illustrations of manners in the popular press. Occasionally they were translated into paintings like Narcisse Diaz de la Peña's *La Lecture du roman* (c. 1845; fig. 60), which features a young "bourgeoise" reclining with her dog and her novel in a deeply shadowed wood. She is propped up on one elbow, her head resting coyly on her hand; her mouth betrays a trace of a smile, presumably prompted by the passage she reads. Diaz's placement of the reader in a forested setting that is a kind of physical equivalent to the romance and emotion of her novel is increasingly common after 1840. This iconographical shift—which I discuss at length later in this chapter—mirrors and, I argue, intersects an identical change in representations of Mary Magdalene during the July Monarchy.[34]

Many figurations of la liseuse moderne respond to written material expressing apprehension about the consequences of exposing young girls to the wrong books. These texts focused mainly on the models of infidelity

60. Narcisse Diaz
de la Peña. *La Lecture
du roman.* c. 1845.

and domestic irresponsibility that such books promoted. In his discussion
of the exploitation of the ouvrière, for example, Jules Simon decried the
popular novel as the sad mirror of its culture. Thirty years ago, he com-
plained, "une femme n'était intéressante dans un roman . . . qu'à condition
de trahir la religion, la société, sa parole, son mari, et ses enfants."[35] Now,
according to Simon, women are seduced by these texts into decadent and
ultimately destructive decisions such as that made by the daughter of
Marie-Jeanne, heroine of the popular 1835 drama by Dumerson and Alex-
andre, *La Femme du peuple.* Marie-Jeanne's daughter, Amélie, seeks to over-
come her class constraints by aligning herself with the world of letters, "des
ouvrages à la mode" that are concerned with "suicides, des assassinats, des
adultères."[36] We see the normally dutiful Amélie begin to defy her mother
and ignore instructions to stay away from "cabinets de lectures." Eventually
she begins smuggling the novels of George Sand and Paul de Kock into her
bedroom. Ultimately, despite her mother's efforts, these "romans en vogue
. . . faits pour empoisonner les coeurs" drive this once stable and dutiful
daughter to attempt suicide.[37]

*Reading Through the Body*

Painted expressions of this preoccupation with the dangers of books occur principally in one variation on the theme of la liseuse that responded to a thematic crossover between high and low culture and that appealed to the growing clientele for soft pornography. The crossover was, in part, inspired by a transformation in conventions of the female nude that began in the eighteenth century. The nudes of Watteau and Boucher, for example, increasingly reject the legitimizing contexts of biblical and mythological themes in favor of voyeuristic glimpses of contemporary anonymous women engaged in the intimate rituals of bath or toilette. Many nineteenth-century appropriations of this convention add reading to the list of rituals of intimacy in which the male spectator would enjoy seeing a female nude engaged.

Two lithographs, Wattier's *Ce que l'on voit trop souvent* (1828; see fig. 1) and Achille Devéria's *Le Roman du jour* (1832; fig. 61) are representative of

61. Achille Devéria. *Le Roman du jour.* 1832.

the growing body of nineteenth-century popular prints addressing this subject. In both, several young women recline together on a bed or divan and take turns reading aloud. Both offer an illicit glimpse of exposed breasts that signifies the near-masturbatory effects of the text.

Before the nineteenth century, painted images of sexual abandon and play usually responded to some physical human stimuli and occurred in mythological scenes or moments of religious ecstasy. One of the few prototypes for the nineteenth-century vogue for autoeroticism exists within genre scenes of women writing or reading letters, such as Jean-Baptiste Greuze's *The Letter Writer* (c. 1800; fig. 62). Unlike earlier manifestations of this theme, like Dirck Hals' *The Dreamer* (1631), in which a woman receives information in a letter but must temper any excitement that it might generate because a servant is present, Greuze's writer is sexually charged. She stops in the middle of her letter to daydream either about its contents or its intended audience. The sexual nature of the reverie is suggested by her posture—she is slouching forward, cheek resting on her hand, eyes cast dreamily upward—and by her exposed shoulders and upper chest.

Nineteenth-century treatments of la liseuse déshabillée are more of a Second Empire phenomenon. Several iconographical traditions commingle after 1850 and complicate the genre of la liseuse. The state of undress and the exposed breasts conflate influences from a number of unlikely sources. Though the reader's deshabille could be said to merely perpetuate, in modern terms, an eighteenth-century taste for scenes of "intimacy for its own sake," it might also be seen as a perverse transmutation of the lofty and sacred themes of the nursing mother and the *caritas romana*.[38] Though many representations of women giving nourishment to a child or to a male parent betray a subtext of sensual pleasure, that pleasure is at least superficially legitimized by its cultural associations with maternal or filial duty.[39]

Auguste Toulmouche's *Young Girl with a Book* (1857; fig. 63) is rich in its confluence of such sources. It injects an eighteenth-century *scène galante* with a nineteenth-century interest in female literacy. But the nobility and posture of Toulmouche's reader connect her as well with the elevated tradition of the sibyl or the caritas romana. This reader's hair, profile, and classically draped nightclothes have a great deal in common with a work like Sir Thomas Lawrence's portrait *Mrs. Jens Wolff* (1803–15; fig. 64). In Lawrence's more restrained version of the subject, the sitter is fully clothed and posed as Michelangelo's Erythrean sibyl. Like her counterpart in the Toulmouche painting, she leans her head on her hand, absorbed in a book. Rather than a novel, however, Mrs. Jens Wolff is engrossed in an oversize

volume of engravings of the ceiling of the Sistine Chapel. It would appear that only the reading of novels requires the opening of one's blouse.

Toulmouche's *Young Girl with a Book* is also related to eighteenth-century paintings of Roman charity like those of Louis-Jean-François Lagrenée the Elders (1765) and François-Xavier Fabre (1800). In Lagrenée's and Fabre's treatment of the theme, the pious daughters bear noble Roman profiles as they modestly turn away from their feeding fathers. Their clothing is draped loosely to allow easy access to the breast as soon as the jailer leaves the cell. Toulmouche also ennobles his subject. Her elegant drapery and twisted seated posture, like the Lawrence, evoke a Michelangelesque sibyl whose text instructs rather than inflames. Moreover, her breast is completely and unashamedly exposed, the nipple centered, iconic. This work is either a very subtle satire of the caritas romana genre or, more likely, an effort to superimpose a layer of artificial academic dignity onto a degraded popular theme. Toulmouche transforms a boudoir scene into an allegory of modern female nurture.[40] Thus, he embraces the lessons of his teacher Gleyre on how to capture several audiences simultaneously and still remain competitive for Salon jury selections.

The erotic subtext of Toulmouche's *Young Girl with a Book* is unusually foregrounded in a painting by Belgian artist (and student of Philippe Van Bree) Antoine Wiertz, *La Liseuse de romans* (1853; fig. 65). Surrounded in her bed by the popular novels of Alexandre Dumas fils, which are supplied to her by an incubus, a naked and nearly faceless woman reads and revels in the obvious sexual pleasure she derives from the texts. Observing her from the privileged vantage point of the foot of her bed, we are invited to watch the autoerotic frenzy of her twisting torso by the well-positioned mirror before which she obligingly spreads her legs.

The mid-nineteenth-century preoccupation with the iconography of women reading and its attendant contemporary reality cannot be exaggerated. Its many manifestations replay the flourishing debates about educational reforms for women and concern over the growing female presence in the publishing industry. For some the reading woman signified corruption while for others she evoked maternal and civic duty. Generally, though, as suggested by Victor Orsel's *Le Bien et le mal,* women's new access to the word was diminished and controlled by overlaying its representation with the same tired paradigms that had decontextualized and dehistoricized women for centuries (1832; fig. 66).[41] Orsel's altarpiece, which reinvokes some of the religious origins of this iconography, personifies good and evil in the figures of two women, one reading and one not. Illustrative of Comte Charles de Montalembert's efforts to rejuvenate the principles and forms of

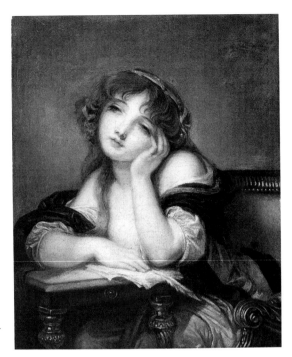

62. Jean-Baptiste
Greuze. *The Letter
Writer*. c. 1800.

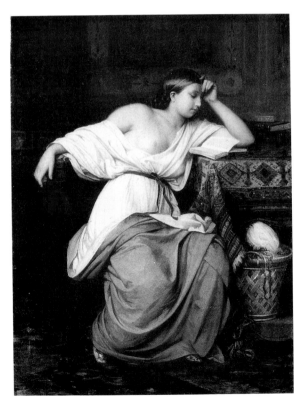

63. Auguste
Toulmouche. *Young
Girl with a Book*. 1857.

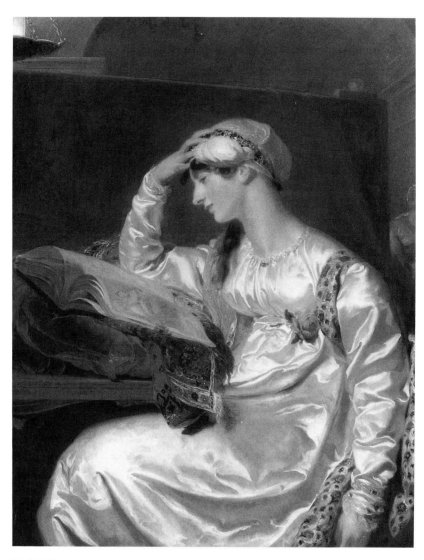

64. Sir Thomas Lawrence.
*Mrs. Jens Wolff.* 1803–15.

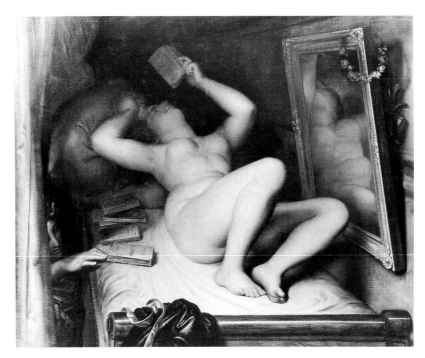

65. Antoine Wiertz. *La Liseuse de romans.* 1853.

Christian art in the modern age, *Le Bien et le mal* relies on nineteenth-century scenarios of salvation and damnation for its manifesto of morality. The incarnation of goodness is a dignified golden-haired woman who piously reads from her book of wisdom under the protective shield of a guardian angel. She is related to the pious figures of Elinga and Bonvin just as her counterpart, the incarnation of evil, responds to the slouching, misguided readers of Watteau and Wattier. Though Orsel's evil principle is punished for the text she rejects rather than victimized by the text she consumes, she shares the features and life pattern of la liseuse déshabillée. The consequences of the reading habits of both women—who are damned if they do and damned if they don't—are narrated in painted medallions that encircle the panel. The virginal, straightbacked reader enjoys a life of marriage, motherhood, and fidelity. Her slumping, dark-haired alter ego suffers violation, the premature death of her illegitimate child, and finally suicide.

The use of the fallen book as a sign of sexual transgression is not unique to Orsel's *Le Bien et le mal.* It is an alternative iconography for the misdirected female reader that is particularly common in the genre of book illustration. The paradigmatic equation of the fallen book with the modern

*Reading Through the Body*

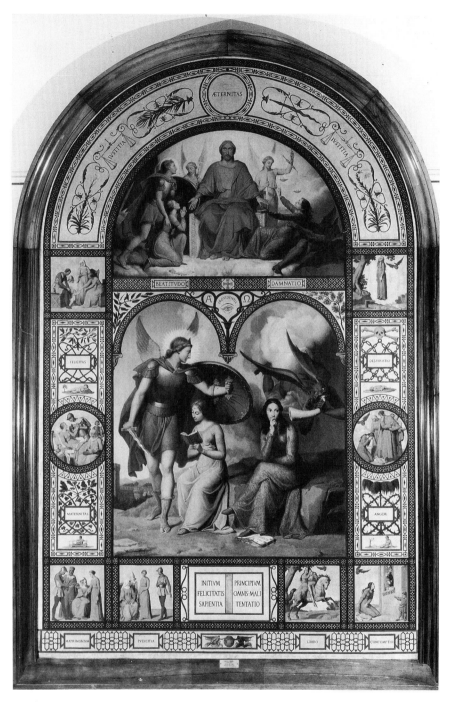

66. Victor Orsel. *Le Bien et le mal.* 1832.

"fall" is demonstrated by a comparison of almost identical vignettes published in *L'Illustration* in 1844 to illustrate scenes from two novels. Tony Johannot's lithograph of a scene from George Sand's *André* (fig. 67) is virtually interchangeable with one published several weeks later illustrative of a passage in Rousseau's recently reissued *Julie, ou la nouvelle Héloïse* (fig. 68). In both, male and female are pictured seated at a table at the moment when their reading has fired the flames of passion. In both that passion is encoded in the open book that has slipped to the floor.[42] The popularity of the conceit is evidenced by its frequent deployment in book illustration as well as by textual allusions to like moments in other books. The descriptive commentary accompanying Johannot's vignette in *L'Illustration*, for instance, compares Julie and Saint-Preux to Françoise de Rimini and "son malheureux amant."[43]

The reference to the story of Paolo and Francesca is logical given the parallels in the two stories and the enormous popularity of Dante's account of these ill-fated thirteenth-century lovers. Between 1800 and 1860 Paolo and Francesca's adulterous love was the subject of plays, prints, musical compositions, and paintings. The nineteenth-century preoccupation with this theme is routinely explained as the romantic fascination with Dante and the Middle Ages. But the fact that the vast majority of paintings of Paolo and Francesca represent the moment when these virtuous people fall from grace, a moment symbolized by the fallen book they had been reading together, seems to demand a contextualization of this vogue within contemporary discussions of the dangers of reading as well. According to the narrative, Paolo and Francesca try to rechannel their mutual attraction into platonic friendship. They are undone as they read together the story of Lancelot and Guinevere's illicit love. It is that moment, when the book slips from their fingers, that was chosen by Ingres (1819), William Dyce (1837), Devéria (1838; fig. 69), Decaisne (1841), and Cabanel (1870) to express the essence of the tale.

The fascination with the intimacy of couples reading only grew in the nineteenth century. The sharing of dangerous knowledge that would prompt a fall from from grace provided artists with a sexually charged subject that did not risk impropriety. To comprehend the subtle ways in which this activity suggested peril and iniquity to its nineteenth-century audience, one might look at a twentieth-century parallel, Margaret Atwood's 1985 novel *The Handmaid's Tale*, a nightmarish allegory about a postnuclear disaster culture.[44] To facilitate the urgent task of repopulating the planet, women are stripped of all rights, including the right to read, that might deter them from their principal duty. This is particularly crucial for the handmaids, the corral of still fertile women who are mated monthly with a

67. Tony Johannot.
*André.* 1844.

68. Tony Johannot.
*Julie: ou la nouvelle
Héloïse.* 1844.

69. Achille Devéria.
*Françoise de Rimini et
Paolo.* 1838.

male authority figure under the watchful supervision of his sterile wife.
Atwood's novel follows the movements of Offred, who is eventually sum-
moned by her commander for unsupervised visits. The foreplay with which
these evenings always begin is reading, the arousal of his invitation to her to
join him momentarily in the community of empowerment that is legally
forbidden to her. Similarly, nineteenth-century interpretations of Paolo
and Francesca or Julie and Saint-Preux focused on moments when these
couples were stimulated to the point of uncontrol by reading, which mo-
mentarily balanced the scales of power and undermined conventions of
decorum.

   A twelfth-century couple whose narrative inspired frequent re-
hearsals of this theme was Abélard and Héloïse; she was the first French
woman of ideas. Historical surveys of French women writers always begin
with Héloïse, the gifted niece of an official of the Cathedral of Notre Dame

*Reading Through the Body*

who was seduced by her tutor, Pierre Abélard. Their notoriety was guaranteed by the preservation of their elegant and poetic love letters, letters that have been translated and republished hundreds of times—eighty-three times between 1800 and 1860 alone.

Though their story has been valued since the twelfth century, an actual cult of Héloïse and Abélard evolved in the seventeenth century following the publication of several pseudohistories and the earliest consolidation of their letters.[45] Interest in the couple was sustained in the eighteenth century, first through Alexander Pope's poem "Eloisa to Abelard" and then through the dozens of imitations it inspired, the most important of which is Rousseau's *Julie, ou la nouvelle Héloïse* (1761). Rousseau's Julie played a critical role in shaping the modern romantic conception of Héloïse as the embodiment of the principle of pure and sublime love, as "la grande sainte d'amour" as she came to be known.[46] Within movements among romantic philosophers and historians to elicit secular replacements for discredited Christian dogma and typologies, Héloïse became one of several women of ideas cast in the role of redemptrice of France.

The modern femme-messie, described at length in Chapter 2, was in many ways an ideal conflation of Mary and Mary Magdalene. Because the world's corruption was seen as the work of men, its salvation, according to figures like Prosper Enfantin, Jules Michelet, Edgar Quinet, and Alphonse Esquiros, required an opposite sensibility—one that derived from the model of the Virgin who "a conçu la loi d'amour mystérieuse prophétie de l'ordre social futur."[47] The verity of that female ideal in the nineteenth century, however, required her refashioning in modern terms. Thus, the credibility of religious love and passion came to depend on prior knowledge of earthly love and passion. When Héloïse joins an order of nuns and embraces God it is laudable because she has known the alternative.

As many nineteenth-century religious reformers sought to replace the concept of blind faith with informed choice, figures like Héloïse and Julie—whose transfigurations were preceded by a fall—came to be regarded as initiatrices. Like Mary, they were models of self-sacrifice and pure love. And, like Mary Magdalene, they had experienced and chosen to forgo the pleasures of the body to follow the word of God—or at least its modern equivalent. Julie gives up Saint-Preux for the bourgeois trinity: reliable husband, home, and motherhood. *Julie, ou la nouvelle Héloïse* was a potent modern reconstruction of the first woman of ideas, a critical part of the cultural mechanism that diminished the intellectual achievements of Héloïse in the nineteenth century. Julie was the model for nineteenth-century figurations of la mère-éducatrice, the reprioritized Héloïse whose intellect and talent were now only relevant to the education of her chil-

dren.[48] The name Héloïse is invoked often in the mid-nineteenth century —by Jules Michelet, Ernest Legouvé, Henri Martin, and others—as the hope and salvation of modern society. But it is her fictionalized and normalized alter ego, Julie, whom they are crediting with the preservation of France. The achievement and historical narrative of the old and "real" Héloïse was not easily adapted to the modern imperative of maternity and domesticity, so her legend was tampered with a bit and replaced by the new and improved version: "Si une seule femme peut représenter L'Epouse dans toute sa grandeur, c'est Héloïse" [If one woman alone can represent the spouse in all her greatness, then it is Héloïse].[49]

From the eighteenth century on, the popularity of the subject of Héloïse in the visual arts—this woman of ideas who puts aside knowledge of all kinds—corresponded to its currency in popular theater and literature. Though several treatments of the subject were exhibited at the Salons in the 1780s and 1790s following the publication of *La nouvelle Héloïse,* the theme enjoyed its greatest vogue among the French Romantics who had an even higher stake in promoting this model of female self-sacrifice.[50] The story of Héloïse and Abélard was retold and reinterpreted by Chateaubriand, Guizot, Quinet, Legouvé, Houssaye, and Michelet, to name just a few. Its revival during the July Monarchy was sporadic. The first followed the long and well-received run of Bourgeois and Cornu's play *Héloïse et Abélard* in 1836, which inspired paintings by Granet (1838), Tassaert (1838), A. Benouville (1838), A. Colin (1838), and Durupt (1837).[51] The second group of responses appeared after the 1848 publication of a series of articles on the subject by Charles Remusat. Like depictions of Paolo and Francesca, most returned to the theme of the reading couple. An 1839 drawing of the subject by Jean Gigoux, entitled *Ardeurs insensées,* is representative of the theme's treatment in this period. The image pictures the innocent and beatific Héloïse being seduced first by the words and then by the ardor of Abélard. Gigoux places Héloïse at center, seated with closed eyes and hands crossed modestly in her lap as Abélard hovers above, covering her face with kisses and caressing her breast. Again the concept of abandon is encoded in the book they had shared before dropping it to the floor.

The identification of Héloïse with wifely duty and societal redemption increases in proportion to the decreasing concern for recovering her words and ideas. The details of her life and the legacy of her writings are put aside during the nineteenth century, during the age of history. She is one of a dozen women of ideas whose narrative is recovered and transmuted in order to reaffirm the "historical accuracy" of a larger psychosexual narra-

tive. Héloïse's biography—like those of Sappho, Charlotte Corday, and Théroigne de Méricourt—is rendered more rather than less ahistorical. Her story and the story of other great women of ideas that preoccupied the French in this era were increasingly interchangeable, and this interchangeability is suggested everywhere in the language of the period. Théophile Thoré, for instance, introduces his discussion of Delacroix's painting of *Madeleine* in 1845 with this image: "Prenons le sujet de la Madeleine, cette Cléopâtre qui se convertit en Héloïse."[52] Similarly, Théophile Gautier's ninety-page guide to Paul Chenevard's encyclopedic program for the Panthéon calls attention to the inclusion of "Héloïse, cette Sapho chrétienne."[53]

The process of constructing reductive fictions out of complex lives is fundamental to Jules Michelet's lengthy discussion of Héloïse in his *Histoire de France* (1833), wherein she is used alternately as a trope for the evils of Jesuit education and for "la grande révolution religieuse" of the Middle Ages. Unconcerned with documenting her talent and disseminating her writings, Michelet uses the Héloïse narrative to construct a forerunner for his revision of Christianity. The singlemindedness of his enterprise, which stripped women of real power by idealizing them as the stable hearth of the bourgeois home, the anchor and salvation of modern France, is revealed in his influential reversal of the centuries-old tradition that had cast Héloïse as the victim and redemptrice of the opportunistic Abélard. The woman of ideas, Héloïse, is diminished in *Histoire de France* by Michelet's decision to restore and psychologize Abélard. This effort is reinforced by Guizot, Jules Simon, and Charles Remusat, who join Michelet in the 1830s and 1840s in championing Abélard as a lone voice for humanistic discourse in the mystical abyss of the Middle Ages. They focus on Abélard's persecution by Saint Bernard and other intellectual lessers and decry his removal from teaching responsibilities, a punishment that eerily foretells Michelet's controversies and fate at the Collège de France in the 1840s.[54] When Michelet described Abélard as the son of Pélage and the father of Descartes, Fénelon, and Rousseau, it was undoubtedly all he could do to refrain from adding his own name to the lineage of giants.[55]

The dehistoricization of Héloïse, as the ironic consequence of her promotion to the ranks of femme-messie, requires contextualization within the proliferation of alternative religious philosophies articulated during the 1830s and 1840s, many of which focused on the construction of history as a series of divine revelations bringing us closer to a climactic moment of redemption.[56] Nearly all of the revisionist doctrine—from Saint Simon's "nouveau Christianisme" to Auguste Comte's "religion de l'humanité" to

Pierre Leroux's doctrine of social equality—involved a renegotiation of biblical gender paradigms and a search for a female redemptrice for France's debased culture.[57] Regeneration is at the core of all the philosophical literature on religion in the nineteenth century. Most of this material locates 1789 as either the apocalyptic beginning or ending of an age of religious mission. The preoccupation with the concept of regeneration is evident in the earliest post-Revolution apologias for the church like Vicomte François René de Chateaubriand's *Le Génie du Christianisme* (1802) and Alphonse de Lamartine's *Méditations poètiques et religieuses* (1820). In fact, this preoccupation was almost physicalized during the Restoration within Louis XVIII's ill-fated plans to restore the Eglise de la Madeleine as an expiatry chapel; the design called for the prominent display of a sculpture of the church's patron saint "sous les traits de la France et dans l'attitude du repentir."[58] This concern persisted into the July Monarchy in the writings and sermons of Félicité Robert de Lamennais and Jean Baptiste Henri Lacordaire, Catholic moderates who were trying to combat anticlericalism by renegotiating the chasm that has historically separated religious devotion and democratic ideals.

The choices for a messianic savior to lead the regenerative mission were varied. Catholic moderates were quite content to keep the one they had. Others, like Louis Philippe, Béranger, Balzac and Heine, worshiped the cult of Napoleon. The notion of a female initiatrice was favored by social reformists, who were principally utopian socialists. Though the role of women was integral to most alternative religions proposed in this period, women ultimately were valued as domestic cult objects to be coveted and carefully monitored. This was particularly true for Comte and Michelet, who saw women exclusively as wives and mothers, invaluable to the trinity of work, family, and patrimony that was the guarantor of social harmony. Comte and Michelet were two of the most influential philosophical architects of the bourgeois religion of family that came to dominate western culture in the nineteenth century. They saw marriage as the reconstitution of two inseparable parts (male and female) into a perfect androgynous whole. Those involved in lives or relationships that did not produce or preserve a family structure were considered deviant.

The utopian socialist cult of female messianism that flowered during the July Monarchy was unique in its challenge to the traditional institutions of marriage and family and its veneration of a female type that was neither a wife nor a mother. The mission to locate and empower a redemptrice was connected to the socialist dogma tying women's emancipation to general emancipation. Sickened by the cycles of poverty and unemployment that had accelerated during the industrialization of France, utopian socialists

*Reading Through the Body*

called for a total transformation of society that inspired experiments in communal living, proposals for the eradication of privilege in regard to property and voting rights, and the rehabilitation of women, especially working-class women who came to emblematize the alienated and exploited worker. Among socialists, it was la femme du peuple who was idealized as an initiatrice, though it did not take these heavily recruited ouvrières long to realize that the talk of female empowerment was to remain just that.

The working-class femme messie was championed by Pierre Leroux, Jules Simon, and others. But her most notorious and influential solicitation came from the Saint Simonists, who defined her role in religious rather than political terms. The male Saint Simonist hierarchy rejected the construct of female guilt and sin on which bourgeois Christianity is based and preached the virtues of sexual freedom and experimentation.[59] This revisionist policy was reinforced by a highly publicized declaration of the need for female equality within the Saint Simonist power structure that was concretized in a mission to find la mère, a female counterpart to the group's leader, Prosper Enfantin. The leadership issued pamphlets, like Saint-Amand Bazard's *Aux femmes sur la mission religieuse dans la crise actuelle* (1831), calling for the restoration of "un couple SUPREME, symbole vivant de l'amour" to lend credibility to the mission.[60] Even an autonomous separatist venture launched by the prolétaires Saint-Simoniennes embraced this notion of engaging in an *oeuvre de régénération* that would guarantee "plus de guerre, plus d'antipathie, amour pour tous."[61]

An even more provocative community devoted to the concept of a female prophetess were the Evadamistes, a socialist fringe cult that worshiped an androgynous figure called Le Mapah. Unlike the Saint Simonists, they did not bother with the theoretical empowerment of an actual woman. Le Mapah simply dressed as and declared himself a sublime recoupling of the unnaturally divided male and female self.[62] Most significantly, the Evadamistes contributed substantially to the revision of Catholic gender paradigms. They advocated the worship of Mary over Jesus, but a Mary whose identity had converged with that of Mary Magdalene. The reunification of spirit and flesh in the figure of a Magdalene, often referred to as "une nouvelle Eve," was an idea that permeated the art and art criticism of the July Monarchy: "Loin d'être un instrument de péché, les filles d'Eve sont devenues . . . un instrument d'édification . . . qui se metamorphose, comme dans le Saint-Simonisme, en prêtre social, . . . une sorte de missionaire."[63]

The rhetoric of la nouvelle Eve offered a corrective to the dialectic of redemption and debasement. Though the theorized convergence of Mary and Mary Magdalene was intended to challenge the paradigms of female

representation, it ultimately reinforced them but with a more effective disguise. Logically, one of the principal arenas for experimentation was within the iconography of the reading penitent Magdalene, one theological version of la liseuse. This theme signifies the moment when concerns of the mind merge with those of the body. But rather than eliciting new forms to articulate a revisionist position, representations of the reading Magdalene during the July Monarchy for the most part perpetuate the old normalizing conventions of the female figure. Thus, what should be an icon of vision and contemplation reinforces the essentialist notion of woman as vulgar flesh. Before elaborating on the appropriation of the Magdalene and its conflation with la liseuse as a means of containing the powerful image of woman of ideas as femme-messie, I will contextualize the resurgence of interest in the penitent saint during this period.

The re-redeemed Mary Magdelene was an important figure for philosophers of religion and history whose writings dominated the 1830s and 1840s. She came to be identified with a host of historical precursors and descendants like Sappho and Héloïse, whose sins were regarded not as liabilities but as prerequisites to initiation. Defined in relation to the penitent saint, these figures were assigned a place within the genealogy of secular incarnations of an apostolic ideal believed to appear at intervals throughout the course of history.

Mary Magdalene satisfied the needs of several different ideologies in the search for an emblem of regeneration. For traditionalists attempting to revalidate the ancien régime, Mary Magdalene was a purgative symbol of France's disloyalty to patriarchal authority in 1789.[64] To liberal neo-Catholics interested in reviving the ethical structure of religion without reempowering its corrupt institutions, Mary Magdalene's narrative underscored the church's historical betrayal of Christ's message of charity and fraternity. But as I have indicated, her strongest following was among socialist reformers who saw the prostitute turned saint as the ideal reminder of the social patterns of exploitation and inequity that they sought to dismantle. Her veneration offered a conceptual model for the reversal of power hierarchies, allowing the disenfranchised to assume the leadership of the movement toward social regeneration.

The figure of Mary Magdalene was adaptable to a variety of roles, in part because her biography remained so sketchy. Years of debate still have not resolved the question of whether the prostitute who anointed Christ's feet is the same woman to whom he appeared after the Resurrection. Nor do we know if either (or both) of these women can be identified with Mary, the sister of Lazarus and Martha. Moreover, like Héloïse and other histori-

cal and mythical *femmes fortes*, Mary Magdalene's legend was stretched and twisted to suit the needs of the "his-story" tellers. The elasticity of her narrative only enhanced her utility as myth material.

Many of the writings devoted to the recovery and reformulation of religion identified the visual arts as a crucial means of disseminating the new word. Emile Broussais' *Régénération du monde* (1842), Charles Louandre's series of articles titled "Du mouvement Catholique en France depuis 1830" (1844), and Emile Montegut's *De la Maladie morale du dix-neuvième siècle* (1848), are just three of dozens of pleas issued during the July Monarchy to restore or reinvent the moral and ethical structures associated with religion. In most, the process is reliant on and identified with a mission to restore substance and purpose to the visual arts. The power of this sentiment is most easily demonstrated numerically. In 1833 only twenty religious paintings were shown at the Salon. By 1838 there were eighty-six; in 1842 the number had grown to one hundred sixty-one.[65] The mid-century renaissance of religious art and the elaborate government system of patronage that sustained it has only begun to receive the study it warrants. Bruno Foucart and Michael Paul Driskell are among the few art historians who have distanced themselves far enough from the narrative of modernism to address the quantity and influence of religious art.[66]

The explosion of religious painting in the 1830s and 1840s responded to a variety of impulses. Of principal importance was the renewal of the Catholic Church and the outpouring of writings that theorized Christian art. François Rio and Comte de Montalembert were key figures in the reassessment of the Catholic pictorial tradition in this period and the promotion of the early Renaissance primitives as the model for modern religious painting. But in addition to the theoretical structure provided by the Catholic orthodoxy (which in fact produced relatively few artist/priest practitioners), there was a large and eclectic body of religious works reacting to romantic, socialist, humanitarian, and Protestant impulses as well. All of this activity was further stimulated by an elaborate campaign of church renovation and redecoration sponsored by the government in the 1830s and 1840s. Within the flowering of modern religious painting, there was one theme in particular that is of principal concern to this study. It is the cult of Mary Magdalene—"symbole vivante de l'amante éprouvée dans nos sociétés mauvaises"[67]—that provides the greatest insight into how the experience of the reading and writing woman inflected and was itself inflected by the conventions of high culture.

Mary Magdalene was actively promoted in this period as an ideal subject for the artist.[68] Some of this interest was stimulated in the 1840s

by a well-attended series of lectures by the Dominican monk Jean-Baptiste-Henri Lacordaire at Notre Dame de Paris. His sermons prompted particular interest in the saint's legendary mission in Provence, where she purportedly spent the last thirty years of her life in isolation. In fact, Mary Magdalene's meditation and prayer in the woods of Saint-Baume was the subject chosen most often for treatments of this theme after 1845.[69]

Between 1801 and 1827 the appearance of works treating the subject of Mary Magdalene at the Salon was irregular. In 1806 and 1812 one work was hung; in 1808, 1814, 1819, and 1822 there were two, and in other years none at all (1810, 1817). The most ever exhibited was three, in 1824 and 1827. But between 1831 and 1848, one hundred ten paintings of Mary Magdalene were hung at the Salon, a figure that does not begin to suggest the number actually generated in these years. The majority appeared in the 1840s: eight in 1840 and 1841; eleven in 1842 and 1844; and fourteen in 1848.

But the cult appeal of Mary Magdalene as a subject for the artist predates the July Monarchy. In 1827, for instance, Delphine de Girardin wrote a fifty-six-page poem about the saint from which she read selections at several salons in Paris. A major study of women poets published in the *Revue des deux mondes* in 1842 described that work as Girardin's only worthwhile endeavor, not because of any value inherent to the poem but because the subject elevated even the most turgid writing. "Quel magnifique sujet à traiter pour un véritable artiste, que la vie de la pécheresse de Judée! . . . L'amour antique et l'amour chrétien se réunissent en elle."[70] The popularity of Mary Magdalene among artists and critics was frequently explained as this marriage of sensual and spiritual beauty, Venus and Mary all in one. An early-nineteenth-century exemplum of this convergence that stimulated several generations of responses was Antonio Canova's *Penitent Magdalene* (1794–96; fig. 70).

Canova's marble, commissioned by a prelate but ultimately possessed by the Italian collector Sommariva, was shown in the Paris Salon of 1808.[71] Proclaimed by Stendhal the greatest work of modern times, Canova's *Magdalene* was widely admired and imitated. Half-kneeling, half-prostrate, the saint assumes an attitude of humility and contemplation. Her shoulders slump, her head droops, and her eyes are fixed on the cross that she balances across her thighs. The posture and iconography (a skull resting beside her) indicate that she is reconciled to heaven. But her corporeality and sensuous display of flesh suggest another agenda. The youth and sexuality of Mary Magdalene, who is theoretically in the midst of a thirty-year period of solitary penance and deprivation, ignored the liturgical tradition but guaranteed Canova a large and enthusiastic audience. Canova's reliance on

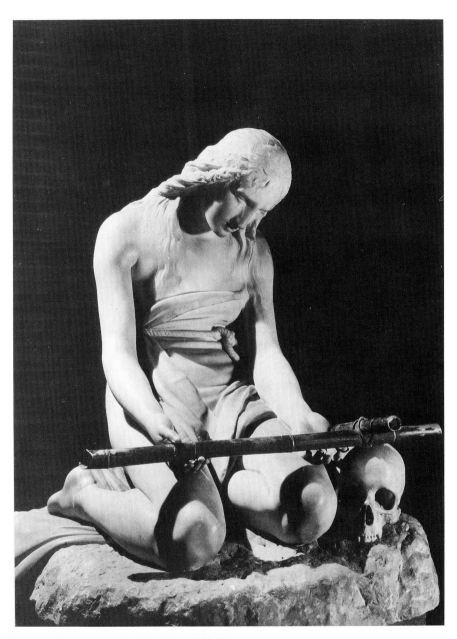

70. Antonio Canova. *Penitent Magdalene*. 1794–96.

that winning duality of eroticism and piety was underscored by the altar, which his patron, Sommariva, had built to house it, that Francis Haskell describes as "half chapel, half boudoir."[72]

The influence of this sculpture persisted into the July Monarchy: the figure of Mary Magdalene on the pediment of the newly restored Eglise de la Madeleine, for example, was modeled after Canova's. Many paintings and sculptures of typologically related figures quoted Canova as well.[73] The object's cult status is described often in memoirs and letters of the period. In her *Lettres Parisiennes* (1844), for example, Delphine de Girardin (using her journalistic pseudonym le Vicomte de Launay) documented the current craze for the object: "Ce jour-là, l'objet merveilleux qu'on allait admirer par caravanes était la Madeleine de Canova. Et l'on n'entendait que ces mots: 'Avez-vous vu la Madeleine de Canova?—Je viens de voir la Madeleine de Canova.'"[74]

The context in which she documents the mania for Canova's marble is a piece of living theater comparable to what visits to Sommariva's original installation for the Madeleine must have been like. Girardin writes of Carnival season in February 1844, specifically about the year's most celebrated fête at the home of Madame la duchesse de Galliera, who, we are told, arranged wonderful music and conversation and a superb sampling of high fashion. But what truly distinguished the duchess' party, Girardin reports, was her handling of the ritual pilgrimage: "ce moyen ingénieux de désen-combrement subit" this ceremonial "voyage de curiosité fait à travers les vastes salons et les galeries en fleurs pour aller admirer un objet d'art merveilleux."[75] This rite apparently required that the art object be kept in a secluded part of the house for a long period of time in preparation for this moment of "rebirth," which symbolically reenacted the religious narrative of regeneration anticipated by the Carnival season. Carnival, of course, is the period of revelry in late February that ends with Lent, forty days of fasting and penitence observed between Ash Wednesday and Easter, the celebration of Christ's resurrection. What more appropriate art object to unearth than a copy of Canova's *Magdalene,* the subject of which is represented during her own ordeal of fasting and penitence and who, according to the liturgy, was the first person to whom the Risen Christ appeared. And what more resonant environment in which to display the Madeleine than in the home of a woman "séduisante et spirituelle" (the very same combination used to describe the penitent saint) who is surrounded by illustrious personages from around the world swooning to the chords of Rossini and, like the sinning Mary Magdalene, "parées de velours et de satin, de perles et de diamants."[76]

Reproduction and marketing of Canova's *Magdalene* during the July Monarchy was not restricted to private ritual; it had its place in the public domain as well. The work was frequently invoked in philosophical writings about art and social reform to concretize an abstract principle. Fourierist art critic Gabriel-Désiré Laverdant, for example, relies on the Canova *Penitent Magdalene* to illustrate the doctrine of mystical love he endorses as the guiding force of modern France: "Continuez donc, artistes. . . . Prenez surtout la Madeleine pour enseigner le respect de la femme et la vraie loi de l'amour. . . . Madeleine, la servante de l'homme sensuel, déserve pure amante de Dieu."[77]

The confluence of two traditions, Mary Magdalene's identification with pleasures of the flesh and the Virgin's with spiritual purity (like Sommariva's marriage of boudoir and altar) continued to inform discussions of the saint in the 1830s and 1840s. It is most prominent, however, in the writing of utopian socialist theorists. Within Laverdant's rhetoric, for example, the dichotomy is posed in almost sociological terms: "Marie,—c'est l'image mélancolique de la mère laborieuse, dévouée, inquiète. . . . Madeleine, . . . la martyre des passions brutales."[78] Saint Simonist Alphonse Esquiros returns to this duality to argue for greater sexual freedom for women and to challenge the equation of physical pleasure with sin. His essay "La Beauté de la femme selon le Christianisme" (1846) identifies Mary Magdalene with Venus in order to propose a new ideal that blends pagan with Christian sensibilities: "La figure de la femme qui crut en Jésus-Christ" combines "la beauté invisible" of Mary with "la beauté visible" of Venus. For Esquiros, this female ideal functions as a prophetess of a new world order: "Elle servira de même à réhabiliter le sexe dans toutes ses manifestations."[79]

The July Monarchy cult of Mary Magdalene was undoubtedly encouraged by the decade-long renovation and decoration of the Eglise de la Madeleine, the project with which Louis-Philippe inaugurated his campaign of church restoration in Paris. Just as figurations of the saint were routinely manipulated to satisfy the propagandizing needs of a variety of ideologies, so her church served an array of political interests as well. Plans for the new church of the Madeleine date to the mid-eighteenth-century reign of Louis XV. Though the first stone was laid in 1763, the church was not completed until March 1842. Construction was interrupted alternately by money problems and changes in administration that inevitably meant redefinitions of the project. Napoleon reconceived the church as a temple to the glory of his French armies. Louis XVIII envisioned it as an expiatory church dedicated to the memory of Louis XVI and Marie-Antoinette. Not

until the reign of Louis-Philippe was the project completed, perhaps because he did not tamper with the most recent conception of the building. Though he briefly considered consecrating the church to the victims of *Les Trois glorieuses*, the three-day revolution that brought him to power, he must have recognized that further expenditures by and humiliation of the deposed royalists were not in his best interest.

Although the government-sponsored decorative campaign for the Eglise de la Madeleine must take at least partial credit for the vast increase in the number of painted and sculpted representations of Mary Magdalene during the July Monarchy, ironically the project itself is remarkable for its deemphasis on the life of the patron saint. Louis-Philippe preserved the Restoration plan that called for a cycle of six paintings in the hemicycles representing the life of Mary Magdalene. The paintings were to climax in a large mural for the apse depicting the apotheosis of the saint. But by the time the project was completed, the figure whose genealogy and glorification had been most strongly secured was Louis-Philippe, not Mary Magdalene.[80] The commissions for the six smaller murals were ultimately split among six artists, dissipating any coherence the cycle might have had. And, in the apse, the apotheosis of the saint was replaced by Jules-Claude Ziegler's *Histoire et glorification du Christianisme*. Michael Driskell's description of Ziegler's painting as an ideological advertisement for the July Monarchy is a convincing one. The artist's encyclopedic assemblage of the glorious lineage and triumph of Christian thought—as evidence of Louis-Philippe's beneficence, intellect, and heritage—does, as Driskell asserts, affirm the legitimacy of the constitutional monarch's claims to the throne.

What this program does not do, as contemporary observers noted, is deal thoughtfully with the iconography of Mary Magdalene. Ziegler's idiosyncratic vision, which downplays the significance of the figure whom the project was to honor, formed the subject of a two-part essay on the church decoration published in *L'Artiste* in 1841: "N'eut-il pas été plus raisonable en effet que la peinture la plus importante de l'église de la Madeleine rappelât plus directement la Sainte sous l'invocation de laquelle ce monument sera consacré? . . . La figure de la Madeleine . . . est précisement la plus molle et la plus insignifiante."[81]

Mary Magdalene's place and role in Ziegler's pantheon of Christian greats is minimal. But then women played a relatively small role in the rhetoric and iconography of July Monarchy propaganda. A constitutional monarch whose critics dubbed him Lolo Phiphi was likelier to appropriate the masculinist legend of Napoleon (who is at least as prominent in the

*Reading Through the Body*

mural as Mary Magdalene) to justify his claim to the throne than the legend of a female messiah. Nor would one in power who claimed to have rejuvenated the precepts of 1789 choose to identify his reign with the concepts of remorse and redemption. That was the province of the opposition: legitimists who regarded the Revolution as a moment of shame and leftist republicans who saw its aftermath as the true embarrassment.

For Louis-Philippe's critics, the legend of Mary Magdalene provided several narratives useful in spotlighting the spiritual and ethical bankruptcy of the age, several of which received expression in visual terms. The messianic programs of Enfantin and Leroux, for example, which required not only the location of a femme-initiatrice but her coupling with a divinely inspired male counterpart, had its parallel and, in a sense, its origins in orthodox Christianity. The model for Enfantin's couple suprême, whose transcendent love was to redeem France, was the *amour mystique* between Jesus and Mary Magdalene. This subject was particularly popular among neo-Catholics in the 1830s and 1840s. Mme de Hérain's *Jésus apparaît à la Madeleine* (1835; fig. 71), for example, generated a great deal of commentary. It was engraved and reproduced in several journals, including the *Journal des artistes* and the *Journal des femmes*.[82]

Hérain's work features a blond and beatific Mary Magdalene kneeling at the feet of the risen Christ, whose halo and still animate cloak retain the magical afterglow of his resurrection. The two look directly and lovingly into each other's eyes and gesture uninhibitedly in each other's direction. An article that accompanies the engraved copy published in the *Journal des femmes*, "Madeleine. Nouvelle légende," elucidates the religion of love implicit in Hérain's painting: "Cet amour mystique lui fit pour ainsi dire une autre âme, une autre vie; . . . Amante du Christ . . . elle avait compris l'amour pur, l'amour des anges, le seul qui ne finit pas."[83]

This act of profound trust—when Jesus appears to Mary Magdalene and charges her with her apostolic mission—was also significant for feminist socialists like Alphonse Esquiros, who identified it as a liturgical foretelling of the duties of the modern femme-messie: "En chargeant Madeleine d'annoncer sa résurrection aux disciples Jésus commence dans la personne de cette pécheresse la mission et le grand apostolat de la femme, qui sera d'annoncer au monde la résurrection de l'humanité."[84] The perception of this encounter as the ideal expression of l'amour mystique informs the work of Esquiros' close friend Théophile Gautier as well. In Gautier's poem "Magdalena" (1832–38) a narrator recalls a visit to an old provincial church where he was inexplicably drawn to a painting of Mary Magdalene kneeling at Christ's feet. The painting was most remark-

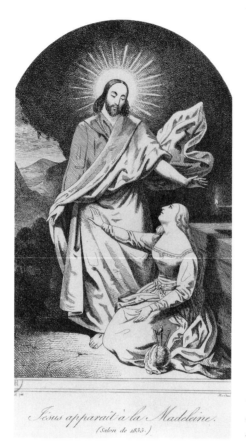

71. Engraving after Mme de Hérain. *Jésus apparaît à la Madeleine.* 1835.

able for what appeared to be its internal illumination, which the poem attributes to the nature of its subject, sublime love.[85]

A second approach favored by the Catholic orthodoxy in the 1840s was the painting of parables, especially parables of Christian charity. One of its major practitioners, Jean-Baptiste Besson (otherwise known as Père Hyacinthe), was a disciple of Philippe Buchez and Lacordaire. Like Fra Angelico, Besson was a Dominican monk and painter whose work mediated between his aesthetic and religious convictions. His treatments of the subject, for the most part, rehearse the narrative of Christ's compassion and remind us that salvation is an option for all sinners.[86]

Mary Magdalenes like Besson's were perceived by reformers as the ultimate victims of a corrupt capitalist society. Because misery and suffering was considered the prerequisite of regeneration, these Magdalenes

*Reading Through the Body*

were given the dubious honor by Alphonse Esquiros, Pierre Leroux, and others of leading the progress of humanity. Their condition, likened to Christ's Passion, was the guarantor of future glory. As Alphonse Esquiros writes, her heart "quoique souillée, contient encore quelques gouttes de cette liqueur précieuse et inestimable de l'amour que Marie-Madeleine versa sur les pieds de Jésus comme un vase de parfum."[87] Esquiros and Besson sought rhetoric and imagery that would engender our compassion as it did Jesus's. "Il n'y a jamais eu d'autre révélateur que Jésus Christ, fils de Dieu," wrote Besson in 1837, "et sa dernière révélation, c'est la morale de charité."[88]

Didactic visual and literary imagery imploring the revitalization of the Christian precepts of charity appeared with greater frequency in the 1840s as the cause of both legitimists and republicans.[89] Among the most famous and well-received illustrations of religious principle are Emile Signol's *Jesus Christ and the Woman Taken into Adultery* (1840; fig. 72) and its pendant *Jesus Christ Pardoning the Adulterous Woman* (1842; fig. 73), which visualize a parable from St. John the Evangelist. Signol's archaizing style, like Besson's and Hérain's, was ideally suited to didactic, theological subject matter. In the work of all three artists, a shallow friezelike space provides a backdrop for the psychological and spiritual drama that is center stage. Signol, much like Besson, juxtaposes a slumped and crying Mary Magdalene with an upright pillar, but his architectural symbol of strength merely reiterates the noble verticality of the real thing, Jesus Christ. In *Jesus Christ and the Woman Taken in Adultery,* Christ points toward the Mary Magdalene figure in a gesture meant to signify the dictum carved beneath his feet: "Let he who is free of sin cast the first stone." In Signol's sequel image, the Savior is shown pardoning the fallen woman, as we are meant to do, and gently helping her to her feet.[90]

Though painted interpretations of transcendent love and the virtues of forgiveness remained popular throughout the July Monarchy, the favorite Mary Magdalene iconography was that of the penitent saint bewailing her sins or being reconciled to heaven in the rocky landscape of Saint-Baume. In the former she is shown either prostrate on the ground or kneeling at the entrance to a cave with hands clasped. In the latter, her arms are extended upward, she is meditating, or she is reading a book.

These last two themes are particularly relevant to my discussion of la liseuse and painted manifestations of the woman of ideas. Both offer models of interiority capable of challenging the trope of woman as flesh. They revitalize conventions critical to the iconographical refashioning of woman as thinker. The attributes of the meditative and reading Mary Mag-

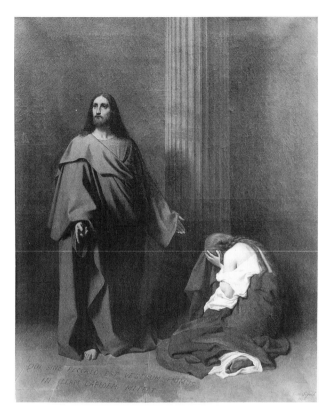

72. Emile Signol. *Jesus Christ and the Woman Taken in Adultery.* 1842.

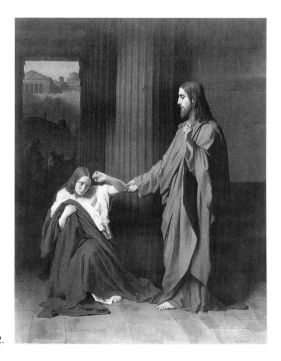

73. Emile Signol. *Jesus Christ Pardoning the Adulterous Woman.* 1842.

dalene, formalized in the seventeenth century, include some combination of a skull, book, candle, and crucifix.[91] The iconography and the emphasis on contemplation of mortality strongly identifies her with figurations of melancholy and vanitas.

Melancholia, which often is figured as a female deep in thought, derives from Florentine neo-Platonism. It personifies knowledge capable of action only after divine intercession. Its correlation with the penitent Mary Magdalene contemplating the inspirational model of Christ is obvious. The most famous and influential early-nineteenth-century treatments of the saint that underscore her connection with the melancholic's invocation of divine inspiration is Canova's *Penitent Magdalene* (see fig. 70), in which the saint stares down at the crucifix that is a reminder of death and a symbol of redemption.

A second reading of melancholia that was of principal importance in the 1830s and 1840s involves its identification with the artistic temperament. According to sixteenth-century astrological writings, the creative mind was born under Saturn and, therefore, wavered precariously between madness and genius. Many artists' self-portraits are modeled after figurations of the melancholic struggling with the process of transmuting Pure Idea into a mundane but visible form. The convergence of the themes of melancholia and Mary Magdalene are discussed at length at the end of this chapter.

The figure of Mary Magdelene reading, another emblem of interiority, was also revived in the early nineteenth century. Its relevance to discussions of women's education made it an obvious visual analogue to the iconography of la liseuse. It is specifically in the iconography of la liseuse outdoors that her image intersects with that of Mary Magdalene. The image of the reclining reading woman often appeared anecdotally in landscape painting of the 1830s through the 1850s. As a modern and fashionable incarnation of the wood nymph, la liseuse functioned as a trope for the sexual appeal of *natura naturans*.[92] The nineteenth-century intellectual campaign to sell the idea of natura naturans principally to a male bourgeois audience began during the July Monarchy. It promoted the utopian concept of periodic retreats from the public spaces of the city into the feminized and spiritually rejuvenating arena of the countryside. This reinvention and packaging of natural nature, which is discussed at length by Nicholas Green in *The Spectacle of Nature,* was marketed in sources ranging from landscape painting to travel literature and medical theory. Though the encouragement to replenish oneself by engaging in ritual communions with nature was directed at a male bourgeois clientele, women played a part in both realms, metropolitan and rural. But that role, no

matter how varied, was one of receptacle or vessel. They were either the objects of sexual fantasy, the guardians of a sanctified and domesticated space of renewal, or fleshly metaphors for the reassuring cycles and eternal rhythms of nature. The iconography of the "undiscovered" woman reading in a poetic landscape setting satisfied all of these categories. At the same time, it infused a contemporary image of *une liseuse* in an often identifiable rural setting with the connotations of timeless truths.

Gustave Courbet's *La Liseuse d'Ornans* (1868–72; fig. 74) offers an erotic *sous bois* encounter with a modern woman in nature. He telescopes and frames our view of la liseuse, who is seated in a secluded but nonetheless public wooded area that affords her at once the privacy to enjoy her novel and enough risk of discovery to further arouse her, a risk italicized by the picture's indulgence of male voyeuristic fantasy. Like Wiertz, Courbet has us watch the undiscovered liseuse during her symbolic masturbatory rite, her use of the novel to arouse herself. The arousal is suggested by the playful manner in which she fingers her loose hair and by her slipped chemisette nestled loosely around her right breast.

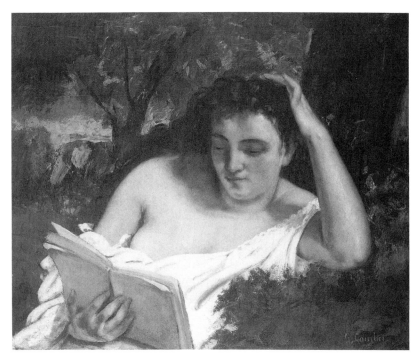

74. Gustave Courbet. *La Liseuse d'Ornans.* 1868–72.

*Reading Through the Body*

The sexualized content more commonly was retained but downplayed in favor of more decorous themes: the contemplative retreat into the nurturing countryside or the image of the penitent reading Magdalene in the wilderness of Saint-Baume—or some combination of the two. One of the earliest and best-known treatments of a reading penitent was attributed in the nineteenth century to Correggio (fig. 75).[93] A blond Mary Magdalene reclines sensually in a grotto with one bent arm supporting her head and the other cradling the text. Her upper body and feet are bare, and she is completely absorbed by her reading. Correggio's work, like Canova's, was admired and imitated by many generations of artists and critics. In his Salons of 1763 and 1767, for instance, Diderot raved about the painting's successful blend of religiosity and sensuality. In the nineteenth century, modern versions of the penitent Mary Magdalene were often compared—favorably or not—with the Correggio, which was frequently reproduced. In 1841, for example, it appeared in the *Journal des artistes*, where it was perhaps seen by Narcisse Diaz de la Peña and appropriated as his model for *La Lecture du roman* (see fig. 60).[94] There is no textual evidence to prove that Diaz was looking at Correggio's painting when working on *La Lecture du roman*, but the formal parallels and the iconographical relations between the works suggest that he was.[95] Both are painted sous bois, a hallmark of Barbizon painting that produces a mysterious and evocative effect as well as a rich play of light and shadow. Both Diaz's and Correggio's subjects recline on the ground and are propped up on their elbows, engrossed in a text. They also share certain facial characteristics, principally the lowered eyes and closed rosebud mouth. In fact, Diaz spent a lot of time studying originals and reproductions of Correggio, to whom he was drawn, he said, "like a moth to the flame."[96] Given the availability of the image in reproductions, the formal similarities between the works, and his well-established admiration for the artist, it is difficult to believe that Diaz's transmutation of une Madeleine into une liseuse was not done self-consciously.

A similar conflation of la liseuse with a Correggio-like Mary Magdalene occurs in the work of Corot. Corot used the theme of the reading woman in a poetic landscape setting fairly often in his career. One finds this, for example, in his *Forest of Fountainbleau* (c. 1830; fig. 76), in which a reclining liseuse in the left foreground—whose posture and sensuality strongly resemble that of Diaz's reader—functions as a conduit or intercessor through which we gain access to the pleasures of the landscape behind and before her.

Among Corot's more than seven treatments of this theme is one that directly conflates la liseuse with the penitent saint: *La Madeleine lisant*

75. Engraving after painting attributed to Correggio. *La Madeleine au désert.* 1841.

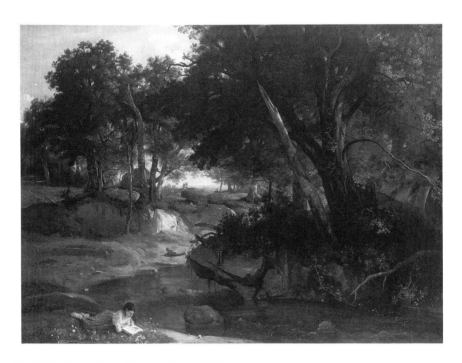

76. J. B. C. Corot. *Forest of Fountainbleau.* c. 1830.

(c. 1854; fig. 77), which is chronologically and compositionally related to Courbet's *La Liseuse d'Ornans.* Though the figure is also seated outdoors, the composition, unlike that in Corot's *Forest of Fountainbleau,* is focused entirely on the body of the reading woman. The young woman sits upright with her legs extended, framed by a landscape environment. Her left arm cradles a book and her right arm rests outstretched on her legs before her. Her head is bent forward, and she is completely involved with her text. Her body forms a right triangle in the foreground: her extended legs and right arm forming its longest side and leading our eye along its strong diagonal to the focal point of the composition—the brightly lit square of Madeleine's completely nude upper torso, which is neatly framed for presentation by her shadowed face and neck, her upper arms, and the open book perched just beneath her breasts.

Corot's *Madeleine lisant* is related to a second conventional presentation of the reading penitent that was revitalized during the July Monarchy. The presentation pictures the saint seated on a rock, often in front of a cave. Several iconographical models for this type were accessible to artists in this period, the most well-known of which was a second version of Correggio's *Magdalene* (fig. 78) that was in the collections of the Louvre during the July Monarchy.[97] Camille Roqueplan's *Ste. Madeleine* (1837; fig. 79) derives from the Correggio. Like Diaz and Corot, Roqueplan conflates his treat-

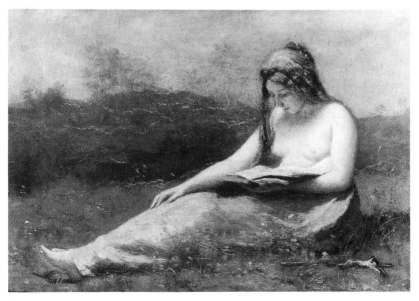

77. J. B. C. Corot. *La Madeleine lisant.* 1854.

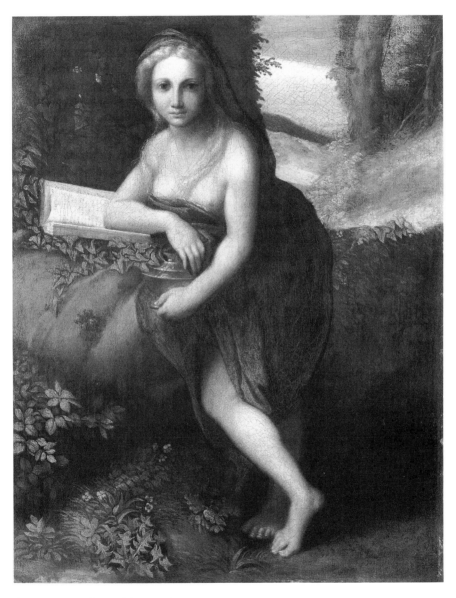

78. Correggio. *The Magdalene.* c. 1515.

ment with the tradition of la liseuse. He genericizes the figure, making it difficult to identify it as a religious subject without the title. And, like Correggio, he places the saint on a stump in a shadowed wood with her text and bare upper chest illuminated. And finally, like contemporary representations of la liseuse, Roqueplan's Madeleine looks down and reads the book before her.

The picture's hybrid nature did not go unnoticed. Théophile Thoré commented in his salon review that Roqueplan's "La Madeleine dans le désert est une coquette raffinée. Il n'y a là, comme vous pensez bien, ni Madeleine, ni désert; mais prenez la Madeleine pour une belle fille et le désert pour une belle campagne" [La Madeleine dans le désert is a sophisticated and appearance-conscious woman. As you realize, neither Madeleine nor the desert exist; but take Madeleine for a young girl and the desert for a beautiful countryside].[98] Thoré's criticism is a common one in commentaries concerning representations of Mary Magdalene in this period. Many critics noted the increasing frequency with which treatments of the penitent saint were being generalized and secularized into scenes of coquettes reading. One explanation for this trend is suggested by an earlier, seemingly unrelated passage in Thoré's review that identifies Roqueplan as one of several bourgeois artists who succeed by lowering their standards for their clientele. In fact, discussions of the decline of *la grande peinture* and of art generally were often incorporated as prefatory remarks to Salon reviews. For many, the review was an opportunity either to bemoan the fall of the old social order, whose members were the patrons of great art, or to advise on accommodations in size and subject matter appropriate to the new tastemakers, the members of the middle class.[99] The blending of la liseuse and la Madeleine represents precisely the kind of accommodation recommended by Théophile Gautier in his "Salon de 1833" essay. Removed from the heroic and erudite tradition of la grande peinture, this particular confusion of artistic genres would have been compelling to the growing upper-middle-class clientele, the class most closely associated with the phenomenon of the bluestocking and the group for whom the debate over female involvement in the literary industry was most resonant.[100] Roqueplan's *La Madeleine dans le désert,* like Auguste Toulmouche's *Young Girl With a Book* (see fig. 63), satisfied the desire for works that were at once topical and historicizing, erotic and erudite.

Théophile Gechter's *La Madeleine au désert* (1844; fig. 80) is a sculptural manifestation of the same phenomenon. It, too, borrows its pedigree from Correggio's seated and reading Mary Magdalenes. But even more than Roqueplan, Gechter superimposes the saint with the persona of la liseuse déshabillée. The marble Mary Magdalene has shed even the most

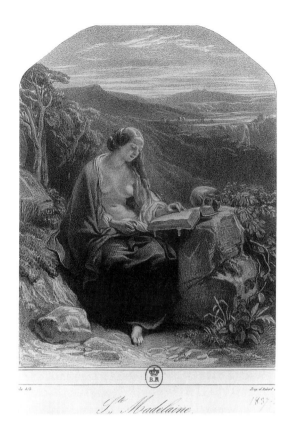

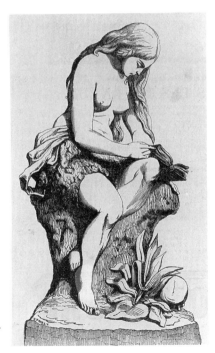

79. Lithograph after Camille Roqueplan. *Ste. Madeleine*. 1837.

80. Engraving after T. Gechter. *La Madeleine au désert*. 1844.

subtle efforts at modesty and decorum. While Roqueplan's painted figure is bare-breasted, the rest of her body is concealed by a more than ample cloak; though some of her hair hangs loose, most is pulled back and pinned up to reveal a still innocent face. Gechter's Madeleine, on the other hand, is more naked than not. Only her hips and groin are covered by a piece of drapery. Furthermore, her long hair is completely untended, and she slouches, riveted to her book, more like Emma Bovary than the penitent saint. Finally, the medium of the work requires the almost complete absence of an iconographically specific background, the grotto in Saint-Baume. Though she sits on a craggy rock, which has a shrub and a skull at its base, the principal focus is the figure whose compositional isolation and three-dimensionality only heighten her sexuality and overzealous involvement with her book.

The pictorial interplay between conventions of la Madeleine and the reading woman has literary parallels. As this chapter demonstrates, la Madeleine has always been an elastic construct responsive to the needs of a variety of ideologies and agendas. During the July Monarchy the term *Madeleine* was referentially expanded to encompass all manifestations of female deviance. In addition to its association with the biblical saint, it was an idiom for the actress and prostitute. Her typological fluidity generated a rich variety of story lines that—given the large number of novels and plays titled "La Madeleine"—obviously appealed to July Monarchy audiences. Didactic and formulaic tales of fallen women were particularly prevalent in popular theater. Within this genre, a common explanation for Madeleine's fall was her exposure to bad books.

Anicet and Bourgeois's play *Madeleine,* which premiered on 7 January 1843 at the Théâtre de l'ambigue-comique, is the story of a young peasant girl whose mother died in childbirth. Without maternal guidance, the girl turned in her childhood to books that enflamed her passions. As a consequence, she ends up, like the personification of evil in Victor Orsel's *Le Bien et le mal,* pregnant, unmarried, and nearly driven to suicide. This scenario is echoed in *Marie-Madeleine,* one of many popular novels with that title published in the 1840s. When her dead fiancé's brother asks how she ended up destitute and desperate, Madeleine confides that after her mother (too) died in childbirth, "My father brought me books he himself had never read. I read at hazard. No one directed my choice. . . . I grew up there educated by the poets and by solitude."[101]

The convergence of the traditions of la liseuse and la Madeleine during this period of increasing female literacy and participation in the community of words and ideas was, in many ways, quite logical. What bears

examination are the ironies and contradictions encoded in this process. For la liseuse moderne, reading is the catalyst of her fall; for Mary Magdalene, it is the agency of salvation. What is the effect then of merging two traditions whose signs are the same but whose significances are different? One historical effect was to undermine whatever positive efforts were being made by social reformers and romantic philosophers to complicate the dichotomy of virgin and whore, Mary and Mary Magdalene, that has for centuries defined womanhood. Another effect was the reinscription of that gendered opposition within the deep structure of French culture.

The increasingly common image of a woman reading in the nineteenth century—reclining or seated, with shoulders and breasts exposed—stirred immediate associations with the reading Mary Magdalene. The female act of reading, of partaking in the community of ideas, was thus forever linked with sin and contrition. The demand for modern interpretations of the saint's penance during the July Monarchy did not inspire a demand for new forms. In general, artists turned, as they always had, to their pictorial inheritance.

The example of Correggio seems to have been favored for its responsiveness to contemporary anxieties over the dangerous union of woman and idea. But the conceptual affinities between Correggio's vision of the reading Mary Magdalene and the nineteenth-century construct of the reading woman are, in part, a function of the Italian artist's indifference to the qualities of contemplation, personal sacrifice, and enlightenment that constitute the essence of the saint's legend.[102] Correggio's painting and its imitators operate as agents of normalization that divorce Mary Magdalene from her ethical and intellectual identity. Mary Magdalene's hermitage is reduced to a decorous premise for painting a female nude, a fact evidenced by the evolution of the theme after the Revolution of 1848, after feminists had been muzzled and their issues buried. In the 1860s and 1870s, when the major voice of liberal republicanism belonged to the virulently misogynist P. J. Proudhon, Mary Magdalene lost all association with the life of the mind. Works like Paul Baudry's *La Madeleine pénitente* (1858) and Jules Lefebvre's *Marie-Madeleine dans la grotte* (1876; fig. 81) discard the book and anything else suggestive of interior processes as they surrender to the apparently irresistible impulse to make the saint indistinguishable from Venus or any other nude in the woods.

Like Héloïse—and, as we will see in Chapter 5, like Sappho—Mary Magdalene was increasingly dehistoricized and disengaged from the morally significant aspects of her legend. Ironically, she became the quintessential example of the dangers of mixing women and books. The fact that her

81. Jules Lefebvre. *Marie-Madeleine dans la grotte.* 1876.

reading is redemptive and enlightening is disguised by a visual culture that
will not acknowledge and therefore cannot see the simultaneous existence
of a female body and a female self. It is this culturally encoded estrange-
ment that makes the identity of the woman of ideas so hard to claim and
locate, particularly in the visual arts.

The few efforts to deconstruct the objectifying conventions of the
female figure were made by women of ideas themselves or by their
staunchest friends and supporters. There were isolated, public gestures
like that of the founder and editor of the *Gazette des femmes*, Marie-
Madeleine Poutret de Mauchamp, who sought to legally add "Madeleine"
to her name in 1838.[103] There were attempts by male feminists to mediate
or explode gender stereotypes by eliciting parallels between the modern
woman of ideas and her biblical prototypes. M. L'Abbé de la Treyche's
*Mystère de la Vierge* (1844), for example, goes so far as to recommend
George Sand, in whom the qualities of Mary and Mary Magdalene are said
to converge, as the inspirational model for modern women: "La femme
s'est régénérée. . . . Au lieu de s'inspirer exclusivement de Sainte Thérèse,
elle s'est inspirée de l'auteur de *Lélia*" [Woman reformed herself. . . . In-
stead of being exclusively inspired by Saint Theresa, she was inspired by the
author of *Lélia*].[104] Most commonly, private meditations by women of ideas
in memoirs and letters explore their connections with the penitent saint.[105]

Pictorial experiments with the themes of la liseuse and la Madeleine that in some way incorporate the concept of the woman of ideas also occur principally in private imagery. A handful of works attempted to revise the syntax of the female body by deploying a fluid discourse that freely linked the traditions of the artist/melancholic, the woman of ideas, and Mary Magdalene. These works responded to the efforts of Christian socialists and utopianists to empower a female messianic figure whose otherness would permit her to transcend *le mal du siècle*. P. J. Proudhon's diatribe against these efforts in *La Pornocratie,* against *l'influence féminine* to which he attributes the failure of the 1848 revolution, offers a direct and abusive rehearsal of the discourse that ties artist-melancholic to penitent saint and woman of ideas.[106]

After wondering, "Where were the men in the provisional government," he reminds us of the sorry substitutes that dismantled the revolutionary cause: "Lamartine, artiste; Crémieux, artiste; A. Marast, artiste; Louis Blanc, artiste. . . . L'élément féminin était ici en majorité" [The feminine element was predominant here]. To expose the corruption of the Republic's fatal reliance on these artistes, these femmes-hommes, Proudhon invokes and transmutes the July Monarchy myth of Mary Magdalene as redemptrice: "Jésus a parlé à la Madeleine; c'était une artiste. La vraie courtisane, au sens antique du mot, était une artiste, une prêtresse même."[107]

Proudhon launches an attack that blurs all distinctions between socialists, artists, women, whores, and Mary Magdalene with the figure who, at one time or another, had been tied to all of these identities: George Sand, who sparked much of the reaction that favored and opposed the kind of radical social reform that argued for the liberation of women. A reading and writing woman who engaged in nontraditional sexual relationships and adopted a masculine name and clothing, Sand was the quintessential Magdalene in both her messianic and whorish incarnations. To those like L'Abbé de la Treyche, Sand's compassion and capacity for love made her an ideal blend of Mary and Mary Magdalene.[108] To others, like Proudhon, she was a sexual and political deviant who reflected and effected the degeneration of France.

Not surprisingly, this liseuse, whose novels and whose life presented the most compelling complication of the virgin-whore dialectic dominated efforts to visualize the multiple identities of the female prophet. Two portraits of the writer attributed to Louis Boulanger, for example, suggest how Sand emblematized the harmonized bisexuality of the modern artist-priest. Louis Boulanger's portrait of George Sand in tondo format (fig. 82) dating

to the late 1830s, consists of a bare-shouldered, disembodied head. Her solemnity and deeply shadowed face combined with the absence of any iconographical detail suggests that it is an image of Melancholy. Though in the Documentation du Louvre it is given the title *George Sand en Madeleine,* the figure's virility and cropped sculptured hair connect it more strongly both with the androgynous ideal of the femme-messie and the hermaphroditic traits of the artist-melancholic.[109]

Studies of a solitary female head intended to personify melancholy were not unusual during the July Monarchy.[110] Interest in this genre, particularly among artists and writers like Boulanger and Sand, who were associated with the movement known as romanticism, was revitalized during this period. Baudelaire, Nerval, Gautier, and Hugo were among those who selected the figure of a female contemplative as a metaphor for the creative self and turned often in their work to the theme of melancholia.[111]

Boulanger's association of Sand with the melancholic (and the Documentation du Louvre's with Mary Magdalene) is understandable for several reasons. First, within popular literature and social commentary there are caricatural variants on the theme of melancholia, connecting it to the affectations of the contemporary bas-bleu.[112] There are also essays, short stories, and even paintings that venerate Mary Magdalene as a feminized alter ego of the male artist-melancholic.[113] But most significant, in the case of Boulanger, whose principal allegiances were to the community of artists and writers who revered Sand, was his understanding of her work.

George Sand was one of the principal innovators of a common romantic prose genre, "the novel of the individual." Like Saint-Beuve's *Volupte* (1834) and Alfred de Musset's *Confessions d'un enfant du siècle* (1836), Sand's *Indiana* (1831) and *Lélia* (1833) belonged to this autobiographical and confessional mode, which tracks the fall and eventual restoration of a moral hero plagued by melancholic despair. For the characters, the malaise is usually a reaction either to the social condition of women, to class inequities that diminish relations between the sexes, or to a loss of spiritual and religious conviction. Sand's haunting portraits of "les enfants du siècle" and widely publicized conversion in the late 1830s to a Christian socialist "religion of humanity" underpin her portrayal as melancholic.[114]

A second portrait by Boulanger, an ink drawing that is correctly titled *George Sand en Madeleine* (fig. 83), visualizes the discursive contiguities between the artist-melancholic and the woman of ideas as modern Magdalene. Boulanger adopts a fairly conventional presentation for his devotional image of penitence. In the foreground George Sand is seated in contemplation on a rock in front of a cave. The subject of her thoughts is

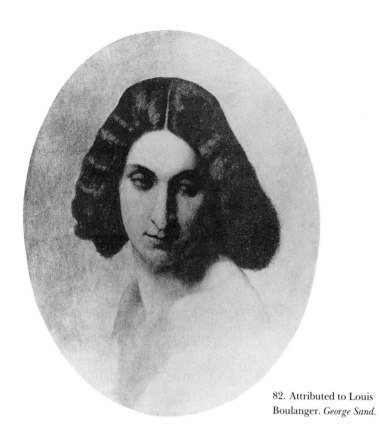

82. Attributed to Louis Boulanger. *George Sand.*

83. Attributed to Louis Boulanger. *George Sand en Madeleine.* c. 1839.

physicalized by a crucifix in the distance. Unlike most representations of this subject, however, Mary Magdalene is fully clothed. She wears a loose-fitting tunic that neither conceals nor highlights her gender. The focus is the woman in meditation, the woman formulating ideas. There is no distracting slipped chemise or raised skirt to divert our attention from the internal processes of Mary Magdalene.

Efforts like Boulanger's to assimilate the lesson of the woman of ideas and explode the false dichotomy of female body and female mind were most common among those who belonged to literary and artistic communities in which women were important members. Though experiments like Boulanger's are more prominent in private imagery, there are a couple of exceptions.[115] In Thomas Couture's *Le Fou* (1860), for example, the female prisoner who exemplifies compassion and sympathy is given George Sand's face. Auguste Clesinger also exploits the symbolic power of the writer when he places in the hand of his marble personification of melancholy a book inscribed to George Sand.

Artists who incorporated the idea or image of the woman of ideas into their work usually shared close personal and professional ties with female writers. This connection undoubtedly sensitized them to the romantic equation of artistic inspiration with a feminized self. In some it inspired the desire to invent a visual language that would complement and further complicate textual revisions of the traditional contructs of womanhood. One public image whose attempt to challenge the dichotomy of female flesh and female spirit has gone unnoticed: Eugène Delacroix's *Madeleine dans le désert* (1843–45; fig. 84).

Delacroix's painting attracted a great deal of attention at the Salon of 1845. Though some critics applauded its "romantic poetry" and "perfect tonal harmony," most registered confusion about its ambiguous relation to its stated theme.[116] Delacroix was accused of ignoring the character of his subject: "Je n'ai pas reconnu Madeleine au désert. . . . On se demande, . . . si c'est la figure d'une femme qui rêve, d'une femme qui dort, ou d'une femme qui vient de mourir . . . pourquoi baptiser cette oeuvre du nom sacré de Madeleine?" [I did not recognize Madeleine in the desert. . . . One wonders, . . . if it is the face of a dreaming woman, of a sleeping woman, or of a woman who has just died, . . . why give the sacred name of Madeleine to this work?].[117] But even though similar criticisms had been lodged against such painters of Mary Magdalene as Camille Roqueplan for the excessive corporeality of their figures, Delacroix's detractors accused him of erring in the other direction. His saint had too convincing an interior life.

In fact, what appears to have been genuinely unusual about this painting was its fidelity to its subject, not its indifference. Delacroix's pre-

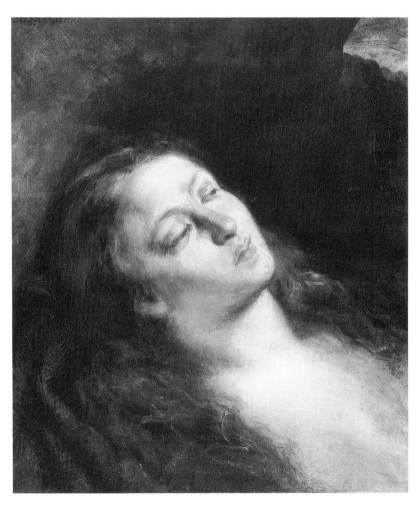

84. Eugène Delacroix.
*Madeleine dans le désert.* 1845.

sentation of the Mary Magdalene legend was unsettling because of its commitment to the expression of female interiority. What was truly radical about the image was that Delacroix chose to represent the thought processes of the saint by eliminating her body. Had Delacroix called this painting of a woman's head "Rêverie" or "Mélancolie" it would have been unremarkable. But to empower an image of the female mind by granting it a specific female identity and divorcing it from its gendered aspect was heresy. Most devotional images of the saint's penitence subvert the expression of self-sacrifice and contemplation by their carnality. Delacroix's disembodied portrait of Mary Magdalene is strange because it is so emphatically cerebral and noncorporeal. It is, literally, a woman of ideas.

The saint's facial features bear a striking resemblance to the Boulanger portraits of George Sand. All have an ovoid face distinguished by an overlong aquiline nose whose tip forms a strong diagonal back up to the outer edges of the nostrils. Each gives its subject large and heavy-lidded eyes accentuated by the thin regular arch of the eyebrow and a small, curvaceous mouth punctuating the almost perfectly circular protrusion of her chin. Though Delacroix, even more than Boulanger, had reason to conflate the identities of George Sand and Mary Magdalene, it is unlikely that he did.

As one of Sand's closest friends, Delacroix was more than familiar with how her religious and social agenda mirrored that of the penitent saint.[118] Delacroix was introduced to Sand in 1834 when he was commissioned by François Buloz, her publisher at the *Revue des deux mondes,* to paint a portrait of her that was to be engraved and reproduced for her readership. Delacroix's famous androgynous image of George Sand with cropped hair and in men's clothes was the product of this arrangement. The meeting was the beginning of a thirty-year friendship that is documented in the profusion of letters they exchanged. When Sand was in Paris, they saw each other often at musical soirées and in Sand's own home, which was a regular gathering place for artists, writers, and musicians from all over Europe. When she retreated to her country residence in Nohant, they wrote to each other, and Delacroix visited whenever possible.

In June 1842 and again in July 1843, just before he began work on *La Madeleine dans le désert,* Delacroix enjoyed a blissful vacation in Nohant that he characterized as *une vie de couvent.*[119] After he returned to Paris, he complained in his letters of the boredom and depression that he suffered in leaving the country. The only remedy for his malaise, he confessed to Sand, was work and his ability to conjure up her image: "Je vous vois toujours devant mes yeux, . . . à chaque heure du jour je vous suis."[120] Delacroix describes Nohant as an idyllic religious retreat peopled by modern incarna-

tions of biblical prototypes: "Les femmes ont toutes l'air de ces figures douces qu'on ne voit que dans les tableaux des vieux maîtres. Ce sont toutes des Sainte Anne."[121] He formalized this impression in a painting of *The Education of the Virgin* that he completed during his stay at Nohant in 1842. The models for Saint Anne and the Virgin were Sand's maid and goddaughter. Though there is much to suggest that he had George Sand herself in mind when he turned, twelve months later, to another religious subject, *La Madeleine dans le désert,* such a conclusion would be too easy.

I contend that George Sand in some way informs Delacroix's treatment of Madeleine but not in terms of physical likeness. The features of the saint resemble the writer's, but they are eerily close to those of many other female (and male) artists depicted in romantic portraiture as well. As I detail in Chapter 5, this kind of physiognomic formula informed a great deal of visual and literary description in this period. The characteristics of genius and melancholy—the pristine, high forehead; the huge, Sumerian eyes; the Roman nose—were generically applied to portraits of literary and musical artists. Judging by Delacroix's letters and his portrayals of Sand in 1834 and 1838, she was for him first and foremost a mind, and her model informs his characterization of the interior life of Mary Magdalene.

In mediating the thematic contiguities between artist-melancholic and Mary Magdalene, Delacroix attempted in part to counter the force of conventions that expunged the possibility of a woman of ideas. But his revision only reinscribed more deeply the split between female body and female mind. For Delacroix, the head of Mary Magdalene, distinct from her body and its taint of female carnality, must have signified the essential creative spirit. The romantic concept of artistic inspiration was the creation of men; what better expression of its intangibility and otherness than the impossible rupture between woman of idea and woman of flesh? Though Delacroix's impulse was to elide the culturally encoded dichotomies of womanhood, his amputation of Mary Magdalene's gendered parts only reaffirmed them. Thus, even the most reverential efforts to elicit an iconography of female interiority were subverted by a culture wherein the power of a woman's intellect is extinguished by the fetishization of her body.

The permanence of the woman of ideas' condition—the chronic incompatibility of her material and spiritual being—is underscored by the syllogism with which Victor Hugo characterized George Sand when she died: "La forme humaine . . . masque le vrai visage divin, qui est l'idée. George Sand était une idée; elle est hors de la chair" [The human form masks the true face of the divine, which is the idea. George Sand was an idea; she stands beyond flesh].[122]

# 5

*Portraits of the Woman of Ideas: Muse and Sphinx*

The most immediate and accessible manifestation of the woman of ideas in high art occurs in portraiture. The increase in works devoted to women of letters and scenarios from their novels during the July Monarchy is documented in a caustic paragraph in Charles Baudelaire's "Salon of 1846." In a section devoted to portraiture, Baudelaire compares the formulaic and pedantic practitioners of what he calls "portraits as history"—Flandrin, Amaury-Duval, and Lehmann—with the degenerate practices of the bluestocking, whom these artists continually chose to paint. He asserts that David and Ingres, the masters of the "historical" or classical school, spawned a generation of dull and simpleminded draftsmen who "share the prejudices of certain modish ladies, who have a smattering of debased literature."[1]

The portraits of these "modish ladies" remind Baudelaire of "the following wise words of the dog Berganza, who used to run away from bluestockings as ardently as these gentlemen seek them out: "Have you never found Corinne quite impossible? . . . At the thought of seeing her come near me, in flesh and blood, I used to feel an almost physical oppression. . . . Whatever the beauty of her arms or her hand, I could never have endured her caresses without feeling slightly sick."[2] The digression from his commentary on portraiture rehearses arguments he makes elsewhere for the superiority of the romantic to the classical sensibility in art. Never

acknowledging any motivations for the creation of pictures beyond purely aesthetic ones—motivations that might complicate or moot his distinction between poetic and pedantic, romantic and classic—Baudelaire fuels his critique of the latter artistic practice by misleadingly assigning it full blame for the revival of interest in a degraded subject, the woman of ideas. He connects the growth in representations of the woman of ideas with the misguided priorities of the contour-crazed producers of "historical portraits." Though Flandrin, Amaury-Duval, and Lehmann did produce a lot of work in this genre, so did other artists that he privileges elsewhere in his criticism as the more talented and poetic practitioners of interpretative pictures—what he calls "portraits as fiction." Artists who represented the woman of ideas did so for pragmatic reasons: they were either commissioned or they shared a professional or personal relationship with the writer. Arrangements like these were as common among romantic painter-poets who produced pictures "full of space and reverie" as they were among classicists, who possessed such "admirable simplicity of mind."[3]

The bluestocking portraits to which Baudelaire refers are works like Henri Lehmann's images of the Princess Christina Belgiojoso and Mme Clémentine Karr (fig. 85). Lehmann was criticized often in the press, less for his affinity for the bluestocking than for his *pinceau systématique* and his propensity for painting women "qui a l'air d'habiter le ciel plutôt que la terre."[4] Lehmann was in fact prone to a formulaic treatment of the femme pensée. The faces of Belgiojoso and Karr, for example, are disconcertingly similar. Their heads are perfect ovoids set atop elegant cylindrical necks. Their masklike features are utterly symmetrical: two thick, arched brows pasted above two huge, dark eyes that directly engage the viewer, and long, centered, aquiline noses that terminate just over the center of delicate but resolutely closed mouths. But what remains unobserved about the sameness of Lehmann's facial types is that it is not arbitrary. The haunting community of dark women depicted in his portraits are women of ideas. Their generalized features are not the consequence of his ineptitude or lack of imagination; they correspond to textual and visual descriptions of the physiognomy of female intellect in this period. Historically, the category of the woman of ideas has been preserved only in its grotesque, caricatural form. What Lehmann's portraits offer—and what Baudelaire and others refuse to name—is the reverential version of this female type.

Rather than acknowledge and authorize reverent portraits of the woman of ideas, Baudelaire uses them to reinforce his false polarity between male traditions, the painterly versus the linear, the avant-garde versus the retrograde. He subverts any effort to individuate and temporally locate these women by processing them as universal female subjects valued

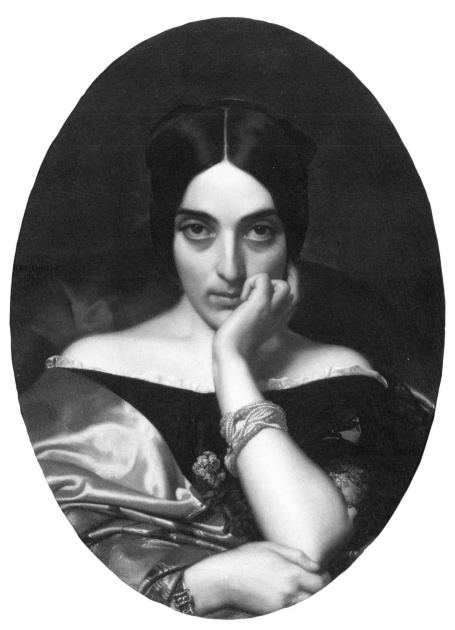

85. Henri Lehmann.
*Portrait of Mme Clémentine Karr*. 1845.

only by the backward painters of the "historical school." Misconstruing *bluestocking* and *Corinne* as interchangeable terms, Baudelaire rhetorically erases the distinction between the modern woman of ideas and the literary muse of the ancien régime. To acknowledge the innovative aspect of these portraits would be to grant the transformative power of the artists he chooses to condemn as unoriginal. Moreover, it would concede the enhanced economic and social status of the woman of ideas that those changes in portrait conventions signify.

Pictorial representations of the woman of letters did change in this period. Though the majority were commercially motivated and paradigmatic, a handful of exceptions exist. Some elaborate private, esoteric narratives chronicling some aspect of the writer's biography. Others operate iconically and in self-conscious relation to the pictorial tradition of the woman of ideas. It is the exception that Baudelaire denigrates in his discussion of portraiture, the deviations from the safe and normalized muse persona that had dominated treatments of the femme-auteur since 1800. As I detail in Chapter 1, in the late eighteenth and early nineteenth century the conception of the woman of ideas as muse was shaped largely in response to the example of Germaine de Staël. Despite De Staël's efforts to complicate and historicize the femme-auteur, this figure continued to be typologized and portrayed as a muse, a guardian of the creative arts, an inspirational spirit who gives the male poet his song and sings it through his lips. That conception was first tampered with in the 1830s and 1840s when the preeminent embodiment of the nineteenth-century muse—the salonnière who writes and reads poetry in the private spaces of the home—was altered. Though the salonnière remained an influential presence, she was to some extent overshadowed by the naissance of the professional woman writer, who produced novels and critical articles in the public domain instead of poetry and conversation in the drawing room. It was the novelist, not the "poetess," who came under attack by Baudelaire, and, subtextually, it was the pictorial reformulation of the muse portrait that he critiqued in his "Salon of 1846."

The new and powerful figuration of the woman of ideas appeared in what I call the sphinx portrait. The self-possession, interiority, and transformative power conveyed in works like Lehmann's portraits of Princess Belgiojoso and Mme Clémentine Karr were disconcerting, not inspirational, to many male critics. The sphinx portraits, which began to appear in the late 1830s, blended two striking currents, one general and one specific, both images of power: the bourgeois realism of Ingres' riveting portraits of wealthy women and the heroic idealization in romantic imagery of the most important woman of ideas during the July Monarchy, George Sand.

Discarding the conventional reliance on external theatrical codes (props, costume, gestures) to communicate the female sitter's identification with intellect, the sphinx portrait emphasizes the internal strengths of the woman of ideas. There are no lyres, tunics, or laurel wreaths. There are no stormy skies or upturned gazes. Female intellect is conveyed physiognomically and through the relation the portrait establishes with the viewer. Enormous ebony eyes—iconic, centered, and directly engaged with the viewer—are its most compelling element. They are principal among the standardized features to which Baudelaire refers—the dark hair, the long, aquiline nose, and the black, transfixing eyes that control our relation to the portrait. And they are used continuously in the literary and visual arts of the 1830s and 1840s to characterize the new woman of ideas. It is the same set of features by which Honoré de Balzac describes Félicité des Touches— his ideal of female intellect—in the 1838 novel *Béatrix:* "The face . . . has the purity of a Sphinx's head. . . . Her hair, black and thick, falls in plaited loops over her neck, . . . accentuating very finely the general severity of her features . . . a full broad forehead. . . . the eyebrows, strongly arched . . . eyes in which fire sparkles now and again like that of fixed stars."[5] It was widely acknowledged that Balzac modeled the character after the quintessential woman of ideas, George Sand. What has gone unrecognized is that she is her physiognomic double as well. It is Sand's visage, or what was perceived as its equivalent, that determined the features of Balzac's idealized femme-auteur. And it was her face—regularly characterized by her contemporaries as sphinxlike—after which the "bluestocking portrait" was modeled.

The frequent characterization of Sand as sphinx (a winged monster with a woman's head and a lion's body who taunts men with riddles they cannot answer and then kills them for their trouble) is consistent with the imagery of transgressive masquerade that I have described in relation to the writer in Chapter 2. The singularity of Sand's position, as one of the few women to figure prominently in a male-dominated literary community, makes the sphinx an almost predictable metaphor. It resonates with both the power and the treachery of her difference. But it also portends the ultimate containment of the sphinx's female excess as it is scripted in Sophoclean and psychoanalytic oedipal paradigms.[6]

Rather than offer a comprehensive survey, this chapter will selectively examine changes in motifs and forms within portraiture of the woman of ideas. Focusing on representations of three women writers—Louise Colet, Marie d'Agoult, and George Sand—it will elicit the dialogue that took place in this period between pictorial conventions of the literary muse and the reconstituted woman of ideas. Through an examination of the femme-

auteur portrait, it will reinvoke the dialectic of resistance and containment that characterized the woman of ideas and her representation by a male-dominated artistic community during the July Monarchy. Before analyzing these changes and the part they played in efforts to restructure gender myths, it is necessary to outline the issues of the early-nineteenth-century muse portrait and the transformation of the literary industry that empowered the femme-auteur to redefine her identity.

## Sappho and the Muse Portrait

A favorite portrait motif of the late eighteenth century was what Mario Praz has called "the lady with the lyre."[7] This variety of *portrait déguisé* has been contextualized as part of the practice of refashioning women as heroic personages, such as Diana or Cleopatra, and as part of the overlay of neoclassical detail that characterized art in this period. The muse persona—often seated out-of-doors, dressed in a classical costume, and strumming a lyre—was adopted for a variety of female types, which ranged from witty salonnières to professional femme-auteurs.

The woman with literary pretensions was distinguishable from the woman of talent by her posture, facial expression, and relation to the lyre— the instrument of divine inspiration. In L. Gauffier's *Portrait of a Lady Seated in a Landscape* (1794), for example, the muse persona is merely part of a Greco-Roman veneer. The subject coyly reclines against a tree trunk before a patch of landscape that spotlights the Villa Maecenas at Tivoli. Her heavy lids and barely restrained smile identify her as more of a coquette than a muse.

Mlle Rivière's *Portrait of a Lady with a Lyre* (1806; fig. 86), on the other hand, depicts a more serious variety of muse. In addition to the portraitist's comprehensive integration of neoclassicizing detail, the figure is seated upright, holding and playing her lyre. Her grave regard, directed squarely at the viewer, conveys the integrity and purposefulness with which she practices her art. In fact, her sincerity and ability to play the lyre suggest that she may not be a muse at all; she is more likely an incarnation of Sappho.[8]

Though the category "muse" and the proper name "Sappho" were often used interchangeably in the nineteenth century, there is a significant difference. A muse is one of nine sister goddesses in Greek mythology who preside over learning and the arts. They inspire male genius, nurturing rather than generating a creative product. Sappho, however, was an ancient Greek lyric poet whose talent was ranked with Homer's. But the modern identity that French fantasy and pseudohistory were largely re-

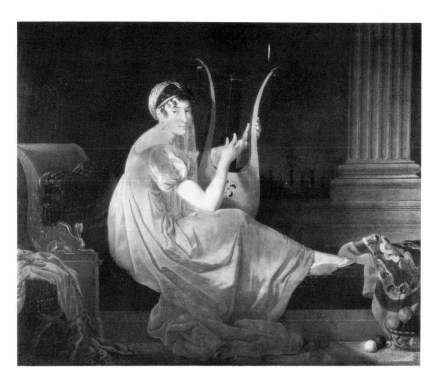

86. Mlle Rivière. *Portrait of a Lady with a Lyre.* 1806.

sponsible for constructing for her retains little evidence of this talent.[9] The verifiable details of Sappho's intellectual status and literary production have been obscured by conventionalizing fictions of female desire. Thus, she often is misleadingly referred to as the tenth muse, an identification that contaminates many visual and textual representations of the poet.

The systematic recovery of Sappho's life and work began in the sixteenth century. But its consolidation and formulation really date to the mid-seventeenth century, when the French literary canon was constituted. From this period on, the French dominated Sappho scholarship.[10] Their continuous concern with the first woman of ideas was motivated by men and women of letters who chose to identify themselves with the poet. But the historicizing narratives that were created for Sappho were increasingly censorious of the most important elements of her life—her creative production and her lesbianism.

As Joan DeJean's powerful study *Fictions of Sappho* (1989) demonstrates, between 1600 and 1990 Sappho was variously scripted to signify the plight of the female victim, political activism, debilitating artistic melan-

cholia, and homoerotic love.[11] Her period identifications were fluid because they were determined by current cultural metaphors, not the examination of historical documents. The fiction that most continuously and powerfully shaped public perceptions of Sappho is the narrative of her abandonment by a young lover named Phaon. This legend, which has been enshrined as fact, dates to 1612, when Ovid's *Heroides* was unearthed, translated, and published.

Ovid's text consists of a series of fictive letters from women to men who have abused their love and abandoned them. It concludes with the one historical figure to be featured in the book, Sappho. But, as DeJean observes, Ovid makes no distinction between fact and fiction, as the narrative that unfolds in Sappho's letter is entirely fabricated. Erasing all reference to the lesbian community in which she lived, the community to which her love poetry was dedicated, Ovid normalizes the poet by inventing a story of her all-consuming passion for a man, Phaon. The text not only denies her the female community to which she was devoted, it robs her of her artistic identity as well. In Ovid's tale, the vision of Phaon's youthful flesh overwhelms the older woman and prompts her to stop writing. When Phaon abandons her for a woman his own age and she is faced with the double loss of her lover and her creative power, Sappho commits suicide by leaping from the rocks of Leucadia.

It is the conventionalized, heterosexual Sappho who predominates in literary and textual representations of the poet in the first half of the nineteenth century. The iconography of the despondent, abandoned woman was particularly appealing to artists in Napoleon's retinue.[12] Napoleon was contemptuous of contemporary literary women, particularly Germaine de Staël, whose salon was a haven for opponents to his regime and whose highly popular novels and essays often contained scathing critiques of his militarism and paternalism. Not surprisingly, the painters who most successfully competed for government commissions to pictorially aggrandize the emperor were among those who contributed most substantially to the conventionalization of the woman of ideas in the plastic arts. These artists depicted Sappho either as the abandoned woman driven to suicide or as the degenerate whore surrendering her intellectual and spiritual gifts for the ephemeral pleasures of male flesh.

Baron Gros, whose contribution to the Napoleonic legend is well documented, produced one of the most influential figurations of the humbled poet, *Sappho at Leucade* (1801; fig. 87).[13] This nocturnal scene, so often used in textbooks to demarcate the beginning of romantic painting, is a poetic evocation of despair. The entire composition is bathed in a greenish-blue hue, and the full figure of Sappho is seen in profile as she is about to

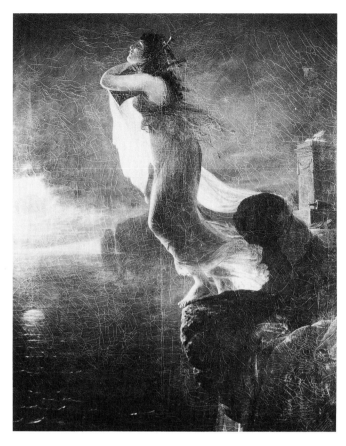

87. Baron Gros. *Sappho at Leucade.* 1801.

leap from the rocks. She clutches her lyre to her chest and teeters on the balls of her feet. Her chin is raised, her eyes are closed, and she faces heavenward. The upward curve of her chest, face, and drapery appear to defy gravity and create the illusion that she will ascend rather than drop. Gros depicts an expiatory ritual that liberates Sappho from her carnality. In this one fictive moment she is punished for her genius and lesbian past, reconstructed as a female victim, and redeemed for the literary canon.

Gros's glorification of suicide was controversial and curious for a painter with strong ties to a government that had consistently and vociferously condemned such representations as immoral. DeJean is convincing when she argues that "France's new regime may have had a stake in the violent self destruction of the original woman writer."[14] The consistency with which Napoleon's entourage worked to reinscribe the traditional gen-

der paradigms that were under constant attack by Germaine de Staël and her circle is conveyed in a picture by Jacques-Louis David, another architect of the Napoleonic myth. David's *Sappho and Phaon* (1809; fig. 88) illustrates an earlier moment in Ovid's narrative when the poet yields to the carnal temptations of Phaon. A centered, seated Sappho is shown swooning at the unexpected touch of her young lover. Depending on our sex, we are invited by the respective gazes of the couple to share Phaon's fatal and absolute power of seduction or Sappho's orgasmic submission. Phaon's dominating stance, above and behind the poet, suggests the effortlessness with which he is able to make this woman submit: he casually leans against her chair and crosses his feet as if unaware of the proximity of his right hand to Sappho's exposed breast; his left hand curls sensually around to cradle her chin and cheek; and his facial expression reads as impassive and indifferent to the seductive power he has exercised. His control is contrasted with Sappho's utter abandon. We see her just at the moment when her formerly erect body, which had been engaged in an improvised performance on the lyre, yields limply to the touch of her lover. She is doubly violated by Phaon, who toys with her, and by Eros, who kneels before her and takes advantage of her moment of ecstasy to remove the lyre—her creative power—from her still-raised arms.

The relinquishment of the lyre is a popular motif in early-nineteenth-century Sappho imagery. David's student, Ann-Louis Girodet, for example, made frequent use of it in an illustrated edition of Sappho's poetry that he published in 1829. In several of the engravings, Sappho is shown allowing the lyre to slip from her grasp. This image is a forerunner of the conceit discussed in Chapter 4: the dropped book that signifies the sexual abandon of reading couples.

Within history painting, few early-nineteenth-century works present an empowering vision of the woman of ideas. Nicolas-André Monsiaux's *Socrates and Aspasie* (1801; fig. 89) is one of the rare exceptions. This image must be contextualized within French Hellenism and the growing fascination with the subject of courtesans in antiquity. Dozens of essays and books published in the nineteenth century commented on the educational privileges available only to women in the haetairae of ancient Greece. Studies were usually motivated by a writer's simultaneous engagement in contemporary debates over female education. Struck by the irony of a culture in which female degradation was rewarded with the opportunity to participate in and learn from conversations about philosophy, poetry, and politics, authors of such pieces frequently concluded with a plea for a more sensible and equitable distribution of modern educational resources.[15]

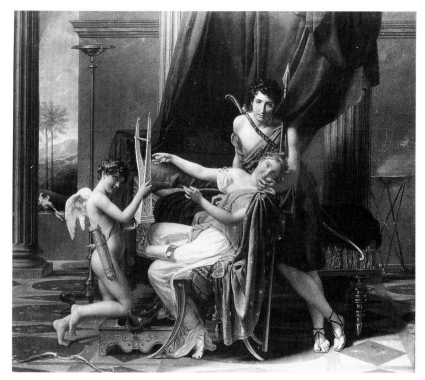

88. J. L. David. *Sappho and Phaon*. 1809.

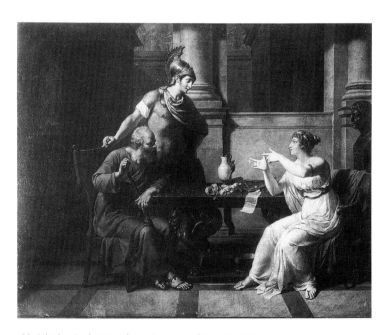

89. Nicolas-André Monsiaux. *Socrates and Aspasie*. 1801.

Monsiaux's oil features Socrates and Aspasia seated at a table, engrossed in conversation. Aspasia (c. 470–410 B.C.) was a Greek consort noted for her combination of brilliance and beauty. According to classical lore, Socrates and Pericles (who ultimately divorced his wife and married Aspasia) visited Aspasia regularly to refine their cultural tastes and engage in stimulating debate. In Monsiaux's highly unusual image, Socrates the sage sits passive and quiet at one end of the table with Pericles standing behind him. Both male figures are silent and rapt by the argument Aspasia makes. Fully clothed, she leans animatedly forward, using her fingers to count, and perhaps demonstrate, aspects of her point. Her papers and lyre rest before her on the table; she communicates her ideas not through a musical instrument but through the traditionally male devices of aggressive gestures and spoken words.

It is in muse portraiture more than history painting—particularly in those portraits that elicit the myths of Sappho—that the efforts of Napoleon's retinue to devalue female intellect are most effectively countered. Elisabeth Vigée-Lebrun's portrait of Germaine de Staël, commissioned by the writer herself, is one of the few nineteenth-century instances in which a sapphic figure is pictured alone and in full control of her creative powers. The portrait of *Mme de Staël as Corinne* (1808–9; fig. 90) was the product of a collaboration between two of the most powerful women in France at the beginning of the nineteenth century, painter and salonnière Vigée-Lebrun and writer-philosopher De Staël. Together they reformulated and referentially expanded this portrait déguisé tradition.

De Staël assumes the identity of Corinne, the heroine of her enormously successful 1807 novel about a female genius who is unwilling and unable to conform to social norms. As I detail in Chapter 1, Corinne was the first woman of ideas portrayed in a novel, and she was critical to the formation of a fictive and actual model of female independence and intellect. As the novel opens, Corinne, "dressed like Domenichino's sibyl," is about to be crowned on the steps of Rome's capitol and honored as the city's preeminent poet. Corinne is not merely a muse or a "lady with a lyre"; she is the modern incarnation of the esteemed ancient lyric poet Sappho.

Corinne, the most celebrated woman in Europe, sacrifices her achievements and even her literary gift for a younger man who eventually abandons her. As DeJean observes, De Staël perpetuates many of the Ovidian fictions embraced by the entourage of her sworn enemy, Napoleon, but she makes several important revisions. First, Corinne's talent and acclaim, which are foregrounded in the early chapters of the novel before she even meets Oswald, are her own; they owe nothing to him or his greatness,

as Ovid suggests is the case with Sappho and Phaon. And Oswald is mesmerized by her, not the other way around. Second, though Oswald, like Phaon, does leave the poet for another woman, De Staël represents this as his weakness. Oswald chooses a golden-haired "true English wife" because he lacks Corinne's strength to resist the constraints of social convention. Furthermore, Oswald suffers for his weakness, haunted for the rest of his life by the image of the superior woman he truly loved. Finally, De Staël's Corinne is more than just another fiction of Sappho. It is a self-conscious critique of the legal, social, and political condition of the woman of ideas in France and a reaffirmation of her abilities. It is the reempowered Sappho whom Vigée-Lebrun evokes in her study of De Staël.

Like many muse portraits, Vigée-Lebrun's painting features De Staël "en Corinne" out-of-doors, seated before a mountain whose peak is punctuated by a Greek temple. Showing the writer dressed in a tunic and peplum, in full control of her creative powers, De Staël's image reminds us of the woman-of-talent variety of muse portrait. But its introduction of a new motif directly associated with the sapphic identity of Corinne thereafter shades the muse portrait. The juxtaposition of De Staël's eyes raised heavenward for inspiration and her gesture toward the lyre became after 1808 a staple for muse portraits seeking direct identification with the specifically modern conflation of De Staël-Corinne-Sappho.[16]

This iconography was appropriated and reconstituted by another of the Napoleonic court painters, Baron Gérard. In 1819 he was commissioned by Prince Auguste of Prussia to paint a posthumous portrait of De Staël en Corinne.[17] Though better known for his military scenes and portraits of the emperor, Gérard was asked to re-create a scene from the novel. Gérard made full use of the facial attitude and gestures of the serious woman of talent that Vigée-Lebrun had formulated in her portrait of De Staël, but his selection of a passage from the fiction to illustrate transmutes the earlier image of sapphic glory into an image of aborted female power.

In Gérard's *Corinne at Capo Miseno* (1821; fig. 91) De Staël-Corinne is seated before a still smoking Mount Vesuvius, surrounded by her devoted followers, among them her lover Oswald (whose features are those of Prince Auguste). They have come to honor her and hear her improvisatory performance. But this is not any performance; it is her final improvisation in the novel, which ends abruptly as "Corinne [grows] mortally pale" when she foresees her own fate in the verses she improvises: "The passions rule us with a tumultuous tyranny allowing neither freedom nor repose."[18] It is the stifled and despairing Corinne-De Staël whom Gérard chooses to paint, the Ovidian Sappho whose creative spirit has just been silenced by mel-

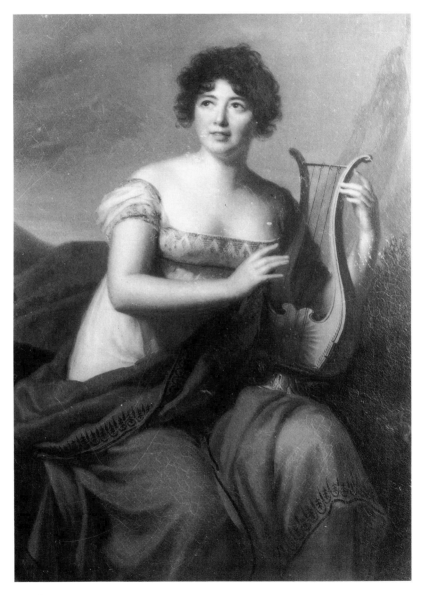

90. Elizabeth Vigée-Lebrun.
*Mme de Staël as Corinne.* 1808–9.

ancholy. Though De Staël's novel rescripted Ovid's narrative, making Corinne's suicide after she is abandoned by Oswald an enabling and trans-figurative act, Gérard's picture fixes the poet at the end of her creative life, the defeated artist and woman, passively resigned to the consequences of female deviance.

The Corinne portrait was one of several public rituals of the early nineteenth century that replayed aspects of this popular novel. There were re-creations of Corinne's coronation, performances on the lyre guitar, which had become an essential feature of all Parisian salons, and the most fashionable women with literary ambitions engaged in public recitations of passages from De Staël's novel. "The reading of this work," according to artist and writer Etienne-Jean Délécluze, "[was] like a poisoned drink for all the girls of wit who aspire[d] to writing."[19] The girl of wit who was Cor-inne's most accomplished imitator was Delphine Gay, who preserved throughout the July Monarchy the most reactionary and normalizing fic-tions of Sappho.

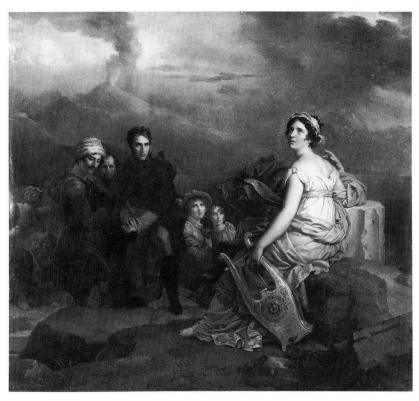

91. François Gérard.
*Corinne at Capo Miseno.* 1821.

Delphine Gay was the daughter of Sophie Gay, a prominent poet and active supporter of women writers during the Empire and Restoration. Gay fashioned her daughter after her friend Germaine de Staël, even naming her after the heroine of De Staël's first novel, *Delphine*. She arranged social gatherings to provide occasions for Delphine to perform selections from her own work; the most famous of those gatherings took place at the salon of Mme Récamier. Delphine, standing beneath Gérard's painting of *Corinne at Capo Miseno* (which Prince Auguste gave to Récamier), improvised poetry to the strains of a lyre guitar. Gay cultivated her daughter's identification with De Staël-Corinne, accompanying her on pilgrimages to Capo Miseno and booking readings for her at several historically significant sites in Paris.[20] Her efforts paid off as her contemporaries rhetorically inscribed this identification, referring to Delphine variously as "Notre Corinne enfant, prêtresse de la lyre" and "la dixième muse."[21]

Delphine Gay's appropriation of a trivialized version of the Corinne persona gave her recognition yet guaranteed her immunity from the insults hurled at most women of ideas during the July Monarchy. Even after she adopted a male pseudonym and began writing a regular gossip column she managed to avoid the bluestocking epithet. This was accomplished, in part, by her shrewd marriage to the powerful newspaper magnate Emile de Girardin, whom no writer in search of work could afford to alienate, and in part by her decision to remain a poet rather than try her hand at a novel. Poetry was the arena of the muse while the novel was the work of the bluestocking. Disassociating herself from the community of femmes-auteurs, Gay styled herself an old-fashioned muse-salonnière. Even the male pseudonym she selected, Vicomte de Launay, resonated with the culture of the ancien régime.[22]

Gay provided the Parisian literary community of the July Monarchy, much of which gathered at her salon and looked hopefully to her husband for employment, with an acceptable model of female intellect. By capitalizing on her association with Corinne and Sappho while rescripting their female challenge in more conventional terms, Gay made herself palatable to a variety of sensibilities, a woman of ideas with the emphasis on "woman." And she preserved into the 1830s and 1840s the unthreatening and inaccurate conflation of muse and Sappho.

Interest in Sappho flourished during the July Monarchy. New translations and pseudohistorical fictions multiplied and diversified, motivated in part by anxieties over changes in the French literary community and the growing influence of les femmes-littéraires, whom Delphine Gay described in her gossip column as "les fléaux de l'époque." Sappho, like Mary Magdalene, was variously characterized as the redemptrice of France, a symbol

of tortured female sexuality, and a courtesan. The fluidity of her identity in this period is emblematized by a feeble but germinative article published in 1822 that infected representations of Sappho for the remainder of the century. In *Notice sur la courtisane Sapho,* Allier de Hauteroche, a former Napoleonic officer, resurrected an old theory that posited the existence of two Sapphos, one a poet and the other a courtesan. This double Sappho theory, though based on the flimsiest evidence, was embraced by writers like Théophile Gautier, Jules Michelet, and Emile Deschanel, who were predisposed to seeing the female body and the female mind as incompatible entities.[23]

This split resonates in the work of the two artists who produced the most powerful images of Sappho in this period, Théodore Chassériau and James Pradier. Both artists had strong ties to literary communities that valued their female membership (in fact, the same communities to which Henri Lehmann belonged). Théodore Chassériau's close friendships with Christine Belgiojoso, Marie d'Agoult, and Delphine Gay (de Girardin), which had evolved within the context of these communities, generated a series of portraits of the writers and undoubtedly stimulated his interest in the subject of the first woman of ideas, Sappho.[24] Chassériau's first treatment of the theme in 1840, *Sapho se précipitant dans la mer,* owes a great deal to Baron Gros's painting of 1801. Like Gros, Chassériau presents Sappho clutching the lyre to her chest as she prepares to leap from a precipice above the ocean. The uniformity of facture and hue, blurring distinctions between figure and environment and encouraging us to see the suicide as a transcendent act that liberates the poet from her painful materiality, is also reminiscent of Gros. Where Chassériau's interpretation differs is in its greater emphasis on facial expression, supernaturalism, and atemporality. We are given a frontal view of the poet. She does not look away from us with closed eyes, turned upward to heaven; instead, her deeply shadowed eyes remain wide open, staring downward and off to the right. Furthermore, she is not precariously balanced on the edge of a rock; neither of her feet is secured on any surface. She appears to float next to the cliff. The arching upward curve that forms the painting's dominant compositional rhythm promises her ascension. The bowed line of the precipice echoes in her tunic, forearm, and flowing hair that is in places indistinguishable from the impasto of the stormy sky behind her. Furthermore, there is nothing in the painting beyond its title to definitively locate it in a particular time and place.

Chassériau's 1840 *Sappho* perpetuates the Ovidian fabrication of the poet's suicide but emphasizes the poet's thought process over her victimization. Like the sphinx portraits executed by his friends Lehmann and

Flandrin, Chassériau's *Sappho* exchanges the heavenward gaze for the meditative interiority of the woman of ideas. This is even more true of his 1849 version of the subject, *Sapho prête à se précipiter du rocher de Leucade* (fig. 92), which pictures Sappho seated in profile on the rock, staring solemnly down into the sea, contemplating her choices. The heaviness and despair of the figure is relieved only by the illuminated verticality of her right arm, which reaches up to grasp a higher point on the mountainside to slow her psychological descent. Our attention is focused on her thoughts in several ways: first, all overt references to her gendered parts are concealed by large swatches of generalized drapery that force us to read the figure through more sexually neutral categories of posture and gesture; second, there is a complete absence of any iconographical detail that would identify her with certainty as Sappho. This image must be contextualized within the phenomenon discussed in Chapter 4 of increasingly genericized treatments of the female contemplative. Like contemporary representations of the penitent Mary Magdalene, Chassériau's Sappho offers an image of interiority valued for its messianic potential as a metaphor for the feminized creativity of the artist who will guide France toward its spiritual rebirth.

Sappho also shared Mary Magdalene's malleable identity in this period, available for remolding according to the needs of the mythmaker. At the same time she was being hailed as a redemptrice she was being sensationalized and exploited as a sexual deviant. Between 1845 and 1850 there was a resurgence of interest in Sappho's bisexuality both in tabloid literature and among a circle of writers gathered around Charles Baudelaire. *Les Lesbiennes de Paris* (1845) was one among many exposés published in the late 1840s—at the height of female politicization and vocality—with the purpose of identifying contemporary women of ideas who were suspected of engaging in homosexual activity. The couple that was most titillating to Parisian audiences was George Sand and actress Marie Dorval. Several writers capitalized on the sensationalism of these *amours lesbiennes* to promote their own forays into sapphic fiction. Baudelaire, for example, previewed *Les Fleurs du mal* several times before its publication under the title *Les Lesbiennes*.[25] This contemporary fascination is re-created in Arsène Houssaye's chapter entitled "Où il n'est pas question du Rocher de Leucade" in *Les Confessions: Souvenirs d'un demi-siècle 1830–1880,* which explains how the name Sappho became synonymous in this period with female homosexuality. Houssaye's interest in the sexual preference of Sappho and the parallels between her life and that of the contemporary woman of ideas informs a series of works he published in *L'Artiste,* most notably a typological study comparing Plato with Jesus Christ and Sappho with Mary Magdalene, and a play entitled "Sapho."[26] The article that prob-

92. Théodore Chassériau.
*Sapho prête à se précipiter
du rocher de Leucade.* 1849.

ably stimulated the most interest in the poet and her sexual preference was socialist Emile Deschanel's "Etudes sur l'antiquité. Sappho et les lesbiennes" that appeared in 1847 in *Revue des deux mondes.* Deschanel challenges Ovid's fiction and reconfigures the double Sappho theory to argue that there were two Sapphos who were courtesans, one a lyre player and the other a poet of the highest rank. Deschanel argues that she was a courtesan because she could not be anything else; in ancient society the only women allowed the advantages and freedoms required to become great writers were courtesans. But the most significant aspect of his article, which altered the course of Sappho history in the nineteenth century, is the assertion that her poetry reveals her homosexuality.

Though it is not clear exactly how much this lesbian fetish influenced the plastic arts before 1850, it is clear that the title "Sappho" guaranteed notoriety and audience.[27] James Pradier's two uncommissioned sculpted versions of Sappho completed in 1848 and 1852 were nurtured in this climate. They in turn generated a great deal of commentary, much of

which focused on the artist's entrepreneurial sensibility. The 1848 *Sapho* (fig. 93) is an ornate, full-length standing figure of the poet/courtesan. The stateliness of her form and the extravagance of her elegantly draped tunic, jewels, and coiffure are contrasted with the languid droop of her head. Her chin has nearly slumped to her chest in despair, and her face is entirely self-absorbed, indifferent to the extravagance that surrounds her.

The dissonance between Sappho's interior and exterior life corresponds to Deschanel's widely read article, which at once redeems Sappho the courtesan (and subtextually the sexual practices of the modern woman of ideas) and diminishes Sappho the poet. The singularity of Pradier's approach to this subject is conveyed by Théophile Gautier, who expresses surprise that "La Sapho . . . est entièrement vêtue. . . . Ordinairement, il [Pradier] concentre la vie dans le torse, qui est pour lui le principal du corps humain" [The Sapho . . . is dressed . . . completely. . . . Usually, he (Pradier) would focus life on the torso, which is for him the most important part of the human body].[28] He characterizes Pradier's emphasis on the contemplative aspects of this female form as unusual for the sculptor: "La prédominance de la tête sur le reste du corps est un sentiment spiritualiste et chrétien ignoré de l'antiquité . . . et Pradier est un päyen pur, adorateur de Zeus, d'Hèrè, . . . et surtout d'Aphrodite" [The predominance of the head over the rest of the body is a spiritual and Christian idea, ignored by the ancients . . . and Pradier is a pure pagan, who worships Zeus, Hèrè, . . . and especially Aphrodite].[29] Pradier's restrained treatment of the poet's corporeal presence is most strikingly demonstrated by a comparison with an engraved copy (fig. 94) of the sculpture that was published in *L'Illustration* in 1848.[30] The copyist's version showcases and enlarges Sappho's breasts and hips, making her buxom and voluptuous shape the focus of the image.

Pradier's decision to identify the poet as a thinking courtesan can be explained in a number of ways. There was contemporary textual support for such an approach, and as I demonstrate in Chapter 4 in reference to representations of Mary Magdalene, there was a body of work that venerated the woman of ideas as a redeemed sinner uniquely qualified to serve as the prophetess of a new age. More likely, however, Pradier was reacting to what he perceived as one of the most marketable themes of his age, a theme that integrated contemporary interest in the messianic figure of the artist-melancholic; the usefulness of Hellenism to the redefinition of French culture, prostitution, and education for women; and the consequences of the increasing prominence of the woman of ideas.

Pradier is often described by his contemporaries as more a businessman than an artist. Though he sent many well-received, large-scale works

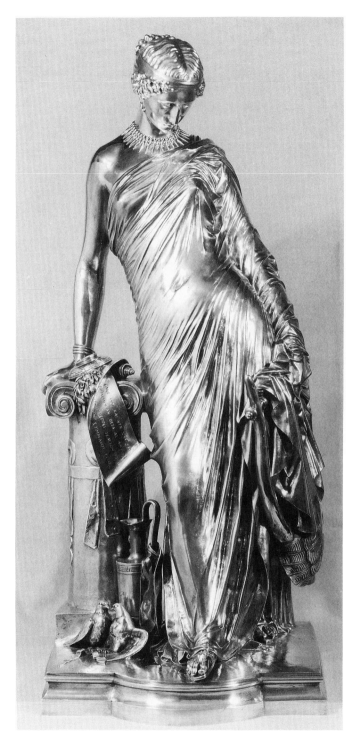

93. James Pradier.
*Sapho.* 1848.

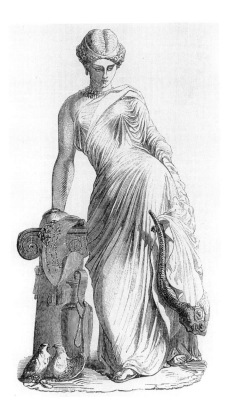

94. Engraving after
James Pradier. *Sapho.*
1848.

to the Salon, he is most often remembered for his popularization of stat-
uettes, small reproduceable sculptures of contemporary celebrities or senti-
mental subjects. The sculptor's mass production of these objects, which
appealed to bourgeois tastes, was likened to the way an orange tree pro-
duces oranges.[31] To critics arguing aesthetic purism or the social mission of
art, he was a degenerate seeker of celebrity, "en vendant des turpitudes
pour égarer, fasciner et démoraliser la jeunesse."[32]

The entrepreneurial possibilities of sculpture did appeal to Pradier.
When he was unable to sell the 1848 Sappho, for instance, he turned over
the rights of reproduction to the Maison Susse to guarantee the sculpture's
widespread dissemination in copies. Then, in December 1849 he cast an-
other version of the piece in silver to sell at La Loterie des artistes. His *Sapho*
was the featured item at the sale and the centerpiece of its advertising
campaign. The casting process and the extravagance of the new material
prompted a lot of commentary in the press about the sculpture's "value."[33]
In a detailed article that further enhanced the object's mystique, Théophile
Gautier likened the workmen to Vulcan and the process to some alchemical

miracle. The bottom line, according to Gautier, is "cinq mille francs d'art et vingt mille francs pesant d'argent."[34]

The publicity and notoriety of the 1848 *Sapho* motivated Pradier to create a second piece. Though the second monumental treatment of the poet was not completed until 1852, it appears that a popular statuette was circulated several years earlier. Thus, rather than making multiple small copies of a highly acclaimed monumental work, as was the usual procedure, Pradier capitalized on the success of his statuette to produce a large-scale version for the salon.

The conception of Pradier as a key player in the commercialization of the sapphic myth in this period is inscribed in Alphonse Daudet's 1884 novel *Sapho*, about a street whore with a heart of gold named Fanny Legrand. Fanny's chance at true love with a younger man, Gaussin, is threatened when he learns, bit by bit, of Fanny's former lovers. The hardest story to accept is her liaison with a sculptor named Cadoudal, for whose widely circulated statuette of Sappho she was the model. Gaussin is tormented by the memory of this cheap reproduction, which even he and his friends had manhandled. Daudet's account of the commodification of Sappho into a banal accessory of the bourgeois home was based on Pradier's capitalist venture. The success of the Sappho statuette was a function of its ability "to carry the antique type over into modern times and expose the modernity of ancient times."[35] Bourgeois audiences embraced the opportunity to mask their complicity in the lurid and unsettling aspects of contemporary female sexuality with a veneer of neoclassicizing dignity. Conflating the identities of the first woman of ideas and the contemporary prostitute in the form of an affordable and portable statuette, Pradier gave his patrons the power to possess and thereby defuse the threat of female deviance. The widely circulated sculptures contributed to the dehistoricization of Sappho that removed her from her temporal and historical context. In the early nineteenth century the poet was diminished by her generalization as a muse. By the mid-nineteenth century, the first woman of ideas was received as a *grisette,* just another creature of the sexual marketplace.

## The Author Portrait

It was not only the first woman of ideas whose representation was commodified during the July Monarchy. The same was true for her descendants in the form of the author portrait. Such a portrait, which was most often executed in a reproducible medium, was a possessable token of the cult of personalities marketed by entrepreneurial publishers and book sellers who sought larger readerships and subscription rates. The celebrity-

hood cultivated by and for writers came to rely heavily on cheap portable likenesses that were mass-produced in the form of medals, lithographs, engravings, and portrait statuettes of the type associated with Pradier.[36]

The marketing of authors was enhanced significantly by the infusion of women into this community of the famous, particularly women with a propensity for illicit love affairs and cross-dressing. The woman of ideas historically has been identified with the commercial aspects of literature as a means of denigrating her contribution. But it was precisely this process that provided women with the opportunity to circumvent culturally constructed barriers to their participation. New patterns of production, distribution, and consumption expanded the book industry that had, until 1830, produced fixed quantities for small, wealthy, homogeneous audiences. After 1830, in large part because of printing innovations that made publishing cheaper and faster, the book industry was transformed from a gentlemanly profession into a lucrative business that mass-produced titles for a clientele that was larger and more diversified.[37] This clientele created an unprecedented demand for a new product that did not require specialized, gender-biased training. The cultivation of women writers responded to need and to increased concern with marketing. The merchandizing of a writer's personal life and physical appearance was more successful when the subject was female. Like novel serialization, advertising, and price-cutting, the mass-production of writer portraits and the exploitation of the fetishistic fascination with the female body were just good business.

Many portraits of female intellectuals in this period were tied to the selling of a product. Some were commissioned by entrepreneurial publishers interested in using the authorial power of the printed word and image to secure the reputation and profitability of their writers. Others were arranged by the writer herself to contribute to the construction of the public fiction that was to define her celebrity and identity. Like the strategic adoption of male pseudonyms and the publication of novels that replayed infamous autobiographical anecdotes, portraits of women of ideas were often more expressive of a public myth than they were individual likenesses.

The selection of an artist for such a portrait was usually the by-product of a previous personal or professional relationship. Opportunities for writers to interact with visual artists were plentiful in the 1830s and 1840s. The burgeoning of women's magazines after 1830, like *La Mère de famille* (1833–36) and the *Journal des mères et des jeunes filles* (1844–47), provided one arena of contact. The *Journal des femmes* (1832–38), for instance, brought together Marceline Desbordes-Valmore, Eugénie Foa, Sophie Gay, Jules Janin, Alphonse Karr, and Eugène Sue with Achille and Eugène

Devéria. Similarly, the staff of *Le Musée des familles,* which began publishing in 1834, included writers Sophie Gay, Delphine de Girardin, Victor Hugo, and Frédéric Soulié, as well as the painters Horace Vernet and Henri Lehmann.

The visual and literary artists who contributed to such journals often met or were reintroduced under the auspices of one of several Paris salons. International communities of writers, politicians, artists, and philosophers gathered regularly at the homes of such notables as Marie d'Agoult and Christine Belgiojoso, where they collaborated on projects that ranged from the production of new journals to the illustration of books to the commissioning of portraits. As I have indicated, one of the most important July Monarchy salons, where cooperative ventures were concerned, was that of Delphine (Gay) de Girardin. Her guests included Victor Hugo, Pierre Ballanche, Honoré de Balzac, Eugène Sue, Virginie Ancelot, Jules Janin, Henri Lehmann, and Théodore Chassériau, among others. Her salon provided a particularly fertile environment for business projects because of her marriage to newspaper mogul Emile de Girardin, who wielded the power to underwrite and support any enterprise.[38]

Girardin's salon provided the inspirational ground for several special book projects launched in this period to capitalize on the trendiness of the femme-pensée. A large number of femme-auteur portraits were commissioned for reproduction in the *Biographie des femmes auteurs contemporaines* (1837), *Les Célébrités contemporaines* (1845), and *Heures du Soir, livre des femmes* (1833). These volumes offered a select audience a series of elegant books containing biographical sketches, poetry, short fiction, and engraved portraits of prominent contemporary women.[39]

The three women who inspired or choreographed the most provocative femme-auteur portraits during the July Monarchy were Louise Colet, Marie d'Agoult, and George Sand. Their appeal was a function both of their prolificity and of their sapphic proclivity for unconventional relationships with prominent younger men. The likenesses of these women were regularly mass-produced in the form of engraved portrait vignettes that were used as frontispieces in their novels and essays, illustrations for articles in the popular press, and celebrity prints. Many of these images were formulaic, presenting a half-length figure of the writer with her head in three-quarter profile; most often, their overlarge dark eyes stared inspirationally off into the distance à la Corinne and their small, determined mouths perched above firm chins. Many of the engraved portrait vignettes have a sameness about them, in part because they are of a reproducible medium several times removed from the original. The subtle variations in posture, gesture, coiffure, and clothing get lost in the narrow tonal range and pre-

scriptive approach to the female figure. But their similarity was also a function of their typological identity; they were meant to be identifiable first and foremost as femmes-auteurs and then as individual women. By reinvoking and genericizing the stance of the sapphic muse or the gaze of Corinne, these portraits offered a quick and cheap method of identifying a product with an infamous female type.

Though the example of Sappho's resistance was nearly effaced by her commodification, there were repeated attempts by nineteenth-century women of ideas to recover that example and make use of that commodification for their own purposes. The three authors discussed in the remainder of this chapter—Louise Colet, Marie d'Agoult, and George Sand—represent a spectrum of opposition that ranged from actually working within the social norm to problematizing and challenging it.

One femme-auteur who successfully worked the system, maximizing her opportunities for exposure, publicity, and monetary reward, was Louise Colet. Though Colet is remembered today principally as the mistress of Victor Cousin, Gustave Flaubert, Alfred de Musset, and Alfred de Vigny, she was also the author of several novels, more than eight volumes of poetry, two plays, more than ten books on historical or political subjects, and dozens of articles published in *Le Monde illustré, La Revue de mode, Le Moniteur universel,* and *Le Messager de Paris.* Self-consciously modeling herself after Germaine de Staël and Juliette Récamier, whose salons she had attended as a young woman, Colet was discovered early by Julie Candeille, who was a musician and actress. Candeille managed Colet's social and early professional life, teaching her the art of networking—of using social relationships to secure standing in the literary community. Colet launched her writing career in the mid-1830s, at first responding to the demand for poems and essays to fill the pages of the growing number of French journals and then enlisting the support of important friends with connections. One of her biggest promoters was songwriter and poet Pierre Jean de Béranger, who helped her publish her first collection of poems, *Fleurs du midi,* in 1836. In 1837, through her friendship with several important members of Louis Philippe's family, she was able to secure a place on the government pension rolls, where she remained for the rest of her life. In 1839 her reputation was dramatically enhanced when she won a prize from the Académie française for her poem about Princess Marie d'Orléans' acclaimed sculpture of Joan of Arc. It was the first of two prizes that she would receive from the Académie. Like Délphine de Girardin, Colet was able to form friendships with both supporters and opponents of the government, ensuring her long-term security in the publishing industry. Though her ambition and shrewd maneuvering was the norm rather than the exception

in the literary industry (and pales in comparison with a figure like Balzac), she was and continues to be characterized as an untalented opportunist.

During her period of career consolidation Colet became the close friend of another artist criticized for self-promotion, sculptor James Pradier. Though the date and circumstance of their meeting is unknown, their relationship was intimate enough by 1837 to prompt Pradier to execute a statuette of Colet, the modern woman of ideas whom he referred to as Sappho (fig. 95). Pradier had obviously begun thinking about the ancient lyric poet long before 1848, the date of his earliest Sappho sculpture. And, given his identification of Colet with the first woman of ideas, it is not surprising that he created such a marketable product.[40]

The statuette, which shows Colet stretched out along a strip of beach, is evocative of Sappho. But her "goddess sage" also derives from her connection with "Il Penserosa," a verse composed by Milton in 1632 about which Colet had written a series of poems in the late 1830s. Like Penserosa, whose "rapt soul sit[s] in [her] eyes" which "with a sad leaden downward cast" are [fixed] . . . on the earth,"[41] Colet stares down to the right, her lips closed tightly, her head resting on her right hand in a romantic cliché of Melancholy. Pradier repeated this formula for brooding melancholy two other times in his oeuvre: in a self-portrait drawn between 1835 and 1840 and in an undated statuette of Molière, the figure about whom Colet wrote, in 1843, her second prize-winning poem for the Académie française.

The statuette is a portrait of Colet, but it is also an advertisement for her next book of poems and an icon of a very marketable romantic sensibility. Pradier capitalizes on this highly valued bourgeois construct—the private thoughts of the individual—by making it available through cheap reproductions to anyone with a few francs and a mantel. He does not bother downplaying the exploitative aspects of his production as he would with the monumental figures of Sappho in the late 1840s and early 1850s when he is playing to salon juries and art critics. The disconcerting disjunction between Colet's head and body in this private image was meant to appeal to the audience for erotica. While the writer's face communicates a kind of serious abandonment to the world of thought, her awkwardly arranged body communicates sexual display. Pradier reinvokes the more lurid examples of the early-nineteenth-century muse portrait as he arranges the reclining Colet with an unnatural and uncomfortable frontality. Instead of allowing her to ease back into a seated pose, in which the hourglass symmetry of her body would twist out of sight, the sculptor props her up by the tailbone. Her upper and lower torso stiffen forward and allow us to read every contour through her tightly fitted costume.[42] This internal dissonance, more common in caricatural representations of the woman of

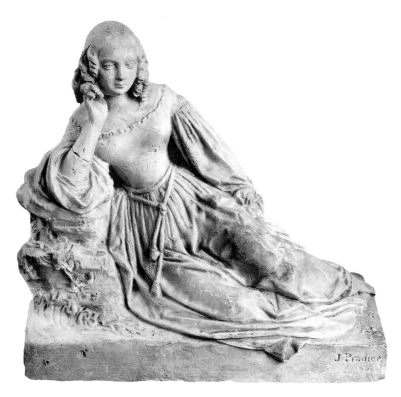

95. James Pradier. *Louise Colet*. 1837.

ideas, as in Alcide Lorentz's lithograph of George Sand, conveys female intellect as a pretense betrayed by the agenda of the body.

Another femme-auteur whose portrait was painted, drawn, or engraved on numerous occasions during the July Monarchy is Marie d'Agoult. Like Colet, she is remembered only in relation to a prominent male; she was the lover of Hungarian composer Franz Liszt. But while figurations of Colet capitulate to every available normalizing category of female behavior, representations of Marie d'Agoult contain elements of resistance. Agoult's identification with the Ovidian model of Sappho—her characterization as the muse who sacrifices everything for a younger man prone to infidelity—was first constructed by her contemporaries in the late 1830s in the popular press, in fictionalized versions of her humiliation, and in portraiture. Ironically (and unintentionally), it was the portrait executed by one of her closest and most devoted friends, Henri Lehmann, that most powerfully fixed her cultural identity as the muse of male genius and most effectively buried the record of her literary productivity.

When Liszt met Marie d'Agoult in 1835, she was married and had two children. To escape the disapproval and scandal their liaison generated, they left Paris, traveling first to Switzerland and then to Italy. During their stay in Rome in 1838 and 1839 in the community gathered about Ingres (then the director of the Villa Medici), Agoult and Liszt established friendships with a number of painters, including Ingres himself, Chassériau, Amaury-Duval, and Lehmann. The painter with whom Marie d'Agoult shared the closest relationship was Lehmann, who became a lifelong confidant.[43] The letters they exchanged throughout their lives reveal their devotion to each other. In 1839 the writer requested that Lehmann become godfather to Daniel, her first son with Liszt. Between 1839 and 1846 Lehmann painted or drew more than six images of the writer, the most famous of which is the half-length oil in tondo format at the Musée Carnavalet (fig. 96).

Lehmann completed the painting in 1843, several years after he and Agoult had returned to Paris. Surprisingly little has been written about this striking oil, which was executed during one of the most volatile and transformative periods of the writer's life. It is usually installed misleadingly in museum spaces as a pendant to Lehmann's portrait of Liszt (fig. 97), completed three years earlier. The authority of this coupling within the arena of the modern museum has permanently identified the two portraits as the passionate genius and the worshipful muse, and as an example of the angst and interaction among the arts that one associates with "the romantic era." Though, in fact, the paintings are narratively engaged, they do not preserve a record of the dominant-passive dynamic of Liszt and Agoult's relationship as their juxtaposition suggests. They document a time in which, despite Liszt's betrayals, Agoult remained constant. And they preserve a moment when, instead of submitting to despair, Agoult asserted her autonomous creative voice under the male pseudonym Daniel Stern.

Temporally, the portraits of Liszt and Agoult frame a period of intermittent separation that ultimately led to their permanent estrangement in 1844. Liszt began a several-year-long European tour that required him to be away a majority of the time. They corresponded frequently and were reunited for short visits, but the constant reports of Liszt's infidelities, both from friends and from the composer himself, created friction that resulted in the final rupture. These years were also marked for Marie d'Agoult by a series of breaks with old friends whose private and public successes were painful reminders of her precarious position. Most painful was her alienation from George Sand, with whom she and Liszt had spent time at Nohant and had introduced to Chopin. Envious of Sand's professional achievements and the mutuality of her relationship with Chopin, Agoult began in

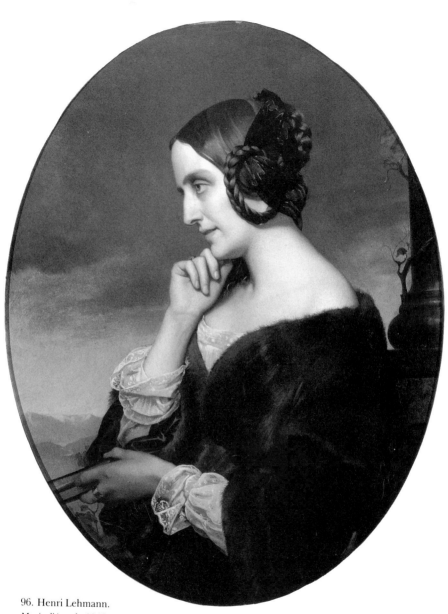

96. Henri Lehmann.
*Marie d'Agoult.* 1843.

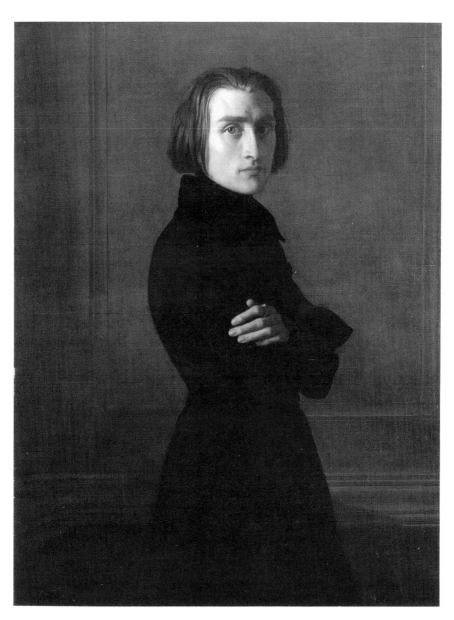

97. Henri Lehmann.
*Franz Liszt.* 1840.

the late 1830s to malign the novelist in letters and conversations.⁴⁴ This came back to haunt her in 1838, when Balzac began serializing his novel *Béatrix,* which recounts the victimization of the gifted and angelic writer Félicité des Touches (publically acknowledged as George Sand) by a vain, ambitious, and talentless bluestocking named Beatrix de Rocheguide (recognized by Balzac's readership as Marie d'Agoult). Outraged and certain that Sand was behind this assault, Agoult grew even more public and bold in her condemnations. In 1841 she began using her new forum, Emile de Girardin's newspaper *La Presse,* and the initial anonymity of the male pseudonym to ridicule Sand with the authority of the printed word. She savaged Sand's new novel, *Horace,* and promoted the work of her new community of friends, who came to know her in her new incarnation as Daniel Stern. Her articles and art reviews foregrounded writers and painters who were regulars at the salon she had reestablished in Paris after Liszt began his tour. This group, which she perceived as her loyal friends, included the artists who had gathered about Ingres at the Villa Medici in the late 1830s.⁴⁵ The subject of her art reviews and of the instruction she and Lehmann received during their meetings with Ingres in Rome in the late 1830s elucidates the 1843 portrait.

The format and composition of the half-length study (see fig. 96) build on several studies Lehmann made: a small painted head study completed in 1839 in Italy and two three-quarter-length drawings of the writer shown seated that were done in Paris in 1842. Though all three show the writer in profile engaged in deep meditation, they do so to quite different effects. The painted head study is in many ways closest to the final version for its iconic drama. The contrast of the ivory skin against the darkness of the costume and backdrop give the figure a power and three-dimensionality that could never be achieved in a drawing. It is a public image—*une médaille romaine,* as Champfleury dubbed it in his 1846 Salon review. Her turban, hair, face, and neck read as sinewy abstract shapes that rhyme interactively with the tondo and charge the picture. The 1843 portrait incorporates elements from each of the earlier drawings, but its final conception also was shaped by Lehmann's involvement with Ingres before and just after they returned to Paris and by the painter's impulse to produce an image that was consistent both with the public fiction of Marie d'Agoult and with the private vision these two friends shared.

One need only read Daniel Stern's early art reviews and Lehmann's letters to understand the significance of Ingres for both writer and painter. Several of Agoult's early art reviews were manifestos of loyalty to Lehmann's teacher. Her first article for *La Presse,* on 12 December 1841, for example, was a diatribe against Paul Delaroche's hemicycle paintings for

the Ecole des Beaux-Arts, a project that was generally well received but that Stern deemed unprincipled, full of contradiction, and antithetical to the example set by Ingres. Her first direct homage was published on 7 January 1842 in an article valorizing Ingres in the context of a private showing at his home of the *Portrait of Cherubini*.

The closeness of the relationship between Ingres and Agoult can be gleaned from the writer's correspondence with Lehmann, which indicates that Ingres was a periodic dinner guest at Agoult's home and a regular adviser to her on artistic matters.[46] Ingres' enthusiasm for Marie d'Agoult is verified in a letter she received from Lehmann in 1839 in which he insists that "Il [Ingres] ne cesse d'extasier sur votre esprit, sur votre amabilité, sur votre bonté."[47] That enthusiasm must, in part, have stimulated Ingre's interest in the series of portraits of Agoult that Lehmann began in 1839. But they must also have been of interest because of their relation to several projects in which Ingres was involved simultaneously and for which he had requested Lehmann's assistance.

In October 1840 Lehmann wrote to Agoult explaining that Ingres had enlisted his help on a painting that he was not at liberty to discuss.[48] From Ingres' journal we know that project was the *Portrait of Cherubini* (fig. 98). In a number of letters written in 1840 and 1841, Lehmann confided to his friend about his frustration at the amount of time his work for Ingres consumed and his distress over his inability to prepare the four canvases of his own, including the head study of Marie d'Agoult, that he had hoped to submit to the Salon jury.[49] His letters articulate the sense of duty that allowed him to subordinate his own needs to those of his mentor. Though the details of his responsibilities remain unclear, the highly secretive nature of the collaboration and Lehmann's continual apologies for being unable to reveal the content of his work suggest that he played a substantial part in the painting of the Cherubini portrait. The striking similarities between Lehmann's slightly later portraits of Mme Karr and Cristina Belgiojoso and the muse of lyric poetry in Ingre's *Portrait of Cherubini* raise the possibility that Lehmann painted the muse, a figure who was intended as the antithesis of the composer. While the shrouded figure of the brooding Cherubini—whose every wrinkle and facial line is exaggerated with the same naturalistic detail Ingres used for Louis Bertin ten years earlier—is the image of modern genius, the atemporal figure of the muse, whose Roman costume and facial mask are illuminated by a harsh white light, is an idealized apparition of antique beauty. The exaggerated symmetry of her presentation, the flawless oval face, the huge Sumerian eyes, and the aquiline nose foretell Lehmann's sphinx portraits of the mid-1840s.

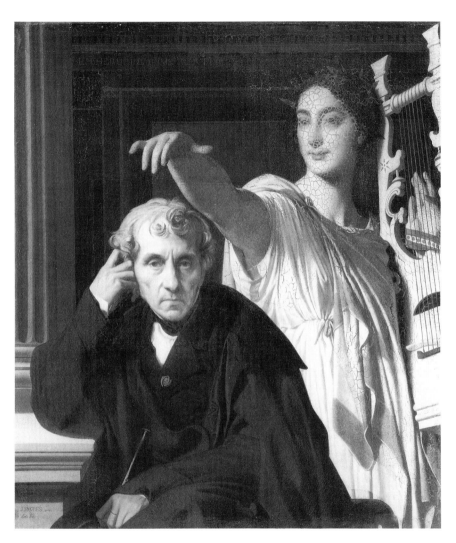

98. J. A. D. Ingres.
*Portrait of Cherubini*. 1842.

Ingres needed Lehmann's help in 1840 and 1841 because he was overextended in his work at the same time that he was involved in the tedious process of completing his tenure as director of the Villa Medici and moving his atelier back to Paris. Ingres had begun the *Portrait of Cherubini* in 1839; it was completed in 1842, only with Lehmann's help. Ingres was freed in 1840 to go back to work on *Antiochus and Stratonice,* a work commissioned six years earlier by Ferdinand-Philippe, the Duc d'Orléans. The interaction between Ingres and his student—which was constant in these years—significantly influenced the final conception of Lehmann's 1843 portrait of Marie d'Agoult.[50]

The precise evolution of the portrait is not described in the correspondence. It must have been a private afterthought following Lehmann's well-received exhibition of the 1839 head study of Marie d'Agoult at the Salon of 1842 and his completion of a commissioned portrait drawing in 1842.[51] Lehmann executed the drawing of Agoult (and probably conceived the idea for a portrait) just as Ingres was beginning work on his portrait *Comtesse d'Haussonville* (fig. 99).[52]

The parallels between Marie d'Agoult and Louise d'Haussonville had to have been apparent to Ingres and Lehmann. Haussonville, like Agoult, perceived herself as something of an outsider given her non-French, Protestant heritage. The former was born in Switzerland and the latter in Germany. Agoult's lifelong identification with the most influential woman of ideas and disseminator of German culture in the early nineteenth century, Germaine de Staël, provided an even stronger connection with Haussonville, who was Anne-Louise-Germaine de Staël's granddaughter. Within their respective literary communities, Haussonville and Agoult were renowned and respected for their beauty, intelligence, and political independence. Ingres, who moved between these communities, was privy to characterizations of both Haussonville and Agoult. Ingres met Haussonville at the Villa Medici in Rome in 1840, just after Agoult had returned to Paris. And he witnessed the launching of both women's writing careers, which began within six months of each other. A comparison of the portraits of these women of ideas suggests that these coincidences did not escape Lehmann, either. He appears to have appropriated one of the most talked-about conceits from Ingres' picture of Haussonville for his depiction of Marie d'Agoult.

Seen from its opposite vantage point, Agoult's right arm and hand mirror that of the Comtesse d'Haussonville. The verticalized arm of both women rests against the upper chest and terminates in identical gestures of contemplation. Commentaries on Ingres' portrait locate the source of that

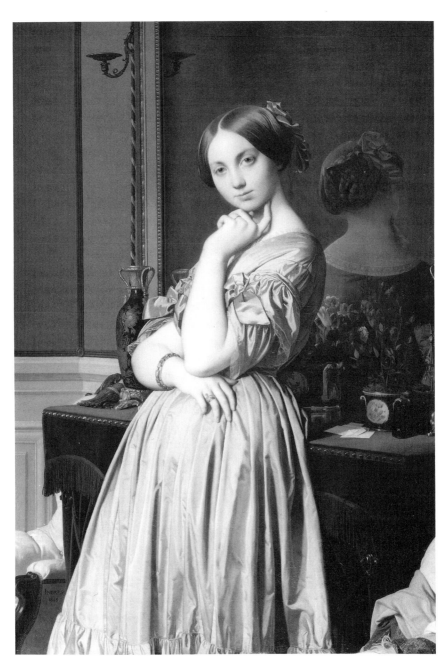

99. J. A. D. Ingres. *Comtesse
d'Haussonville*. 1845.

unusual gesture in his recently completed *Antiochus and Stratonice* and in ancient Roman painting and sculpture.[53] Ingres' practice of complicating and elevating the lowly genre of portraiture through art historical quotations was adopted by Lehmann, who also turned to antique prototypes for his study of a modern woman of ideas.[54]

In his 1843 portrait of Marie d'Agoult (see fig. 96), Lehmann conflates Haussonville's modern gesture of the female contemplative with a figural element from an ancient painting whose narrative intertextually engaged the life of his subject. Agoult's stance is a direct quotation from the Ulysses and Penelope mural in the Macellum in Pompeii. Her figure mirrors that of Penelope—with the exception of the hand gesture, which is Haussonville's. Versions of this gesture that signified the contemplative woman in the 1830s and 1840s had appeared in portraits of George Sand, Delphine de Girardin, and others. To some extent, Lehmann's precise duplication of the elegant variation Ingres used in his treatment of Louise d'Haussonville reflects the closeness with which he and his teacher were working in this period. But it is even more a function of his conception of the portrait as a kind of pastiche of in jokes, a rhebus of the private details of Agoult's life, and a testimonial to the intimacy of their friendship.[55]

Lehmann's decision to make Marie d'Agoult's pose echo that of Penelope was logical given the timing of their first meeting in 1838 and the content of many of their letters and conversations in the early 1840s. Lehmann was initially the confidant and portraitist of Liszt and Agoult, but during Liszt's absence he was primarily the devoted and ever-present friend of the writer, providing comfort and distraction from the frequent reports of her lover's infidelities. In spite of the constant humiliation she suffered through stories of Liszt's licentious behavior and, despite the overtures of a great number of men interested in taking his place (and Liszt's encouragement of their efforts), Marie d'Agoult remained faithful. It is her intelligence and virtue that Lehmann underscores by her figuration as Penelope.[56]

The painting's pastiche of quotations and details suggest that this is as much a portrait of her state of being as it is a record of her likeness. The Penelope allusion documents her admirable and unwavering fidelity, and the appropriation of Haussonville's hand gesture, together with the volume clutched in her left hand, signals her recent cultivation of an autonomous identity as the writer Daniel Stern. The harmonious integration of these temporally disparate elements is symbolized by a bizarre piece of foliage just behind the figure. Its solitary leaf and sparse tendrils echo the posture and curvy elegance of Agoult's silhouette. The foliage is an arabesque, a fashionable device among romantic writers and painters that is

used both to describe forms that are at once natural and exotic and to signify a transcendent recombination of seemingly unrelated or dissonant elements into a unified whole. Lehmann's conception of the portrait as a reconciliation of the disparate aspects of Agoult's life is presaged in a letter he sent to the writer in October 1839 describing his thoughts about a backdrop for his earliest rendering of her likeness: "J'ai supposé un fond tendu de soie gris bleu, entrecoupé par des pilastres Renaissance en stuc ou marbre violet à fond doré, ornés d'arabesques en grisailles" [I imagined a background with blue-gray silk hangings, interspersed with Renaissance pilasters in purple stucco or marble on a golden background, ornamented with arabesques in grisaille]. The network of arabesques he describes becomes, in 1843, a single emblem of the arabesque, which would have both fashionable public appeal and complex, private significance: "Il fallait une arabesque; au lieu de me rendre facile en la copiant, j'ai préféré me la rendre amusante en la composant et en donnant aux symboles les plus usités de cette époque-là, un sens éminemment zyotique, hiéroglyphique pour la masse ignare, intelligible seulement pour vous" [I needed an arabesque, and instead of making my task easy by copying it, I preferred to amuse myself by making it up and by giving the symbols most used at this time an eminently zyoptic meaning (a combination of exotic and Marie's nickname  Zy), hieroglyphic for the ignorant masses, and intelligible only for you.][57]

In spite of Lehmann's admitted concern with marketability, he intended to create a private homage to his friend that acknowledged both her fidelity and her newly established identity as a woman of ideas. Though Lehmann's portrait was a testimonial to Agoult's dismantling of the Ovidian sapphic paradigm (she launched her career and claimed her literary voice *after* her abandonment by a modern Phaon), the painting's permanent installation—like its display at numerous exhibitions of romantic imagery in the past fifty years—restores the writer to a normalized, deferential relation to Liszt.

George Sand was the only author able to recover a sapphic model of resistance during the July Monarchy and challenge the cultural objectification of the woman of ideas. There are more portraits of Sand than of any other woman of ideas in the mid-nineteenth century. Many of them are genuine and documentable; but many others have been identified with the writer only through a vague resemblance to one of the images with a verified provenance. The frequency with which these false identifications have been made was the subject of an article in the *Mercure de France* in 1924 that sought to discredit the misattributions. Although the article correctly

assesses the commercial motivations behind this practice, it sets up a false and misleading dichotomy between the pure and the impure portrait. It ignores the fact that most of the "real" portraits were also commercial ventures.[58] Most significantly, the article—like all subsequent treatments of this issue—ignores the question of why there have been so many portraits of women with features that resemble Sand's that greedy dealers have been able to claim them—and often have claimed them—as the nineteenth-century femme-auteur. What has remained unobserved is the phenomenon of the sphinx portrait, the variant on the femme-auteur that irritated Baudelaire for its rejection of the muse persona with which the woman of ideas was traditionally categorized. The sphinx portrait's reformulation of the femme-auteur portrait to emphasize the interiority of the sitter exclusively in physiognomic terms responded to the pictorial and physiognomic model of the most successful and respected woman of ideas, George Sand.

I raised this subject briefly at the end of Chapter 4 in the context of Delacroix's 1845 painting *Madeleine dans le désert* (see fig. 84). Placed beside other portraits of Sand, Mary Magdalene strongly resembles the writer. But, as I point out in Chapter 4, the same observation could be made if we compared the Delacroix to other femme-auteur portraits that had adopted the prescribed physiognomy of the modern woman of ideas. The hallmarks of bluestocking portraiture as described by Baudelaire—"The horror of little eyes . . . little brows, and cheeks glowing with joy and health"— describe George Sand. More than any woman of the period, her "books [were] in everybody's hands," and her "portraits [were] everywhere to be seen."[59] It was, therefore, logical for writers to identify themselves with and capitalize on Sand's eminence and visibility.

Those in the book trade assigned to market the growing body of work by women writers whose names and faces were still relatively unfamiliar, along with the core of painters like Jean Gigoux, Achille Devéria, and Julien Boilly, who significantly increased their income with lithographic female celebrity portraits, generalized from the likeness of the one female celebrity with international name and face recognition. The perception of Sand as the quintessential female intellect in relation to which all others were secondary informs an article published in 1844 in *L'Illustration*. According to both text and illustration Sand is "à la tête des femmes de lettres contemporaines."[60] In the engraved collage of portrait medallions that accompanies the piece (fig. 100), Sand's enlarged (it is double the size of the other six) and centered portrait floats encircled by the others, like the pistil to its petals or like Saturn to its moons. Sand's seriousness and self-presentation became the model, particularly after 1840, to which many

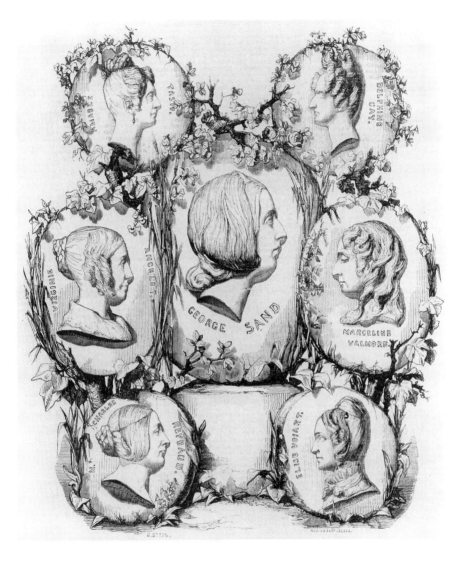

100. Anonymous engraving.
*Les Femmes de lettres françaises*
*contemporaines.* 1844.

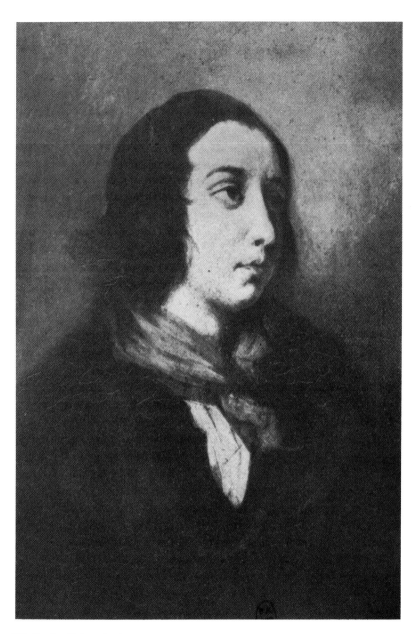

101. Eugène Delacroix. *George
Sand Dressed as a Man.* 1844.

femme auteurs conformed. Her elaborate and self-conscious construction of an authorial persona independent of the muse motif has had a lasting influence over the modern femme-auteur portrait.

One of the earliest and most well-known portraits of Sand is Delacroix's *George Sand Dressed as a Man* (1834; fig. 101), the painting that provided the first occasion for their meeting. Historically, the portrait has been considered noteworthy for its "romantic" qualities and its expression of Delacroix's new painting style. But it is more significant as the first visualization of the new female power Sand had achieved through her literary transvestism and easy manipulation of cultural codes of behavior. The picture, commissioned in 1834 by her publisher, François Buloz, editor of the *Revue des deux mondes*, was defined from the start as a commercial venture to promote the books and reputation of the author. The oil was to be engraved and reproduced for subscribers to his journal. The writer is shown from the chest up in a mannish frock coat and loosely tied cravat. She gazes melancholically up and off to the left. One of the most striking and evocative features of Delacroix's portrait is the blunt inelegance of Sand's short, cropped hair. The writer's letters and memoirs allow us to contextualize that detail and the image as a whole in relation to her recent break-up with Alfred de Musset.

Choreographing life to imitate art, Sand followed the example set by the heroine of her own novel *Indiana* (1832) and cut her hair as a dramatic gesture of remorse. She placed the hair along with a final love letter in a skull she purchased for the occasion and sent it to de Musset. Her diary entries for that period describe her much as she is seen in the painting. They tell of lonely evenings in the pit at the theater, where she wore men's clothes to accommodate her short hair and looked up into the boxes for a glimpse of de Musset. The entries also recall the sessions in Delacroix's studio during which she confided her difficulties and sought his advice.

Sand's portrait was both a merchandising strategy and an assertion of difference. An engraved version executed by Luigi Calamatta was published in the *Revue des deux mondes* on 15 July 1836 and was reused as the frontispiece for several of Sand's novels. The original by Delacroix hung in Buloz's drawing room and was considered one of the attractions of Paris for international literati. Buloz and Sand both seem to have understood the importance of circulating the myth of the writer in the form of a portrait that would intertextually engage the themes of her novels and the private details of her life. Several letters exchanged between Sand and Buloz debate the format and dimensions of the copies of Delacroix's portrait, not to mention the number of free prints she would receive for distribution to friends and associates.[61]

The portrait functioned for more than twenty years as part of an elaborate network of self-advertisement in the plastic and literary arts that capitalized on the Sand-de Musset relationship. In 1835, one year after Delacroix's portrait was completed, de Musset published his *Confession d'un enfant du siècle*, a novel based on his romance with Sand that made use of the love letters she returned following their rupture. And slightly more than twenty years later, just after de Musset's death in 1857, Sand produced *Elle et Lui*, an act of revenge in which de Musset is depicted as an irresponsible gigolo who abuses his truly talented and industrious mistress, Thérèse (Sand). To further capitalize on the popularity of this private-public fiction, Paul de Musset (who was not even a writer) avenged his dead brother by publishing *Lui et elle*, a novel that simply reversed the dynamic of the lovers' relationship established in Sand's prototype. Never one to be left out, Louise Colet, Alfred de Musset's last involvement, added a third volume to this chronicle. She used her book, entitled simply *Lui*, to lay Musset to rest and declare a new and truer affection for Gustave Flaubert.

The portrait of Sand, in part, must be seen within the context of strategies developed by men and women writers who needed to distinguish themselves in a crowded market. But while other women adopted, as Sand had, a male pseudonym, no one else constructed through costume, behavior, and literary output such a thorough and integrated challenge to gender conventions. Delacroix's portrait gives concrete visual authority to the double gender identity Sand had begun to cultivate as early as 1832, when she adopted her male pseudonym and masculine clothing and began generating fictional female characters with the traditionally masculine traits of intellect and free will. Her transvestism became the site of her power and diminishment. In the 1830s she was regularly characterized by admirers and detractors as "ni un homme, ni une femme."[62] For some, that transsexuality made her "tout simplement, . . . un des beaux génies littéraires qui aient lui sur le monde"[63] and for others the underlying cause of "la ruine de toutes les institutions sociales et de toutes les lois divines et humaines."[64]

Part of the power of Delacroix's 1834 portrait of Sand is its reinvocation and revision of what had been for a quarter-century the dominant portrait tradition for the femme auteur. Like the Corinne-inspired portraits of the early nineteenth century, Sand is shown looking upward for an inspiration that we presume exists outside of and apart from her own abilities. Though Delacroix's image retains that motif, the reevaluation of its apparatus has begun, a process most likely guided by Sand herself. Although the portrait maintains the gaze, it rejects the classical finish and romanizing details (the lyre, tunic, and turban), and with them the construction of the woman of ideas as muse. It presents an alternative to the

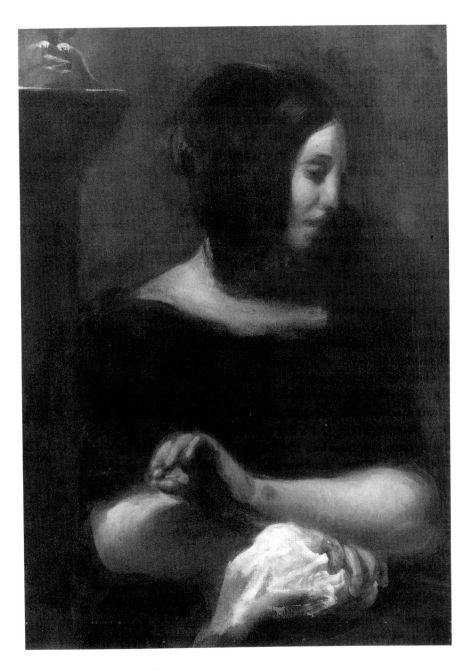

102. Eugène Delacroix. *Portrait
de George Sand* (fragment). 1838.

centuries-old sapphic fiction that one encourages female intellectualism not for its inherent value but for the pleasure and further stimulation of the male intellectual community.

Delacroix's second and unfinished portrait of Sand in 1838 (fig. 102), which demonstrably reflects the writer's concept even more than Delacroix's first portrait, further experiments with the muse motif that had predominated in femme-auteur portraits and preconditioned the reality of the woman of ideas. Originally part of a double portrait of Sand and Chopin, this canvas was cut into two images sometime between 1865 and 1873, probably for commercial reasons. Sand had to persuade Delacroix to do the joint portrait and a reluctant Chopin to sit for it. A piano was installed in Delacroix's studio on the rue des Maurais Saint-Germain, and the two were painted there, Chopin seated at the piano and Sand sitting behind him turned to her left, her eyes lowered and mouth slightly opened in a gesture of listening.

Sand probably was inspired to commission this private image as a result of her work on the five-act dialogue *Les Sept cordes de la lyre* (1838), which attempted in format and content something more philosophical than her novels of the early 1830s. Moved by the syncretist principles of Pierre Leroux's Christian humanitarianism, Sand went to work on this much less marketable book that articulated the new identity of a divinely inspired artist-priest whose mission was to synthesize and impart her wisdom to the public. Sand wrote of this period in her life as a turning point in which Pierre Leroux cured her of her romantic skepticism and self-involvement and introduced her to the more important purpose of "ardent charity, fraternity, equality, humanity in one word."[65]

Sand's conversion to Christian socialism in the late 1830s prompted a rethinking of personal and artistic goals that resulted in her reappraisal of the theatrical arts in terms of its messianic potential. She came to value the dramatic arts' inherent availability to synaesthetic forms that she believed could be used to regenerate larger and more economically diverse communities. Sand, who began writing plays in this period and ultimately opened her own theater in Nohant, reconceived the theater as a secular replacement for the church, wherein actors and actresses functioned as modern priests and the audience as devoted congregation. Like the rituals of the Catholic church, the theatrical production synthesized words, music, and visual stimuli (a combination she also used to characterize her relationship with Chopin and Delacroix). *Les Sept cordes de la lyre,* which she began writing in August 1838, just two months after her liaison with Chopin began, was Sand's earliest experiment with synaesthesia using aural as well

as visual effects. Choral singing and harp music are used to express the intuitive artistic impulses of a priestess character named Hélène, the daughter of a musician.

The dialogue focuses on the efforts of Albert, a philosopher-teacher, to disabuse Hélène of her foolish and nonscientific approach to art. Her lyre is taken from her and given to a sequence of false artists—a poet, a painter, a composer, and a critic—none of whom can produce music with it. But all Hélène need do is hold the instrument to generate transcendent harmonies. In each act Albert breaks another string on the lyre in an effort to find a rational explanation for the mystical alliance between Hélène and the instrument. Each break triggers a new debate that illuminates some aspect of the destruction, injustice, and violence that characterize the conventional male presence (symbolized by Albert) on earth. By the end, the roles of teacher and student have been reversed, and Albert, through his feelings for Hélène, becomes aware that love is the only permanent and worthy truth. Having accomplished her mission, Hélène breaks the last string herself and liberates her spirit and that of the lyre from its confining materiality. The play ends with the ascension of the redemptrice and the redemptive reeducation of Albert.

In addition to its exposition on true art, *Les Sept cordes de la lyre* was also a celebration of the ideal love that Sand shared with Chopin. The painting that she insisted Delacroix begin synthesizes the world of written, painted, and musical images through its representation of a dialectical process. The title of the play obviously reinvokes the muse tradition, specifically the muse of lyric poetry, whose attribute, the lyre, is the symbol of inspiration. But Sand and Delacroix reconceive this iconography and discard the premise of the female muse as a conduit who presides over the creative arts and gives the male poet his song. This double portrait overturns conventions of gender and atemporality associated with muse imagery. Far removed from the cold linearity and sculptural clarity of traditional treatments of the muse that rely on an ancient vocabulary of forms, this portrait blurs contours, invites the interpenetration of tones, and uses an agitated facture to express the sense of process and passionate immediacy. More significantly, it is the man, not the woman, who makes the music in this picture. It is Chopin who performs for her, who adopts the characteristically female outward gaze, and whose costume and posture eerily recall Delacroix's 1834 depiction of Sand. Sand assumes the traditionally male position of enchanted audience, absorbing and meditating on the inspiration of her male muse. As if to preempt any temptation to read her as a passive female presence, she holds in her left hand—the only part of her body that pro-

jects toward the viewer—a smoldering cigarette. Delacroix's reasons for leaving this work unfinished, and the owner's for cutting it into pieces, are unknowable. One can only conjecture about the nineteenth-century viewer's ability to process the reversal of that male-female dynamic as a harmonious whole.

George Sand exercised greater control over the construction of her authorial persona than any other woman in the period. The commission, conception, and dissemination of portraits was one of several methods she used to elicit and imprint her persona on French culture. In the prefaces to her novels, for instance, the place where theoretically the author's "real" voice—as distinct from the fiction that followed—could be heard, she constituted herself as a male subject, at once equal to and different from her male peers.[66]

Several of Sand's contemporaries appear to have been aware of and sympathetic to her strategic interplay of textual and visual imagery. In an 1841 article on George Sand, for instance, Théophile Thoré proposes that her portraits and novels demarcate the different phases of her life and work: "Et il se trouve, est-ce un hasard? qu'ayant été faits à certains intervalles, ils expriment à merveille les trois phases principales de sa vie et de son talent."[67] Thoré praises Sand for her brilliant choice of the passionate Delacroix to paint her portrait in 1834. He, who was engaged in a comparable challenge in the visual arts, was precisely the one to paint "l'auteur d'*Indiana*, de *Leone-Leoni*, de *Lélia* surtout."[68] Thoré identifies the second phase as a period of confidence and self-possession for George Sand epitomized by Auguste Charpentier's 1839 portrait (see fig. 23). "C'est l'auteur d'*André*, des *Lettres d'un voyageur*, [et] des *Lettres à Marcie*."[69] Charpentier was a student of Ingres' who had distinguished himself with a portrait of Alexandre Dumas at the 1837 Salon. Attracted to his portrait style, Sand called him to Nohant in April 1838 to paint her picture and those of her children. When Sand unexpectedly was called away to Paris, Charpentier remained at the estate to begin his studies of th ⌐ children and to formulate his thoughts about the writer. Those thoughts are preserved in the form of letters to his aunt: "I am still spellbound by this famous Madame Sand. . . . All of the things that are said about her are abominable calumnies. Mme Sand is the best mother and the finest woman one can imagine."[70] The calumnies to which Charpentier refers are most likely the charges of sexual aberrance that Sand, in a sense, invited by her androgynous self-presentation in the early 1830s. As I detail in Chapter 2, Sand volunteered her body in the early 1830s as the public site on which gender issues would be debated. By 1838, as Delacroix's later unfinished double portrait sug-

gests, the challenge had been registered and culturally imprinted, and a very different presentation was required to terminate Sand's identification with the waning "romantic revolution" and signal her utopianist reorientation under the influence of Pierre Leroux's Christian socialist humanitarianism. Charpentier's aesthetic sensibility—in every way different from Delacroix's—and reverential mission to rectify misreadings of Sand's ethical and sexual conduct made him an ideal candidate to execute the second public portrait of the writer.

Charpentier's picture is a three-quarter-length view of Sand resting her right hand on a chair that stands before her.[71] It is an image of maturity and confidence, without any explicit gender challenge. It is, however, like all portraits of Sand, a costume piece. Her current masquerade involves a Spanish motif. She wears a black satin long-sleeved dress that hugs her arms and waist and seems to merge with the diaphanous mantilla that hangs loosely off her dark mass of shoulder-length hair. The caliginous tones and tactility of her costume contrast dramatically with the bouquet of wildflowers in her hair and the pearly whiteness of her face and neck, which is replayed in the cameo at her waist and in a crucifix that hangs prominently and anomalously around her neck to announce her conversion. Her gaze is neither self-involved nor in pursuit of inspiration. It is a confident, fixed, and direct engagement of her audience. It is the first instance of the sphinx persona that came to dominate treatments of Sand and that appeared with greater frequency in representations of other women of ideas throughout the nineteenth and early twentieth centuries.

This portrait generated a great deal of positive reaction when it was shown at the 1839 Salon. Most agreed with Alexandre Decamps that the figure exuded "une si puissante intelligence, tant de fermeté de caractère unie à tant de bonté et de calme."[72] But other critics, particularly those with whom Sand was in direct competition, like playwright and journalist Jules Janin, specifically addressed the issue of her pictorial metamorphosis from femme-homme to belle femme as concrete evidence that she consorted with the devil. In describing this "tête de sphinx," Janin explains that "un simple dessin ne pouvait suffire à reproduire cette creature multiple. . . . La femme qui est belle, et l'homme qui est fort."[73]

The reconciliation of these two diverse natures—this male and female side, which Janin characterizes as sphinxlike—became a preoccupation of Sand's work after 1838 during what Théophile Thoré characterizes as the third phase of her career. In his article on Sand's portraits Thoré demarcates this phase by a remarkable image of the writer, drawn by Luigi Calamatta (1840; fig. 103), that provided the occasion for his discussion of Sand. The critic predicts that it is this image, in which her double gender is

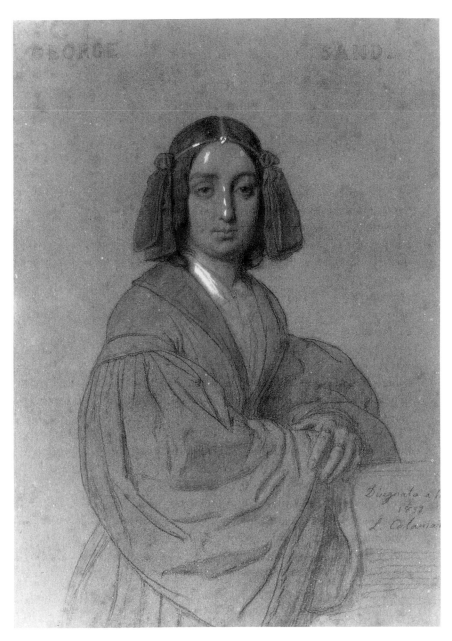

103. Luigi Calamatta.
*George Sand.* 1840.

naturalized and harmonized in an androgynous unity, by which she will be remembered and judged.

Calamatta and Sand met in 1835 when he was hired by François Buloz to execute the drawing after Delacroix's portrait that would be used to reproduce the image for publication in the *Revue des deux mondes*. Though Calamatta was mostly faithful in his reproduction of Delacroix's painting, he did schedule sittings with Sand and alter several details; most notably he restored the writer's long hair, which had grown back. This encounter began a long and close friendship between Sand and Calamatta. He became a regular visitor to her homes in Nohant and Paris, and she went out of her way to enlist the help of her journalist friends to advance his career. At one point she wrote an article commending Calamatta's engraving of Ingres' *Voeu de Louis XIII,* which she published in *Le Monde.*[74]

Thoré correctly characterizes Calamatta's 1840 drawing of George Sand as an image of a philosopher-priestess. In this highly classicizing drawing, Sand stands sagely in what look like magistrate's robes with her crossed arms resting on a block of carved stone. She poses "majestueusement comme un sphinx, femme par la coiffure, homme par le vêtements."[75] According to Thoré, this image of Sand as "the sphinx" and redemptrice will be the guarantor of her immortality. "C'est l'auteur de *Spiridion,* . . . et de ce roman . . . le *Compagnon du tour de France,* où le peuple est réhabilité par la beauté, l'intelligence et la vertu."[76]

During the 1840s Sand consolidated a modern sapphic identity that was compelling to both men and women. Her self-transformative powers, concretized in pictorial and written texts, challenged traditional categories of gender and replaced them with a new androgynous authority which she alone embodied. Physiognomically, she integrated male and female traits: "Toute la partie supérieure de la figure, le front, les sourcils et les yeux, indiquent l'artiste, pendant que le caractère de la femme se révèle dans la bouche et dans le ligne inférieure du visage."[77] Like other women of ideas in the early nineteenth century, Sand was figured in relation to an ancient Greek model of womanhood. But unlike her peers, who were historically contained by their identification with the normalizing category of muse, Sand managed to retain control over her own public myth, replacing the passive and victimized muse with a transcendent image of self-empowerment and authority—the sphinx.

# Conclusion

In an essay on the symbolics of power, Clifford Geertz writes that all political authority is constituted and authorized within a "cultural frame" or "master fiction." During the ancien régime the body of the king was the focal point of France's master fiction.[1] The displacement of monarchic authority in 1789 required the construction of an alternative, compensatory body of symbols. That alternative, generated by the propagandists for the new bourgeois republic, was as gendered and rooted in a politics of the body as the system it supplanted.

Female allegorizations of such political values as liberty, peace, and reason provided the most common substitutes for the iconic imagery of the king.[2] The classicizing, tranquil visages of these allegorical figures were useful in several ways. First, their generalized female forms offered a striking antipode to the particularized, patriarchal appearance of the king; their multiplicity and relative interchangeability clearly marked the transition from the rule of an individual monarch to a system of governance informed by democratic principles and implemented by "the people." Second, most of this imagery succeeded in camouflaging the violence and upheaval that had characterized the birth of the Republic.

Most, but not all. Interspersed with such reassuring figurations of cultural stability as the *Seal of the First Republic* (see fig. 3) is a different kind of female allegorical imagery—imagery that unsettles more than it calms

and that evokes rather than disguises political and social discord. This imagery, as I explain in Chapter 1, evolved in the context of female political activism during the French Revolution. It was an activism that spawned dialectical cultural mythologies of the woman revolutionary that persisted throughout the nineteenth century: the monstrous whore on the barricade and the heroic femme du peuple.[3] In the popular imagination these symbolic representations of female activism, responsive in part to the existence of "actual" women acting in the public sphere, came to inform the category of the woman of ideas.

Historians and social mythographers like Lynn Hunt and Marina Warner, who examine conventional female allegorical imagery of the late eighteenth and early nineteenth centuries inevitably remark on the discrepancy between the abstract attributes and powers associated with women by such imagery and the legal and economic state of actual French women in this period. Although I recognize the polemical force and legitimacy of such an observation I question the polarity it implies. The real and the symbolic are not mutually exclusive categories. There is a great deal of slippage between these two poles.[4] In many ways, that slippage has been the subject of this book.

In fact it may be more useful to speak of the real and the symbolic as interdependent—even mutually constitutive—agents and objects of social redefinition than as polarized entities between which perceptions slide. Historical figures like Héloïse and George Sand prompted the typological constructions of les bas-bleus and les femmes socialistes and were, in turn, culturally framed by these typologies. Both the historical figures and the typologies, moreover, activate and are activated by allegorical figurations of the beautiful and hideous republic. Thus the boundary between historical individual, cultural stereotype, and political symbol is inevitably blurred. Whether we speak of George Sand as the signifier of social upheaval in 1848 or of le bas-bleu as the incarnation of Germaine de Staël's Corinne or of the women on the barricade like Théroigne de Méricourt, we are speaking of a realm that is neither simply the actual nor the symbolic. The fluidity of this realm guarantees that any female body—the historical Sand, the typological bas-bleu, or the metaphorical Liberty—can be invoked as a kind of blank page, a site on which the narratives of French national and sexual politics can be penned.

As I argue throughout, state and sexual politics in late-eighteenth- and early-nineteenth-century France were scripted on the same imaginative site. The elaboration of a new national symbolics of power simultaneously entailed the articulation of an erotics of power. Both were

constructed on the doubly allegorized—idealized and monstrous—female body.

Thomas Rowlandson's *The Contrast* (1792; see fig. 4) offers an example from the late revolutionary period of the prevalent allegorical image that couples two female figures to establish a contrast between ideal and debased political principles. The choice is between a moral, law-abiding citizenry and the protection of private property signified by the classical restraint and noble countenance of British Liberty and the anarchism and cruel injustice encoded in the body of French Liberty—a wild-eyed furie with exposed breasts and the head of Medusa who is pictured gleefully standing atop a freshly decapitated body.

This kind of doubling image occurs during the July Monarchy as well, and in a similar context—the recovery of certain elements of the master fiction of the French republic after the 1830 Revolution. *La Belle et la bête* (fig. 104), for example, offers a critique of the challengers to Louis-Philippe's juste-milieu government. The print appeared in the 7 July 1833 issue of *La Charge,* a comic illustrated journal that frequently served as the mouthpiece of the "citizen-king." The journal was launched in 1832 in response to the success of *La Caricature,* which had achieved its own success in large measure through its satires of Louis-Philippe. *La Charge* is remarkable for its dearth of textual references to prominent actual women, or to

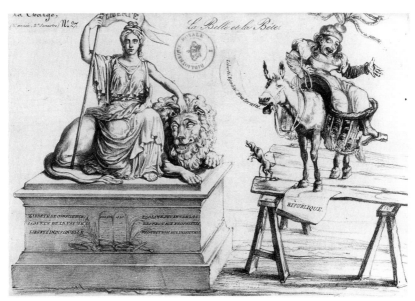

104. S. Durier. *La Belle et la bête.* 1833.

any women at all, for that matter. There is barely a mention of the Duchesse de Berry, Claire Demar, or Marie-Madeleine Poutret de Mauchamps, all of whom were strong challengers to July Monarchy politics. *La Belle et la bête*, which corresponds to numerous July Monarchy caricatures of the woman of ideas that juxtapose saintly and maternal women with demonic female deviants, offers insight into Louis-Philippe's strategy for negotiating his own ambiguous relationship to the oppositional heritages of the ancien régime and la Grande Revolution. It relies on a polarity of the beautiful and the grotesque female body to claim a distinction between the principles of the Republic and the Republic itself. Thus, one can safely identify with the principle of personal freedom emblematized by the heroic and classicizing figure of Liberté at the same time that one disassociates oneself from the Republic's gluttonous consumption of personal liberties, represented by a misshapen hag. The palatable and beautiful Liberté is dressed in toga and sandals; she is centered, frontal and erect, and seated atop a lion. Both icons of strength are supported by a rectangular stone base into which is carved the Charter of 1830 (the very guarantor of certain personal and intellectual freedoms—most notably freedom of the press—that had secured Louis-Philippe's power in 1830 and facilitated the journalistic climate that nearly led to his demise just two years later).

In contrast to the serenity and calm of la belle Liberté is the disfigured irregularity of la bête. The danger of excess freedom—the voices that taunted Louis-Philippe daily in the republican and legitimist press, for example, until he suppressed them in 1835—is personified as a hunch-backed shrew with only one good eye. Her jaw opens widely to reveal a set of rotting teeth, a detail mirrored by those of the braying ass on which she sits. The dignity of the most sacred attribute of the Republic, the Phrygian cap, is undermined by the addition of a bouquet of clownish ribbons on which are scrawled empty promises. The threatening instability of this mockery of republican values is objectified in the makeshift base, two randomly placed sawhorses.

The juxtaposition of the beautiful and hideous female body, informed as it is by the conventional view of divided womanhood, was a multipurpose paradigm. As I discuss in Chapter 3 in the context of Daumier's caricatures of the woman of ideas, its invocation could as easily silence feminist voices as undercut the most outspoken enemy of those voices: the masculinist ethos of French republicanism. There is no one way this paradigm works, and there is no one politics with which it is connected. The scripting of political commentary on the female body was equally common among legitimists and republicans.

Louis-Philippe's gendered narrative of the symbolics of power was

tailored to a very different set of needs than was its eighteenth-century model. Rather than announcing the replacement of monarchy with republic, the citizen-king's earliest narrative marked the reconciliation of France's competing legacies: dynastic authority and its revolutionary challengers, legacies that had been gendered as a male-female polarity. But because Louis-Philippe at once needed to identify with and contain these legacies to justify his tenuous claims to real monarchic authority, he chose a strategy of masculinization for both.

The majority of official images generated during his reign assert a masculinist authority. Louis-Philippe relied on the cultural frame of the female body only indirectly, for symbolic representations of the erotics of power. In the melange of monarchic iconography and republicanism that characterized the propaganda imagery of the July Monarchy, the bipartite contrast of female allegorical imagery often was collapsed into a single, doubly valent image. A second type of allegorical image that appeared with frequency in *La Charge* compresses the paradigm of female dividedness into a single figuration of female duplicity or dissimulation and draws on representations of the woman of ideas as a gender hybrid or male impersonator. *Une Vieille Fille* (fig. 105), published in *La Charge* on 17 November 1833, reinvokes counterrevolutionary imagery of the late eighteenth century to malign republicans and journalists at the same time. Here the timeless beauty of an idealized allegorical figure of the French Republic has been subsumed by a diabolical creature whose ambiguous sexuality signals a threat to bourgeois norms. The transsexual figuration of political threat stands waiting for the flimsy rhetorical justifications of a literal sans-culotte journalist scribbling at his-her desk to satisfy his-her appetite for random destruction. The bankruptcy of republican rhetoric is betrayed by a portrait bust of Robespierre that forms the apex of the pyramidal composition and the mass of dead bodies stuffed in provisions baskets beneath the "Manifesto of the Rights of Men."

The dangers implied in the contrast between la belle and la bête are personified in the brawny masculine creature wearing the dress of a working woman in *Une Vieille Fille*. The threat of his-her masquerade is conveyed in the genital description of the two collaborators pictured. While the sans-culotte journalist has only a table corner between his two bare legs, the allegorical figure of the Republic wields a butcher's knife between his-hers. The knife reads at once as male penile weapon and, more convincingly, as a female threat of castration, as the year "1793" emblazoned on it implies.

The confusion and transmutation of conventional gender identity and hierarchy was a tactic relied on often in *La Charge* as a means of diminishing republican challengers to the juste-milieu policies of Louis-

105. M. D. *Une Vieille Fille.* 1833.

Philippe. As I have suggested, this strategy was essential to bolster a consti-tutional monarch relegated to the traditionally female position of having to legitimize his claims to real monarchic authority. But this paradigmatic visualization of the erotics of power, this identification of targeted groups as the transsexualized voices of physiognomic misfits, was quickly turned back against Louis-Philippe himself. His masculinist political narrative was undermined regularly by its feminization. Thus Louis-Philippe's critics also scripted their political narratives on the female body.

The July Monarchy, for example, was regularly characterized as a matriarchy dominated by Louis-Philippe's politically astute sister, Ade-laide, and his erudite and literary daughter-in-law, Princess Hélène. Arti-cles in legitimist and republican journals alike warned of the unnaturally strong feminine influence within the July Monarchy government. In *Cinq ans d'un Grand Règne* (a title punning on the idea of a "reign" and a "reine," or queen), a satirical play that appeared in *La Mode* in 1835, the first five years of Louis-Philippe's reign are characterized as a regency. The crises of each year are personified by symbolic female figures who make up the cast.

Mme 1830, for example, is also referred to as *le cholera* and Mme 1832 as *la guerre civile*.[5] The tactic of exposing the actual female voices behind juste-milieu policy receives its most direct expression in a series of stories about "Lolo Phiphi" that were published in *La Caricature* in the early 1830s. Lolo Phiphi is identified as one of the new legion of women rulers in Europe that included Christine of Spain and Victoria of England.[6] In France, where the Salic Laws declare it illegal and unnatural for a woman to govern, the regendering of the king's body into a sexual hybrid raised all kinds of questions about his political legitimacy—questions that were already quite resonant in 1831. As James Cuno has demonstrated, Louis-Philippe was haunted in the early years of his reign by rumors and pamphlets circulating in Paris that questioned his paternity.[7] The story, in part, was generated from the tales about his father, the Duke d'Orléans, and his notorious infidelities. It was embellished with an elaborate narrative about baby swapping wherein the Duke and Duchess d'Orléans were purported to have exchanged their female infant for a male heir while traveling in Italy. The claim was that Louis-Philippe was in actuality an Italian jailkeeper's son.

Thus the figuration of Lolo Phiphi draws on the rumors surrounding his "authentic gender" and lineage. It raises the possibility that Louis-Philippe is the ultimate dissimulator, that the masculine body of the king is mere masquerade, and that his unnaturally feminized reign is the trace of his "actual" origins. Like the physiognomic and psychosexual metaphor of *la poire*, which was born at the same time and on the pages of the same journal, Lolo Phiphi was a sign of transgression that disrupted the normalizing narrative of manliness and family stability that Louis-Philippe had scripted.

Images conflating Louis-Philippe and the female allegorical figure of Liberty, wherein his body, too, becomes the passive site of masculine texts, where the authority of his "real" body is dissipated by its allegorization, offer the most powerful instances of this strategy of transsexualization. Images like figure 106, which appeared in *La Caricature* on 26 May 1831, represent Louis-Philippe as the satanic perpetrator of gender masquerade and fraud. Desperately clutching his "Ordonnances" in his raised right hand, Louis-Philippe is shown standing at the edge of a precipice. He casts a shadow on the stone wall behind him that reads as Liberty, the female allegorical figure of the new republic. In the shadow, the ordonnances appear as a dagger with which Liberty is about to commit suicide. Louis-Philippe's appropriation and betrayal of the revolutionary ideals of 1830 are frequently portrayed as this kind of transsexual nightmare (fig. 107). In *Le Chienlit crotte de toutes les manières* (1833; fig. 108), we see Louis-Philippe wearing the dress and Phrygian cap of Liberté. As the text that accom-

106. A. Dep. . . . . . . . . . . . *!!* 1831.

panies the image in *La Caricature* informs us, this "carnival freak" runs down the middle of the street ("le juste-milieu de la rue"), followed by jeering children, who dodge the feces he/she emits from all parts of his/her body. These conflations of Louis-Philippe and Liberté, in a sense, wield the most potent form of emasculation, in which the authority of his "actual" body is dissipated by its allegorization. It is a strategy emblematized by the castration image that frames the figure of "le Chienlit"—the angry-faced young boy just behind his/her raised skirts whose hand grasps an erect sword bearing at its tip a miniature poire.

The grotesque creatures of uncertain gender that were used to personify political threat in the pages of *La Charge* and *La Caricature* at this moment of revitalized female activism in both literary and political arenas have their counterparts in caricatures of the woman of ideas. Just as Louis-Philippe was cast as the threatening dissimulator, George Sand was demonized as a monstrous femme-homme, as the sign of social upheaval. As I

107. S. Durier. *Indécrottable . . . !* 1833.

le chienlit crotte de toutes les manières

L. de Becquet, rue Childebert N°9

On s'abonne chez Aubert, galerie vero d'odat

108. A. B. *Le Chienlit crotte
de toutes les manières.* 1833.

demonstrate in Chapters 2 and 3, the woman of ideas was typologized and analyzed obsessively during the July Monarchy, particularly during periods of revitalized press censorship of overtly "political" subject matter. Interest in such intellectual women as George Sand, Flora Tristan, and Jeanne Deroin derived from their increased visibility within the political arena and literary community. But as I have suggested, the woman of ideas also assumed an emblematic importance in this period that transcended her specific identity as novelist or suffragist. Neither courtesan nor Madonna, the intellectual woman signified an alternative female model in the nineteenth century that challenged the sanctioned gender categories of the bourgeois French republic. The ease with which she operated in the public domain of the mass media, her access to the discursive structures of French culture, and her intimate involvement in controversies over class fluidity and social reorganization made the woman of ideas an ideal emblem of political threat.

More than unearthing a body of understudied material or reconstructing an alternative nineteenth-century model of female empowerment, I seek in this book to reconstitute a symbolic discourse that cuts across distinctions between artistic genres and between high and low culture. I offer a way of seeing and reading images that have normalized or rendered invisible the social challenges to which they once responded. I demonstrate how art of the period functioned to reimpose a conventionalizing social framework on unruly female types. The fundamental challenge to the foundation of the French social order posed by the Revolutions of 1830 and 1848 could not be expressed in conventional political terms without exposing a strain of reactionary conservatism, and thus a confusing state of self-contradiction, in many of the ostensible revolutionaries themselves. Thus this challenge and the sense of threat it engendered often found expression and deflection in a visual and verbal vocabulary of primal male anxiety. The dark and hideous side of the revolutionary enterprise required a figuration that spared the revolutionary idea itself but that presented a scapegoat—something that one would logically seek to exorcise. That figuration was of grotesque and hideous womanhood.

# *Notes*

### Introduction

1. The phrase "woman of ideas" is borrowed from Dale Spender's book *Women of Ideas and What Men Have Done to Them* (London: Routledge and Kegan Paul, 1982), a book that attempts to explain why the history of female emancipatory efforts remains so inaccessible.

2. For a discussion of the notion of legitimate versus illegitimate pursuits for women in this period see Adéline Daumard, *La Bourgeoisie Parisienne de 1815 à 1848* (Paris: SEVPEN, 1963).

3. Joan B. Landes, *Women in the Public Sphere in the Age of the French Revolution* (Ithaca: Cornell University Press, 1988), 204. See also Dorinda Outram, *The Body and the French Revolution: Sex, Class, and Political Culture* (New Haven: Yale University Press, 1989).

### Chapter 1: The Woman of Ideas in France During the *Ancien Régime*

1. See Madelyn Gutwirth, *Madame de Staël, Novelist* (Urbana: University of Illinois Press, 1978), prologue; and Ellen Moers, *Literary Women* (New York: Anchor Press, 1977).

2. Adéline Daumard, *La Bourgeoisie Parisienne de 1815 à 1848* (Paris: SEVPEN, 1963), 359.

3. See Léon Abensour, *La Femme et le féminisme avant la révolution* (Paris: Editions Ernest Leroux, 1923).

4. There are many studies on the relation between socialism and feminism. For a discussion of the activities of the woman of ideas during the July Monarchy see Marilyn Boxer and Jean Quataert, eds., *Socialism and Women: European Socialism and Feminism in the Nineteenth and Early Twentieth Centuries* (New York: Elsevier, 1978).

5. Carolyn C. Lougee, *Le Paradis des femmes: Women, Salons, and Social Stratification in Seventeenth-Century France* (Princeton: Princeton University Press, 1976).

6. Lougee, *Le Paradis des femmes*, 99.

7. Evelyn Bodek, "Salonnières and Bluestockings: Educated Obsolescence and Germinating Feminism," *Feminist Studies* 3 (Spring–Summer 1976): 186.

8. Lougee, *Le Paradis des femmes*, 38.

9. See P. J. Miller, "Women's Education, Self-Improvement, and Social Mobility—A Late Eighteenth-Century Debate," *British Journal of Educational Studies* 20 (1972): 302–14.

10. Jean Larnac, in the seminal *Histoire de la littérature féminine en France* (Paris: Editions Kra, 1929), declares the eighteenth century as the most truly feminine in our history (139).

11. "Ordonnance des donations" (1731), article 9.

12. "On se plaint, en Perse, de ce que le royaume est gouvérné par deux ou trois femmes. C'est bien pis en France, où les femmes en général gouvernent, et non seulement prennent en gros, mais même se partagent en détail toute l'autorité" (Charles Montesquieu, *Lettres persanes* [1721; reprint, Paris: Editions Gallimard, 1949], 276).

13. Mary Durham Johnson, "'Old Wine in New Bottles': The Institutional Changes for Women of the People During the French Revolution," in *Women, War and Revolution*, Carol Berkin and Clara Lovett, eds. (New York: Holmes and Meier, 1980), 122–23.

14. See Frédéric Soulié, *Physiologie du bas-bleu* (Paris: Maison Aubert, 1842).

15. See Jane Abray, "Feminism in the French Revolution," *American Historical Review* 80, no. 1 (February 1975): 43–62; and Joan Landes, *Women in the Public Sphere in the Age of the French Revolution* (Ithaca, N.Y.: Cornell University Press, 1988).

16. Taxation populaire involved the appropriation of store merchandise and the negotiation of its fair price by popular vote. For a discussion of this phenomenon see Darline Gay Levy, Harriet Branson Applewhite, and Mary Durham Johnson, eds., *Women in Revolutionary Paris, 1789–1795: Selected Documents with Notes and Commentary* (Urbana: University of Illinois Press, 1979).

17. Levy, Applewhite, and Johnson, *Women in Revolutionary Paris*, 15.

18. Ibid., 22.

19. Claire Moses, *French Feminism in the Nineteenth Century* (Albany: State University of New York Press, 1984), 11.

20. Levy, Applewhite, and Johnson, *Women in Revolutionary Paris*, 4.

21. See Marina Warner, *Monuments and Maidens: The Allegory of the Female Form* (New York: Atheneum, 1985).

22. Lynn Hunt, "Engraving the Republic: Prints and Propaganda in the French Revolution," *History Today* 30 (October 1980): 14–15.

23. See Neil Hertz, "Medusa's Head: Male Hysteria Under Political Pressure," *Representations*, no. 4 (Fall 1983): 27–54; Catherine Gallagher, "More About Medusa's Head," *Representations*, no. 4 (Fall 1983): 55–57; and "Medusa's Head," in *Sexuality and the Psychology of Love*, Philip Rieff, ed. (New York, 1963). A concrete example of this confusion of the whore on the barricade with the heroic femme du peuple is an 1849 drawing by Achille Devéria in the collections of the Musée Carnavalet (D.8467). It is a nude female allegorical figure that Devéria appears to have used alternately as a study for his image of the new Republic and as a plate for his 1850 lithographic series entitled *Filles d'Eve*. The historical individual who provided much of the metaphorical substance for these allegorizations of political chaos was the late-eighteenth-century activist Théroigne de Méricourt. (On the persistent power of Méricourt in the nineteenth-century imagination see Albert Boime, *Thomas Couture and the Eclectic Vision* [New Haven: Yale University Press.]) The cross-dressed Théroigne de Méricourt also figures in Alphonse de Lamartine's *Histoire des Girondins*, in which he characterizes the mob moving toward the Tuileries as made up of

three distinct groups: "(a) bataillons des faubourgs armés de baionnettes; (b) hommes du peuple, sans armes; (c) horde pêle-mêle confus d'hommes en haillons, de femmes et d'enfans, suivait en désordre une jeune femme, vêtue en homme, un sabre à la main, un fusil sur l'épaule et assise sur un canon trainé par des ouvriers aux bras nus. C'etait Théroigne de Méricourt" (quoted in "Un Fragment de l'Histoire des Girondins par M. de Lamartine," *La Mode*, 16 March 1847, 470).

24. Marquis de Marie-Jean Antoine Condorcet advocated full political equality for women. See Condorcet, "The First Essay on the Political Rights of Women," in *Sur l'admission des femmes au droit de cité*," trans. A. D. Vickery (Letchworth, Eng.: Garden City Press, 1912).

25. In his 1849 study *Histoire morale des femmes*, Ernest Legouvé quotes several post-Revolution antifeminist reactions, including this paragraph from *Le Moniteur* du 9 Brumaire, 1793: "Les femmes peuvent-elles exercer les droits politiques et prendre une part active au gouvernement? Peuvent-elles déliberer, réunies en sociétés populaires? Le comité s'est décidé pour la negative . . . les femmes sont peu capables de conceptions hautes, de meditations serieuses, et leur exaltation naturelle sacrifierait toujours les intérêts de l'état à tout ce que la vivacité des passions peut produire de désordres" (405).

26. See Carol Duncan, "Happy Mothers and Other New Ideas in Eighteenth-Century French Art," *Art Bulletin* 55 (December 1973): 570–83.

27. "Lequel vous donne meilleure opinion d'une femme . . . de la voir occupée des travaux de son sexe, des soins de son ménage, environnée des hardes de ses enfans, ou de la trouver écrivant des vers sur sa toilette, entourée de brochures de toutes les sortes?" (Jean-Jacques Rousseau, *Emile, ou de l'éducation*, vol. 2 [Paris, 1762], 98).

28. Ibid.

29. "Mais j'aimerois encore cent fois mieux une fille simple et grossierement élevée, qu'une fille savante et bel-esprit qui viendroit établir dans ma maison un tribunal de littérature dont elle se seroit la présidente. Une femme bel-esprit est le fléau de son mari, de ses enfans, de ses amis, de ses valets, de tout le monde. De la sublime élevation de son beau génie, elle dédaigne tous ses devoirs de femme, et commence toujours par se faire homme à la manière de Mlle de l'Enclos" (ibid., 98).

30. Germaine de Staël, *Oeuvres complètes de Madame La Baronne de Staël-Holstein*, vol. 1 (Paris: Firmin Didot Frères, 1844).

31. "Ces lettres sur les écrits et le caractère de J. J. Rousseau ont été composées dans la première année de mon entrée dans le monde; elles furent publiées sans mon aveu, et ce hasard m'entraîna dans la carrière littéraire" (*Oeuvres complètes de Madame La Baronne de Staël-Holstein*, 1: 1). This reevaluation of Rousseau is discussed by Vivian Folkenflik in *An Extraordinary Woman: Selected Writings of Germaine de Staël* (New York: Columbia University Press), 40.

32. "Et que devrait-on penser d'un époux assez orgueilleusement modeste pour aimer mieux rencontrer dans sa femme une obéissance aveugle qu'une sympathie éclairée? Les plus touchants exemples d'amour conjugal ont été donnés par des femmes dignes de comprendre leurs maris et de partager leur sort, et le mariage n'est dans toute sa beauté que lorsqu'il peut être fondé sur une admiration reciproque" (*Oeuvres complètes de Madame La Baronne de Staël-Holstein*, 1: 2).

33. See Chapter 5 for a full discussion of De Staël's treatment by Napoleon's retinue. For a nineteenth-century account of Germaine de Staël's influence and of the paradigmatic circumstances that produced a woman of ideas see Elisa de Mirbel, "Biographie de Mme Guizot," *Journal des jeunes filles*, no. 8 (August 1846): 248–51.

34. *Oeuvres complètes de Madame La Baronne de Staël-Holstein*, 1: 302.

35. Moers, *Literary Women*, 174.

36. "Un des premiers devoirs des éditeurs de ce recueil, destiné plus particulierement aux femmes" ("Anne-Louise-Germaine Necker, Baronne-Holstein," *La Mode*, January–

March 1830, 74). Bejamin Constant and Germaine de Staël shared a very close personal and professional relationship. They had organized together, for example, the Cercle constitutionnel to combat the Clichyens.

37. "Cet hommage de leur part est un témoignage incontestable de leur respecteuse admiration pour le sexe dont Mme de Staël a été proclamée le Voltaire" (ibid.).

38. Ibid., 75.

39. Ibid., 77.

## Chapter 2: *Le Monde Renversé:* July Monarchy Typologies of the Woman of Ideas

1. There is a substantial body of literature treating this question. See, e.g., Fanny Mongellaz, *De L'influence des femmes sur les moeurs et les destinées des nations* (Paris: L. G. Michaud, 1828); Edouard de Laboulaye, *Recherches sur la condition civile et politique des femmes depuis les Romains jusqu'à nos jours* (Paris: Brockhaus et Avenarius, 1843); and Marc-Antoine Jullien, "Esquisse d'un plan de lectures historiques: A l'influence des femmes considerées dans les différents siècles et chez les différentes nations," *Journal des femmes* (three parts), 6 October 1832, 165–68; 13 October 1832, 185–89; and 20 October 1832, 205–10.

2. *Les Héroïnes parisiennes, ou actions glorieuses des dames, leurs traits d'esprit et d'humanité* (Paris: Pinard, 1830).

3. On the construction of mythic fictions about the historical figures on which Delacroix's *Liberty* appears to be based see Marcia Pointon, *Naked Authority: The Body in Western Painting, 1830–1908* (Cambridge: Cambridge University Press, 1990). The Salon of 1831 catalogues for the "Exposition au profit des blessés, 27, 28, 29 juillet 1830," held at the Musée Royal, list a painting by Hautier of a woman ignoring danger to help a soldier and one by Aubois of a woman dressed as a male soldier.

4. "Les régiments de l'ancienne France c'est enrôlement; les armées de la France nouvelle c'est la levée en masse" ( John Grand-Carteret, *La Femme en culotte* [Paris: Flammarion, n.d.], 36).

5. On the collectivist activities of women see Helga Grubitzsch, "Women's Projects and Co-operatives in France at the Beginning of the Nineteenth Century," *Women's Studies International Forum*, no. 4 (Gronigen, Netherlands: 17–21 April 1984), 279–86.

6. Natalie Zemon Davis, *Society and Culture in Early Modern France* (Stanford: Stanford University Press, 1965), 131.

7. For a discussion of the state of the feminist movement between 1793 and 1830 see Claire Moses, *French Feminism in the Nineteenth Century* (Albany: State University of New York Press, 1984). There was very little feminist activity in that period. The Napoleonic Civil Code had legally inscribed the subordination of women in 1804. There were a few instances of activism, such as the establishment of a free woman's university in Lyon, L'Athénée des femmes, in 1808, and publication of the novels of Germaine de Staël, but only the change in press censorship laws in 1830 provided for a real outlet for a feminist agenda.

8. François-Marie-Charles Fourier, *Théorie des quatre mouvements et des destinées générales* (Paris: Bureaux de la Phalange, 1841). For an analysis of the parallel developments of feminism and socialism see Barbara Taylor, *Eve and the New Jerusalem* (New York: Pantheon Books, 1983).

9. On the battle between Enfantin and Bazard for leadership of the movement see *La Mode,* January–April 1832, 185.

10. The recruitment balls held by the Saint-Simonists were written about frequently in the press. See, e.g., "Une Histoire romantique, Place de la Chaussée D'Antin," *La Mode,*

July–October 1833, 192–97; and Alida de Savignac, "De l'anarchie en morale et des sectes en 1832," *Journal des femmes*, 27 October 1832, 225–27. "Une Histoire romantique" is a fictional account of a young girl with literary tastes who is sucked into the Saint-Simonist world and then corrupted with excesses. De Savignac's article attempts to analyze the particular vulnerability of young French women to the lures of Saint-Simonism.

11. Suzanne Voilquin uses this term to describe the women in the movement in her *Souvenirs d'une fille du peuple ou la Saint-Simonienne en Egypte,* (1866; reprint, Paris: François Maspero, 1978).

12. There are aspects of Saint-Simon's biography that do prefigure the feminist orientation of his followers. Saint-Simon, for example, purportedly went to Germaine de Staël while she was still married and declared: "Madame . . . vous êtes la femme la plus extraordinaire du monde, comme j'en suis l'homme le plus extraordinaire; à nous deux ferions sans doute un enfant encore plus extraordinaire" (quoted in L. Reybaud, "Socialistes modernes," part 1, *Revue des deux mondes* [1836]: 291).

13. "Organisation religieuse: Le Prêtre—l'homme et la femme," *Globe*, 18 June 1831.

14. P. Bazard, "Aux Femmes sur leur mission religieuse dans la crise actuelle," *L'Organisateur* (Rouen: D. Brière, 1831).

15. Prosper Enfantin, *Réunion générale de la famille, 19–20 November 1831* (Paris: Bureau de Globe, 1832), 52.

16. Moses, *French Feminism*, 65.

17. Ibid.

18. Laure Adler, *A L'Aube du féminisme: Les Premières journalistes, 1830–1850* (Paris: Payot, 1979), 37.

19. Moses, *French Feminism,* 258.

20. There is a similar charge leveled against poet Sophie Gay in an article that appeared in *La Mode,* 15 September 1835, 287. Josephine Lébassu published a novel, *La Saint-Simonienne* (Paris: L. Tenre, 1833), that attempted to redeem the reputation of Démar.

21. "Pourquoi n'essaierait-on pas aujourd'hui de lever une bannière autour de laquelle se rangeraient tous les courages? Ce but est le nôtre . . . nous venons aider ces Femmes dans leurs nobles efforts, en créant un Journal qui leur sera entièrement consacré; et, pour montrer à la Femme ce dont elle est capable, nous lui mettrons sous les yeux ce qu'elle a fait déjà" (*Le Citateur féminin. Recueil de la littérature féminine ancienne et moderne* 1 [January 1835]: 1–2).

22. Ibid., 278.

23. La Baronne d'Arthez, "La Jeune fille poète," *Le Journal des jeunes filles,* March 1846, 65–72. La femme pensée is also the persona of Appoline de Sorange in Antoinette-Henriette Clémence Robert's novel *Une Famille s'il vous plaît* (1838).

24. M. Lerminier, "Sur l'histoire de la femme," *La Mère-institutrice et l'institutrice-mère*, October 1834, 2.

25. Ibid.

26. *Journal des femmes*, 6 April 1833, 168.

27. Nanine Souvestre, "L'Empire d'une femme est son ménage," *Journal des femmes*, 1 September 1832, 65. One of the many arguments for shaping the education of women to their domestic mission can be found in "De l'éducation des femmes," *Journal des femmes*, 25 December 1836, 404–6. A powerful complication of the dichotomous view of womanhood can be found in Anne M. Wagner's "Lee Krasner as L. K.," *Representations*, no. 25 (Winter 1989): 42–56.

28. "C'est par l'influence des femmes, bien dirigée, qu'on peut régénérer les hommes, réformer l'éducation et la législation, améliorer les moeurs particulières et publiques, calmer les passions haineuses, prévenir les discordes funestes, faire peut-être un jour cesser le déplorable fléau de la guerre, adoucir enfin la plupart des maux qui désolent la triste humanité" (*Journal des femmes*, 20 October 1832, 209). The regenerative powers and

responsibilities of the mère-éducatrice also form the subject of L. Aimé-Martin's *De L'Education des mères de famille, ou la civilisation du genre humain par les femmes* (1834) and Marc-Antoine Jullien's "A L'Influence des femmes considérées dans les différents siècles et chez les différentes nations," *Journal des femmes*, 20 October 1832.

29. See Patrick Bidelman, *Pariahs Stand Up: The Founding of the Liberal Feminist Movement in France, 1858–1889* (London: Greenwood Press, 1982), 31.

30. Mélanie Waldor, "De l'Influence que les femmes pourraient avoir sur la littérature actuelle," *Journal des femmes*, 20 July 1833, 223–25.

31. For contemporary reactions to this relation see "De la librairie," *L'Artiste* 2 (November 1845): 13–15; and "Bohème littéraire," *Le Charivari*, 2 February 1844, 2. The commercialization of literature through such gimmicks as rewarding book purchases with free lottery tickets is discussed in "Récompense honnête," *La Mode*, October 1835, 161.

32. James Smith Allen, *Popular French Romanticism: Authors, Readers, and Books in the Nineteenth Century* (Syracuse: Syracuse University Press, 1981), 155. An excellent discussion of the literary institutions in modern French culture can be found in Priscilla Parkhurst Clark, *Literary France: The Making of a Culture* (Berkeley: University of California Press, 1987).

33. See "The Paris of the Second Empire in Baudelaire," in Walter Bejamin, *Charles Baudelaire: A Lyric Poet in the Era of High Capitalism*, trans. Harry Zohn (London: NLB, 1973), 35. On the marketing strategies for La Maison Aubert publications see James Cuno, "Charles Philipon and La Maison Aubert: The Business, Politics, and Public of French Caricature" (Ph.D. diss., Harvard University, 1985).

34. In fact, Gavarni himself wrote fiction and poetry. *Madame Acker* is one of his published novels. For a full discussion of Gavarni's close personal and professional relationships with women writers in the 1830s and 1840s see David James, "Gavarni and His Literary Friends" (Ph.D. diss., Harvard University, 1942). For the definitive cataloguing and contextualization of Gavarni's oeuvre see Annette Leduc, Ph.D. diss., Johns Hopkins University, 1991.

35. This aspect of Gavarni's life is treated in detail in Edmond and Jules de Goncourt, *Gavarni, l'homme et l'oeuvre* (Paris, 1925).

36. Gavarni illustrated "La Glace," which was published in *L'Artiste* in 1832 under Abrantes's pseudonym, Constance Aubert.

37. Coverage of Marie-Caroline's plight dominated the pages of *La Mode*, a royalist journal under her patronage. The many articles and editorials on the subject that appeared between 1832 and 1834 usually poked fun at how she could make Louis-Philippe tremble in his boots.

38. See Maurice Taesca, "Un Dîner joyeux chez George Sand," *Revue des deux mondes* 8 (1983): 340–44. The masked ball was an extremely popular social phenomenon during the July Monarchy. The favored activity on these occasions appears to have been the identification of cross-dressers. Constance Aubert details the nature of the sport and the climactic moment of discovery in "Un Bal travesti," *Psyche. Journal de modes. littérature, théâtre, musique* (23 February 1848), 1402–1403. For a compelling recent study of the politics of cross-dressing see Marjorie Garber, *Vested Interests: Cross-Dressing and Cultural Anxiety* (New York: Routledge, 1992).

39. I discuss Sand's orchestration of her public persona in the context of the portraits she had commissioned at length in Chapter 5.

40. Charles Baudelaire called Sand "the Prudhomme of immorality. . . . It is indeed a proof of the degradation of the men of this century that several have been capable of falling in love with this latrine" (Charles Baudelaire, *Intimate Journals,* trans. Christopher Isherwood [New York: Howard Fertig, 1977], 33–34). Much discussion of Sand as an insidious cultural influence was generated in the popular press. See, e.g., Mme Simon-

Viennot, "Célébrités contemporaines: Influence de George Sand," *Journal des mères et des jeunes filles,* May 1844–April 45, 200–211.

41. This paradigm informs "Silhouette biographique: Lettres au peuple par George Sand," *La Silhouette,* 9 April 1848, 1: "George Sand n'a jamais été qu'un écho, écho sonore et magnifique; mais il a fallu toujours qu'il empruntât une voix, tantôt la voix cassée et chevrotant de Pierre Leroux."

42. "Galerie Contemporaine: George Sand," *La Mode,* September 1835, 177. Though the piece is unsigned, Janin did put his name to other versions of the article that appeared in 1835 and 1836.

43. Ibid., 178.

44. Ibid., 177.

45. Ibid.

46. On 16 August 1884, *Le Monde illustré* republished this image as part of a four-page illustrated biographical feature on the unveiling of Aimé Millet's life-size commemorative statue of Sand in La Châtre. The story identifies it as a caricature produced in Bourges in 1848. The image pictures Sand "giving birth" to a host of her male socialist friends, including Duvernet, Fleury, and Planet, friends she protected and sheltered in the aftermath of the Revolution of 1848. It is actually uncertain what the tone of this image is. It does not seem to demonize Sand, as several textual accounts in these years do. Rather, it appears to draw on late-eighteenth-century popular prints of "women of the people" effortlessly giving birth to a new generation of citizens.

47. "Profils républicains: George Sand," *La Mode,* November 1848, 979–88.

48. Ibid.

49. To think of the legitimist and republican presses as opposite sensibilities is wrongheaded. They were united on a number of issues, particularly on attitudes toward female activism. In fact, during spring 1848 a number of caricatures of the woman of ideas appeared in both *La Mode* and *Journal pour rire.*

50. In "L'Inventeur(e) du club des femmes," which appeared in *Journal pour rire* on 20 May 1848, Poutret de Mauchamps's *Gazette des femmes* is named as the precursor of *La Voix des femmes.*

51. The recognition of the class fluidity within this community is the subject of "La Voix des femmes," *Journal pour rire,* 13 May 1848, 4.

52. The lithograph was published in *Le Charivari* on 31 March 1848, 3.

53. The memoirs of Daniel Stern (Marie d'Agoult) and Maxim Du Camp are particularly attentive to this aspect of the Revolution. See Marie d'Agoult, *Histoire de la revolution de 1848,* 5th ed. (Paris: Comon, 1848); and Maxine Du Camp, *Souvenirs d'un demi-siècle* (Paris: Hachette, 1849).

54. For a thorough discussion of these images see Laura Strumingher, "The Vésuviennes: Images of Women Warriors in 1848 and Their Significance for French History," *History of European Ideas* 8, nos. 4–5 (1987): 451–88. Part of the campaign to discredit the Vésuviennes involved conflating their identities with those of the *Voix des femmes* group, even though they were opposed on many issues. Articles like "Autres Bas-Bleus" (*Journal pour rire,* 5 May 1848, 3–4) deliberately and misleadingly confused them with the bluestocking as well.

55. See, e.g., *La Silhouette,* 16 July 1848, 3.

56. Moses, *French Feminism,* 145.

57. Ibid., 147–48.

58. Délphine de Girardin, "Revolution," *Chroniques parisiennes,* 13 May 1848, 440.

59. P. J. Proudhon, *La Pornocratie, ou les femmes dans les temps modernes* (Paris: A. Lacroix, 1875), 166–67. "L'élément féminin était ici en majorité. . . . L'influence féminine a été, en 1848, une des pertes de la République . . . c'était la République tombée en quenouille."

## Chapter 3: *Ménagère ou courtisane:* Daumier's Vision of Female Intellect

1. The phrase *ménagère ou courtisane* is from a quote by P. J. Proudhon cited in "Quelques mots encore sur l'émancipation des femmes," *L'Illustration* 12 (20 January 1849). It reads, "Ou ménagère ou courtisane, il n'y a pas de milieu," and it evokes a dichotomous view of womanhood consistent with Daumier's.

2. Howard Vincent, *Daumier and His World* (Evanston, Ill.: Northwestern University Press, 1968), 125; Oliver Larkin, *Daumier: Man of His Time* (New York: McGraw-Hill, 1966), 50; and Judith Wechsler, *A Human Comedy: Physiognomy and Caricature in Nineteenth-Century Paris* (Chicago: University of Chicago Press, 1982), 154. The other nineteenth-century critic who mentions these series is Champfleury [Jules Husson] *Exposition des peintures et dessins de Honoré Daumier* (Paris: Gauthiers-Villars, 1878). Champfleury reaffirms Daumier's prejudices against *les femmes penseuses* and *les femmes avancées,* but he contextualizes the imagery as well.

3. See Françoise Parturier and Jacqueline Armingéat, *Daumier: Intellectuelles ("Les Bas-Bleus" et "Femmes Socialistes")* (Paris: Editions Vilo-Paris, 1974); and Caecilia Rentmeister, "Daumier und das hässliche Geschlect," in *Honoré Daumier und die ungelösten Probleme der bürgerlichen Gesellschaft* (ex. cat., Berlin: NGBK, 1974). See also Lucette Czyba, paper presented at Daumier Symposium, Bielefeld, Germany, December 1984; paper delivered at "Le Satire imagé" conference, Frankfurt, Germany, May 1988; and Janis Bergman-Carton, "Conduct Unbecoming: Daumier and 'Les Bas-Bleus,'" in Elizabeth Childs and Kirsten Powell, eds., *Femmes d'Esprit: Women in Daumier's Caricature* (ex. cat., Middlebury, Vt.: Christian A. Johnson Memorial Gallery, Middlebury College, 1990), 67–85.

4. Among the most compelling exceptions are "Modernity and the Spaces of Femininity," in Griselda Pollock, *Vision and Difference* (London: Routledge, 1988); and Lisa Tickner, *The Spectacle of Women: Imagery of the Suffrage Campaign, 1907–1914* (Chicago: University of Chicago Press, 1988).

5. Michel Melot, "Daumier and Art History: Aesthetic Judgement/Political Judgement," *Oxford Art Journal* 11, no. 1 (1988): 3–24.

6. Elizabeth Childs, "Exoticism in Daumier's Lithographs," in André Stoll, ed., *Die Rückkehr der Barbaren: Europëar und "Wilde" in der Karikatur Honoré Daumier* (Hamburg: H. Christians Verlag, 1985).

7. For a discussion of the phenomenon of typological imagery during the July Monarchy see "Paris of the Second Empire in Baudelaire," Walter Benjamin, *Charles Baudelaire: A Lyric Poet in the Era of High Capitalism,* trans. Harry Zohn (London: NLB, 1973), 12.

8. In any discussion of caricature it is essential to understand the collaborative nature of the process and the many hands involved in the conception and elaboration of an image. In the case of Daumier, the most cogent discussion can be found in Elizabeth Childs, "Honoré Daumier and the Exotic Vision: Studies in French Caricature and Culture, 1830–1870" (Ph.D. diss., Columbia University, 1989), chap. 1.

9. See, e.g., Eugène Morisseau, "'Indiana' par G. Sand," *La Caricature,* 31 May 1832, 663; and "Bulletin Bibliographique," *La Caricature,* 23 May 1833, 1062.

10. For an examination of the repercussions of the September Laws see Edwin Bechtel, *Freedom of the Press and L'Association Mensuelle-Philipon versus Louis-Philippe* (New York, 1952); and James Cuno, "The Business and Politics of Caricature: Charles Philipon and La Maison Aubert," *Gazette des Beaux-Arts,* October 1985, 97–112.

11. This simplistic division of Daumier's lithographic output also has contributed to the critical neglect of his representations of the woman of ideas. With the exception of emblematic characters like Robert Macaire or of series with clear contemporary political

applicability like "Histoire Ancienne," studies of the later lithographs are rare and often elemental. Such fundamental questions as, "Why were these safe and suitable targets for the satirist after the imposition of Louis-Philippe's September Laws?" have gone unasked.

12. The association of women writers with the corruption of literature is most explicit in caricatures like Grandville and Traviés' "Les Feuilles publiques," which appeared in *La Caricature* on 26 September 1833. The image personifies the newspapers that marketed serialized novels as whores.

13. Frédéric Soulié, *Physiologie du bas-bleu* (Paris: Aubert, 1841–42), 19.

14. For a complete discussion of this phenomenon see Laure Adler, *A l'Aube du féminisme: Les Premières journalistes (1830–1850)* (Paris: Payot, 1979).

15. The trendiness of *la femme émancipée* in the mid-nineteenth century is suggested by her frequent characterization in fiction. Flaubert's La Vatnaz in *L'Education Sentimentale* is, by the author's admission, based on such *femmes socialistes* as Eugénie Niboyet and Jeanne Deroin, whom he observed in 1848. And many of Balzac's novels feature femmes-auteurs drawn from contemporary Paris. In *Béatrix* (1840), Félicité des Touches is modeled after George Sand and the Marquise de Rochefide after Marie d'Agoult. Mme de la Baudraye in Balzac's *La Muse du département* was inspired by George Sand as well.

16. Honoré de Balzac, *The Illustrious Gaudissart*, trans. William Walton (Philadelphia: George Barrie and Son, 1898), 23.

17. *Gazette des femmes* 1, no. 2 (August 1836): 33. The history of this journal is recounted in Claire Moses, *French Feminism in the Nineteenth Century* (Albany: State University of New York Press, 1984). The details of Poutret de Mauchamp's activities are discussed by Marie-Louise Puesch, "Une supercherie littéraire: Le Véritable Rédacteur de la *Gazette des femmes* (1836–1838)," *La révolution de 1848* 32 (June–August 1935): 303–12; and Evelyne Sullerot, *Histoire de la presse féminine en France, des origines à 1848* (Paris: Armand Colin, 1966).

18. "Madame a lu les romans de George Sand, elle a pleuré aux représentations de *Marie*, elle est au courant de toutes les protestations et de toutes les motions insurrectionnelles que les femmes, depuis quelque temps, publient par la voie de la presse et du théâtre" (*Le Charivari*, 17 May 1837, 3–4). "Marie" was a play written by Virginie Ancelot, whose government subsidies were a source of constant irritation to Philipon and a variety of male journalists.

19. This paradigm is also used frequently during the July Monarchy to explain corrupt male behavior, especially that of Louis-Philippe. There is a fascinating sequence of articles between 1839 and 1848 in the legitimist journal *La Mode* that ideally demonstrates this phenomenon. The most common ridicule of Louis-Philippe in the republican and legitimist press was in the accounts of the overbearing female presence and influence in his court, an influence that prompted the constitutional monarch to be nicknamed "Lolo Phiphi." (The representations of Louis-Philippe as androgyne are discussed in the conclusion.) The female relative most often maligned was the king's sister, Mlle Adélaïde, who is represented in the press as a pushy and pretentious woman of ideas. In "La Princesse Marie D'Orléans" (*La Mode*, January–June 1839, 29–36), the death of the only pure and womanly member of the court, the sculptor Princess Marie D'Orléans, is attributed to the unnatural influence of Adélaïde. Adélaïde had been vilified in the press for eighteen years, but when she died in January 1848 her mistakes were absolved by an explanation of the irresponsible way she was educated by her governess, Mme de Genlis. In Alfred Nettement's "Morte de Mlle Adélaïde" (*La Mode*, 6 January 1848, 1–7), the poet Genlis is accused of favoring "la sentimentalité au lieu de la sensibilité, l'affectation de l'érudition plutôt que la science véritable" (2). Ultimately, Genlis is assigned blame not only for the failures of individuals who came under her influence but for the entire July Monarchy government. The government fell and Louis-Philippe was deposed a month

after Adélaïde's death. In the 20 March 1848 issue of *La Mode* the corrupt life and reign of the once-despised Louis-Philippe is also blamed on the influence of that deviant femme de lettres De Genlis, who was at once "écrivant des livres de piété et des romans infâmes; s'habillant en homme" and "était en même temps la maîtresse du père et la préceptrice des enfants" (450).

20. "Curiosités littéraires: Les Demoiselles de lettres," *Le Charivari*, 30 May 1837, 1–2.

21. Jean-Baptiste Daumier was an artisan with artistic aspirations. A glazier and a poet, he had little success in the Parisian literary community and was financially dependent on his son. For the details of his decline and commitment to an insane asylum see Bernard Lehmann, "Daumier Père and Daumier Fils, *Gazette de Beaux-Arts*, May 1945, 297–316. The literary and financial rewards received by such "undeserving" demoiselles de province as Délphine de Girardin must have been irritating to Daumier, who saw his father emasculated by loss of livelihood and inability to attain recognition as an artist.

22. This sarcastic aside is directed at George Sand's history with other women writers. She, who could herself be described as a demoiselle de province, was not known for her interest in offering support to the hundreds of young women who came to Paris to emulate her. On the other hand, she was extraordinarily generous to *les poètes ouvriers* and political exiles in 1848.

23. " . . . prêchant la liberté de la femme et l'asservissement de l'homme" ("Curiosités Littéraires," 3–4). Jules Janin wrotes extensively on this phenomenon of la demoiselle de province in his essay on "Le Bas-Bleu" in *Les Français peints par eux-mêmes* (Paris: N. J. Philippart, 1841–42).

24. See, e.g., "Les Femmes ne peuvent pas avoir l'art de régner, puisqu'il n'ya pas le moindre rapport avec l'art de plaire," *Le Charivari*, 8 September 1837, 1; and "Les Petites misères de la vie royale: Le prince Albert d'Angleterre au grand-duc de Gérolstein," *Le Charivari*, 21 August 1844, 2–4. The antipathy toward the woman of ideas crossed political lines, as is evident in comparable articles that appeared in the legitimist journal *La Mode*. Though the vast majority of articles dealing with this issue appeared in Maison Aubert publications, there were caricatures of Queen Victoria and other women of ideas published in *La Mode* and the *Journal pour rire* simultaneously.

25. Several texts with that title were published in the nineteenth century, including Benjamin Antier-Pollet's *Le Mérite des femmes* (1824). The book in the caricature probably refers to Ernest Legouvé's *Le Mérite des femmes*, first issued in 1830. Legouvé was a Saint-Simonist who argued in favor of improving the educational opportunities and the legal status of women. His most famous work, *Histoire morale des femmes* (1849) was a compilation of lectures he delivered on that subject at the Collège de France in 1848.

26. Jules Michelet writes of his concern for modern marriages (such as those represented by Daumier) in which wives become addicted to novels in *Du Prêtre, de la femme, de la famille* (Paris: Hachette, 1845), 158.

27. Philippe Roberts-Jones, *Daumier. Humours of Married Life*, trans. Angus Malcolm (Boston: Boston Book and Art Shop, 1968), 150.

28. Capo de Feuillades, "Lélia," *L'Europe littéraire*, 26 October 1833, 61–63.

29. Daumier never grants any female writer the exposure of a portrait likeness. This is particularly striking given his talent for the genre exercised in such series as "Les Représentants représentés." Linda Nochlin's essay "Women, Art, and Power" from her anthology of the same title (London: Thames and Hudson, 1988), identifies the two feminists in the image "V'là une femme . . . " from "Les Divorceuses" as Eugénie Niboyet and probably Jeanne Deroin. Though other caricaturists do figure actual feminists, Daumier does not. To grant such women individuation would have been to grant them stature and legitimacy. Furthermore, by August 1848, when this lithograph was published, Niboyet and Deroin had already parted company in a fairly public manner. It is unlikely that they

would be pictured together. "Banquet féminin de la Gaité" (*Journal pour rire,* 25 November 1848, 1) is one of many articles publicizing the rift and delighting in Niboyet's exclusion from the banquets sponsored by the organization she helped found.

30. The term actually originated in the seventeenth century as a derogatory reference to the plain clothing worn by the Puritans. See Evelyn Gordon Bodek, "Salonnières and Bluestockings: Educated Obsolescence and Germinating Feminism," *Feminist Studies* 3 (Spring–Summer 1976): 187. For a full treatment of this subject and the circle that formed around Elisabeth Montagu see Sylvia Harcstark Myers, *The Bluestocking Circle: Women, Friendship, and the Life of the Mind in Eighteenth-Century England* (Oxford: Clarendon Press, 1990).

31. F. Langlé and F. De Villeneuve, *Un Bas-Bleu* (Paris: Marchant, 1844), 12. Langlé and De Villeneuve's Athenais is a barmaid seeking to escape the constraits of her class through an unexpected inheritance. The easiest vehicle of class mobility for a woman in the July Monarchy was to become a bas-bleu, a female type identified principally with the bourgeoisie. Toward this end, Athenais puts herself in the hands of the diabolical Pasiphae de Pont-Chameau ("nasty, evil-minded person"), a George Sand–like figure who schools Athenais in the rituals and politics of the bas-bleu. One aspect of her apprenticeship is an introduction to modern painting. Interestingly, the new style that she is instructed to embrace as a fledgling bas-bleu is realism, represented by a painting of a man contemplating a field of potatoes. This act of politicizing Athenais, reawakening her interest in her own class and regional origins (but now as an urbanized dilettante) promotes the popularly held belief that the bas-bleu commercializes and denigrates sacred literary and artistic traditions. More topically, it also responds to the shift in George Sand's work after her exposure to the ideas of the utopian philosopher Pierre Leroux and presages the paintings of Millet in the late 1840s and 1850s. *Le Compagnon du Tour de France* (1840) was Sand's first in a series of novels in the forties that heroized the French working class and attacked the corrupting influences of wealth and title.

32. " . . . qui flotte entre quarante-cinq et cinquante-cinq ans, . . . [qui a] un corps maigre, . . . le sourire douloureux, . . . [et] une poitrine décharnée" (Soulié, *Physiologie du bas-bleu,* 68).

33. This practice is documented in such sources as *Physiologie de la presse* (Paris: Jules Laisne, 1841). In the staff listings it publishes for *Le Constitutionnel* and *La Presse,* for instance, it includes the editors' wives, Mmes Charles Reynaud and Delphine de Girardin, respectively. Sophie Gay, Emile de Girardin's mother-in-law, is also cited in the staff list for *La Presse.* Louise Bertin, daughter of *Journal des débats* editor Louis Bertin, was the target of the most biting satires. See "L'Ombre d'Euterpe," *Le Charivari,* 13 January 1842, 1.

34. "La dixième muse s'est multipliée dans une proportion effrayante; elle a poussé sans culture, comme les champignons, . . . dans les colonnes des feuilletons, et à la quatrième page des journaux" (Edmond Texier, *Physiologie du poète* [Paris: J. Laisne, 1841], 118). Page 4 refers to the page of the newspaper that featured the gossip column.

35. Soulié, *Physiologie du bas-bleu,* 104. Although Philipon still owned La Maison Aubert, he sold *Le Charivari* in the late 1830s. No archival material exists to document exactly who contributed what to the process of producing caricatures for *Le Charivari,* but it is essential to understand that it was a collaborative effort. In the case of Daumier, the editorial board most likely suggested a topic for a series and he performed the task. Several contemporary accounts (Jules Brisson and Félix Ribeyre, *Grands Journaux de France* [Paris: Jouast Père, 1862] and Champfleury [Jules Husson], *Histoire de la caricature moderne* [Paris: Dentu, 1865]) credit Philipon with authorship of the legends, but Elizabeth Childs has determined that many were written by paid legend writers. For an extensive treatment of the working process of Le Charivari see Childs, "Honoré Daumier and the Exotic Vision."

36. " . . . la plus méchante de toutes . . . " (ibid., 52).

37. Ibid., chap. 5.

38. "Le mari de la muse, ce même qui vaque aux soins du ménage pendant que sa femme entretient un commerce adultère avec Apollon, doit se résigner à perdre tout à fait sa personnalité . . . il n'est que la chose de sa femme, . . . c'est-à-dire son premier domestique" (Texier, *Physiologie du poète,* 120–21).

39. Similar representation of the Saint-Simonist men is found in the early 1830s work of Grandville. Contemporary discussions of Jules de Castellane's support for women writers include "Fleurs et épines," *Psyche,* 22 June 1848, 1539–41; and Eugène Loudon's "L'Académie des femmes," *La Sylphide,* 10 June 1844, 21–24.

40. Among the many examples of caricatures and articles revealing the sexual and political dangers posed by the woman of ideas, a series called "La Police en jupons," published in *Le Charivari* the late fall of 1844 stands out. The stories are of women working for government intelligence who pose as salonnières to lure men into their parlors where they can at once satisfy sexual desires and incriminate themselves as they disclose political secrets. The power of these modern versions of Odysseus and the sirens is suggested by the angry letters from women's journals that *Le Charivari* received and then proudly published as prefaces to each new article in the series.

41. "Vous ne-pourrez la voir; elle est enfermée avec M. . . . Ils sont en collaboration" (Soulié, *Physiologie du bas-bleu,* 50).

42. " . . . a écrire les plus abominables invectives contre la grammaire et les sens commun" (Janin, "Un Bas-Bleu," 371).

43. Ibid., 374, 376. "Ce qu'elle a vendu toute sa vie dans les boudoirs ou dans les tavernes, elle le vendra encore dans les livres" (380).

44. See James Cuno, "Charles Philipon, La Maison Aubert, and the Business of Caricature in Paris, 1829–1841," *Art Journal* 43, no. 4 (Winter 1983): 352–53.

45. " . . . une buveuse d'encre . . . est désagréable à la vue comme à l'esprit" ("Salon de 1844," *Le Charivari,* 10 May 1844, 1).

46. In an article entitled "Les Poètes . . . pour rire," published in another Philipon journal (*Journal pour rire,* 5 August 1848, 1), writers Virginie Ancelot, Hortense Allart, and Louise Colet are berated for being the unworthy recipients of government support and are unfavorably compared with their dignified but poor male counterparts.

47. On 6 April 1848, George Sand celebrated the new Republic by staging a performance, free to "the people," of her one-act play "Le Roi attend" at the Théâtre de la République. See "Théâtre de la République. Première représentation gratuite," *Le Charivari,* 7 April 1848, 2. Among the rights demanded by the *Voix des femmes* group was the right to run for public office. In the 6 April 1848 issue of *La Voix des femmes,* Eugénie Niboyet nominated George Sand to the Constituent Assembly. When Sand responded with condescension to the proposal, the women focused their energies on limited voting privileges. See Moses, *French Feminism,* chap. 6.

48. Robert Justin Goldstein, *Censorship of Political Caricature in Nineteenth-Century France* (Kent, Ohio: Kent State University Press, 1989), 171. For a contemporary nineteenth-century response to the death of the free press and the reimposition of a cautionnement see *La Silhouette,* 16 July 1848, 3.

49. The notion of blaming political failure on unrestrained female activism is common. It can be found in the literature on the 1789 revolution, and it was invoked furiously by such disappointed revolutionaries as P. J. Proudhon (in *La Pornocratie*) to explain the failure of 1848. This instinct to conflate political and sexual anxiety, however, was by no means limited to the extreme reactions of men at the forefront of revolutionary activity. An article titled "Quelques mots encore sur l'émancipation des femmes" (*L'Illustration,* 28 January 1849) demonstrates how widespread such sentiments were. It describes the unprecedentedly vocal women activists of 1848 as the perennial sources of disunity and discord in any male alliance: "Déjà, en 1832, la femme, éternelle pomme de discorde,

avait été la cause de la première scission qui éclata au sein de la communauté saint-simonienne. C'était alors, le père Enfantin qui tenait pour la femme libre et le libre amour que répudiait le père Bazard. C'est aujourd'hui M. Victor Considérant qui défend la même thèse contre M. Jean-Baptiste Proudhon" (334).

50. For an example of the kind of paranoia the socialist community engendered after the June Uprising see "Image 4 Evangelists—Saint Cabet, Saint Leroux, Saint Proudhon, et Saint Considérant," *La Silhouette*, 1 October 1848, 1.

51. Both T. J. Clark in *The Absolute Bourgeois* (1972) and Marie-Claude Chaudonneret in *La Figure de la République* (1987) convincingly argue that Daumier's strongest social and political identification is with the artisan class, the first casualty of the Industrial Revolution and the group that fiercely adhered to the ideal of family. On the artisan identity see R. Gossez, "Diversité des antagonismes sociaux vers le milieu du XIXe siècle," *Revue économique*, no. 3 (1956): 449–50. Anxiety about what was interpreted as the antifamily stance of les femmes socialistes undoubtedly was fed as well by the depopulation statistics circulating in France in the 1840s. See Angus McClaren, *Sexuality and Social Order: The Debate Over the Fertility of Women and Workers, 1770–1920* (New York: Holmes and Meier, 1983).

52. Daumier was also one of the few caricaturists of contemporary manners to avoid mention of two other notorious working-class female types, *les lorettes* and *les vivandières*.

53. See "Chronique," *La Mode*, 16 July 1848, 153. Propaganda arguing for the importance of the family was by no means restricted to the artisan class. The theme of family as the only sane and stable reality in an otherwise corrupt and violent world was a common one. See, e.g., a lithograph by Tony Johannot, "Ou peut-on être mieux qu'au sein de sa famille," that appeared in *L'Illustration* 12 (10 February 1849): 373.

54. In stories like "Le Club des femmes. Appel au sexe," *Le Charivari*, 10 May 1848, and "Encore la Voix des femmes," *Le Charivari*, 17 April 1848, "Les Divorceuses" are likened to the *Gazette des femmes* community gathered around Mme Poutret de Mauchamps twelve years earlier. The decision to devote a series to this subject responds to a strong surge in feminist activity in late summer 1848. For a contemporary account of the association of divorce with la femme libre see Ernest Legouvé, *Histoire morale des femmes* (Paris: Librairie Académique Didier, 1864), chap. 1.

55. On the closure of the Club des femmes see *La Silhouette*, 25 June 1848, 7.

56. This ironic title for Eugénie Niboyet was popularized in *La Silhouette* in June 1848.

57. These events also were satirized and rehearsed in a series of comedies produced during this period, including "Le Club des maris et le club des femmes" by MM. Clairville and Cordier and "Le Vrai Club des femmes" by M. Mery. The journalistic coverage of these events is extensive as well. See "Club des femmes," *Journal pour rire*, 1 July 1848, 2.

58. See "Le Bas-Bleu et son Rapin," *Journal pour rire*, 14 April 1849, 2–3.

59. MM. Varin and Roger de Beauvoir's much cited "Les Femmes Saucialistes" (April 1849, Théâtre de Montassier) debuted the same week Daumier began his series. The play received a favorable and long review in *Journal pour rire*, 14 April 1849, 3.

60. This image relates to Daumier's "Les Papas," a twenty-three–image series issued between December 1846 and June 1849. "Les Papas" is an extraordinary series extolling the virtues of devoted fathers who are seen modeling children after themselves and marveling at physical likenesses. There are also several touching images of intimate moments when they are shown teaching their offspring how to dance or swim. Within the context of feminist activism in the late 1840s reflected in "Les Divorceuses" and "Les Femmes socialistes," "Les Papas" can be understood, in part, as the paternal intervention necessitated by maternal irresponsibility.

61. In his 1945 article "Daumier and the Republic," Bernard Lehmann also notes the similarities, but his comparison remains strictly compositional.

62. In *Histoire de la caricature moderne* (169), Champfleury perceives in Daumier's work a preoccupation with religious subjects when the artist finally is given the opportunity to make and exhibit paintings after the Revolution of 1848. In "Daumier and the Republic" Lehmann publishes Jean Adhémar's research in the Archives Nationales, revealing the details of the state commissions Daumier received during the Second Republic (112) through the support of friends like painter Philippe-Auguste Jeanron in the new Provisional Government. Adhémar discovered that the subjects of several of Daumier's commissioned works, *Magdalen in the Desert* and *Ecce homo*, were chosen by the artist. Lehmann's article goes on to analyze Daumier's attraction to these religious subjects in the context of his friendship with Jules Michelet, who was involved, with his son-in-law Alfred Dumesnil, in an effort to break with the church and establish a personal religion. The intersection of art and alternative religious theory in this period is discussed extensively in Chapter 4.

63. Others have noted the peculiar hierarchy of this painting. Champfleury described the work as "une libre interprétation de la Fontaine, 'Le Meunier, son fils, et l'âne,' prétexte pour peindre trois joyeuses maritornes [whores]," (*Exposition des peintures et dessins de Honoré Daumier*, Galerie Durand Ruel. Paris: Gauthier-Villars, 1878), 22. In book illustrations of the same moment in the La Fontaine tale by Oudry, Silvestre, and Grandville one finds instances of the women sharing the focus with the miller and his son, but never usurping it as they do in Daumier's image. For a discussion of appropriations of the fables of La Fontaine in the nineteenth century see Kirsten Powell, *Image-Text Relationships and the Role of the Classics in Modern France* (Ph.D. diss., Columbia University, 1987).

64. Jeanne Deroin, letter to the editor of *Liberté*, printed in the *Voix des femmes*, 12 April 1848, reprinted in Moses, *French Feminism*, 135.

65. *Opinion des femmes*, 10 March 1849, cited in Moses, *French Feminism*, 135.

66. Jules Michelet, *La Femme* (Paris: Calmann-Levy, n.d.), 66. Michelet receives unqualified praise in *Le Charivari*, particularly during the winter of 1848, when his course at the Collège de France was suspended and he became a symbol of republican thought and free speech.

67. "Dès le berceau, la femme est mère, folle de maternité. Pour elle, toute chose de nature, vivante et même non vivante, se transforme en petits enfants" (ibid., 121).

68. Michelet's feminism, however, translates as finding ways to prevent women from having to work outside the home and encouraging men to take full advantage of the institution of marriage. This plea is not based on any desire to see women treated fairly but rather to prevent the clergy from exerting more control over wives than husbands do. Michelet urges husbands to prevent their wives' "ennui" by engaging them in the activities of the mind and business. Satisfied and stimulated women, he explains, are likelier to assume their natural duties educating future generations. The content of that education, he implores, must be determined by father-citizens rather than by Jesuit clergy.

69. See Marie-Claude Chadonneret, *La Figure de la République: Le Concours de 1848* (Paris: Ministère de la Culture et de la Communication/Editions de la Réunion des musées nationaux, 1987). The theme of charity occurs earlier in Daumier's oeuvre, as Léon Rosenthal was the first to note. A sketchy drawing signifying a painting of charity appears in the background of a caricature published in *Le Charivari* on 15 October 1844 as part of the "Les Philantropes du jour" series. More significantly, this theme was an important part of the alternative religious theories of Jules Michelet and Edgar Quinet in the 1840s and 1850s and a logical dimension of the debates over social inequity that culminated in the 1848 Revolution. These sentiments received visual expression in such images as Alexandre Laemlein's *La Charité*, which was exhibited at the Salon of 1846, and Victor Vilain's bas-relief *La Bienfaisance* of 1847, a graphic reproduction of which forms

the centerpiece of an 1847 article in *Magasin Pittoresque* on charity and the poor (vol. 15, no. 333). Of the many textual examinations of this issue, one of the most popular and influential was J. Stahl's *Le Diable à Paris* (Paris: Hetzel, 1845–46), a two-volume literary and artistic anthology whose contributors include George Sand, Honoré de Balzac, Gavarni, and Bertall. The premise of the book is that Satan, bored with his duties in hell, decides to visit Earth. In Paris, he hosts and interviews a group of hellbound sinners who shock him with their tales of poverty and government indifference. The remainder of the book is composed of essays by well-known writers about life in Paris that Satan solicits in an effort to discover whether, in fact, Paris is worse than hell. These essays, which focus on the discrepancy between rich and poor, climax in Jules Hetzel's "What Are Alms?" Hetzel charges the government with irresponsibility to the poor and demands that alms-giving be required in every civilized state. This sentiment most probably informs Daumier's decision to use Charity as his image of the redemptive Republic. Hetzel's directive that the rich take a lesson from the poor in the matter of charity forms the subtext of a play by Alfred de Musset as well. *André del Sarto*, written in 1833 and revived in 1849, concerns the Italian artist's discovery in his old age that his wife is in love with his best young student. He becomes aware of this at the same moment that he has decided to repent and admit his own sins, that he has been embezzling money from his patron, Francis I, and sacrificing quality in his work for quick monetary rewards. As the king's men are confiscating his paintings, it is the sight of his *Charity* (a painting in the Louvre that is frequently cited as a source for Daumier's image of the Republic) that prompts him to a new generosity in his personal life. Just before drinking a vial of poison, he sends a message to his wife that the widow of André del Sarto is free to marry her lover. The revival of this play in 1849 must have been at once a reinforcement of the Second Republic notion that it was time for older artists to relinquish power to the younger generation and a timely reminder to the increasingly conservative government of the Second Republic of its original commitment to *la question sociale*. See Jules Michelet's discussion of the significance of the painting to republican sensibilities in the chapter entitled "La Charité d'André del Sarto" in his *La Femme* (1852).

70. Though Daumier's competition sketch did earn him the status of finalist, he never finished the contest. According to archival documentation published by Albert Boime, Daumier intended as of 10 June 1848—the date by which finalists had to declare their intention to complete the second phase of the competition—to submit a finished painting. Explanations of his failure to do so are unsatisfactory and always fall back on Champfleury's vague statement that skepticism prevented him from working on a last version ("Salon de 1849," in Champfleury, *Oeuvres posthumes de Champfleury. Salons, 1846–1851* (Paris: Lemerre, 1894), 178. The nature of that skepticism has never been addressed. One must, first of all, consider the public humiliation to which the contest was subjected in both the legitimist press, which referred to it as evidence of the need to reestablish the jury system, and Daumier's own republican community. Furthermore, the June Uprising that signaled the conservative turning point for the Revolutionary government took place only two weeks after Daumier announced that he intended to complete the contest. To create an image of the glorious Republic when the principles of that Republic were slowly eroding must have seemed hypocritical to Daumier. In the literature there also has been some question of whether another version of the painting ever existed. (See Bernard Lehmann, "Daumier and the Republic," *Gazette des Beaux Arts*, January–June 1945, 103–10.) But nowhere in the literature on this painting has the discrepancy between the number of figures cited in *La République* and the number that exist in the Louvre been observed. There are three children in the Louvre painting: two nurse at the woman's breast, and one reads at her feet. Champfleury writes, "Une femme assise porte deux enfants suspendues à ses mamelles. A ses pieds, deux enfants lisent" (reprinted from a 6 August 1848 review in "Le Pamphlet" in *L'Exposition des peintures et dessins de Honoré Daumier* [Paris: Galeries Durand-Ruel, 1878], 21). Arsène Alexandre describes the paint-

ing in the same way as Champfleury in *Honoré Daumier, L'Homme et L'Oeuvre* (Paris: H. Laurens, 1888), 342.

71. The notion of a dichotomized vision of the beautiful and hideous sides of the revolutionary enterprise, sometimes inflected with the metaphor of good and bad motherhood, was pervasive during the Second Republic. According to Karl Marx, for example, "The February Revolution was the nice revolution, the revolution of universal sympathies, because the contradictions which erupted in it against the monarchy were still undeveloped and peacefully dormant, because the social struggle which formed their background had only achieved an ephemeral existence, an existence in phrases, words. The June Revolution is the ugly revolution, the nasty revolution, because the phrases have given place to the real thing, because the republic has bared the head of the monster by knocking off the crown which shielded and concealed it" ("The June Revolution," reproduced in *Articles from the Neue Rheinische Zeitung 1848–49* [Moscow: Progress Publishers, 1972], 47). For examples of the figuration and discussion of this dichotomy in the popular press see the two representations of motherhood by Gavarni in the *Magasin Pittoresque* 14 (1846): 349, 391; "Les Deux Républiques," *Le Charivari*, 10 March 1848, 2; "Les Deux Statues de la république," *Journal pour rire*, 3 March 1849, 2; and "Les Deux Républiques," *La Mode*, 16 April 1848, 117–19.

72. Proudhon's retrospective assessment of female power during the July Monarchy offers the most concise demonstration of the conflation of political and sexual anxiety. In *La Pornocratie, ou les femmes dans les temps modernes* (1875), Proudhon blames the woman of ideas for the failure of 1848: she is the "esprit de confusion et de promiscuité qui, depuis trente-cinq ans, a été la peste de la démocratie et la cause principale des défaites du parti républicain" (75). In fact, he explains the decay of the entire revolutionary apparatus as the feminization of the culture and the prominence of artists in the Provisional Government: "L'influence féminine a été, en 1848, une des pertes de la République. G. Sand, femme et artiste, composant avec J. Favre, autre artiste, les bulletins fameux, . . . ou était l'homme, dans le gouvernement provisoire? Lamartine, artiste; Crémieux, artiste. . . . L'élément féminin était ici en majorité" (166–67).

73. Victor Hugo, "Choses vues," *Oeuvres complètes*, vol. 31 (Paris, 1955), 365–66. " . . . une femme jeune, belle, échevelée, terrible. C'ette femme, que était une fille publique, releva sa robe jusqu'à la ceinture et cria aux gardes nationaux . . . —Lâches, tirez si vous l'osez, sur le ventre d'une femme . . . un feu de pleton renversa la misérable."

74. For a fascinating discussion of Hugo's description and the conflation of sexual and political tension see Neil Hertz, "Medusa's Head: Male Hysteria Under Political Pressure," *Representations*, no. 4 (Fall 1983): 28.

## Chapter 4: Reading Through the Body: The Woman and the Book in French Painting, 1830–1848

1. Philippe Jacques Van Bree (1786–1871) moved from Brussels to Paris in 1811 and began a period of study with Girodet. Between 1816 and 1818 and 1821 and 1833 he lived and worked in Rome. As his paintings suggest, he set up a studio there and took in pupils. See *Autour du neo-classicisme en Belgique* (ex. cat., Brussels: Musée Communal des Beaux-Arts d'Ixelles, 14 November 1985–8 February 1986), 19–20, 225–26. This undated painting has heretofore been dated to Van Bree's sojourn in Rome, but it is possible to be more specific, as the journal read by the seated model, *La Femme libre*, was published only from 1832 to 1834.

2. There is, of course, a long tradition of allegorizing studio pictures; one of the most famous nineteenth-century examples is Gustave Courbet's *The Artist's Studio* (1855).

3. According to Greek legend, Hercules' first labor performed for the King of Argus was to kill the Hemean lion. After accomplishing this task, he wore the skin, which has become his principal attribute. For a discussion of the role of Hercules in French allegorical imagery see Joan Landes, *Women and the Public Sphere in the Age of Revolution* (Ithaca, N.Y.: Cornell University Press, 1988), 163–64.

4. Because these images were produced primarily for private consumption and could easily inherit such alternative titles as *La Jeune fille* or the name of the sitter, it is impossible to determine how many were produced in this period.

5. See Gabriel Weisberg, *The Realist Tradition: French Painting and Drawing 1830–1900* (Bloomington: Indiana University Press, 1980).

6. Charles Baudelaire, "The Painter of Modern Life," in *Baudelaire: Selected Writings on Art and Artists*, trans. P. E. Charvet (Baltimore: Penguin Books, 1972), 431. The other half of the dialectic is, of course, the more masculine quality of the permanent.

7. Ibid., 423, 429.

8. This was particularly true for such artists as Bonvin, Corot, and Fantin-Latour. The seminal work on the gendered spaces of modernism is "Modernity and the Spaces of Femininity," in Griselda Pollock, *Vision and Difference: Femininity, Feminism, and Histories of Art* (London: Routledge, 1988), 50–90.

9. Baudelaire, "The Painter of Modern Life," 397. George Sand, who ordered men's clothing on her arrival in Paris to facilitate her anonymous and inconspicuous passage through the streets, was ridiculed for her efforts.

10. Interestingly, several artists turned not only to the subject of la liseuse but also, as I discuss later in this chapter, to the theme of "La Madeleine" as a kind of alter ego, a feminized self whose alienation was the guarantor of the artist's enlightenment.

11. The most important prototype is St. Jerome. See, e.g., Jan Van Eyck and Petrus Christus, *Saint Jerome lisant* (c. 1430; Detroit Institute of Art), which depicts the saint reading in his study.

12. The location of this work is unknown, but its subject, a mother reading the Bible to her child, is described by J. F. Destigny in his pamphlet "Revue poétique du Salon de 1840."

13. This debate and its terms can also be traced back to religious prototypes. In literature like the eighth-century *Evangelicum of the Pseudo Matthew*, authors often argued that it was the Virgin's superior instruction in the law of God that qualified her to conceive Christ. See Gertrude Schiller, *Iconography of Christian Art*, 2 vols. (Greenwich, Conn.: New York Graphic Society, 1971). This is the same argument revived during the July Monarchy to justify demands for greater educational resources for women.

14. The orientation of girls' education to domestic and maternal issues is best demonstrated by contemporary tracts. See Pauline Guizot, *Education domestique* (Paris: A. Leroux and Constant-Champie, 1826); and Lucille Sauvan, *Cours normal des institutrices primaires, ou directions relatives à l'education physique, morale, et intellectuelle, dans les écoles primaires*, 2nd ed. (Paris: Pitois-Levrault, 1840).

15. See Jeanne Deroin's pamphlet *Aux femmes* (Paris: Auffray, n.d.), reprinted from *La Femme libre* 1, no. 2, August 1832).

16. Carol Duncan, "Happy Mothers and Other New Ideas in Eighteenth-Century French Art," *Art Bulletin* 55 (December 1973): 570–83.

17. On the growing debate over the mère-éducatrice in the nineteenth century see Barbara Coronado Pope, "Maternal Education in France" (paper presented at the annual meeting of the Western Society for French History, December 1975). The ideal mother-teacher was regarded as an agent for humanity's regeneration. If she failed, she received the epithet *femme-dragon*.

18. In his monograph on Delaroche, Norman Ziff reads the oil sketch through the artist's biography, as if the ineptitude that has prompted the mother to redress the child is

symbolic of Delaroche's "personal crisis." Although there is a sense of urgency about the mother, I think it is, perhaps, more useful to think about *The Reading Lesson* as a more subtle and timely version of Victor Orsel's *Le Bien et le mal* (1833; Fig. 77). Both are didactic images warning of the dangers of not reading the right books or of not reading at all.

19. Because literacy and leisure time were less of a given among the working classes, and because for them the empowerment of education was less certain, these images of sacrifice and commitment commanded a kind of religious respect.

20. Rousseau exalted women's maternal responsibilities and denigrated any activity that might involve women in the public sphere. His ideas on education inform most of his writings but are consolidated in *Emile, ou de l'education*, vol. 6 (Paris: Chez Jean Neaulme, 1761).

21. See James Smith Allen, *Popular French Romanticism: Authors, Readers, and Books in the Nineteenth Century* (Syracuse, N.Y.: Syracuse University Press, 1970), 153–66; and François Furet and Jacques Ozouf, *Reading and Writing: Literacy in France from Calvin to Jules Ferry* (Cambridge: Cambridge University Press, 1977), 5–57.

22. This concern is articulated in "Imprimeurs, librairies, bouquinistes, cabinets de lectures," in Alphonse Karr, *Nouveau tableau de Paris au XIX siècle*, vol. 5 (Paris, 1835), 67.

23. There are many modern derivatives of this theme, ranging from a work like Pierre Parrocel's *Jeune femme lisant devant une cheminée* (c. 1735) to Alexandre-Marie Guillemin's *Reading the Bible* (c. 1861).

24. Bonvin, e.g., made a watercolor copy of the Elinga painting in 1846; that piece is now in the collection of the Metropolitan Museum, New York.

25. This subject was addressed frequently in this period. See, e.g., "Le Trembleur ou les lectures dangereuses, *L'Illustration* 2 (1844): 362–78.

26. This conceit appears both in the Beranger and the Bonvin. In Bonvin's *La Servante*, the statuette has been identified as Clesinger's portrayal of Cleopatra (1861), the queen of Egypt whose imperialist and sexual conquests were reenacted frequently during the July Monarchy on the stage and in print.

27. The dangers of bad reading habits among domestics are discussed in "Influence des mauvaises lectures," *Le Semeur* 10, no. 28 (8 July 1840): 224.

28. Mathurin-Joseph Brisset, *Le Cabinet de lecture*, vol. 1 (Paris: Magen, 1843), 13–14.

29. " . . . prêtait aux grandes, en cachette, quelque roman qu'elle avait toujours dans les poches de son tablier"; " . . . valait de longs chapitres, dans les intervalles de sa besogne" (Gustave Flaubert, *Madame Bovary* [New York: Charles Scribner's Sons, 1930], 43).

30. Two well-known popular plays on the subject were Varin and Vanderburch's *Le Roman nouveau*, which opened at the Variétés on 8 August 1833, and N. Founier's *Un Roman intime*, which began its run at the Gymnase on 11 March 1840.

31. "Emma cherchait à savoir ce que l'on entendait au juste dans la vie par les mots de *félicité*, de *passion* et *d'ivresse*, qui lui avaient paru si beaux dans les livres" (Flaubert, *Madame Bovary*, 40).

32. Ibid., 211.

33. "Etudes religieuses: Influence des lectures frivoles," *Journal des mères et des jeunes filles* (April 1845), 141. See also the multivolume *Romans à l'usage des jeunes demoiselles* (Paris: A la librairie de la jeunesse, 1826).

34. Mary Magdalene is pictured frequently in this period as penitent, meditative, and reading in the woods of Saint-Baume.

35. Jules Simon, *L'Ouvrière* (Paris: Librairie de L. Hachette, 1861), 4.

36. MM. Dumerson et Alexandre, *La Femme du peuple* (Paris, 1835), 2.

37. Ibid., 4.

38. Beatrice Farwell, "Courbet's 'Baigneuses' and the Rhetorical Feminine Image," in Thomas Hess and Linda Nochlin, eds., *Woman as Sex Object* (New York: Newsweek Inc., 1972), 42–63. Another example is James Pradier's bronze statuette *La lecture* (1840), which pictures a young woman playfully handling a book she balances on her raised right leg and a pen raised in inspiration in her right hand. The action of the leg (which supports the text) stepping up on a stool, however, tugs the folds of her gown just enough on her thigh to reveal a dark and not very subtle chasm for the viewer to contemplate. The themes of the nursing mother are also related to amazon imagery and representations of Marianne. The interchangeability of these images contains the iconic power of the female body.

39. See Robert Rosenblum, "Caritas Romana after 1760: Some Romantic Lactations," in Hess and Nochlin, *Woman as Sex Object,* 42–63.

40. The obverse, the theme of the intellectual and physical nourishment made possible by the modern educated woman, is also of interest to Toulmouche. See his *Reading Lesson* (1865; Boston Museum of Fine Arts).

41. This work was not anachronistic. J. Bourdet's *Une Petite fille d'Eve* (1840) offers a similar parable of the struggle between good and evil.

42. Achille Devéria's *Le Tasse et Eléonore d'Est* (1829) deploys a similar conceit. The lovers are in bed, and the books they presumably just shared have dropped carelessly to the floor.

43. "Publications illustrées," *L'Illustration* 3, no. 1 (1844): 157.

44. Margaret Atwood, *The Handmaid's Tale* (New York: Fawcett Crest, 1985).

45. Jacques Alluis, *Nouveau recueil, contenant la vie, les amours, les infortunes, et les lettres d'Abailard et d'Héloïse* (Paris: A. Anvers, 1675); and *Les Lettres de Messire Roger de Rabutin, comte de Bussy,* 4 vols. (Paris: Floretin and Pierre Delaulne, 1697).

46. Henri Martin, *Histoire de France,* 4th ed., vol. 3 (Paris: L. Mame, 1836–75), 315. Their popularity was such in the 1830s and 1840s that there were regular pilgrimages to their tomb.

47. "A Ch. Duveyrier," *Oeuvres de Saint-Simon et d'Enfantin,* 2nd ed., vol. 26 (Paris: Dentu, 1865), 16–18.

48. In *Emile, ou de l'éducation,* Rousseau makes clear the distinction between appropriate and inappropriate use of a woman's education. What is unacceptable is the woman of ideas who spends her time writing novels or pamphlets.

49. Ernest Legouvé, *Histoire morale des femmes* (Paris: Librairie académique Didier, 1864), 220.

50. See Taillasson's *Eloïse* (1787) and Robert Lefebvre's *Héloïse en pleurs* (1798).

51. Also, a new and beautifully illustrated translation of the letters was published in France in 1839: E. Ouddol, *Lettres d'Abeilard et d'Héloïse, traduites sur les manuscrits de la Bibliothèque Royale,* 2 vols. (Paris: E. Houdaille, 1839).

52. "Salon de 1845," in Théophile Thoré, *Salons de Théophile Thoré* (Paris: Librairie internationale, 1868), 144–45.

53. "Le Panthéon: Peintures murales," in Théophile Gautier, *L'Art moderne* (Paris: Michel Levy frères, 1856), 56.

54. In 1838 Michelet was named professor of ethics and history at the Collège de France. He was accused of using the classroom for his anticlerical propaganda, and his course was suspended on the eve of the 1848 Revolution in January and reinstated just after. The course was permanently suspended in 1851.

55. Jules Michelet, *Histoire de France, Moyen âge in Oeuvres complètes,* vol. 17 (Paris: Flammarion, 1833–69), 225–26. The perception of Abélard as the forerunner of liberal, humanistic concerns was not unique to Michelet. Having chosen the Middle Ages as a transitional and enlightened "episode" in the history of human progress, nineteenth-

century philosophers of history required a male ancestor whom they could credit with revitalizing and perpetuating the intellectual traditions they would inherit. Jean-Jacques Rousseau openly identified with his fictionalized and modern version of Abélard, Saint-Preux. And Alphonse Esquiros, like Michelet, claimed Rousseau as an incarnation of Abélard in *Histoire des martyres de la liberté* (Paris: J. Bry, 1851), 168. See also Jules Janin, "Héloïse et Abeilard," *La Sylphide* 10 (22 December 1844): 459–68.

56. In *Le Génie du Christianisme* (1842), e.g., Edgar Quinet argues that religion is central to the study of the meaning of history. All institutions, including those of art, are products of religion. And he sees that his job, like that of a modern-day priest, is to elucidate that history.

57. A great deal of literature exploring the influence of women on the moral development of France appeared during this period. See, e.g., L. Cellier, *Les Femmes considérées sous le rapport de leur influence sur le bonheur des sociétés* (Paris: Roy-Terry, 1830).

58. Quoted in *La Sculpture française au XIXe siècle* (ex. cat., Paris: Galeries Nationales du Grand Palais, 10 April–28 July 1986), 197.

59. A. Transon, *Religion Saint Simonienne. Affranchissement des femmes* (Paris: Au Bureau du Globe, 1832).

60. Saint-Amand Bazard, *Aux femmes sur le mission religieuse dans la crise actuelle* (Paris, 1831), 120.

61. *La Femme nouvelle, Apostolat des femmes* (15 August 1832), 2.

62. Little is known about the sculptor Ganneau, who called himself Le Mapah. See Charles Yriarte, *Paris grotesque. Les Célébrités de la rue* (Paris, 1864), 85–124.

63. Charles Louandre, "Du mouvement Catholique en France depuis 1830," *Revue des deux mondes* (1844): part 1 of 3, 130.

64. For an illustration of the position that France will be saved by a female prophet see "Un Mariage Vendéen," *La Mode* 3, no. 4 (1833).

65. Charles Louandre, "Du mouvement Catholique en France," 100.

66. Especially useful are Bruno Foucart, *Le Renouveau de la peinture religieuse en France, 1800–1860* (Paris: Arthena, 1987); and Michael Paul Driskell, *Representing Belief: Religion, Art, and Society in Nineteenth-Century France* (University Park: Pennsylvania State University Press, 1992).

67. Gabriel-Desiré Laverdant, *La Mission de l'art et du rôle des artistes. Salon de 1845*, (Paris: Aux bureau de la Phalange, 1845), 33.

68. See Achille Rousseau, *La Madeleine*, 2 vols. (Paris: Bufquin and Desessarts, 1835).

69. Lacordaire consolidated those sermons in the form of a book *Sainte Marie-Madeleine* that was published in 1860.

70. "Les Femme poetes," *Revue des deux mondes* 3 (1842): 69–70.

71. Francis Haskell, "An Italian Patron of French Neo-Classic Art," *Past and Present in Art and Taste* (New Haven: Yale University Press, 1987), 55–56.

72. Ibid., 56.

73. In his "Salon de 1844," for example, Théophile Thoré cites the Canova marble as the source for Belgian artist M. Geefs' depiction of Geneviève de Brabant.

74. Delphine de Girardin, "Lettres Parisiennes (26 février 1844)," vol. 5, *Oeuvres complètes de Mme E. de Girardin*, 224.

75. Ibid., 223.

76. Ibid., 224.

77. Laverdant, *La Mission de l'art et du rôle des artistes*, 34.

78. Ibid.

79. Alphonse Esquiros, "La Beauté de la femme selon le Christianisme," *L'Artiste. Revue de Paris* 6 (19 April 1847): 101, 103.

80. This important commission was awarded to Paul Delaroche. While Delaroche was in Italy making drawings for the project, Minister of the Interior Adolphe Thiers made

the controversial decision to split the commission to give Jules Ziegler the opportunity to paint the apse. After many appeals and a great deal of public debate, Delaroche was consoled with the commission for the mural in the hemicycle of the Ecole des Beaux-Arts in Paris. For an analysis of this controversy see Michael Paul Driskell, "Eclecticism and Ideology in the July Monarchy: Jules-Claude Ziegler's Vision of Christianity at the Madeleine," *Arts Magazine* 56, no. 9 (May 1982): 119–29.

81. "L'Eglise de la Madeleine. Peinture," *L'Artiste* 2 (1841): 311, 312.

82. *Journal des artistes* 1, no. 19 (1835); *Journal des femmes* 11 (1835): 169.

83. Adèle Daminois, "Madeleine. Nouvelle légende," *Journal des femmes* 11 (1835): 177.

84. Alphonse Esquiros, *L'Evangile du peuple* (Paris: Le Gallois, 1840), 320.

85. Gautier also treats this theme in "Toison d'or," and Alfred de Musset borrows it for his short story "Tableaux d'église."

86. Friedrich Hebbel's 1844 play "Maria Magdalena," which was translated and disseminated widely in western Europe, was one of the most influential vehicles for reviving the doctrine of charity and compassion in this period. It is a secular tale of a modern bourgeois Magdalene whose tragic suicide could easily have been prevented if her father had been more compassionate and less concerned with social mores.

87. Alphonse Esquiros, *Les Vierges folles,* 4th ed. (Paris: P. Delavigne, 1844), 209.

88. Quoted in Bruno Foucart, *Le Renouveau de la peinture religieuse en France, 1800–1860* (Paris: Arthena, 1987), 238.

89. This emphasis on reinspiring acts of Christian charity also functioned, ultimately, to muffle or supplant all discussion of any genuine social reorganization.

90. In an 1842 Salon review of Signol's paintings by L. Peisse in *Revue des deux mondes,* the convergence of Mary and Madeleine is noted: "C'est là . . . tout ce qui peut se dire à propos de la Vierge mystique et de la Femme adultère" (115–16). There undoubtedly was a relation between the increase in images of "femmes adultères" and the surge in clandestine prostitution among the working classes during the July Monarchy and Second Empire. See Alain Corbin, *Les Filles de noce: Misère sexuelle et prostitution aux dix-neuvième et vingtième siècles* (Paris, 1978); and Jill Harsin, *Policing Prostitution in Nineteenth-Century Paris* (Princeton, 1988).

91. For a full discussion see Françoise Bardon, "Le Thème de la Madeleine pénitente au dix-septième siècle en France," *Journal of the Warburg and Courtauld Institute* 5, no. 31 (1968): 274–306.

92. *Natura naturans,* or "natural nature," refers to the cultural construction and commodification of the concept of the countryside or the picturesque that began during the July Monarchy. See Nicholas Green, *The Spectacle of Nature: Landscape and Bourgeois Culture in Nineteenth-Century France* (Manchester: Manchester University Press, 1990).

93. This painting, which used to be in the collection of the Dresden Museum, has been lost since the bombing of that city in World War II. The most well-known reproduction of the work is in Charles Blanc's *Ecole lombarde* (Paris: Renouard, 1875), which attributes the work to Correggio. The nineteenth-century debate over the validity of the attribution is detailed in Ivan Lermolieff [Giovanni Morelli], *Die Werke italienischer Meister in den Galerien von München, Dresden, und Berlin* (Leipzig: Seemann, 1880). The widespread interest in the Dresden Magdalene by Correggio, specifically as an emblem of female redemption, is discussed by Ellen G. D'Oench in "Prodigal Sons and Fair Penitents: Transformations in Eighteenth-Century Popular Prints," *Art History* 13, no. 3 (September 1990): 328–43.

94. An engraved version of this painting was published in the *Journal des artistes* 2, no. 3 (1841): 57. Corot's *Jeune femme étendue et lisant* is another example of interest in this theme.

95. The conflation of the iconography of la liseuse and Mary Magdalene was not unique to Diaz. See Mary Tompkins Lewis, *Cezanne's Early Imagery* (Berkeley: University of California Press, 1989). Though she does not contextualize it, Lewis locates the preliminary ideas and composition for Cezanne's *La Madeleine* in several of the artist's drawings of women reading from the 1860s.

96. Quoted in Jean Bouet, *The Barbizon School* (London: Thames and Hudson, 1972), 105.

97. Anna Jameson, *Sacred and Legendary Art* (Boston: Houghton Mifflin, 1895), 355.

98. Théophile Thoré, "Salon de 1838," *Revue de Paris* 52 (April 1838): 275.

99. See, e.g., "Musée Royal: Exposition de 1831," *La Mode. Revue du monde élégant*, 2 July 1831, 8.

100. The confusion of genres is addressed in F(arcy), "Exposition de 1835 (2)," *Journal des artistes*, 9th year, vol. 1, no. 10 (8 March 1835): 145. Another example of this phenomenon is the much-admired sculpture of M. Grass, *Petite paysanne bretonne*, exhibited at the Salon of 1839 and illustrated in an engraved version in *Magasin pittoresque* 7 (1839): 121. The scantily clad Breton peasant girl is seated on a rock much like Roqueplan's Madeleine. She stares melancholically at the ground as she toes a skull next to her foot.

101. Anon., *Marie-Madeleine*, trans. Lady Mary Fox (London: Longman, Brown, Green, and Longman, 1851), 74.

102. These aspects of her legend were not inaccessible to nineteenth-century artists who were free to revive these traditions. For example, Lacordaire's popular lectures on Mary Magdalen in the 1840s at Notre Dame included the saint's hermitage and teaching mission.

103. Claire Moses, *French Feminism in the Nineteenth Century* (Albany: State University of New York Press, 1984), 106.

104. Louandre, "Du mouvement Catholique en France," 130.

105. The Magdalene, specifically as figured by Canova, was a favorite symbol for the actress and writer Marie Dorval in her conversations with her close friend George Sand. See *Oeuvres complètes de George Sand, Histoire de ma vie* (1847; reprint, Paris: Calmann-Levy, 1925), 205–37.

106. P. J. Proudhon, *La Pornocratie, ou les femmes dans les temps modernes* (Paris: A. Lacroix, 1875), 166.

107. Ibid., 167.

108. This is also very much the characterization of Félicité des Touches in Balzac's *Beatrix* (1838), the figure who is modeled after Sand.

109. According to the Boulanger archive in the Documentation du Louvre, the work at one time was in the private collection of M. le Dr. Cohen. Though it has been assigned this title, there is no documentation to validate it. I believe that it has been confused with Boulanger's drawing *George Sand en Madeleine*, which was in the collection of M. Cantinelli. Both of these images are problematic. They are cited in Aristide Marie's *Le Peintre-poete. Louis Boulanger* (1925) but not in Monica Geiger's *Louis Boulanger, peintre-graveur de l'époque romantique, 1806–1867* (ex. cat., Dijon: Musée des Beaux-Arts, 1970), the next major publication on the artist. Also, there is no substantial mention of Boulanger in Sand's extensive correspondence, even though they had many friends in common. I am less convinced of the attribution of the tondo than of the drawing *George Sand en Madeleine*, which is consistent in style, medium, and format with a series of author portraits (of Dumas fils and Balzac, among others) Boulanger produced in the late 1830s.

110. See, e.g., Thomas Couture's *Rêverie* (1840–41) and Auguste Charpentier's *Mélancolie* (c. 1840).

111. In fact, Jules Michelet's journal refers to the copy of Albrecht Dürer's 1513 engraving *Melancholia I* that hung in his study and which apparently had become a cult object in Paris during the 1830s and 1840s. The appropriation of a female identity by a

male artist seeking to characterize an invisible creative self was not uncommon in the nineteenth century. One fascinating deployment of this theme pointed out to me by Susan Sage Heinzelman occurs in Rebecca Harding Davis' short story *Life in the Iron Mills; or the Korlwoman* (1861).

112. This variant is a kind of evil twin that manifests itself as a vogue among women to affect the posture of *la femme pensée*. In Baudelaire's "The Painter of Modern Life," it is described as the tendency to cultivate "a faraway look in their eyes or a fixed stare" as they assume poses that are theatrical and solemn, "like the play or opera they are pretending to watch" (428–29). In his 1834 poem "Melancholia," Théophile Gautier explicitly links the female personification of melancholia with the woman of ideas: modern melancholy, he writes, "follows the opera, never misses a ball, and . . . with each sigh she breathes a novel."

113. Mary Magdalene was selected by a number of nineteenth-century male artists as a kind of alter ego of female sensibility. *Le Peintre d'enseignes*, for instance, which appeared in *L'Artiste* in 1845, concerns an artist whose childhood parallels that of the modern Magdalene. Orphaned and destitute as a child, he suffers from an absence of faith and true love. It is only in the act of painting "Une Madeleine au désert" and in his search to find a genuinely repentant Magdalene to act as his model that he can redeem himself. There are frequent pictorial puns about "Madeleines" posing for paintings of *La Madeleine* in nineteenth-century caricature. See, e.g., Octave Tassaert's lithograph *Corner of a Studio* (1845) and Gavarni's lithograph *La Madeleine, c'était une femme* (1838).

114. This conversion was, in large part, a response to the writings and lectures of Christian socialist Pierre Leroux.

115. Most of these exceptions build on overused rhetorical paradigms that represent George Sand emblematically. During the July Monarchy, e.g., her appearance and biography were regularly treated as a metaphor for the revolutions of 1830 and 1848. Also in this period, for those in search of an androgynous prophet, she signified the unification of all virtues of male virility and female inspiration.

116. Charles Baudelaire, "Salon de 1845," in *Art in Paris, 1845–1862*, trans. Jonathon Mayne (Oxford: Phaidon, 1965), 3.

117. Arsène Houssaye, "Salon de 1845," *L'Artiste*, 6 April 1845, 210.

118. Sand's novels and well-known acts of compassion (her letters of encouragement and advice to proletarian poets, her underwriting of a journal to provide a forum for the issues of workers, her sponsorship of free evenings of theater for those who could not otherwise attend) were agents of the kind of charity and love that Mary Magdalene symbolized during the July Monarchy.

119. Quoted in Andre Joubin, "L'Amitié de George Sand et d'Eugène Delacroix," *Revue des deux mondes* 21 (15 June 1934): 844.

120. Ibid., 845.

121. Letter from Eugène Delacroix to Pierret (22 June 1842), in André Joubin, *Correspondance générale de Eugène Delacroix* (Paris: Plon, 1936), 112.

122. Victor Hugo, "Obsèques de George Sand, 10 juin 1876," reprinted in Nicole Priollaud, ed., *La Femme au 19e siècle* (Paris: Liana Levi, 1983), 135.

## Chapter 5: Portraits of the Woman of Ideas: Muse and Sphinx

1. Charles Baudelaire, "The Salon of 1846," in *Art in Paris, 1845–1862*, trans. Jonathon Mayne (Oxford: Phaidon Press, 1965), 89.

2. Baudelaire, "Salon of 1846," 89–90. According to Jonathon Mayne, Baudelaire is referring to Hoffmann's *Nachricht von den neuesten Schicksalen des Hundes Berganza*, for

which Hoffmann borrows the character of the speaking dog Berganza from a story by Cervantes. Corinne is the heroine of Germaine de Staël's 1807 novel of that title. The first woman of ideas glorified in a novel, Corinne became the model against which and in relation to all nineteenth-century female intellectuals defined themselves. The Corinne phenomenon is discussed at length in this chapter.

3. Ibid., 88–89.

4. Albert de la Fizelière, "Salon de 1844," *L'Artiste* (1844): 111; and "République des arts et des lettres," *L'Artiste* 30, 160.

5. Honoré de Balzac, *Béatrix* (1838; reprint, New York: Nottingham Society, 1901), 64.

6. A more empowering version of this paradigm can be found in French feminist revisions of the Lacanian formulation of the female hysteric as sphinx. For a celebration of the liberating potential of this persona see Helene Cixous, "The Laugh of the Medusa," in Elaine Marks and Isabelle de Courtivran, eds., *New French Feminists* (New York: Schocken Books, 1981), 245–65.

7. Mario Praz, *On Neoclassicism*, trans. Angus Davidson (London: Thames and Hudson, 1969), chap. 12.

8. My spelling of *Sappho* changes throughout this chapter because, just as the poet is dehistoricized and fictionalized, the spelling of her name is altered at the whim of the writer. When I refer to the ancient Greek lyric poet, I will use two p's; otherwise, I am duplicating alternative spellings as they were published. For an analysis of this phenomenon see Joan DeJean, *The Fictions of Sapho, 1546–1937* (Chicago: University of Chicago Press, 1989).

9. This phenomenon is the same as the one I discussed in Chapter 4 in relation to Héloïse.

10. Though the French remained obsessed with the subject of Sappho until the end of the nineteenth century, their control of the scholarly apparatus was finally challenged in the eighteenth century by the Germans.

11. DeJean, *Fictions of Sapho*, 16.

12. Ibid., chap. 2.

13. Gros was commissioned to paint this picture by General Dessoles, a close friend of Napoleon.

14. DeJean, *Fictions of Sapho*, 176.

15. See, e.g., Emile Deschanel, "Etudes sur l'antiquité. Sappho et les lesbiennes," *Revue des deux mondes* 17 (1847): 330–57.

16. See, e.g., François-Pascal-Simon Gérard's *Portrait of Mme de la Pleigne* (c. 1810). For a lengthy treatment of the manipulation of the muse motif see Helen Borowitz, "Two Nineteenth Century Muse Portraits," *Bulletin of the Cleveland Museum of Art* 66 (September 1979): 247–67.

17. Juliette Récamier apparently functioned as the intermediary; she both recommended the idea to the prince and arranged the details of the commission with Gérard. She also ended up with the painting.

18. Germaine de Staël, *Corinne, or Italy*, trans. Avriel H. Goldberger (New Brunswick: Rutgers University Press, 1987), 244.

19. Robert Baschet, ed., *Journal de Etienne-Jean Delécluze, 1824–1828* (Paris: Bernard Grasset, 1948), 372, 246–47.

20. Delphine Gay was asked to perform, e.g., at the opening ceremonies for Baron Gros's dome frescoes at St. Geneviève. See Praz, *On Neoclassicism*, 265.

21. Louis Belmontet, "Improvisations," *Poèsies complètes* (Paris, 1856), 219.

22. Her efforts to preserve a broad base of support by distinguishing herself from the bourgeois bluestocking included an attack by the Vicomte de Launay against "les femmes littéraires . . . un des fléaux de l'époque" in "Lettres Parisiennes," *Oeuvres complètes de Mme Emile de Girardin*, vol. 5 (Paris: H. Plon, 1860–61), 440.

23. The insistence among nineteenth-century male writers on seeing the female mind and the female body as disparate elements is discussed at length in relation to representations of Mary Magdalene in Chapter 4.

24. Delphine de Girardin also commissioned Chassériau in 1843 to design the costumes for her first play, *Judith*.

25. DeJean, *Fictions of Sapho*, 266.

26. Arsène Houssaye, "De la République de Platon," *L'Artiste. Revue de Paris* (1 July 1848), 173–76. Houssaye's *Sapho, drame antique en trois actes* appeared in three installments in *L'Artiste*, on 15 October 1850, 150–53; 1 November 1850, 167–72; and 15 November 1850, 182–84.

27. Lesbianism was an increasingly common theme after 1850, particularly in the oeuvre of Gustave Courbet.

28. Théophile Gautier, "Salon de 1848," *La Presse*, 23 April 1848, 2.

29. Ibid.

30. "Salon de 1848," *L'Illustration* 11, no. 1 (1848): 211–12.

31. Théophile Gautier, "Nécrologie de James Pradier," *La Presse*, 10 June 1852.

32. *Journal des artistes*, 21 December 1845, 6.

33. See *Statues de chair. Sculptures de James Pradier* (ex. cat., Geneva: Musée d'art et d'histoire, 17 October 1985–2 February 1986), 171–76.

34. Théophile Gautier, "Font de la Sapho," *La Presse*, 9 December 1849, 2.

35. "Nécrologie de James Pradier," *L'Artiste. Revue de Paris*, July 1852, 2.

36. The best discussion of the portrait statuette appears in "Portrait Sculpture," in James Holderbaum, *The Romantics to Rodin, French Nineteenth Century Sculpture from North American Collections* (ex. cat., Los Angeles: Los Angeles County Museum of Art, 1980), 36–51.

37. James Smith Allen, *Popular French Romanticism: Authors, Readers, and Books in the Nineteenth Century* (Syracuse, N.Y.: Syracuse University Press), 103.

38. For a discussion of Girardin's salon see Marcel Bouteron, *Muses romantiques* (Paris: Librairie Plon, 1934), 113, 118. An important prototype for the kind of collaborative venture that evolved from a salon setting to which I refer is the journal *La Muse Française* (1823–24), which was launched by participants in Charles Nodier's *cenacles* at the Arsenal. Other major July Monarchy salons included those of Sophie Gay, Marie d'Agoult, and Christina Belgiojoso, all of whom modeled their gatherings after the most famous early-nineteenth-century salon, Mme Récamier's.

39. Many other femme-auteur portraits were commissioned or reproduced for less expensive and more widely circulated volumes like *Galerie de la Presse* and *Galerie des contemporaines illustres*, collections of celebrity portraits offered on promotional bases to subscribers of Maison Aubert publications.

40. It was in Pradier's studio that Colet met Gustave Flaubert in 1843.

41. John Milton, "Il Penserosa," in *The Portable Milton*, ed. Douglas Bush (New York: Viking Press, 1949), 67.

42. Colet and Pradier appear to have had a long and close friendship. He did another portrait of the writer, a bust that is now lost. On the occasion of his death Colet commemorated the artist with a poem, which she included in her collection *Ce qui est dans le coeur des femmes* (Paris: Librairie nouvelle, 1852).

43. The German Lehmann was ineligible to compete for the Prix de Rome because he was not a naturalized citizen. In 1839 he decided to travel on his own to Italy, where he could study with his former teacher Ingres.

44. Though Agoult had introduced Sand and Chopin in 1835, their romance did not begin until 1838.

45. Like most art critics, Daniel Stern denigrated the art that she judged opposed or inferior to that of her friends Ingres and Lehmann. Her most critical reviews were directed at Delaroche and Papety. Indoctrinated by the lessons of Ingres and the model of

Rome, Stern used her position as art critic to promote the study of antiquity and the cult of Raphael, to which she had first been exposed at the Villa Medici.

46. Solange Joubert, ed., *Une Correspondance romantique, Madame d'Agoult, Liszt, Henri Lehmann* (Paris: Flammarion, 1947), 168–69, 175. The depth of Ingres' admiration is revealed in a drawing he executed in 1849. Marie d'Agoult and her daughter Claire are seated on each end of a sculpted sofa; their intimacy is established by the meeting of their shoes on the single footstool that they share and by the placement of Claire's left hand on the outstretched arm of her mother. The writer sits back confidently in her seat; her back and shoulders are straight and regal, and her head projects forward slightly to engage the viewer. It is a dignified Marie d'Agoult as mère-educatrice who is looked to eagerly for words of wisdom by her daughter.

47. Letter from Lehmann to Agoult, 28 June 1839, in Joubert, *Une Correspondance romantique*, 22–23.

48. Letter from Lehmann to Agoult, 24 October 1840, in Joubert, *Une Correspondance romantique*, 131–33.

49. Letter from Lehmann to Agoult, 16 December 1840, in Joubert, *Une Correspondance romantique*, 137–40.

50. Though Ingres had relocated in Paris by May 1841, leaving Lehmann in Rome for another eight months, he continued to be involved in his student's work. In a letter to Lehmann, Agoult describes a recent visit by Ingres, who had come to see her portrait. She reports that Ingres raved about Lehmann's 1839 head study and found it neccessary only "qu'il remplisse un peu les joues" (Joubert, 169). When Lehmann himself returned to Paris he reclaimed his place in the social community and resumed his collaborative work with Ingres.

51. In September 1841, four months before Lehmann left Rome, he received word from Marie d'Agoult that she required a portrait drawing of herself for Liszt.

52. Letter from Ingres to Gilibert, 26 June 1842, in Boyer d'Agen, *Ingres d'après une correspondance inéditée* (Paris, 1909), 349. The portrait drawing requested by Liszt was completed between 8 March and 7 May 1842. On the earlier date Liszt wrote to Marie d'Agoult asking for a description of the image, and on the latter date he wrote to express his enthusiasm for the image. Lehmann must have used the drawing as a study for the oil, which he had to have begun work on after April 1842, just a month and a half before Ingres executed a preliminary sketch for the portrait of Haussonville.

53. See Théophile Thoré, "Salon de 1846," 59.

54. Encouraged by Ingres during his stay in Italy, Lehmann visited and studied the paintings of Herculaneum and Pompeii.

55. Penelope's limp-wrist-to-chin gesture was well known to Lehmann. It is quoted in Ingres' *Antiochus and Stratonice* as well as in one of Lehmann's portrait drawings of Marie d'Agoult.

56. According to Greek legend, Ulysses was forced to leave his wife Penelope and newborn son Telemachus to lead an expedition against Troy. Though he does not return for twenty years, and though Penelope is pursued by dozens of suitors, she remains loyal and convinced that he will return. Like Penelope in the Macellum mural, Agoult stands at a three-quarter angle facing to her right away from the picture plane. Both women have their hair pulled back in a chignon, and both, seen from an almost complete profile view, stare downward. Their arms identically hug their bodies, the left one bent at the elbow and pulled across the waist as a horizontal support for a vertically raised right arm.

57. Letter from Lehmann to Agoult, 16 October 1839, in Joubert, *Une Correspondance romantique*, 54. The highly stylized and self-conscious environment he envisions for the 1839 head study is achieved only in the 1843 oil portrait.

58. It also ignores the context of private imagery. Although the encyclopedic nature of Sand's letters and memoirs makes it unlikely that any genuine portrait could have

slipped by unnoticed, there is a large body of imagery—produced by such close friends as Alfred de Musset, Pauline Viardot, and Sand's son Maurice during visits to Nohant—that is not specifically commented on in her writings.

59. Curtis Cate, *George Sand* (Boston: Houghton Mifflin, 1975), x.

60. "Femmes de lettres françaises contemporaines," *L'Illustration*, 22 June 1844, 264–67.

61. Letter from Sand to Buloz, 18 July 1836, in Georges Lubin, ed., *Correspondance de George Sand* (Paris: Garnier, 1964–91), 3: 526; and Letter from Sand to Sylvain Lasnier, 25 June 1836, in Lubin, *Correspondance*, 3: 444.

62. "Femmes de lettres françaises contemporaines," 266.

63. Ibid.

64. Jules Janin, "Galerie Contemporaine," *La Mode,* July–October 1835, 178.

65. Letter from Sand to George Henry Lewes, printed in "Quarante-quatre lettres inédits," in Georges Lubin, ed., *Présence de George Sand* (1982): 32–33.

66. Her authority is also underscored by her representation in such anthologies as *Biographie des femmes auteurs contemporaines* (1837), for which she was allowed to write her own biographical statement and pen her own public persona.

67. Théophile Thoré, "George Sand, dessiné et gravé par M. Calamatta," *L'Artiste* 22, 2nd ser., vol. 7 (1841): 10. Thoré was a great admirer of Sand. He dedicated his "Salon of 1846" to her and in his "Salon de 1844" compared her writing to painting.

68. Ibid.

69. Ibid., 10.

70. Cate, *George Sand,* 448.

71. It is known today in its oval format because Sand's daughter Solange, to whom the image belonged after Sand's death, decided to cut and reformat the painting. The original format is known today through a lithographic copy by Lassalle.

72. See Etienne-Jean Délécluze, "Salon de 1839," *Journal des débats,* 7 March 1839; Charles Blanc, "Salon de 1839," *Revue du Progrès,* 1 May 1839, 477; and Alexandre Decamps, "Salon de 1839," *Le National,* 13 May 1839, 1.

73. Jules Janin, "Salon de 1839," *L'Artiste,* 2nd ser., vol. 2 (1839): 260.

74. George Sand, "M. Ingres et M. Calamatta," *Le Monde,* 1 April 1837, 94–104.

75. Thoré, "George Sand," 10.

76. Ibid.

77. Ibid., 9.

## Conclusion

1. Clifford Geertz, "Centers, Kings, and Charisma: Reflections on the Symbolics of Power," in Joseph Ben-Davis and Terry Nichols Clark, eds., *Culture and Its Creators: Essays in Honor of Edward Shils* (Chicago: University of Chicago Press, 1977), 150–71.

2. For extended analyses of this phenomenon see Lynn Hunt's and Joan Landes' work on late-eighteenth-century political allegory: Hunt, *The Family Romance of the French Revolution* (Berkeley: University of California Press, 1992); and Landes, *Women in the Public Sphere in the Age of the French Revolution* (Ithaca, N.Y.: Cornell University Press, 1988).

3. The monstrous aspect of this dichotomy probably derives, in part, from personifications of anarchy that appeared in Gravelot and Cochin's late-eighteenth-century illustrations for Cesar Ripa's *Iconologie,* originally published in 1603. See Maurice Agulhon, *Marianne into Battle: Republican Imagery and Symbolism in France, 1789–1880,* trans. Janet Lloyd (Cambridge: Cambridge University Press), chap. 1.

4. Female allegorical figurations of liberty offer a compelling example of the fluid boundaries between the real and the symbolic. These figurations, which resonated quite differently for supporters and detractors of the republic in France, were fraught with internal contradiction from their inception. For some Liberty was the transcendent symbol of freedom; for others she was the earthbound woman of the people. Accordingly, her features alternated between a dynamic, young, and sexualized Marianne and a staid and classically delineated goddess. Liberty was the most popular of a group of symbolized "sister" principles that included justice, the republic, and victory. While her iconography was more codified than most, her attributes and features remained elastic enough to be confused with the others'. Like the historical representations of Héloïse or George Sand, the identity of Liberty was malleable. One "real" female experience that shaded symbolic figurations of civic virtues was that of the woman of ideas, who, like Liberty, as we have seen, was alternately praised as the messiah of a new world order and vilified as a force of social dissolution. The boundary between real and symbolic was further complicated by the tradition of "live allegory," of actual women acting out the part of Liberty in public ceremonials and revolutionary festivals. See, e.g., Mona Ozouf, *Festivals and the French Revolution*, trans. Alan Sheridan (Cambridge: Harvard University Press, 1988).

5. See also "Crise ministérielle," *La Mode*, January–April 1835, 232.

6. "Lolo-phiphi à la cour d'assises," *La Caricature*, 4 August 1831, 339.

7. See James Cuno, "Charles Philipon and La Maison Aubert: The Business, Politics, and Public of Caricature in Paris, 1820–1840" (Ph.D. diss., Harvard University, 1985).

# Bibliography

## Secondary Sources

Abensour, Léon. *La Femme et le féminisme avant la révolution.* Paris: Editions Ernest Leroux, 1923.

Abray, Jane. "Feminism in the French Revolution." *American Historical Review* 80, no. 1 (February 1975): 43–62.

Adler, Laure. *A L'Aube du féminisme: Les Premières journalistes, 1830–1850.* Paris: Payot, 1979.

Agulhon, Maurice. *Marianne into Battle: Republican Imagery and Symbolism in France, 1789–1880.* Trans. Janet Lloyd. Cambridge: Cambridge University Press, 1981.

Allen, James Smith. *Popular French Romanticism: Authors, Readers, and Books in the Nineteenth Century.* Syracuse, N.Y.: Syracuse University Press, 1981.

———. *In the Public Eye: A History of Reading in Modern France, 1800–1940.* Princeton: Princeton University Press, 1991.

Bardon, Françoise. "Le Thème de la Madeleine pénitente au XVIIème siècle en France." *Journal of the Warburg and Courtauld Institute* 31(1968): 274–306.

Barthes, Roland. *Michelet.* Trans. Richard Howard. New York: Hill and Wang, 1975.

———. *S/Z.* Trans. Richard Miller. New York: Hill and Wang, 1974.

Bechtel, Edwin. *Freedom of the Press and L'Association Mensuelle—Philipon versus Louis-Philippe.* New York: Grolier Club, 1952.

Benjamin, Walter. "The Paris of the Second Empire in Baudelaire." In *Charles Baudelaire: A Lyric Poet in the Era of High Capitalism,* trans. Harry Zohn. London: NLB, 1973.

Berkin, Carol, and Clara Lovett, eds. *Women, War, and Revolution.* New York: Holmes and Meier, 1980.

Bodek, Evelyn. "Salonières and Bluestockings: Educated Obsolescence and Germinating Feminism." *Feminist Studies* 3 (Spring–Summer 1976), 185–99.

Boxer, Marilyn, and Jean Quataert, eds. *Socialism and Women: European Socialism and Feminism in the Nineteenth and Early Twentieth Centuries.* New York: Elsevier, 1978.

Butler, Judith. *Gender Trouble.* New York: Routledge, 1990.

Buust, A. J. L. "The Image of the Androgyne in the Nineteenth Century." In Ian Fletcher, ed., *Romantic Mythologies,* 1–95. New York: Barnes and Noble, 1967.

Chadonneret, Marie-Claude. *La Figure de la République: Le Concours de 1848.* Paris: Ministère de la Culture et de la Communication/Editions de la Réunion des musées nationaux, 1987.

Clark, T. J. *The Absolute Bourgeois: Artists and Politics in France, 1848–1851.* Princeton: Princeton University Press, 1982.

———. *Image of the People: Gustave Courbet and the 1848 Revolution.* Princeton: Princeton University Press, 1982.

Cuno, James. "The Business and Politics of Caricature. Charles Philipon and La Maison Aubert." *Gazette des Beaux-Arts,* October 1985, 97–112.

Daumard, Adeline. *La Bourgeoisie Parisienne de 1818 à 1848.* Paris: SEVPEN, 1963.

David, Deidre. *Intellectual Women and Victorian Patriarchy.* Ithaca, N.Y.: Cornell University Press, 1987.

Davis, Natalie Zemon. "Women on Top." *Society and Culture in Early Modern France.* Stanford: Stanford University Press, 1965.

DeJean, Joan. *The Fictions of Sapho, 1546–1937.* Chicago: University of Chicago Press, 1989.

———. *Tender Geographies: Woman and the Origin of the Novel in France.* New York: Columbia University Press, 1991.

Dijkstra, Bram. "Androgyne in Art and Literature." *Comparative Literature* 26 (1974): 63–73.

Duncan, Carol. "Happy Mothers and Other New Ideas in Eighteenth-Century French Art." *Art Bulletin* 55 (December 1973): 570–83.

Ezdinli, Leyla. "George Sand's Literary Transvestism." Ph.D. diss., Princeton University, 1988.

Flint, Kate. *The Woman Reader, 1837–1914.* Oxford: Oxford University Press, 1993.

Folkenflik, Vivian. *An Extraordinary Woman: Selected Writings of Germaine de Staël.* New York: Columbia University Press, 1987.

Foucault, Michel. *The History of Sexuality.* Vol. 1. New York: Vintage, 1978.

———. "What Is an Author?" In Paul Rabinow, ed., *The Foucault Reader,* 101–20. New York: Pantheon, 1984.

Foucart, Bruno. *Le Renouveau de la peinture religieuse en France, 1800–1860.* Paris: Arthena, 1987.

Furet, François, and Jacques Ozouf. *Reading and Writing: Literacy in France from Calvin to Jules Ferry.* Cambridge: Cambridge University Press, 1977.

Gallagher, Catherine. "More About Medusa's Head." *Representations,* no. 4 (Fall 1983): 55–57.

Garber, Marjorie. *Vested Interests: Cross-Dressing and Cultural Anxiety.* New York: Routledge, 1992.

Gelbart, Nina Rattner. *Feminism and Opposition Journalism in Old Regime France.* Berkeley: University of California Press, 1987.

Green, Nicholas. *The Spectacle of Nature: Landscape and Bourgeois Culture in Nineteenth-Century France.* Manchester: Manchester University Press, 1990.

Grubitzsch, Helga. "Women's Projects and Co-operatives in France at the Beginning of the Nineteenth Century." *Women's Studies International Forum,* no. 4 (17–21 April 1984): 279–86.

Gutwirth, Madelyn. *Madame de Staël, Novelist: The Emergence of the Artist as Woman.* Urbana: University of Illinois Press, 1978.

Hertz, Neil. "Medusa's Head: Male Hysteria Under Political Pressure." *Representations,* no. 4 (Fall 1983): 28.

Hesse, Carla. *Publishing and Cultural Politics in Revolutionary Paris, 1789–1810.* Berkeley: University of California Press, 1991.

Hunt, Lynn. *The Family Romance of the French Revolution.* Berkeley: University of California Press, 1992.

Irigaray, Luce. "Ce sexe qui n'en est pas un." Trans. Claudia Reeder. In I. de Courthivron and E. Marks, eds., *New French Feminism,* 99–110. Amherst: University of Massachusetts Press, 1980.

Kantorowicz, Ernst. *The King's Two Bodies: A Study in Medieval Political Theology.* Princeton: Princeton University Press, 1957.

Kelly, Gary. *Women, Writing, and Revolution, 1790–1827.* Oxford: Oxford University Press, 1993.

Kelly, Joan. *Woman, History, and Theory.* Evanston, Ill.: University of Chicago Press, 1984.

Landes, Joan. *Women in the Public Sphere in the Age of the French Revolution.* Ithaca, N.Y.: Cornell University Press, 1988.

Larnac, Jean. *Histoire de la littérature féminine en France.* Paris, 1927.

Lehmann, Bernard. "Daumier and the Republic." *Gazette des Beaux-Arts,* January–June 1945, 103–10.

Lougee, Carolyn. *Le Paradis des femmes: Women, Salons, and Social Stratification in Seventeenth-Century France.* Princeton: Princeton University Press, 1976.

McWilliams, Neil. *Dreams of Happiness: Social Art and the French left, 1830–1850.* Princeton: Princeton University Press, 1993.

Mélot, Michel. "La Mauvaise mère: Etude d'un thème romantique dans l'estampe et la littérature." *Gazette des Beaux-Arts,* March 1972, 167–76.

———. "Daumier and Art History: Aesthetic Judgement/Political Judgement." *Oxford Art Journal* 11, no. 1 (1988): 3–24.

Miller, Nancy K. *Subject to Change: Reading Feminist Writing.* New York: Columbia University Press, 1988.

Miller, P. J. "Women's Education, Self-Improvement, and Social Mobility—A Late Eighteenth-Century Debate." *British Journal of Educational Studies* 20 (1972): 302–14.

Moers, Ellen. *Literary Women.* New York: Anchor Press/Doubleday, 1977.

Moses, Claire. *French Feminism in the Nineteenth Century.* Albany: State University of New York Press, 1984.

Ozouf, Mona. *Festivals and the French Revolution.* Trans. Alan Sheridan. Cambridge: Harvard University Press, 1988.

Pointon, Marcia. *Naked Authority: The Body in Western Painting, 1830–1908.* Cambridge: Cambridge University Press, 1990.

Puesch, Marie-Louise. "Une Supercherie littéraire: Le Véritable rédacteur de la *Gazette des femmes* (1836–38)." *La Révolution de 1848* 32 (June–August 1935): 303–12.

Radway, Janice. *Reading the Romance: Women, Patriarchy, and Popular Literature.* Chapel Hill: University of North Carolina Press, 1984.

Scott, Joan Wallach. *Gender and the Politics of History.* New York: Columbia University Press, 1988.

Struminger, Laura. "The Vesuviennes: Images of Female Warriors in 1848 and Their Significance for French History." *History of European Ideas* 8, nos. 4–5 (1987): 451–88.

Suleiman, Susan, ed. *The Female Body in Western Culture.* Cambridge: Harvard University Press, 1986.

Sullerot, Evelyne. *Histoire de la presse féminine en France des origines à 1848.* Paris: Armand Colin, 1966.

Taesca, Maurice. "Un Dîner joyeux chez George Sand." *Revue des deux mondes* 8 (1983): 340–44.

Taylor, Barbara. *Eve and the New Jerusalem*. New York: Pantheon, 1983.

Warner, Marina. *Monuments and Maidens: The Allegory of the Female Form*. New York: Atheneum, 1985.

Wechsler, Judith. *A Human Comedy: Physiognomy and Caricature in Nineteenth-Century Paris*. Chicago: University of Chicago Press, 1982.

Weil, Kari. *Androgyny and the Denial of Difference*. Charlottesville: University Press of Virginia, 1992.

Wheelwright, Julie. *Amazons and Military Maids: Women Who Dressed as Men in the Pursuit of Life, Liberty, and Happiness*. London: Pandora, 1989.

Wolff, Janet. *The Social Production of Art*. New York: New York University Press, 1981.

## Primary Sources

Alluis, Jacques. *Nouveau recueil, contenant la vie, les amours, les infortunes, et les lettres d'Abailard et d'Héloïse*. Paris: A. Anvers, 1675.

"Anne-Louise-Germaine Necker, Baronne de Staël-Holstein." *La Mode* 1 (1830): 74.

Barbier, Alexandre. *Salon de 1836: Suite d'articles publiés dans le* Journal de Paris. Paris: Paul Renouard, 1836.

Baschet, Robert, ed. *Journal de Etienne-Jean Delécluze, 1824–1828*. Paris: Bernard Grasset, 1948.

Baudelaire, Charles. "The Painter of Modern Life." *Baudelaire: Selected Writings on Art and Artists*. Trans. P. E. Charvet. Baltimore: Penguin, 1972.

Bazard, "Aux Femmes sur leur mission religieuse dans la crise actuelle." *L'Organisateur*. Rouen: D. Brière, 1831.

Beraldi, Henri. *Les Graveurs du XIXe siècle*. 12 vols. Paris: Conquet, 1885–92.

Blanc, Louis. *Histoire de la Révolution française*. 12 vols. Paris: Langlois et Leclercq, 1847–62.

Brisson, Jules, and Félix Ribeyre. *Grands journaux de France*. Paris: Jouast père, 1862.

Cellier, L. *Les Femmes considérées sous le rapport de leur influence sur le bonheur des sociétés*. Paris: Roy-Terry, 1830.

Champfleury (Jules Husson). *Histoire de la caricature moderne*. Paris: Dentu, 1865.

"Curiosités littéraires. Les demoiselles de lettres." *Le Charivari*, 30 May 1837, 1–2.

Daminois, Adèle. "Madeleine. Nouvelle légende." *Journal des femmes* 11 (1835): 175–77.

Deroin, Jeanne-Victoire. *Aux Femmes*. Paris: Auffray, n.d.

Déschanel, Emile. "Sappho et les lesbiennes." *Revue des deux mondes* 17 (1847): 330–57.

Esquiros, Alphonse. "La Beauté de la femme selon le Christianisme." *L'Artiste. Revue de Paris*, 19 April 1847, 99–103.

———. *L'Evangile du peuple*. Paris: Le Gallois, 1840.

———. *Histoire des martyres de la liberté*. Paris: J. Bry, 1851.

*Exposition des peintures et dessins de Honoré Daumier*. Paris: Gauthiers-Villars, 1878.

Fourier, François-Marie-Charles. *Théorie des quatre mouvements et des destinées générales*. Paris: Bureaux de la Phalange, 1841.

*Les Français peints par eux-mêmes*. Paris: Chez N. J. Philippart, 1842.

Gautier, Théophile. "Salon de 1848." *La Presse*, 21 April 1848.

———. "Le Panthéon, peintures murales." In Gautier, *L'Art moderne*. Paris: Michel Levy fréres, 1856.

Gay, Sophie. *Salons célèbres*. Paris: Dumont, 1837.

Girardin, Delphine de. *Chroniques Parisiennes, 1836–1848*. Paris: Editions des femmes, 1986.

Grand-Carteret, John. *La Femme en culotte*. Paris: Flammarion, n.d.

*Les Héroïnes Parisiennes, ou actions glorieuses des dames, leurs traits d'esprit et d'humanité*. Paris: Pinard, 1830.

Houssaye, Arséne. "Salon de 1845." *L'Artiste*, 6 April 1845, 208–10.

———. *Les Confessions: Souvenirs d'un demi-siècle, 1830–1880.* 6 vols. Paris: E. Dentu, 1885–91.

Hugo, Victor. "Choses vues." In *Oeuvres complètes*, vol. 31, 365–66. Paris, 1955.

Joubert, Soulange, ed. *Une Correspondance romantique, Madame d'Agoult, Liszt, Henri Lehmann.* Paris: Flammarion, 1947.

Karr, Alphonse. "Imprimeurs, librairies, bouquinistes, cabinets de lecture." *Nouveau tableau de Paris au XIX siècle.* Paris, 1835.

Laverdant, Gabriel-Desiré. *La Mission de l'art et du rôle des artistes. Salon de 1845.* Paris: Aux Bureaux de la Phalange, 1845.

Laviron, Gabriel. *Le Salon de 1834.* Paris: Louis Janet, 1834.

Legouvé, Ernest. *Histoire morale des femmes.* Paris: Librairie académique Didier, 1864.

*Marie-Madeleine.* Trans. Lady Mary Fox. London: Longman, Brown, Green, and Longman, 1851.

Martin, Henri. *Histoire de France.* 4th ed. Paris: L. Mame, 1836–76.

Mathurin, Joseph-Brisset. *Cabinet de lecture.* 2 vols. Paris: Magen, 1843.

Michelet, Jules. *Du Prêtre, de la femme, de la famille.* Paris: Hachette, 1845.

———. *Histoire de la Révolution française.* 7 vols. Paris: Chamerot, 1847–53.

———. *Les Femmes de la Révolution.* Paris: Flammarion, 1852.

"Organisation religieuse: Le Prêtre—l'homme et la femme," *Le Globe*, 18 June 1831.

*Physiologie de la presse.* Paris: Jules Laisne, 1841.

Proudhon, P. J. *La Pornocratie, ou les femmes dans les temps modernes.* Paris: A. Lacroix, 1875.

Reybaud, L. "Socialistes modernes," part 1. *Revue des deux mondes* 3 (1836): 290–91.

Rousseau, Achille. *La Magdalene.* 2 vols. Paris: Bufquin and Desessarts, 1835.

Rousseau, Jean-Jacques. *Emile, ou l'éducation.* Vol. 6. Paris: Chez Jean Neaulme, 1761.

Sauvan, Lucille. *Cours normal des institutrices primaires, ou directions relatives à l'éducation physique, morale, et intellectuelle dans les écoles primaires.* 2nd ed. Paris: Pitois-Levrault, 1840.

Simon, Jules. *L'Ouvrière.* Paris: Librairie de L. Hachette, 1861.

Soulié, Frédéric. *Physiologie du Bas-Bleu.* Paris: Aubert, 1841–42.

Staël, Germaine de. *Letters on the Works and Character of J. J. Rousseau.* Translated from French. London: J. J. Robinson, Paternoster, and Row, 1789.

———. *Oeuvres complets de Madame La Baronne de Staël-Holstein.* Paris: Firmin Didot frères, 1838.

Stahl, P. J. *Le Diable à Paris.* Paris: Hetzel, 1845–46.

Stern, Daniel [Marie D'Agoult]. *Histoire de la Révolution de 1848.* Paris: Balland, 1985.

Texier, Edmond. *Physiologie du poète.* Paris: J. Laisne, 1841.

Thoré, Théophile. "Salon de 1845." In *Salons de Théophile Thoré*, 144–45. Paris: Librairie internationale, 1868.

Transon, A. *Religion Saint-Simonienne. Affranchissement des femmes.* Paris: Au Bureau du Globe, 1832.

Waldor, Mélanie. "De l'influence que les femmes pourraient sur la littérature actuelle." *Journal des femmes* (1833): 220–24.

Yriarte, Charles. *Paris grotesque. Les Célébrités de la rue.* Paris: Dupray de la Mahérie, 1864.

# Index